PALGRAVE STUDIES IN THEATRE AND PERFORMANCE HISTORY is a series devoted to the best of theatre/performance scholarship currently available, accessible, and free of jargon. It strives to include a wide range of topics, from the more traditional to those performance forms that in recent years have helped broaden the understanding of what theatre as a category might include (from variety forms as diverse as the circus and burlesque to street buskers, stage magic, and musical theatre, among many others). Although historical, critical, or analytical studies are of special interest, more theoretical projects, if not the dominant thrust of a study, but utilized as important underpinning or as a historiographical or analytical method of exploration, are also of interest. Textual studies of drama or other types of less traditional performance texts are also germane to the series if placed in their cultural, historical, social, or political and economic context. There is no geographical focus for this series and works of excellence of a diverse and international nature, including comparative studies, are sought.

The editor of the series is Don B. Wilmeth (EMERITUS, Brown University), PhD, University of Illinois, who brings to the series over a dozen years as editor of a book series on American theatre and drama, in addition to his own extensive experience as an editor of books and journals. He is the author of several award-winning books and has received numerous career achievement awards, including one for sustained excellence in editing from the Association for Theatre in Higher Education.

Also in the series:

Undressed for Success by Brenda Foley
Theatre, Performance, and the Historical Avant-garde by Günter Berghaus
Theatre, Politics, and Markets in Fin-de-Siècle Paris by Sally Charnow
Ghosts of Theatre and Cinema in the Brain by Mark Pizzato
Moscow Theatres for Young People: A Cultural History of Ideological Coercion and Artistic Innovation, 1917–2000 by Manon van de Water
Absence and Memory in Colonial American Theatre by Odai Johnson
Vaudeville Wars: How the Keith-Albee and Orpheum Circuits Controlled the Big-Time and Its Performers by Arthur Frank Wertheim
Performance and Femininity in Eighteenth-Century German Women's Writing by Wendy Arons
Operatic China: Staging Chinese Identity across the Pacific by Daphne P. Lei
Transatlantic Stage Stars in Vaudeville and Variety: Celebrity Turns by Leigh Woods
Interrogating America through Theatre and Performance edited by William W. Demastes and Iris Smith Fischer
Plays in American Periodicals, 1890–1918 by Susan Harris Smith
Representation and Identity from Versailles to the Present: The Performing Subject by Alan Sikes
Directors and the New Musical Drama: British and American Musical Theatre in the 1980s and 90s by Miranda Lundskaer-Nielsen
Beyond the Golden Door: Jewish-American Drama and Jewish-American Experience by Julius Novick
American Puppet Modernism: Essays on the Material World in Performance by John Bell

On the Uses of the Fantastic in Modern Theatre: Cocteau, Oedipus, and the Monster
 by Irene Eynat-Confino
Staging Stigma: A Critical Examination of the American Freak Show
 by Michael M. Chemers, foreword by Jim Ferris
Performing Magic on the Western Stage: From the Eighteenth-Century to the Present
 edited by Francesca Coppa, Larry Hass, and James Peck, foreword
 by Eugene Burger
Memory in Play: From Aeschylus to Sam Shepard by Attilio Favorini
Danjūrō's Girls: Women on the Kabuki Stage by Loren Edelson
Mendel's Theatre: Heredity, Eugenics, and Early Twentieth-Century American Drama
 by Tamsen Wolff
Theatre and Religion on Krishna's Stage: Performing in Vrindavan by David V. Mason
Rogue Performances: Staging the Underclasses in Early American Theatre Culture
 by Peter P. Reed
*Broadway and Corporate Capitalism: The Rise of the Professional-Managerial Class,
 1900–1920* by Michael Schwartz
Lady Macbeth in America: From the Stage to the White House by Gay Smith
Performing Bodies in Pain: Medieval and Post-Modern Martyrs, Mystics, and Artists
 by Marla Carlson
*Early-Twentieth-Century Frontier Dramas on Broadway: Situating the Western
 Experience in Performing Arts* by Richard Wattenberg
Staging the People: Community and Identity in the Federal Theatre Project
 by Elizabeth A. Osborne
Russian Culture and Theatrical Performance in America, 1891–1933
 by Valleri J. Hohman
Baggy Pants Comedy: Burlesque and the Oral Tradition by Andrew Davis
Transposing Broadway: Jews, Assimilation, and the American Musical by Stuart J. Hecht
The Drama of Marriage: Gay Playwrights/Straight Unions from Oscar Wilde to the Present
 by John M. Clum
*Mei Lanfang and the Twentieth-Century International Stage: Chinese Theatre Placed and
 Displaced* by Min Tian
Hijikata Tatsumi and Butoh: Dancing in a Pool of Gray Grits by Bruce Baird
Staging Holocaust Resistance by Gene A. Plunka
Acts of Manhood: The Performance of Masculinity on the American Stage, 1828–1865
 by Karl M. Kippola
Loss and Cultural Remains in Performance: The Ghosts of the Franklin Expedition
 by Heather Davis-Fisch
Uncle Tom's Cabin on the American Stage and Screen by John W. Frick
Theatre, Youth, and Culture: A Critical and Historical Exploration
 by Manon van de Water
Stage Designers in Early Twentieth-Century America: Artists, Activists, Cultural Critics
 by Christin Essin
Audrey Wood and the Playwrights by Milly S. Barranger
Performing Hybridity in Colonial-Modern China by Siyuan Liu
A Sustainable Theatre: Jasper Deeter at Hedgerow by Barry B. Witham

The Group Theatre: Passion, Politics, and Performance in the Depression Era
 by Helen Chinoy and edited by Don B. Wilmeth and Milly S. Barranger
Cultivating National Identity through Performance: American Pleasure Gardens and Entertainment by Naomi J. Stubbs
Entertaining Children: The Participation of Youth in the Entertainment Industry
 edited by Gillian Arrighi and Victor Emeljanow

Entertaining Children

The Participation of Youth in the Entertainment Industry

Edited by
Gillian Arrighi and Victor Emeljanow

ENTERTAINING CHILDREN
Copyright © Gillian Arrighi and Victor Emeljanow, 2014.
Softcover reprint of the hardcover 1st edition 2014 978-1-137-30545-9
All rights reserved.

First published in 2014 by
PALGRAVE MACMILLAN®
in the United States—a division of St. Martin's Press LLC,
175 Fifth Avenue, New York, NY 10010.

Where this book is distributed in the UK, Europe and the rest of the world, this is by Palgrave Macmillan, a division of Macmillan Publishers Limited, registered in England, company number 785998, of Houndmills, Basingstoke, Hampshire RG21 6XS.

Palgrave Macmillan is the global academic imprint of the above companies and has companies and representatives throughout the world.

Palgrave® and Macmillan® are registered trademarks in the United States, the United Kingdom, Europe and other countries.

ISBN 978-1-349-45482-2 ISBN 978-1-137-30546-6 (eBook)
DOI 10.1057/9781137305466

Library of Congress Cataloging-in-Publication Data

 Entertaining children : the participation of youth in the entertainment industry / edited by Gillian Arrighi and Victor Emeljanow.
 pages cm.—(Palgrave studies in theatre and performance history)
 Includes bibliographical references and index.

 1. Performing arts and children—History. 2. Entertainers—History.
 3. Child labor—History. I. Arrighi, Gillian, editor of compilation.
 II. Emeljanow, Victor, editor of compilation.

PN1590.C45E57 2014
792.083—dc23 2013044363

A catalogue record of the book is available from the British Library.

Design by Newgen Knowledge Works (P) Ltd., Chennai, India.

First edition: May 2014
10 9 8 7 6 5 4 3 2 1

Contents

List of Figures ix

Setting the Scene: An Introduction 1
Gillian Arrighi and Victor Emeljanow

Part I Terms of Engagement

1. Musical Education and the Job Market: The Employment of Children and Young People in the Neapolitan Music Industry with Particular Reference to the Period 1650–1806 15
Rossella Del Prete

2. An American Antebellum Child-Actor Contract: Alfred Stewart and the Shift from Craft Apprentice to Wage Laborer 33
Shauna Vey

3. Children and Youth of the Empire: Tales of Transgression and Accommodation 51
Gillian Arrighi and Victor Emeljanow

4. British Child Performers 1920–40: New Issues, Old Legacies 73
Dyan Colclough

Part II By Children/for Children

5. "How much do you love me?" The Child's Obligations to the Adult in 1930s Hollywood 93
Noel Brown

6. Shifting Screens: The Child Performer and Her Audience Revisited in the Digital Age 111
Gilli Bush-Bailey

7. The Business of Children in Disney's Theater 129
Ken Cerniglia and Lisa Mitchell

8. Young Mammals: The Politics and Aesthetics of Long-Term Collaboration with Children in Mammalian Diving Reflex's The Torontonians 147
Broderick D. V. Chow and Darren O'Donnell

Part III Global Perspectives

9. The "little legong dancers" of Bali: The Rise of a Child Star in Indonesian Dance Theater 167
Laura Noszlopy

10. Child Training and Employment in Taiwanese Opera 1940s–1960s: An Overview 185
Shih-Ching H. Picucci

11. Higher Wages, Less Pain: The Changing Role of Children in Traditional Chinese Theater 201
Mark Branner

12. Defying Death: Children in the Indian Circus 219
Jamie Skidmore

Notes on Contributors 235

Index 239

Figures

4.1	Hilda backstage in the 1930s	79
6.1	Cast of *Here come the Double Deckers*	113
9.1	"Bird of Ill Omen," [1952], John Coast Collection	168

Setting the Scene: An Introduction

Gillian Arrighi and Victor Emeljanow

In his book *Youth, Popular Culture and Moral Panics*, John Springhall writes about the moral panics that have afflicted British and American middle-class observers of young people's behavior since the 1830s. With mounting anxiety they have railed against young people's consumption of and exposure to cheap theater, cheap novels, films, television, and latterly electronic media. As he explains,

> Media panics...proved enduring because of the pioneering cultural position of the young in modernity: from the 1860s as dominant consumers of mass-produced penny serials; from the 1900s as major cinema patrons; from the later 1930s unrivalled as comic-book readers; obsessive television viewers from the 1950s; and from the 1980s accomplished as operators of video recorders and computer games. This cultural power of the young in the world of commercial leisure poses a potential threat to existing power relations.

He goes on,

> ...moral panics often tell us a great deal about adult anxieties—fear of the future, of technological change, and the erosion of moral absolutes—than about the nature of juvenile misbehaviour. Attacks on the media [including theater] thereby act to conceal social uncertainties.[1]

What Springhall omits is the effect of the sheer size of the juvenile population, particularly in urban contexts from the middle of the nineteenth century, upon these middle-class observers. They felt themselves increasingly threatened by the constant presence of young people and sought to impose controlling measures through official committees of inquiry and

ultimately through legislation. In the event, as Springhall documents, they have been outmanoeuvred by the agency of the young people themselves. Of course entrepreneurs have been quick to realize that such agency could be harnessed for commercial profit, that there existed a burgeoning market of entertainment for young people, and, as we shall see, by young people. This awareness, originating in the nineteenth century, remains current today.

The principal focus of this volume is on children and young people as active participants, although in the process of cultural exchange between young people and, indeed, adults, we must be cognizant of its consumers whether young or adult, since such an exchange is fuelled by the willingness and enthusiasm of all to participate. In this equation we must also factor in "need" that embraces the reasons why young people undertake such activities, motivations that might include psychological and economic pressures and circumstances. Geographically, the volume encompasses British and North American perspectives, as well as practices, in Australasia, Italy, India, Indonesia, Taiwan, and mainland China. Thus the several contributions included here address the positioning of children within cross-cultural contexts; the circumstances of their employment within those cultures; the historical contexts that demonstrate some of the tensions between constructions of childhood and the demands placed on children by parents, by potential employers, and by the children themselves; and the attempts made by well-meaning social observers and legislators to organize and control that element in society, which has ultimately proved to be uncontrollable. What they collectively demonstrate is the continuing significance of children as vital constituents of the entertainment marketplace and therefore central to any discussion of its economies. The volume therefore enables the reader to sample attitudes toward children in differing cultural contexts; to compare and contrast conditions of employment across periods, from the eighteenth century, to the interwar years and contemporary twenty-first century practices; and, as well, to consider the role of children in large commercial organizations and on film and television.

TERMS OF ENGAGEMENT

The title of this subcategory contains both literal and metaphorical resonances. The four chapters not only refer directly to terms of employment including contractual arrangements, but they also take into account the conditions in which young people found themselves and the strategies

that they used to make their engagement both personally and economically rewarding. At the same time, they offer snapshots of the intersections between strategic state intervention—the need to find the means to cope with increasing numbers of young people often unemployed or "at risk"—and the desires of young people (and their parents) to overcome often ingrained opposition, which equated involvement in the entertainment industry with an affront to notions of childhood or with a failure to provide young people with a proper foundation for the development of good citizenship, usually based on notions of frugality and hard work. It was difficult for many to reconcile "play" with "pay." Both Rossella del Prete and Shauna Vey address the matter of apprenticeships and contractual arrangements between employers and youthful employees but in two different locations and historical periods: seventeenth and eighteenth century Naples and nineteenth century North America prior to the American Civil War. Del Prete reveals how training children for a musical profession changed the nature of the four Neapolitan conservatoria from orphanages for abandoned children to suppliers of musicians for the theaters and religious institutions of the time. This transition coincided with the emergence of the new school of Neapolitan music and in particular with the development of opera in the mid-eighteenth century. It created a demand for both vocalists and instrumentalists, which the conservatoria were prepared to supply. Thus the conservatoria, which had identified themselves as charitable institutions with strong connexions to local artisans through elaborate systems of child apprenticeships and contracts, found themselves increasingly identified as suppliers of musical laborers hired out for both religious and secular occasions. By the nineteenth century with state intervention that saw the amalgamation of the four conservatoria under one banner, the system of apprenticeships disappeared, as did the need to care for children whose presence thus became increasingly irrelevant. Shauna Vey is also concerned with the erosion of apprenticeships and demonstrates this through the example of a contract negotiated between the mother of 11-year-old Alfred Stewart and his manager Robert G. Marsh who had formed his Troupe of Juvenile Comedians in 1855. She points out that the legal battle, which involved a tug-of-war between Stewart's mother and his manager (and which received wide press coverage), demonstrates the tensions between the received traditions of master/apprentice relationships and a new modality of children as wage earners contributing directly to a family's economy. It also offers an example of the uncertainties that would plague many observers about the definition of work and training when applied to child performers. Within acting families like the Hallams

and Howards, training for the stage was undertaken by parents and relatives. There were no such opportunities for young people wanting to break into the industry from outside those charmed circles other than to attach themselves to managements, which might agree to stand *in loco parentis* for a contracted period of at least two years. Young people and their parents took their chances and as this case study shows, their success was by no means guaranteed.

Marsh's Troupe of Juvenile Comedians visited Australia, performing throughout November at the Princess's Theatre, Melbourne in 1860. Although the British "moral panic" to which we have referred had not yet reached its colonies, it would not be long before discussions about the preponderance of young people would occupy press space. By 1871 children under 14 would represent 42 percent of Australia's white population. In "Children and Youth of the Empire: tales of transgression and accommodation," the authors investigate some of the legal and political correspondences between British and Australian attitudes toward young people within a context of educational and legal interventions, which tried to define childhood, to reclaim it from commercial contamination, and to control the employment of child performers. The case studies included in this chapter concentrate on an aspect of particular social concern, instances where the enforcement of regulations had become especially problematic. In Britain, children who formed part or all of touring companies found themselves liable to face provincial and local licensing courts whose willingness to enforce the law was often questionable or whose various decisions were often mutually incompatible or wayward. Part of the problem lay in the mobility of these companies who might spend no more than a few days in any one location. Such problems were compounded in Australia and New Zealand by the scale of the distances involved. When children's companies toured to the East and might spend months out of direct judiciary control, the problems were exacerbated. The chapter takes the story up to 1914, showing that despite all the earnest efforts, children continued to tour as far as South Africa, India, the Philippines, and Canada.

Most of the children who made up the Australian touring companies, returned to careers or jobs outside the entertainment industry. For them the experience had been one of self-discovery in often harsh terrains and circumstances. It had been a job that they had willingly undertaken. Yet few bothered to document their experiences. Indeed, our knowledge of child performers tends to be dependent on reminiscences and accounts

embodied in the success stories of those who were able to continue their stage or film careers into adulthood. We are familiar with the theatrical dynasties of the Terrys, the Barrymores or more recently, the Redgraves. Yet the voices of "jobbing" actors have rarely been heard. Dyan Colclough returns to the British arena showing that changes in legislative attempts at control in the period from the end of World War I to 1940 perpetuated the measures that had been initiated at the end of the nineteenth century, and points to the irony that such measures, emanating from a view that all child labor was in essence undesirable, should have coincided precisely with a time when the demand for and supply of child performers was inexorably increasing. More significantly, she has been able to utilize the evidence of child performers themselves—"jobbing" and largely undistinguished—whose "testimonies provide a rare opportunity to challenge widely accepted notions of the theatrical child as a submissive, passive, exploited being." They show the children as active agents perfectly willing to collude with parents in demonstrating the inadequacies of legislative restrictions by simply evading them. Certainly exploitation occurred rendering the performer as a victim. Yet the emotional incentive to appear on stage to face an audience's reception remained sufficient to turn a potential victim into an agent.

BY CHILDREN/FOR CHILDREN

The title of the second part of this volume motions to two lines of inquiry that to date remain relatively under-researched in studies of the entertaining child. First, that of the child actor's agency, an inquiry that derives from the acknowledgment that young performers are capable of exercising varying degrees of self-determination and decision concerning their professional performance activities. And second, the matter of children as a significant force in the consumption of entertainments, whether in the company of paying adults at theater shows; in the company of family and other children at the cinema; as fan viewers of favorite television shows featuring young performers; or as the target audience for theatrical initiatives variously named as theater for young audiences (TYA), or theater in education.

Reviewing *The Children's Pinafore* in London in 1879, Clement Scott acutely observed that: "there is nothing that children like better than to see children act"[2] and since at least the latter decades of the nineteenth century, theater, and later film and television producers, have catered to the

consumer power of child audiences. Using Scott's observation as a point of departure, Marah Gubar has recently argued that

> individual children found the sight of thoroughly professionalized child actors arresting, empowering, and even crush-inducing. To presume that all the knowingness and erotic energy in the theatre came from adults in the audience is to indicate our own investment in the ideology of childhood innocence.[3]

While the agency (or otherwise) of the entertaining child and the influence of child consumers do not figure as the primary focus of the four chapters in this part, these two threads nevertheless unify each of these chapters.

Noel Brown's "'How much do you love me'? The child's obligations to the adult in 1930s Hollywood" is the only chapter in this collection dedicated to a filmic genre. In this case, Brown's tight focus is upon the childstar films that proliferated in Hollywood from 1934 to 1938. Featuring highly visible child stars such as Shirley Temple, Freddie Bartholomew, Deanna Durbin, Jane Withers, and Jackie Cooper—children at the vanguard of an unprecedented and global fetishization of "the child"—Brown argues that this suite of movies represent one of the most "visible sites of cultural tension between the social conception of the child as priceless object, and, conversely, as exploitable entity." Mobilizing the rich repository of autobiographic reflections left by some of these actors, Brown positions this film genre within the prevailing social and political tensions of the era, explaining the cultural tastes that contributed both to its immense popularity and its swift decline. As is the case with several of the chapters in this volume, Brown references the Romantic ideal of the child as a source of tension and ambiguity attending scholarly analysis of the entertaining child. In the Romantic tradition, children represent an original and unfallen state of naiveté, with prepubescent childhood a sanctioned period of innocence and play. Brown draws attention to the complex interactions between the various ideals of childhood represented by the Hollywood child stars at the centre of his research, their precocity and knowingness that placed them in a seemingly liminal position between childhood and adulthood, and the exigencies of their labor and their obligations to the adults on whom they were dependent.

The following three chapters in this part also share a methodological thread in that the authors are all "insiders" for the production experiences at the centre of each discrete inquiry—variously as child performer (Bush-Bailey), production team (Cerniglia and Mitchell), and youth mentor/researcher (Chow and O'Donnell). Each of these authors thus brings a particularly personal investment (as well as a personal authority) to bear.

UK theater historian Gilli Bush-Bailey was herself a child television performer who saw (and still sees) her younger performing self as a "professional working actress" throughout her teenage years, which she spent between auditions, professional engagements, and the mandatory requirements of schooling. In her nuanced reflection upon her work in the early-1970s television series *Here Come the Double Deckers* (produced for trans-Atlantic viewing in the United Kingdom and the United States), Bush-Bailey draws out the tensions between Western society's ideal of "normal" family life and the "normal" childhood, and late-capitalist Western society's vexed response to industrial conditions that support talented children to train and earn professional wages for their labor in the entertainment industry. The two unifying threads of this part of the volume—the agency of the child actor, and the child as audience—coalesce in Bush-Bailey's chapter when she interpolates her lived experiences as a youthful actor in this internationally successful children's show, with the adult reminiscences of people who were child fans of Bush-Bailey's alter-ego in *Here Come the Double Deckers*. Here then, the author cracks open scarcely acknowledged questions concerning "the ambitions and aspirations of the child audience."

The contemporary working conditions and contractual arrangements for children employed by the Disney Theatrical Group (DTG) in both its Broadway productions and its national tours of highly visible shows such as *The Lion King* and *Mary Poppins* are discussed in the next chapter by Ken Cerniglia and Lisa Mitchell. Both authors are employees of DTG and thus their professional experience and access to colleagues and industry professionals has enabled a relatively rare "insider's" perspective on Disney's work with professional child stage actors. While the Disney Theatrical Group's employment of children in professional music theater has been considerable since the 1994 hit show *The Beauty and the Beast*, the authors remind us that Broadway precedents date at least from the mid-twentieth century with shows such as *The King and I* (1951), *The Sound of Music* (1959), *Oliver!* (1960), and *Annie* (1977), all of which employed sizable child choruses of (respectively) Siamese youngsters, von Trapp family singers, Victorian workhouse children, and orphans.

Theatrical outreach to children and young people has a long history in Western cultures, whether as an educational tool, as an applied creative strategy for personal or community development, or to nurture theater audiences of the future. Cerniglia and Mitchell extend their discussion of the DTG's engagement with children from the stages of Broadway to the organization's educational workshops and outreach program for elementary

school-age children in several US cities. The chapter thus explores Disney's approach to "the business of employing children to create theater [and] the business of employing theater to educate children."

Challenging dominant paradigms of theatrical outreach to young people in Canada—and, by extension, other developed Western nations where the processes and practices of TYA, and theater for/in education have been institutionalized for many decades—Broderick Chow's and Darren O'Donnell's chapter focuses on the work of Toronto-based Mammalian Diving Reflex, a performance company that has shifted its productions from socially engaged arts practice "by and for adults" to participatory performance projects, events, and interventions in which children are "full collaborators" with active input at all stages, from concept to performance. Mammalian Diving Reflex's first international success came with *Haircuts by Children*, but it is upon The Torontonians (a "nested mentorship" program involving 20 teenagers and 15 adults) and their *Nightwalks with Teenagers* that "insider" O'Donnell—the artistic director—and "outsider" Chow concentrate much of their chapter. Arguing that current Canadian cultural policy directed at children and youth enshrines a "blind spot" concerning the development of the next generation of artists, the authors explore an alternative paradigm that is currently "under construction" in the evolving processes of The Torontonians. This chapter provides then a progress report, as it were, on an experimental project that will see "the kids" inherit the company they are key contributors to when they reach their 20s (in approximately 2020).

GLOBAL PERSPECTIVES

As one of the authors in this third part of our volume, Shih-Ching H. Picucci observes in the opening to her chapter about Taiwanese opera of the twentieth century, issues concerning the contribution of children to traditional or otherwise "local" entertainments occurring in non-European contexts have been insufficiently examined. While this is a potentially huge field of investigation awaiting further scholarly attention, the chapters in this part open inquiries into traditional performance practices in four discrete cultural contexts beyond the Euro-centric sphere of influence. One of the prominent threads that links these chapters are traditional training methods for child performers, here in the specific fields of Balinese *legong* dance (Noszlopy), Taiwanese *gezaixi* or song drama (Picucci), Chinese *xiqu* (Branner), and circus from the Kerala region of India (Skidmore). Also threading throughout this part is discussion of the

changing significance and cultural position of these traditional entertainments in the wake of immensely forceful influences for change, such as globalization, the tourist gaze, or the surge to adopt capitalist economic models—influences that can also give rise to tendencies that mythologize, rejuvenate, or stultify traditional performance genres, depending on the cultural complexities attending each form.

Through the singular lens of a biographical study of the Balinese dancer, Ni Gusti Raka Rasmini, social anthropologist and Indonesia specialist Laura Noszlopy focuses on the 1952 Dancers of Bali tour of Broadway and the West End. Three little girls from Ubud in central Bali, collectively referred to as the "little *legong* dancers" became the unwitting stars of this *gamelan* and dance show, supported by Indonesia's first president, Soekarno as "a useful tool for Indonesian cultural diplomacy in the West" and entrepreneured by English impresario John Coast, whose singular goal was to bring the traditional performing arts of Bali to the attention of Western audiences. Through this study of the training and touring conditions experienced by Raka Rasmini—who was 12 years old when employed as a professional member of the Dancers of Bali tour—Noszlopy also examines "the socio-religious and professional roles of children in Balinese dance theatre." As for the long-term influence of the tour of 1952, Noszlopy suggests a causal link to the contemporary prominence of child dancers in showcases of traditional Balinese dance that are now staged for foreigners.

Shih Ching H. Picucci's study brings to light the distinct form of *gezaixi* or Taiwanese opera, a form that emerged from the folk songs of the Taiwanese province of Yilan during the early years of the twentieth century and subsequently evolved throughout the following decades, both in the face of, and as a result of, the political and social upheavals in Taiwan during the course of the twentieth century. Examining the contribution of children to this artform through the careers of three of its female stars, Ming-hsueh Hung (1936-), Li-hua Yang (1944-), and Little Ming Ming (1941-), Picucci examines the political events that gave rise to the custom for females to take the lead male role of the *xiaosheng* (this is one of several practices that sets Taiwanese opera apart from the better-known Beijing opera), the training of child performers (a substantial number of whom were girl children either sold or given to the opera troupes), and the Confucian notion of the ideal child (an outlook that is sharply contrasted with the Romantic image of the child in Western culture) and the influence of Confucianism upon the children of the opera troupes and in the broader society.

10 Gillian Arrighi and Victor Emeljanow

Mark Branner, the author of "Higher Wages, Less Pain: The Changing Role of Children in Traditional Chinese Theater," spent the period 1995–1996 as the first foreign student enrolled at the Sichuan Opera School where his classmates were children studying to become traditional Chinese theater performers. Mobilizing his own experiences of training in *xiqu*, the inclusive Mandarin term for an art that synthesizes the various divisions of acrobatics, singing, acting, dancing, and pantomime, Branner surveys the customary 7–8 years of training that children have traditionally undergone in order to enter the lowest ranks of the profession. The concept of *chi ku*, a mainstay of pedagogy that literally means to "eat bitter" and thus suffer through the hardships of preparing for a professional career in the traditional Chinese theater, is examined by Branner. Also considered here are the social and economic policies that have wrought rapid changes within mainland China over the past several decades, altering the cultural significance of its traditional performance forms and the prevailing conditions under which the coming generation of young performers are studying.

Field work methodology, so fundamental to the material of Branner's chapter, is also pivotal to the discussion of the final chapter of our volume. Jamie Skidmore's investigation of the circumstances through which children have become indentured to circuses operating primarily in the Kerala region of India, of their training and living conditions within the circus communities, and the risky nature of their oftentimes dangerous performances, was supported by the Shastri Indo-Canadian Institute in 2004. Since that time, an increasing child-mindedness in India's social policy led the Supreme Court of India in 2011 to ban the employment of child performers in India's circuses. Skidmore's insights into the plight of indentured child laborers in India and the movements for social change that are currently working to improve life prospects for these children, brings our volume that began with the plight of orphaned children in Naples in the seventeenth century, to a provisional close.

Moral panics, social and cultural upheavals, and technological revolutions have impacted on children as well as on adults. Yet children and young people appear to have accommodated such changes far more successfully than their elders. They have sought outlets for creative expression and achievement through engagements with the entertainment industry in its various manifestations—local, national, and international—with indefatigable enthusiasm and commitment. We hope the various chapters in this volume which offer glimpses of this commitment will spur scholars to investigate the phenomenon of entertaining children with similar indefatigable enthusiasm.

NOTES

1. John Springhall, *Youth, Popular Culture and Moral Panics: Penny Gaffs to Gangsta-Rap, 1830–1996* (New York: St. Martin's Press, 1998), 160–1.
2. Clement Scott, "The Children's Pinafore," *The Theatre* new (3rd) series 1: 38 (January 1, 1880).
3. Marah Gubar, "Who Watched the Children's Pinafore? Age Transvestism on the Nineteenth-Century Stage," *Victorian Studies* 54:3 (Spring 2012): 410–26, at 410.

Part I Terms of Engagement

1. Musical Education and the Job Market: The Employment of Children and Young People in the Neapolitan Music Industry with Particular Reference to the Period 1650–1806

Rossella Del Prete

INTRODUCTION

From the second half of the eighteenth century, Southern Italy began to show a sensitivity toward the role of human resources as a key contribution toward economic development, a theory that issued from the Enlightenment period. With the double objective of the exploitation by the State of a cheap workforce and of the reduction of poverty and criminality rates, the destitute became the new focus of vocational training and the Kingdom of Naples implemented a public education scheme in the areas of welfare and literacy. Part of this implementation saw the four existing Neapolitan Conservatories transformed from welfare institutes for poor and neglected children into training academies for musicians. A significant rise in demand for Kapellmeisters, singers, instrumentalists, music teachers, and copyists came from both religious (churches, monasteries, and oratories), and secular institutions (theaters, music-copying houses), and saw civic institutions contribute to this development. The object of this chapter is to show the interaction between economic and cultural pressures upon the vocational training of this workforce.

The social characteristics of Neapolitan musicians underwent a profound transformation during the seventeenth century, when musicians of noble descent were replaced by a plethora of new composers belonging to the far less wealthy working and middle classes. One explanation, and the most useful for our purposes, can be found in the process of consolidation of special educational facilities. The four Neapolitan music conservatories, which I list at a later point, were soon able to produce "skilled labor," which up to then had been the prerogative of chapels and musical institutions that had flourished from the fifteenth century onwards. The demand for music increasingly turned to profane practices (musical theater and concerts) and the phenomenon also influenced the chapels—they began to receive performers (singers and instrumentalists) no longer trained within the religious context, but in the new "schools of music."

The transformation of the four Neapolitan conservatories (male charity institutes for poor and abandoned children) into vocational training centers for musicians has proven to be a unique case in Italy and can therefore be considered of great interest. This transformation was governed primarily by economic principles and it thus marked the advent of a music market together with the birth of the *Scuola Musicale Napoletana*.[1] The origins of the Neapolitan conservatories coincided with the need to face an ever increasing request for musical services, both religious and lay, on the part of various local institutions (oratories, congregations, private academies, and, at a later date, opera theaters), and to find sources of income to cover the huge costs of management and assistance.

Although factories, prisons, and vocational schools present throughout the whole Kingdom of Naples attempted to provide training, the absence of a clearly defined policy by the ruling Bourbon dynasty and the rather haphazard State management did not fulfill the objective of economic efficiency advocated by the Neapolitan Enlightenment. The high costs of management and the difficulty in training an inherently unindustrious workforce, more interested in the fulfillment of their primary needs, contributed to make the training in the various charitable establishments even more complicated. However, in the long run, the outcome was positive and progressively overcame the ingrained resistance against the training of children, with the implementation of specialized laboratories and the construction of a special model of music education. The demands imposed upon children by parents, religious institutions, and theater managers in the late seventeenth and eighteenth centuries gradually underwent considerable changes.

A new cultural model, widespread during the eighteenth century, contributed to the social transformation of the family and consequently modified the handling of family relationships. The "job" as a musician was often handed down from father to son. Musicians acquired their initial technical training mostly in the family (if someone was already involved in the musical profession) or from the choirmaster of the cathedral on the principle of the transmission of local artisan craft from master to pupil. Music, therefore, was seen as a family bond, as self-celebration or praise, as a diversion, and also as a tool for salvation and redemption, for the recovery of legality and social relations and as a professional opportunity for the children of the Southern Italian proletariat and middle class.[2]

THE ECONOMIC, SOCIAL, AND MORAL BENEFITS OF APPRENTICESHIP

Over the course of half a century the four Neapolitan conservatories came into being: Santa Maria di Loreto (1537), Sant'Onofrio a Capuana (1578), Pietà dei Turchini (1583), and Poveri di Gesù Cristo (1589).[3] Originally intended as orphanages, they rapidly evolved as social, charitable, and educational functions with music as their core interest.

In the middle of the sixteenth century the city of Naples, emerging out of a long period of political instability, underwent an extraordinary increase in population, which caused social disparities and serious conditions of extreme poverty. Due to the lack of a public assistance policy, it became necessary to deal with the problem of rampant poverty through a recourse to private assistance and charity that materialized in the opening of boarding schools, orphanages, hospitals, and other institutions. Generally these were in the hands of lay or religious congregations and, more often than not, resulted from the initiative of single benefactors.[4]

For the orphaned or abandoned children of these conservatories, the European principle of *renfermement*, or "locked-up isolation," recommended reeducational strategies founded on work, a fundamental tool for social control: through work, the poor were socially and morally recuperated, especially if they were young, and were incentivized to self-subsistence. To this end, allowing young children living in the conservatories to work in craft shops as apprentices had a double significance. On the one hand, it directed them toward a trade and granted them a social status to put to use when adults; as well, it replaced an absent family for abandoned orphans. The artisan and his family became the adoptive family of the young apprentices hosted in the shop, which often doubled as the artisan's

home.[5] This family custody procedure undoubtedly had a very high educational and symbolic value inasmuch as it solved a series of problems (the provision of resources to maintain the child, hosting in a family setting, training for a craft to reuse as an adult), as well as raising funds for those conservatories that undertook to guarantee assistance to the highest number of orphaned or abandoned children.

Children from the four conservatories were directed to different handcraft and manufacturing activities. In a first phase children aged between 7 and 13 were almost exclusively directed toward trades (lace worker, silk weaver, cap maker). Music was used only as an accompaniment to catechesis and a necessary complement of liturgical functions. The institute governors entered into an agreement with the artisans who hosted the little orphans. The *istromento*[6] provided for a specific commitment by the master artisan: to teach the *figliolo*[7] the trade, to offer him "board and clothing and to treat him well for at least six consecutive years," to give him also "a new garment made of Naples fabric," then hand the boy over to the conservatory governors and pay 10 ducats to the conservatory for services rendered. Delays in the hand over or payment resulted in a fine for the artisan of six ducats per month for the length of the delay. In this way, the master artisan was bound to respect the agreement, and expenses for the maintenance of the child were guaranteed. Moreover, an already productive workforce returned to become part of the institute and thus contribute to its revenues.

Some *figlioli* were gathered by the governors who periodically roamed the city streets looking for orphans or "ill-guided" children, others were pointed out by people who took charge of them and guaranteed the payment of their boarding costs. From the records that register the vicissitudes of the *figlioli* we can trace a long list of admissions that offer a set of interesting data: name, geographical origin, age, length of stay, *plegio* or recommendatory person, the admission and exit procedures, and, for the years following 1650, the course of musical studies the *figlioli* embarked upon. Information also sheds some light on the dynamics of Neapolitan poverty, hinting at the typology of the artisans of that time and the social lineage of those who were to become pupils of the musical conservatories.

For children admitted to the Nautical Art School connected to the Santa Maria di Loreto conservatory there was a further vocational path— that of becoming hands on board a ship.[8] Nautical studies were common in Naples at the time and, in a further attempt to save as many abandoned children as possible, this pathway enabled homeless youths to learn a new trade and join the crews that set sail from Naples toward Genoa and other

ports. The pupils' admission age was set at 13 and the king recommended almost all of these particular placements.[9]

The overall movement of the *figlioli* (all boys) registered in each conservatory was always very irregular, varying according to the departure of those who had reached the end of their *istromento*, to the number of *free piazze*,[10] and to events that made the socioeconomic conditions of the city more complicated from time to time. The number of young guests in each institute fluctuated, on average, around 100, but in the Santa Maria di Loreto Conservatory, for example, the overall number of *figlioli* could be far higher as they did not all reside within the institute. This was the first of the Neapolitan conservatories and the largest of the four. Located near the port of Naples in an area characterized by a great deal of artisanal activity, it offered the widest selection of crafts and trades to the *figlioli*.

Even after the *figlioli* started receiving musical instruction and had been introduced to the "musical profession," contact with the artisanal world continued. Throughout the sixteenth century musical activity was an accompaniment to devotional practices and liturgical events but during the following century music schools began to assert themselves in their triple role of educational agency, professional formation center for musicians, and "music factory." By the beginning of the eighteenth century, the educational and formative approach of the conservatories changed course: music had become the main socioreligious art of the time. Initially, the reeducating mission consisted in entrusting boys found in the streets to shops. Then these institutes realized that music, used primarily as a tool to educate and to save souls, could in itself become an art to be practised in places other than just artisans' shops. Thus, after an initial musical education, which the children acquired while carrying out their apprenticeship, the conservatories started to provide ecclesiastical institutions and small private theaters with musicians and cantors.

There were essentially two factors that contributed to the transformation of the four orphanages into music schools: the necessity to find alternative sources of revenue to cover administrative and assistance expenses, and the need to face the ever increasing demand for religious and lay "musical services." New professional outlets in a wider musical and theatrical system were identified, first at an urban, then at the national level. The schools also extended their scope to foreign countries, stimulating a European demand for the services of the Neapolitan School of Music.[11] New professional roles such as music teachers, copyists, singers and instrumentalists, as well as set designers, lute-makers, tuners, and theater assistants started to appear and, among the artisans' shops, "harmonic shops"

began to emerge where the best known Kapellmeisters surrounded themselves with particularly promising apprentices and professionals they could rely on to form well-tested and tightly knit work groups.

THE EDUCATIONAL STRUCTURE OF THE MUSICAL SCHOOLS

Throughout the seventeenth century, the admission procedure was prompted by an administrative policy that was exclusively connected to charity. In the course of the eighteenth century, the system changed and admissions were decided by educational rules that were more selective and connected to musical demand. Once admitted to the conservatory the boys were placed in different groups on the basis of their natural inclinations. There were those who seemed more suited to learning a craft or a trade, or simply to carrying out mundane household tasks within the institute. Those who appeared to have an aptitude for the study of letters and therefore music became *figlioli educandi*. Attempts to launch a musical career sometimes failed, as when the children were devoid of talent, but in the better cases, if they had learned to play an instrument they could still develop as musicians. In time, the admission practice varied in connection with demands from abroad and the internal requirements of the institute itself.[12] Among the guarantors[13] of the pupils (above and beyond the various city artisans) there were some "music artisans" such as Gaetano Albano, master trombonist, who stood as guarantor for the pupil Gaetano Costa, admitted to the study of winds, strings, or singing (*fiati, corde o canto*); and Nicola Mancini, master organist, who performed the same function for Ferdinando Murganza and Giuseppe Domenicucci who also embarked on their studies of winds, strings or singing. Generally speaking the registrations in the four Neapolitan conservatories expanded to an ever greater extent with the admission of middle- and lower-class children: some of the candidates for admission were also from the wide-reaching Kingdom of Naples (not merely Neapolitans), and many of them attained musical prominence.[14]

Having established their mission, the conservatories hosted pupils and boarders. The boarder was admitted between 7 and 8 years of age and paid an admission fee and an annual boarding cost, which differed according to whether he was "a foreigner," a *regnicolo* (citizen of the Kingdom of Naples), or a Neapolitan. The amount owed could decrease on the basis of the pupil's financial capabilities, the talent of the *figliolo*, and the recommendations that went with him. Often, though, the pupil was older, around 18–20 years of age, and already had harmonic skills, in which case

he only paid the admission fee. He was accompanied by the recommendatory support of artisans or traders and committed himself to serve the conservatory for the number of years agreed upon with the governors.

The best *figlioli* usually obtained what was known as a *piazza*, the post of tenor, soprano, violinist, trombonist, oboist or Kapellmeister in the conservatories, and thus became not only "free board students" but also assistant teachers. Their lessons, given and controlled with regularity, were considered of great value for their companions. Among the activities entrusted to the *figlioli*, the copying of the music papers (which launched and supported a musical publishing market still in its infancy) was considered very important.

The Statutes of the four conservatories decreed that on the first Sunday of each month, the deputies should inform the governors which and how many indigent children needed to be taken in by the institutes. On the same day, the *maestri* (to be understood as a combination of house master and a music or artisanal skills teacher) were summoned and the children were entrusted to them to be "educated, punished and instructed." Both the pupils and boarders were housed in the conservatories and, upon being admitted, they pledged to "serve" the institute for the entire period of their stay (and occasionally even beyond), thus guaranteeing a crucial musical and financial continuum. The pupils who entered the conservatories at 18 or 20 already possessed a form of musical education, while the boarders admitted at about 8 years old pursued a more regular course of studies, with the period stipulated by the act of admission being between 5 and 12 years. The length of stay varied considerably depending on the age of the child when admitted, the kind of musical studies he was to embark upon, his financial means, and the method of payment. The child's stay in the conservatory was rarely uninterrupted and the commitment to remain on the premises, stipulated in the act of admission, was not always maintained. The youngest children often longed to go back home or even to escape. The rules and regulations were hard to bear as, for most of the boarders, the stay in the conservatory was enforced and not the result of a free choice. Should a child run away from the institute, the *maestri* and governors sought him out and punished him harshly by depriving him, temporarily, of the possibility of being absent from the conservatory, and by using any means they deemed fit to reestablish his good conduct.

As they depended on private benefactors for their subsistence, the conservatories expected their pupils to be well-mannered when in society, a sort of external "presentability" destined to satisfy the prejudices and

expectations of the benefactors rather than the needs and requirements of the beneficiaries. Indeed, once a week, a quarter of an hour was given over to lessons on how to be an upstanding citizen and a good Christian; once a month, the rules of the conservatory were read to the children so they "should not be forgotten." The uniform supplied to the children always had to be impeccable, especially during the "musical outings." It was made up of a "tunic (*sottana*) and a turquoise robe (*zimarra torchina*)" given to the child upon admittance to the institute. In winter, a knee-length surplice was worn on top and had to be handed in to the cloakroom when the children returned from their outings. The pupils all wore identical shoes especially made for them by the *maestro scarparo* (master cobbler) who worked for the conservatory.

A child admitted to the conservatory was not given his uniform unless he had previously lodged his *istrumento* (the act or charter of admission that specified the duration of his stay) and paid the 12 ducats, which covered his admission fee. Besides the uniform, he was also granted a bed with mattress and blanket. Those who could not afford the entrance fee were not entitled to the bed or the blanket, items which they sometimes brought from home. The children slept in dormitories organized as follows: 25 beds for the youngest, 13 beds for the eunuchs, 21 beds for the "halfways" (*mezzani*), who were neither the youngest nor the oldest, and 31 beds for the oldest.

As was clearly stated in the Statutes, the basic requirements for those admitted to the conservatories were: devotion, good manners, avoidance of sloth, modesty, silence, obedience, and diligence. Religious duties, compulsory for all, involved serving at daily mass, attending all sacred functions and confessing regularly. Special confessionary rituals took place three times a year: at Christmas, Easter, and prior to the celebration of the Patron Saint. In the event of insubordination, confession was considered an invaluable remedy as it hopefully led to reconciliation, respect, and good manners.

The children were expected to serve the oratory and the church, located within the conservatory, providing free assistance during the celebration of mass and the processions. They were watched over by the rector with the help of the vice rector, the *commissi* priests, and the teachers in charge of grammar, instruments, and music. The children were split up into brigades, each led by a head of brigade and a Kapellmeister. The rules to be followed were numerous and strict; they mainly concerned the type of behavior to be maintained when in or out of the conservatory and the church, during lessons and in the canteen. The Rector's task was to teach the children

good manners and decency and to make sure they applied themselves, on the basis of their individual abilities, to the study of grammar and both vocal and instrumental music. The children were occasionally allowed to visit their relatives. On these visits they were accompanied by a priest whose role was simply to accompany the children and to always keep them within sight, though in fact many never returned to the institute. The children were to stay with their school mates at all times and never wander around town alone. During festivities and on Carnival Thursday they were only allowed to leave the institute for funerals or other musical commitments. The governors rarely allowed pupils to spend the night outside the conservatory, and permission to eat out could only be granted by the appointed *mensario* supervisor. The rector himself supervised all musical commitments outside the institute and groups of singers were not allowed to perform outside Naples if this involved staying overnight or performing in private houses. Every week the rector selected the children who were to serve in church; he also established the timetable for grammar and music lessons and all the other devotional activities, whether scholastic or at the service of the conservatory.

The children's day began at dawn when one of the prefects rang the bell. The prefect or one of the *commisso* priests in charge of each dormitory, intoned the psalm *Laudate Pueri Dominum*, and while the children were getting dressed they recited the *Miserere me Deus*. When washed and dressed, the children lined up in twos and headed for the oratory where they sat in their designated seats and devoted a quarter of an hour to "mental oration." A further 15 minutes were spent on prayers and litany and finally they took part in the daily mass. Having fulfilled their devotional duties, the children collected their books and set off for the study of letters. Here again lessons began with a prayer. School work was then carried out for two hours and time was measured by the *maestro*'s hourglass. When the lesson was over, the prefects took their assigned group of children to the various singing or instrumental music classes where the music teachers illustrated the parts to be studied, first individually, and then collectively. The music lesson was followed by a recital of the third part of the rosary and then lunch was served in the canteen, accompanied by the reading of a spiritual lesson or an extract from the lives of the saints. Lunch was followed by half an hour of recreation after which the bell for silence was rung. In the afternoon, the children once more attended lessons at the school of letters, together with a music lesson taught by the Kapellmeister or, more often than not, the *mastricelli* (older or more competent students). This was followed by an hour of sacred history, civic ethics, and decorum, and

finally the children recited litanies in the church. At the close of the day the pupils were allowed another recreational period followed by dinner and the return to the dormitories.

In line with the hierarchical division of tasks, life within the conservatory was regulated by a number of other official figures. However, they all answered to the rector. Clearly the rector's role was of fundamental importance as he acted as an intermediary between the children, the "personnel," and the governors. In order to maintain discipline over the *maestri*, the rector kept an ongoing register of their lessons and any absences were tallied at the end of each month. At the end of the month the governors inspected this register and the *mesate*, or monthly stipends, were then paid. As regards salaries and stipends, the general impression during the second half of the eighteenth century is that there was a condition of stability that, though lagging behind the increase in prices of the time, appears to be in line with other local organizations.

The pupils were accustomed to practising all together in one large room, each on his own instrument, amidst an ambiance of constant noise. Charles Burney visited the conservatory of Sant'Onofrio in the autumn of 1770 and witnessed a situation consisting of the simultaneous performance of "seven or eight harpsichords, more than as many violins, and several voices, all performing different things, and in different keys": the cellists and wind-players practised elsewhere, some in other rooms, some on the stairs. Burney could not avoid noting how this practice contributed to increasing the "slovenly coarseness" and the lack of taste, precision, and expression that characterized the young pupils' public performances.[15] Perhaps by the end of the eighteenth century the increased numbers of pupils, together with the presence of elderly teachers (who earned very low wages), had resulted in a certain rigidity in the teaching and a consequent failure to adapt to the demands of the musical market.[16]

MUSICAL PATRONAGE

The first professional engagements of the *figlioli educandi* were musical services for private patrons, religious congregations, and popular festivals. For the latter, the demand could be addressed by one or more soloists or by a group of instrumentalists; private parties could request "angel choirs" made up of treble voices for several occasions, but mostly the requests were for funeral rites; convents, congregations, or parishes took advantage of the participation of the *figlioli* for masses, processions, or solemn liturgical ceremonies.[17]

Through policies and certificates of credit taken out with public city banks, religious congregations, or private benefactors often guaranteed the educational boarding costs for a *figliolo*, or, in the best of cases, they took upon themselves to provide the economic support of one of the conservatories. The family bond established through the various actions in favor of the *figlioli*'s rehabilitation was reaffirmed by the fairly common procedure of giving the donor's family name to the beneficiary *figliolo*. In the second half of the seventeenth century patronage was mainly religious with churches, city congregations, monasteries, or convents in the city and its surroundings absorbing a great deal of the services provided. Private citizens frequently requested services for funerals; to redeem their sins, wealthy ladies and gentlemen bequeathed part of their inheritance to the institute and, to seal their passing away in a state of forgiveness, they requested the company of the "music angels."[18] The musical performances most requested were "music, funeral rites and angel songs," all of which were remunerated and took place outside the institute. These performances were an important form of apprenticeship as they provided a taste of working life long before the pupils left the conservatory. Contracts for these services were established with the conservatories; each contract contained the description of the various phases of the liturgical year where a music service was required and might demand a "simple or full paranza," "choirs," "assistance to the Kapellmeister," and various other forms of entertainment (motets, symphonies, and more).[19]

Several reasons could lead a youth to enter an institute voluntarily. For a musician who did not belong to the madrigalists' circle, customarily a group of three to six instrumentally unaccompanied singers, or to one of the court theaters, entering a conservatory meant not only musical training but also work. The pupils could be used for "music services," but only with the permission and the mediation of the institute they belonged to, and on condition that a large part of the receipts refilled the common funds of the conservatory. According to its own principles and requirements, the institute filtered various "professional" occupations of the *figlioli* and for many it was difficult to resist the temptation of artistic and musical offers when they came from requests external to the conservatory. The *figlioli* were required to maintain a sober code of conduct, especially when the older boys, more requested by the entertainment world, were tempted by personal offers, which would have launched them into a musical and theatrical career of much greater importance.

The percentage of eunuchs among the conservatory pupils was quite substantial: the practice of castration during prepubescence was relatively

common at the time, to better exploit the particular vocal talents of children and to maintain their sweet and high-pitched vocal timber. In spite of the very strict prohibitions, many families exploited this practice to favor inclusion of their children as boy sopranos of church choirs, thus hoping for their future inclusion among the clergy.[20] Moreover, in order to indulge the fashion for *castrati*, the theaters resorted more and more to the conservatories to form their choirs. The soprano voice was preferred to such an extent that even the male parts were interpreted by sopranos or contraltos but mainly by castrati. Previously confined to sacred music, the castrati revolutionized opera music: they became extremely sought-after celebrities, notwithstanding the severe criticisms against the primitive custom of neutering.

PROFESSIONAL OPPORTUNITIES

Theater impresarios became interested in the singing performances of children, even though the theater environment was known for its promiscuity and lax morality. While theater commitments made it possible for the children to escape the most inflexible rules of the institute (which established they were not allowed out at night), work in the theater also prevented them attending the evening lessons held by the *mastricelli*, considered to be the most vocationally useful. Moreover, if the children returned home very late after having sung at the theaters, it was difficult to respect the numerous "contracts for music and *paranza*" with churches in town where, generally speaking, children were required during the early hours of the morning. All things considered, the profit derived from working at the theater proved to be counter-productive, at least for the institute.

Nevertheless, during the 1780s payments for the *figlioli*'s music services increased, as their participation at performances in the city theaters increased. In the mid-eighteenth century, Villeneuve described the advantages, both social and economic, for pupils of conservatories, due to the frequent contact with their pupils in Naples and elsewhere:

> every time a church or a coterie wished to stage a musical execution, a letter was sent to the Dean with a request for the services of 20, 30 or more boys for a modest but agreed upon fee. The institution benefited from this because it contributed to its upkeep and multiplied the number of artistic occasions in the city.[21]

In spite of their complaints, both the musicians and the administration benefited from a system that offered great advantages for as long as the

income from musical activity was sufficient to guarantee conservatories their own autonomy from superior authorities (for example the Court), whose demands were beginning to surpass the artistic resources of the institutes.

From 1791, the balance sheets of the conservatories began to show evidence of new sources of income and, consequently, a clearer "public" profile. In 1791, the royal delegate Saverio Mattei was appointed to play an active part in the administration of the conservatories in order to improve their conditions educationally and economically. This was the beginning of what is known as the "compulsory administration" phase of the institutions. It attempted to establish a new *ordo studiorum*, which compelled the pupils to tackle religious plain chant, the cantatas by Leo, Durante and Scarlatti, as well as the best theoretical treatises. So, the outcome of the compulsory administration entrusted to Mattei was a return to the teaching of strict contrapuntal forms and of the so-called *stile antico*. These teachings had never been absent from the Neapolitan Conservatories though the establishments had always attempted to keep up to date with new trends. Besides, the four institutes had always been characterized by educational tendencies that were more pragmatic than doctrinaire and above all, they had felt the need, even since the beginning of the musical school, to accommodate the tastes and requests of clients who provided indispensable support for their activities.

At the end of the seventeenth century, when the laws of supply and demand started to govern Italian life and theatrical production, the musicians' and the opera singers' professional energies were mainly channeled toward achieving economic success. When the pupils of the conservatories realized they could earn large amounts in exchange for their musical performances (as long as they were ready to bear the brunt of the long, stressful hours which work in the theater entailed and from which the carefully structured life in the conservatories shielded them), they yielded to the attraction of the entertainment world. Though without financial guarantees (given the uncertainties of theatrical payment), this lifestyle compelled them to acquire managerial ability and an entrepreneurial *savoir faire* so as to protect their own interests. When their juvenile fervor was over, the more mature musicians realized how very precarious their work was and started to set their sights on a permanent job such as long-term employment as a Kapellmeister, preferably in an ecclesiastical institute, or a teaching post in one of the four Neapolitan conservatories or local music schools (in the nineteenth century). Such positions would have certainly guaranteed a continuity of work for the musicians. They

would have acquired a residential permanency (as opposed to the itinerant life of opera singers), respect for their professional standing, as well as supplementary rewards due, for example, to career advancements from a junior teaching position to a senior one. However, such jobs usually offered relatively low salaries by comparison with the proceeds the musicians could earn at the theater.[22]

The educational tendency followed by schools in the eighteenth century appears to have been mainly aimed at the development of instrumentalists, largely violinists. There were quite a few wind pupils, especially toward the end of the century, when numerous musicians joined the military marching bands. The "musical outings" of the conservatory pupils continued and despite the fact that the Neapolitan music industry was beginning to feel the effects of the economic problems that the city experienced toward the end of the century, their performances were still much in demand.

A NINETEENTH-CENTURY POSTSCRIPT AND EVALUATION

During the nineteenth century, the underpinnings of private charity changed. By then, the rapid accelerations in the Neapolitan economic and social fabric made the structure of private charity inadequate. Moreover something akin to a cultural revolution took place; after the unification of Italy (1861), the state adopted new measures to deal with poverty and the treatment of abandoned children was regulated by new laws. This modified the traditional privately sponsored approach toward poverty, thereby reducing the resources of charitable institutes. To this we must add the greater demand of the music market for *virtuosi* compared to the rich storehouse of instrumentalists graduated from the conservatories—this imbalance between demand and potential supply was clearly detrimental to the future of the four institutes. The end of the individual conservatories was now in sight and, in 1807, by royal decree, they were reduced to a single new institution, the *Real Collegio di Musica di San Sebastiano*. This marked a first step toward the "nationalization" of the Conservatory of Music, sealed by its definitive transfer to the *Conservatorio di Musica di S. Pietro a Majella*. A further positive aspect was the fact that all the pupils housed in the new *Real Collegio di Musica* now stayed in a college exclusively for musicians.

A period of transformation and reform in the field of musical education then began: a governor at the head of the institute was to supervise

the overall conduct of the *maestri* and the other members of staff, together with the moral upbringing of the pupils, and the financial and administrative running of the conservatory. Likewise, a director of music was to oversee the children's musical education. Preferential treatment was granted to those pupils destined to become composers or Kapellmeisters and they were taught their letters and learned the basics of geography, history, elocution, and poetry; as for musical education, in the true sense, the basic teaching was that of counterpoint.

The teaching staff was made up of a number of *maestri*. One teacher for each instrument and subject: counterpoint, sacred and secular composition, oboe, clarinet, trumpet, cello and double bass, bassoon; two teachers for vocals and harpsichord (one for the beginners, the other for the more advanced students); and two teachers for violin (one for the beginners, the other for the more advanced students). The pupils (who were entitled to a hundred scholarly grants, known as *piazza franca*—to be awarded by the royal administration) had to be at least 10 years of age at the time of admittance and no older than 16. They could attend their course of studies for no less than 8 years and no more than 10. Compared to the way in which the conservatories had been managed throughout the eighteenth century, the novelty consisted in the fact that the pupils could no longer be sent outside the institute to "make music." It was only in the year that preceded the end of their official course of studies that the pupils could benefit from special permission to leave the conservatory and attempt to make a living by teaching private students or being taken on by theaters or churches as Kapellmeisters.

Thus by the end of the nineteenth century the whole structure and composition of the four Neapolitan Conservatories had changed dramatically. No longer needing to maintain a charity structure but functioning as a specialized training institution for professional musicians, young children no longer formed part of the student intake. Moreover, the close connection between students and artisan apprenticeships had been eroded. In the summer of 1806, the officials responsible for the reform of the conservatory system again proposed that both attributes be maintained, designating the Loreto as an *education* conservatory for pupils up to the age of 16, and the Pietà dei Turchini as a *performance* conservatory where the pupils would be taught counterpoint and "practical music" for at least five years. The establishment of a single college financed exclusively by the royal treasury saw the last, seemingly inevitable, stage of a long series of economically and educationally motivated transformations.

NOTES

1. This usually refers to the group of composers associated with opera in the eighteenth century. The conservatories played a key role in fostering this new musical development.
2. For further information on the charity, educational, administrative, professional, and musical aspects of two out of the four Neapolitan conservatories see Rossella Del Prete, "La trasformazione di un istituto benefico-assistenziale in scuola di musica: una lettura dei libri contabili del Conservatorio di S. Maria di Loreto in Napoli (1586–1703)," in *Francesco Florimo e l'Ottocento musicale*, eds. Marina Marino and Rosa Cafiero (Reggio Calabria: Jason Editrice, 1999), 671–715; "Un'azienda musicale a Napoli tra Cinquecento e Settecento: il Conservatorio della Pietà dei Turchini," *Storia Economica* 3 (1999): 413–64; and "Legati pii, patronati e monti di maritaggi del Conservatorio di S. Maria della Pietà dei Turchini in Napoli", *Rivista di Storia Finanziaria* 7 (2001): 7–32; see also Del Prete, "Il musicista a Napoli nei secoli XVI-XVII: storia di una professione," in *Il lavoro come fattore produttivo e come risorsa nella storia economica italiana*, eds. Sergio Zaninelli and Mario Taccolini (Milano: Vita & Pensiero, 2008): 325–35 and "I figlioli del Conservatorio della Pietà Napoli nella seconda metà del Settecento: percorsi di studio e opportunità professionali," *Nuova Rivista Storica* 1 (2009): 205–22.
3. Little has been done by way of a complete history, except in the pioneering studies of Salvatore Di Giacomo, *Il Conservatorio di Sant'Onofrio a Capuana, S. M. della Pietà dei Turchini* (Palermo: Sandron, 1924), and *Il Conservatorio dei Poveri di Gesù Cristo, S. M. di Loreto* (Palermo: Sandron, 1928).
4. On poverty in Italy see Vera Zamagni, *Povertà e innovazioni istituzionali in Italia dal Medioevo ad oggi* (Bologna: Il Mulino, 2000).
5. On models of artisan families and on the transmission of the trade from father to son, see Giovanna Da Molin and Angela Carbone, "Gli artigiani nel Mezzogiorno d'Italia nel XVIII secolo: modelli differenti delle famiglie, del matrimonio e del controllo degli assetti produttivi," in *La famiglia nell'economia europea dei secoli XIII-XVIII*, ed. Simonetta Cavaciocchi (Prato: Fondazione Internazionale di Storia Economica "F. Datini," 2009): 305–24.
6. This is the name given to the contract that sealed the entry into a conservatory of the child and regulated the relationship with the artisan who accepted him in his shop. The *istromento* was written out with the help of the notary trusted by the institute.
7. This is the term for these children, all of whom were boys.
8. On the nautical instruction of the Kingdom of Naples see Raffaella Salvemini, "Formazione e avviamento al lavoro nei reclusori e nei convitti del Regno di Napoli alla fine del Settecento," in *Il lavoro come fattore produttivo e come risorsa*, cit.:187–98; also Maria Sirago, "Scuole per il lavoro. La nascita degli Istituti "professionali" meridionali nel dibattito culturale tra fine '700 e '800," *Rassegna Storica Salernitana* 16 (1999): 130.

9. Several royal despatches allowed the admission of *figlioli* to the Nautical School during the years 1751–88. In 1751, only 12 *free places* for the *figlioli* of the S. Maria di Loreto were available and the King decided to fill them with the children of sea officers and, in order to have Michele De Leonardis, Master of the Nautical Academy, among the teachers of the school, he stepped in personally, augmenting the master's salary with 9 ducats per month [Archive of the S. Pietro a Majella Conservatory in Naples, S. Maria di Loreto Conservatory (from now on A.M.L.), *Scuola di Nautica*].
10. The *piazze* were grants that made it possible to finance study, professional careers, religious vocations, or business activities. Derived from income based on property and real estate investments, the purpose of the *piazza* was to increase the boarders' income.
11. Michael F. Robinson, *Naples and Neapolitan Opera* (Oxford: Clarendon Press, 1972).
12. Sporadically, for example, there was a need for musicians with a bass voice or for hunting horn players, etc.
13. The *pleggeria* (recommendatory system) consisted of a warranty offered mostly by artisans or traders to pupils and, at times, to boarders, which amounted to approximately 50 Ducats. The sum was deposited as a guarantee and the warrantor took upon himself the responsibility of answering personally in case the pupil left the conservatory without completing his *istromento* (through which he had committed himself to "produce" for the institution for a certain number of years). See Del Prete, *Un'azienda musicale a Napoli*, 435–36.
14. In the eighteenth century, the Conservatory of Pietà dei Turchini attracted almost exclusively young musicians from the Neapolitan hinterland, except a small percentage of *regnicoli* (citizens of the Kingdom of Naples) broadly speaking and groups of foreigners from Rome, Pisa, Florence, Milan, Genoa or even from abroad: Lyon, Paris, Malta, Moscow, Bavaria, and Portugal.
15. Charles Burney, *The Present State of Music in France and Italy; or the Journal of a Tour through those Countries. Undertaken to Collect Materials for a general History of Music* (London, 1771), 324–27, at 325.
16. See Del Prete, *Un'azienda musicale*, 458.
17. The *figlioli* of the four institutes could be told apart by the different colors of their uniforms: red and turquoise for the Poor, turquoise for la Pietà, white for Loreto, white and brown for Sant'Onofrio.
18. At the time, the conviction of the need to invest spiritually in the redemption of souls (*pro remedio animae*) was very widespread. The individual conscience was influenced by the Counter-Reformation rhetoric that warned people about the danger of eternal damnation for those who, when passing away, had not taken care of those in need. Many testamentary instructions therefore favored the convergence of a great part of the wealth of single people into the funds available to charity institutions. Such instructions were conditioned by treaties on "how to die well" and by the indications of several congregations, who prepared their members for a "good death." See Alberto

Tenenti, *Il senso della morte e l'amore della vita nel Rinascimento* (Torino: Einaudi, 1977), 62–111.
19. A *paranza* was composed of a certain number of *figlioli* (between 12 and 20) sent to congregations or involved in a procession, to accompany with songs and instruments the celebration of a particular religious or popular ceremony.
20. Patrick Barbier, *Gli evirati cantori* (Milano: Rizzoli, 1991).
21. Josse de Villeneuve, *Lettre sur le méchanisme de l'opéra italien* (Napoli: Duchesne 1756), 108.
22. In 1689, Alessandro Scarlatti earned 120 Ducats per year as maestro in the conservatory of S. Maria di Loreto. Three years earlier, his operatic commitment had yielded as much as 300 Ducats. See Francesco Degrada, "L'opera napoletana," in *Storia dell'opera,* eds. G. Barblan, A. Basso, vol. I (Torino: Utet 1977), 237, 275, 332.

2. An American Antebellum Child-Actor Contract: Alfred Stewart and the Shift from Craft Apprentice to Wage Laborer ✃

Shauna Vey

On July 27, 1857, Mrs. Hannah Stewart of Cincinnati, Ohio, signed a contract with Robert G. Marsh of New York binding her son Alfred to perform for two years with a theatrical troupe Marsh managed. This was an economically pivotal time for boy workers in all walks of life as traditional apprenticeships mutated into cash wage jobs. The Marsh-Stewart arrangement encompasses elements of both the traditional craft apprenticeship and its successor, the wage job. The case of Alfred Stewart illustrates how the US antebellum theater aligned with contemporaneous industries in treating child performers less like artists and craftsmen and more like laborers. The contract illuminates the dissolution of apprenticeship as the dominant path to an adult acting career.

The Marsh-Stewart documents provide useful insights into the terms under which a child actor worked during the mid-nineteenth century in the United States. The contract can be found in the New Orleans City Archives, housed in the Louisiana Division of the New Orleans Public Library, within a file relating to a suit brought before the Third District Court of Louisiana in 1858.[1] The handwritten contract—three pages of lined, blue legal paper—is signed by Hannah Stewart (widow), her son Alfred Stewart, Robert Guerineau Marsh, and two witnesses. Marsh's florid signature is twice the size of the others. The document in the Louisiana archive is most probably Marsh's copy, submitted in response

to court proceedings challenging the contract in the spring of 1858, ten months after its execution.

In addition to the contract, the file contains several other documents relating to the 1858 suit; Alfred's age may be deduced from two of them. A letter from Mrs. Stewart's lawyer states that Alfred is "aged between eleven and twelve years." An April 1858 letter from an examining doctor states that the boy is "about twelve years of age." Therefore, Alfred was probably eleven years old when Marsh signed him in the summer of 1857. According to the contract, Alfred would begin performing with the Marsh troupe immediately while his official, two-year term would begin on September 15, 1857, seven weeks later. Mrs. Stewart would receive $5 a week for the interim period. Alfred's wages would be $250 for the first year of the contract, and $500 for the second year. In addition to providing board, Marsh will bestow "care and attention usual for a father to furnish, taking care of him in sickness and in health."[2] All of Alfred's clothing, and any presents that the boy received, were designated as Marsh's property.

The Marsh Troupe of Juvenile Comedians had been founded in 1855.[3] Its featured performers were Robert Marsh's own children, eight-year-old Mary and her younger brother George, supported by about two dozen other children. The troupe presented popular plays and farces, such as *The Honey Moon, Toodles,* and *The Naiad Queen,* a fantasy extravaganza about knights and sea creatures. First produced in America by W. E. Burton in 1840, *The Naiad Queen* held the stage for a quarter century.[4]

The Marsh Troupe was playing in Alfred's home town of Cincinnati, Ohio, when the contract was signed. Alfred made his first appearance with the company one week later, in New York City. For his debut, Alfred sang the "Marseillaise", but typically his songs were called "Whiskey in the Jug" or "Trust to Luck." Billed as "the young Irish comedian and vocalist," Alfred played characters named "Brian O'Linn," "Paddy Murphy," and "Ragged Pat" in farces titled *The Limerick Boy* and *The Happy Man*. He was sometimes paired with the Marshes, but more often presented in his own afterpiece or in a number called simply, "Irish Song." In a short agreement subsequent to the original contract, Marsh had agreed to Mrs. Stewart's request that Alfred perform "as much of Irish farces and his own pieces and songs as can possibly be done by the Marsh Juvenile Comedians," and that Alfred would be taken out of any non-Irish pieces at his mother's request.[5] The wave of immigration that had brought two million Irish to America had swelled audiences for a sentimental tenor or some comic blarney. In advertisements designed to appeal to this audience, Alfred was one of the few company members to receive featured billing.[6]

Although Stewart's employment may appear to be a simple economic exchange of labor for wages, the terms actually echo several elements of a traditional craft apprenticeship agreement under which other boys worked at the time.

THE TRADITIONAL CRAFT APPRENTICESHIP[7]

Numerous scholars have documented the apprenticeship system that young America inherited from England.[8] The arrangement served educational, social, and economic functions. Nina Lerman described the system as practised in Philadelphia's antebellum manufacturing community:

> It provided a means for transferring technical knowledge—and thus economic opportunity—from generation to generation...a master cared for and educated the child, and the child served faithfully as an increasingly knowledgeable assistant. The knowledge acquired by a male apprentice in particular was generally assumed to prepare him for appropriate adult work—to provide the means of economic independence.[9]

Apprenticeship was a standard path to a career in many fields.[10] Apprentices were bound to masters for a specified period of time during which masters provided clothes, food, shelter, and training. The apprentice owed obedience and respect to the master; the master owed the apprentice knowledge. Socially, the master functioned as a kind of father, protecting and guiding his young charge, who usually boarded in the master's home. Many extant letters include requests from parents and/or reassurances from masters that apprentices will be given guidance in all areas, including spiritual and financial.[11] The master and the father were in some respects alter egos. In the absence of the father, the master assumed a father's authority and responsibilities. Conversely, some fathers assumed the role of master, taking on their own children as apprentices. As W. J. Rorabaugh noted, "Many youths learned trades from their fathers, from relatives who lived nearby, or from neighbors."[12] The defining elements of the traditional craft apprenticeship were the combination of work and training for youth under a master's care.

Traditionally, many actors were trained in their youth through a kind of apprenticeship similar to their contemporaries in crafts. During the English Renaissance, boys were apprenticed to theater managers or other adult players in commercial companies. Edel Lamb notes that it was expedient for theaters to "imitate and appropriate other legal structures, such

as those of the guilds and the process of apprenticing youths to masters."[13] The all-boy chorister companies initially obtained boys through impressment, but after 1606, these companies also adopted a modified apprenticeship system.[14] In whatever way their performers were recruited, these chorister companies always maintained the linkage between work and training that is the hallmark of the craft apprenticeship system.[15]

An example from early America illustrates the practice of training within families that was common in craft apprenticeships. The Hallams, who crossed the Atlantic in 1752, provided on-the-job training for their children, Lewis, Jr., Helen, and Adam; their niece Nancy joined them in 1759.[16] With this foundation, Helen and Nancy appeared as adult actresses.[17] The early training received by Lewis Hallam, Jr., sustained him over a 50-year stage career during which he served as boy actor, scene partner to his mother, leading man, and manager of the troupe. While Lerman specifically discusses manufacturing apprenticeships, her words also describe Lewis Hallam's path: "Sons of proprietors often ... began an apprenticeship with their fathers, leading eventually to partnership in the firm."[18]

Two nineteenth-century acting families trained their children in a similar fashion. In 1852, four-year-old Cordelia Howard began performing with her parents, George Howard and Caddie Fox Howard, in their family-based troupe. Caddie Fox and her brothers had acted as children and became successful performers as adults. Young Cordelia was being trained to do the same when she appeared as Little Eva in *Uncle Tom's Cabin*.[19] Cordelia Howard made a sensation in the part, which she continued to play for the next nine years—with her parents in supporting roles. Although the family certainly profited from Cordelia's enormous fame, she felt that they were also grooming her for a future career.[20]

Kate and Ellen Bateman, contemporaries of both Cordelia Howard and Alfred Stewart, were also children trained by their parents: Hezikiah L. Bateman, a theatrical manager, and Sydney Cowell Bateman, an actress and playwright.[21] While Ellen retired in 1856, Kate's early training formed the basis for an adult career as an actress and acting teacher.

These theatrical examples from the seventeenth, eighteenth, and nineteenth centuries illustrate an apprenticelike system in which children were trained in the craft of acting by their parents or other professionals with the clear expectation that they would join, and later succeed, their parents or masters in the trade.

Scholars of the traditional craft apprenticeship agree that by the mid-nineteenth century, the system had been eroded by a number of factors.[22]

The emergence of factories undermined the need for individual skill.[23] As the economy shifted more and more toward cash-wage jobs, masters had to provide apprentices with wages and, in turn, apprentices increasingly had to pay for their own clothing and board. Rorabaugh writes, "By 1834 apprentices in Rochester, New York, were rarely living in the households of their masters, and there is every reason to believe that this new pattern prevailed wherever the cash wage had replaced the barter economy."[24]

The substitution of cash for cohabitation broke down the paternalistic conditions on both sides. Masters frequently became less caring; boys became less respectful. Apprentices had more autonomy than ever before and felt entitled to make their own decisions or break their contracts.[25] There had always been quarrels and lawsuits, "But the boldness with which apprentices now asserted their right to decide matters for themselves and to walk out when they did not like the conditions of their work was something new."[26] Gains in independence and wages were offset by losses in education and security. Even the term "apprentice" was undermined as some factory owners used this label simply as an excuse to pay low wages for work that included no training. Child workers lost the network of protection. As Rorabaugh writes, "In the end old-fashioned apprenticeship was swept away by a wave of change that engulfed traditional society and its artisan culture through the power of concentrated capital, the genius of mechanical innovation, and the ideology of individualism and self-help."[27]

THE MARSH-STEWART CONTRACT IN CONTEXT

The Marsh-Stewart contract reflects the ruptures occurring in the nontheatrical trades. Although the term apprentice is not used in the Marsh-Stewart agreement, the document includes elements typical of apprenticeships: a specific time bond, housing, and the paternal care of a master. Virtually all apprentices were bound for a specific period of time; seven years was common but Quimby noted bonds as short as two years and as long as twenty years.[28] The Marsh-Stewart contract stipulates a two-year period during which Alfred would be under the care, custody, and control of Robert Marsh. The contract identifies Marsh as a resident of New York and the widowed Mrs. Stewart as a resident of Ohio. Alfred would be utterly dependent on Marsh for house and board. The most traditional feature of the Marsh-Stewart contract is the language used to describe Marsh's responsibility. He would furnish "care and attention usual for a *father*" (emphasis added). This language, wholly absent from

modern labor agreements, disrupts the contract's commercialist purpose. It harkens back to advice about the master's role first published in 1821: "To them you stand in the parent's place; they are to receive the treatment of sons."[29] With his signature, Marsh accepted the paternal function of the master. The contract also uses a phrase that today is more associated with marriage covenants than with labor deals. Marsh is to care for Alfred "in sickness and in health." Clearly, Marsh would be acting *in loco parentis,* just as apprentice masters had for centuries.

The most modern element of the Marsh-Stewart contract is the salary, $250 for year one, equivalent to the purchasing power of about $6,790 in 2012.[30] In 1852, little Cordelia Howard and her mother had jointly been paid one hundred dollars a week.[31] While Alfred's salary is much less than this, it still compares very favorably to that of children working in other fields during the 1850s. Typical were machinist apprentice John Rogers who earned 50 cents a day and apprentices at Baldwin Locomotive Works who were paid just under $170 per year (about 68 percent of Alfred's first year wages).[32] Information on the salaries of other antebellum child performers is sparse.

Another modern innovation was the payday recipient. Historically, the small wages paid to apprentices covered their out-of-pocket expenses, but as the nature of apprenticeships changed, so did the destination of their earnings. The earnings of children came to be seen more and more as a component of the family economy, rather than a boy's pocket change.[33] During the 1840s and 1850s apprentice wages were increasingly turned over to parents. Hannah Stewart seems in tune with this trend by arranging for all of Alfred's earnings to be sent to her directly. The contract makes no provision for any pocket money at all for Alfred.

Provisions for the end of Alfred's engagement also break with tradition. According to Quimby, "Almost no apprentice left his master at the termination of his indenture without being given either clothes, tools, money, or some combination thereof." This gratuity was called freedom dues, and clothes were by far its most common form.[34] Alfred's clothes, as per custom, were to be provided by Marsh. At the end of the engagement, however, all of Alfred's clothing would revert to Marsh. This not only included his costumes, but "all wearing apparel, wardrobe, clothing or dresses of any kind whether used on the stage or not."[35] The contract also anticipates the possibility that Alfred will develop a gift-giving fan-base, stipulating that any presents Alfred received over the course of the contract, "from the public or other parties," would also become Marsh's property. This stipulation stands in blatant contradiction to the custom of giving gifts to an

apprentice at the termination of his labor and belies the paternal relations implicit in other aspects of the agreement.

The aspect of the Marsh-Stewart arrangement that resists easy categorization is training. Initiation into a trade was the *raison d'être* of the traditional apprenticeship, yet the Marsh-Stewart contract makes no mention at all of training. The term "apprentice" is not used; in the language of the contract, Alfred is "hire[d] to" Marsh. While Alfred was not an apprentice *per se*, the training element so germane to traditional apprenticeship was *ipso facto* contained in the working arrangements between Alfred, an actor, and Marsh, his director.

An examination of Marsh's role bears this out. Robert G. Marsh worked as a professional actor in the 1840s and early 1850s.[36] After organizing the juvenile company, he frequently performed alongside the children, playing, for example, the role of "Amphibeo," the evil dwarf, in their 1855 production of *The Naiad Queen*.[37] The company's standard billing listed the troupe as "under the management of R. G. Marsh," and newspapers frequently referred to the training the performers received, as in these comments from the *New York Times*, the *New Orleans Picayune*, and the *Argus* of Melbourne, Australia:

> Twenty-four Juvenile Comedians *under the direction of their tutor*, Mr. Marsh.[38] (emphasis added)
>
> With splendid scenery, rich costumes, elegant paraphernalia, complete mechanical arrangements, abounding in startling effects, and…thirty-one *highly trained* little auxiliaries.[39] (emphasis added)
>
> A company of some 30 young people…who have been collected together for theatrical purposes, *instructed evidently with great care in the business of their profession*, several of them possessing considerable talent.[40] (emphasis added)

These writers have assumed that Marsh actively trained the children in the troupe. The reference to him as "tutor" signals an assumption that Marsh functioned as a traditional master. Alfred Stewart joined the other children in many of the company's farces; in 1858, he assumed the role of "Amphibeo" previously performed by Marsh.[41] It seems reasonable to conclude that, in these productions, young Alfred was receiving performance training from R. G. Marsh.

Thus, the Marsh-Stewart contract comprises contradictory elements reflective of the shifting historical moment of its execution. Marsh is positioned as both an old-fashioned, paternalistic master and a modern profit-driven employer. Alfred is presented both as a boy who needs a father's

care and a laborer in a wage economy. Mrs. Stewart has a dual identity as widowed mother and shrewd promoter looking after her property. Given these inherent contradictions, and the pervading climate in which boys felt emboldened to walk out if they didn't like working conditions, it is not surprising that the arrangement ended prematurely.

THE MARSH-STEWART CONTRACT CONTROVERSY

In February 1858, the Marsh troupe began a successful, six-week engagement at Spaulding and Rogers' Museum and Amphitheatre in New Orleans, Louisiana. Business manager "Doc" Gilbert Spaulding had been booking the company annually with great success.[42] Stewart was given his usual featured billing and the performances had been well received.[43] On March 26, the Third District Court of New Orleans issued a writ of *habeas corpus* commanding R. G. Marsh to produce Alfred Stewart in court so that the boy could be examined by a physician. Mrs. Stewart had sworn a statement that Alfred was "seriously afflicted in health by a dangerous disease."[44] Marsh immediately filed a counter complaint asserting his right, under the contract, to retain Alfred within his care, custody, and control. In this instance, Mrs. Stewart may be seen to be operating under assumptions associated with a traditional apprenticeship, that is, that Marsh would act as a father. By failing in his paternal responsibility to care adequately for Alfred's health, Marsh had broken the contract. Marsh's businesslike response emphasizes the legal obligation of the state of Louisiana to uphold a contract signed in the state of Ohio.

Mrs. Stewart's counsel changed tactics and used a legal limitation to women's rights as a justification to challenge the legality of the original contract. Mrs. Stewart alleged that, "At the time that the instrument was made, she had not been recognized by the state of Ohio as the legal guardian of said Alfred and therefore could not bind him." She was a widow and the court confirmed that, "By the laws of Ohio, a...guardian or tutor cannot bind the minor...unless he has taken the oath and has complied with the other formalities required by law." Mrs. Stewart had taken the guardian's oath on August 28, 1857, one month after she had signed the contract with Marsh.

On March 30, 1858, the court decided in Marsh's favor. An examining physician found Alfred "in every respect sound and healthy."[45] The case was dismissed, but on the very next day—March 31, 1858—Mrs. Stewart filed an appeal.[46] Precise details of the events that followed cannot be

adduced from the documents in the Louisiana Archives, which indicate a different outcome from that announced in the newspapers. The archive includes a three-page judge's opinion that reviews all of the prior claims and counter claims. Because a court had already ruled on Albert's health, the judge stated that, "The only point upon which the court is called upon to decide is whether the defendant detained the person of Alfred Stewart legally or illegally." The judge explained that Mrs. Stewart became Alfred's legal guardian one month after signing the contract with Marsh. At that point, she had the legal authority to terminate the contract. However, Mrs. Stewart continued to accept her payments from Marsh; she even entered into a second agreement concerning Alfred's performance of Irish and non-Irish pieces. The final sentence of this short accord states: "This agreement does not conflict or make void any existing contract or agreement." The judge reasoned that the original agreement was validated by Mrs. Stewart's actions after she gained full legal guardianship: her entry into the second arrangement and her continued receipt of profits:

> This last agreement is certainly in my opinion a ratification of the former one. Her incapacity at the time of entering into the first contract was relative not absolute and when she became capacitated by law, she had immediately the right to purge it of all illegality existing at the time. The [plaintiff] cannot be permitted now to claim the benefit resulting from an illegality when she has solemnly received those benefits by her own acts.[47]

The judge denied the application for a writ of *habeas corpus*; Marsh did not have to return Alfred to Mrs. Stewart. Thus, according to the court documents in the Louisiana Archive, Marsh prevailed in both the initial case and the appeal, but Alfred never performed with the juvenile troupe again. The *New York Clipper* proclaimed: "It has at length been settled by the New Orleans courts that little Alfred Stewart shall be delivered into the custody of his mother and will probably start out on a starring expedition."[48]

CONTROVERSY

During 1858 and 1859, the controversy surrounding Alfred Stewart shifted from the courtroom to the pages of the press. The *Clipper* was integral to the postlegal spat, offering catalyzing editorial comment as well as providing a forum for Stewart and Marsh partisans. In June 1858, the *Clipper* published a letter from Edward Warden, possibly the English actor of

that name who produced the first US version of *Ixion*, the burlesque later popularized by Lydia Thompson.[49] Warden's letter stated that: "Master Stewart was taken from the Marsh troupe on account of ill treatment."[50] The judge's opinion and the statement of the examining physician both contradict Warden's assertion. Moreover, both the *Clipper* and the (*New Orleans*) *Picayune* had previously announced that Mrs. Stewart's case had failed to prove ill treatment. Was Warden unaware of this contradiction, or simply allied with Mrs. Stewart and determined to retry the case in the court of public opinion?

Warden's letter provoked a response from a Marsh supporter in New Orleans who wrote using the nom de plume "Justice":

> To set the minds of the public right on the subject, and to do justice to Mr. Marsh... I would inform you and others that Mrs. Stewart signally failed in proving *any ill* treatment but gained possession of her son by breaking of the contact she had made with Mr. Marsh; because at the time it was made, she had not been *legally* appointed his guardian, which was done after the contract was made, she sought to annul it on these grounds and succeeded.[51] (italics in original)

The pen name and the italics in the original underline the writer's belief in Marsh's character, but the writer's facts are shaky. "Justice" seems unaware that the judge had refused to accept Mrs. Stewart's technicality as justification to set aside the contract. Thus, while Alfred's separation from the Marsh troupe is certain, the means of his release was blurred—perhaps intentionally— in public discourse.

Hannah Stewart would soon write her own letter to *Clipper* editor, Frank Queen. In early 1859, the Marsh troupe planned a return engagement to the Spaulding and Rogers' Amphitheatre in New Orleans. Doc Spaulding made arrangements with Mrs. Stewart for the young Irish comedian to appear as a guest star with his former company, but the announced appearance did not occur. The *Clipper* commented: "For some reason not yet clearly explained, Stewart was not allowed to perform, although last year he was the favorite among the company. Another job for the lawyers perhaps."[52] Mrs. Stewart quickly responded:

> Cincinnati, Ohio, April 29th, 1859... Sir: Seeing a notice in the theatrical column of your paper on the 9th, and another on the 30th, concerning Master Alfred Stewart not being allowed to perform in New Orleans, and as Mr. Marsh does not publicly give any reason, I will endeavor to place the facts before you as they really are.

Stewart makes no reference to the technicality of legal guardianship, but returns instead to her initial charge. She writes that Mr. Marsh hated her:

> Which hatred arises from the fact that I took the child away by law because he outraged every condition by which he obtained him; he got the child by fraud and misrepresentations, which I was not willing to submit to, so I took him away from him and exposed him, and this is the whole secret.[53]

Mrs. Stewart alleges not only that Marsh behaved badly, but that she had proved that fact in court. Her allegation is contradicted by court documents as well as announcements in at least two newspapers but, apparently, she still wanted the public to believe Marsh had acted badly. Her summary of the facts follows:

> About the middle of January the agent of Spaulding and Rogers called upon me to ascertain if Master Stewart could be engaged for New Orleans to play at the Amphitheatre with the Marsh Children, during their stay there, and pledging themselves to let Marsh have nothing to do with him except in the capacity of stage manager; that Master Stewart was merely to play with the Marsh Children as he would play with any other company, in any other theatre. I sent the child to meet his engagement according to the contract, and the first intimation I had that he did not play it was through the newspapers... I wish to say a few words in justice to Mr. Spaulding—I do not think he had any intention of injuring either the child's reputation or feelings; and he assured me that if Mr. Marsh had not been indebted to him for a considerable amount (and it was the only hope he had of recovering his money, and his motive for engaging Master Stewart was to make the business good enough to enable him to get his own) he would have insisted on the boy playing, or he (Mr. Marsh) should not have played in his theatre.[54]

Several observations may be made concerning this section of her letter. First, since leaving the Marsh Troupe, Master Stewart had apparently earned some success. Doc Spaulding, an experienced theater manager and "a model of the new capitalist age," thought the boy would bolster ticket sales.[55] Second, Mrs. Stewart is still at pains to paint a public picture of Marsh as someone from whom her son needs protection. She emphasizes Alfred's vulnerability by repeatedly referring to him as a child. Third, only through reading the *Clipper* did Mrs. Stewart learn that Alfred did not perform. Clearly, she is not traveling with her son; he is in New Orleans as she writes from Cincinnati, over seven hundred miles away. The newspaper is the conduit between mother and son. Mrs. Stewart's comments suggest that she continued to act on Alfred's behalf in business matters; there

is however no indication of whom, if anyone, is acting in *loco parentis*.[56] Mrs. Stewart's letter concludes:

> As to whether there will be more work for the lawyers or not, depends upon the payment of the money, as the dates become due; so far they have been paid as soon as due; we shall see if the rest is the same. I hope Mr. Marsh feels bigger since he has shown his littleness by venturing his spite on a little child whose only fault is being more talented than his own. Master Stewart has no father, but he has a mother who will defend him as long as she lives. By giving this explanation in your valuable paper, you will much oblige, Yours truly, HANNAH STEWART[57]

In this ending section, Mrs. Stewart restates the two themes present throughout the letter: business and motherhood.[58] She had been collecting profits from Alfred's work and does not fault Marsh in business practice, but her tone changes when she speaks as a mother. "Master Stewart," now 13 years old and four states away, is referred to as a "little child" whose hurt feelings need to be considered. He has been victimized by a spiteful man. Mrs. Stewart seeks to wound Marsh—not Marsh, the businessman—but Marsh, the father. By insulting Marsh's children, Hannah Stewart reveals the intensely familial nature of the conflict. The reference to Alfred's dead father recalls the role that she expected Marsh would play. Mrs. Stewart's passionate rhetoric indicates a sense of personal violation by Marsh's failure in his traditional role as protector. The mother now has assumed the father's task and vows "to defend [her child] as long as she lives." Just as in the initial contract, the language of Mrs. Stewart's letter indicates dual roles for both Marsh and herself. Both Mrs. Stewart and Mr. Marsh conducted business on a modern cash-basis, treating Alfred as the commodity being traded. However, Mrs. Stewart clearly had a simultaneous expectation that Marsh would function as a traditional master, that is, as a father figure.

BEYOND THE MARSH-STEWART CONTRACT

After leaving the Marsh Troupe in 1858, Master Stewart immediately started appearing individually, with engagements documented through the beginning of 1860.[59] The continuity of his performance schedule, the positive doctor's report, and the initial court's finding for Marsh all undercut Mrs. Stewart's claim that her son was too ill to fulfill his commitment to the juvenile company. Why did he leave the Marsh troupe? Although Alfred is the center of this story, his voice is missing from the written record and the degree of his personal agency is unknowable. While he

received good press notices under Marsh, any number of factors could have made him eager to leave the troupe—even the example of other boys who restlessly walked away from apprenticeships, impatient with instructions from masters and lured by fast cash.

Perhaps Alfred was simply a dutiful son and his mother had instigated the change. It's impossible to tell if her motive was to build her son's future or cash in on his present. The ambiguities of this story speak to the shift among parent/child relations and apprentice/worker paradigms. During this period generally, parental enthusiasm shifted from securing training for their children to securing immediate income from their children. While other antebellum theater families such as the Howards and the Batemans, continued in the old family craft tradition, Mrs. Stewart may have reflected the newer mode in positioning Alfred as a source of immediate income for herself. In this way Mrs. Stewart may be a precursor of the industrial age parent so familiar from the late nineteenth century.

The Stewart case not only illuminates a mid-century change in craft apprenticeships, it also suggests some interesting contexts for future trends in child protection, financial agency, and actor training. In 1876, by the time Alfred was 30 years old, New York State passed the first US law to protect child performers from their parents or exploitive managers.[60] In doing so, the State tacitly acknowledged the demise of the paternalistic, caring master that Mrs. Stewart had expected to find in R. G. Marsh. This well-intentioned law focused on the health and safety of child performers, but left their finances alone. If Alfred lived to be 93, he would have seen a law that finally awarded child actors the right to own their own income. California's 1938 "Coogan Law" was inspired by another dutiful son who discovered upon adulthood that his mother and manager owned every cent he had earned during a long childhood career.[61] Later in the twentieth century, parental control, such as that exerted by Mrs. Stewart, was routinely disrupted when child actors protected their earnings by becoming legally emancipated, that is, attaining legal adult status, while still in their teens. The Marsh-Stewart contract, with its provision that Alfred's salary be sent directly to his mother, may have set the stage for these later trends.

The end of the craft apprenticeship model created the need for a new paradigm in actor training. By 1879, the supply of experienced actors could not keep up with demand and the *Illustrated Dramatic Weekly* "called on universities to train actors, just as they did doctors and lawyers."[62] However, the shift between old and new paradigms was not a smooth one. Professional acting schools for adults began to spring up even as some

actors maintained that childhood stage experience was the best teacher.[63] As late as 1911, British stage star Ellen Terry claimed, "You can't have grown actors without child actors," but the child protection movement and the expansion of compulsory schooling created obstacles to childhood stage work.[64] Academic education came to be more valued than childhood stage experiences. The Broadway impresario David Belasco expressed doubts about starting children on the stage early, even when they had talent. He urged parents instead, "to supervise with the greatest care its health and education under domestic influences, and then give it a later start on the stage."[65] Children were still popular as performers, but they seemed to be offering their quickly vanishing youth rather than their craft.

Alfred Stewart did not achieve fame as an adult. His significance does not rest on his talent as a performer. Rather his story illustrates a pivotal moment in theater history, when child actors joined the ranks of other child workers whose youths were increasingly spent earning fast money, rather than learning crafts to serve them a lifetime. The case of Alfred Stewart illustrates how the antebellum theatre aligned with contemporaneous industries in the United States with regard to child workers.

NOTES

1. The author thanks archivist Irene Wainwright of the New Orleans Public Library; the Office of the Dean of the School of Liberal Arts of New York City College of Technology, City University of New York for document reproduction support; and Mary Bellamy, whose research assistance was supported by the Emerging Scholars Program NYCCT/CUNY.
2. New Orleans Public Library, Louisiana Archives, docket 12246, henceforth, LA Archives.
3. *New York Times,* December 5, 1855. Citations from the *New York Times, New Orleans Picayune,* and various Georgia and Virginia newspapers are from the New York Public Library's onsite Historical Newspapers database. All citations from the *New York Clipper* are from the microfilm collection of the Performing Arts Library of the New York Public Library.
4. J. S. Dalrymple, Esq. *The Naiad Queen,* with Original Casts, Costumes, and the whole of the stage business correctly marked and arranged by Mr. J. B. Wright, Assistant Manager of the Boston Theatre. (Boston: William V. Spencer), 2.
5. LA Archives.
6. Ads, reviews, and news items in *The New York Clipper, The New York Times, New Orleans Picayune,* and *Macon (Georgia) Telegraph* between 1855 and 1860.

7. The term "apprenticeship" has been used to describe a variety of situations including indentured servitude and the binding out of paupers and foundlings. Apprenticeships varied drastically relative to the economic and social class of the individuals involved. This essay uses the term as defined in W. J. Rorabaugh, Ian Quimby, and others to refer to a class of boys who were bound out for the express purpose of learning a craft (see note 8).
8. See W. J. Rorabaugh, *The Craft Apprentice: From Franklin to the Machine Age* (New York: Oxford University Press, 1986); Nina E. Lerman, "Preparing for the Duties and Practical Business of Life: Technological Knowledge and Social Structure in Mid-19th-Century Philadelphia," *Technology and Culture* 38:1 (January 1997): 31–59; Brian P. Luskey, ""What Is My Prospects?": The Contours of Mercantile Apprenticeship, Ambition, and Advancement in the Early American Economy," *The Business History Review* 78:4 (Winter 2004): 665–702; Richard D. Stott, *Workers in the Metropolis: Class, Ethnicity, and Youth in Antebellum New York City* (Ithaca, NY: Cornell University Press, 1990); Ian Quimby, *Apprenticeship in Colonial Philadelphia* (New York: Garland, 1985; reprint of MA thesis, University of Delaware, 1963).
9. Lerman, "Preparing for the Duties," 41–42.
10. Quimby identified 68 different crafts in eighteenth-century Philadelphia, 30.
11. See Rorabaugh, *The Craft Apprentice*, passim.
12. Rorabaugh, *The Craft Apprentice*, 99.
13. Edel Lamb, *Performing Childhood in the Early Modern Theatre: The Children's Playing Companies (1599–1613)* (New York: Palgrave Macmillan, 2009), 57, 56. Andrew Gurr asserts that arrangements were not so formal, *The Shakespearean Stage 1574–1642*, 4th ed., (New York: Cambridge University Press, 2009), 113–14.
14. Lamb, *Performing Childhood*, 56–57.
15. Gurr, *Shakespearean Stage*, 46.
16. Robert J. Myers and Joyce Brodowski, "Rewriting the Hallams: Research in 18th Century British and American Theatre," *Theatre Survey* 41:1 (May 2000), 1. See also Don B. Wilmeth with Tice Miller, *Cambridge Guide to American Theatre* (New York: Cambridge University Press, 1996), 182.
17. Myers and Brodowski, "Rewriting the Hallams," 5.
18. Lerman, "Preparing for the Duties," 41.
19. Laurence Senelick, *The Age and Stage of George L. Fox, 1825–1877* (Hanover, NH: University Press of New England, 1988), passim.
20. Cordelia made the decision to retire at 13. Cordelia Howard Macdonald and George P. Howard, "Memoirs of the Original Little Eva," *Educational Theatre Journal* 8:4. (December 1956), 281.
21. See also Heather M. McMahon, "Profit, Purity, and Perversity: Nineteenth-Century Child Prodigies Kate and Ellen Bateman," (PhD diss., Indiana University, 2003); Robert Samuel Badal, "Kate and Ellen Bateman: A Study in Precocity" (PhD, diss., Northwestern University, 1971).

22. While Quimby and Luskey aver that the erosion had begun as early as the American Revolution, other scholars including Rorabaugh and Lerman point to many examples of the practice continuing up to the Civil War. I am not concerned here with pinpointing the beginning of the decline or prioritizing among the factors that have been identified as contributory. My argument relies on the results of the change, about which there is general agreement.
23. For example, an early shoe factory in Lowell, Massachusetts, stopped taking in apprentices. Boys tended machines but did not learn how to make an entire shoe. Rorabaugh, *The Craft Apprentice*, 60, 68–69.
24. Ibid., 73.
25. Ibid., 38.
26. Ibid., 139.
27. The content of this paragraph and all of the quotations are taken from Rorabaugh, *The Craft Apprentice*, 60, 73, 74, 139, and 209.
28. Quimby, *Apprenticeship*, 37.
29. *A Father's Gift to His Son on His Becoming an Apprentice* (New York: Samuel Ward & Sons; Baltimore, MD: Samuel S. Ward & Co., 1821), quoted in Quimby, *Apprenticeship*, 7.
30. Lawrence H. Officer and Samuel H. Williamson, "Purchasing Power of Money in the United States from 1774 to the Present," Measuring Worth, 2009, accessed October 6, 2013, http://www.measuringworth.com/index.php.
31. Senelick, *Age and* Stage, 63. An adult member of the same company earned $18 perweek. As a young actor in 1842, Cordelia's father had been paid $8 perweek (18). For actors' salaries after 1880, see Benjamin McArthur, *Actors and American Culture, 1880–1920* (Philadelphia, PA: Temple University Press, 1984). There is no comparable study for the antebellum period.
32. Rorabaugh, *The Craft Apprentice*, 141; Lerman, "Preparing for the Duties," 42.
33. Stott, *Workers in the Metropolis*, 101.
34. Quimby, *Apprenticeship*, 52
35. LA Archives.
36. *North American,* December 31, 1847 vol. LXV, issue 16205, advertisement p3 col 5; [Philadelphia] *Public Ledger,* February 26, 1848, vol. XXIV, issue 133 p2; J. S. Dalrymple, *The Naiad Queen,* lists "Mr. Marsh" as Sir Rupert in Burton's 1848 production. George Odell, *Annals of the New York Stage* (New York: Columbia University Press, 1927), vol. V, 596; vol. VI, 140, 191, 229. Thomas Allston Brown, *A History of the New York Stage from the First Performance in 1732 to 1901* (New York: Dodd, Mead and Co., 1903), 306, 308, 311, Google Books, accessed July 17, 2010.
37. Brown, *New York Stage*, 126; *New York Times,* August 13, 1857 advertisement with cast list.
38. *New York Times,* December 5, 1855.
39. *Picayune,* March 18, 1858.
40. *Argus* (Melbourne, Australia), November 4, 1860, National Library of Australia, accessed June 20, 2010.

41. *Picayune*, March 18, 1858.
42. On Spaulding, see John S. Kendall, *The Golden Age of the New Orleans Theatre* (Baton Rouge, LA: Louisiana State University Press, 1952), 477–79; and David Carlyon, "Spaulding and Spicy Rice," chapter 6 of *Dan Rice: The Most Famous Man You've Never Heard of* (New York: Public Affairs, 2001).
43. *Picayune*, March 26, 1858.
44. LA Archives. All of the documents discussed in this paragraph are in the same location.
45. The statement from Dr. Warren Brierhill certifying Alfred's health is dated April 2, 1858, after the court had decided in Marsh's favor. However, the judge's opinion in the appeal states that the question of Alfred's health was determined by the initial court. The examination was probably conducted several days before the statement was signed. Another possibility is that Mrs. Stewart had arranged for a different doctor to examine Alfred prior to March 30, 1858, but no documentation exists to support this thesis.
46. *Picayune*, April 22, 1858; *Clipper*, May 1, 1858.
47. The judge's opinion uses the term "relator" here. Both "plaintiff" and "relator" are used throughout the LA Archive documents to indicate Mrs. Stewart.
48. *Clipper*, May 29, 1858.
49. Kurt Gänzl, *Lydia Thompson Queen of Burlesque* (New York: Routledge, 2002), 84.
50. *Clipper*, June 5, 1858.
51. *Clipper*, June 26, 1858.
52. *Clipper*, April 9, 1859.
53. *Clipper*, May 7, 1859.
54. Ibid.
55. Carlyon, *Dan Rice*, 100.
56. If Mrs. Stewart had a written contract with Spaulding, it remains undiscovered. None of the documents examined for this essay enlarge upon the terms of their agreement.
57. *Clipper*, May 7, 1859.
58. A study of twentieth-century child actors noted issues that arise when parents function as agents or business managers. Mothers who acted in dual capacities were later evaluated by their adult children as less caring and more over-controlling. See Lisa J. Rapport and Matthew Meleen, "Childhood Celebrity, Parental Attachment, and Adult Adjustment: The Young Performers Study," *Journal of Personality Assessment* 70:3 (June 1998): 484–504, esp. 499.
59. *Richmond (VA) Enquirer,* May 28 and June 1, 1858; *Richmond Dispatch*, June 2, 3, 4, and 5, 1858; *New York Times,* July 9, 1858; *Clipper*, June 5 and 9, 1858, July 3, 10, and 17, 1858.
60. See Benjamin McArthur, "'Forbid Them Not': Child Actor Labor Laws and Political Activism in the Theatre," *Theatre Survey* 36:2 (1995): 63–80, and Shauna Vey, "Good Intentions and Fearsome Prejudice: New York's 1876 Act

to Prevent and Punish Wrongs to Children," *Theatre Survey* 42:1 (May 2001): 53–68.
61. New York State did not pass its own version until March 25, 2003, *an act to amend the estates, powers and trusts law, in relation to establishment of child performer trust accounts for child performers* (7510-B).
62. *Illustrated Dramatic Weekly*, March 8, 1879: 4–5, cited in McArthur, *Actors and American Culture, 1880–1920*, 99.
63. James H. McTeague, *Before Stanislavski: American professional acting schools and acting theory, 1875–1925* (Metuchen, NJ: Scarecrow Press, 1993).
64. *New York Tribune*, March 5, 1911, clipping in Society for the Prevention of Cruelty to Children, "Children of the Stage" scrapbook 15, Office of the New York Society for the Prevention of Cruelty to Children.
65. David Belasco, *Theatre Through its Stage Door*, 1919, reissued, ed. Louis V. Defoe (New York: Benjamin Blom, 1969), 132.

3. Children and Youth of the Empire: Tales of Transgression and Accommodation ∾

Gillian Arrighi and Victor Emeljanow

During the first decade of the twentieth century theatrical troupes that comprised child performers were a feature of the transnational touring routes throughout Australasia and "the East," as the vast territory north of Australia to Shanghai, and west to the subcontinent of India was colloquially termed. Often referred to as "lilliputian" or "juvenile" companies this type of performance was a phenomenon particular to the historical moment, the result of interwoven strands of empire, culture, and modernizing progress. As we shall see, most of the young performers were engaged in Australia. Quite apart from comic operas, pantomimes, variety, and burlesque, these troupes also transmitted intangible yet reaffirming ideas about youth, and empire, cleverness, and the future. Audiences with a predilection for the bright and precocious young emissaries from the outer reaches of the Empire sustained the existence of these troupes for three decades; the highest density occurred during the years 1900–1910. With itineraries that sometimes included South Africa and Canada, the Empire (as distinct from "the East") constituted their geographic range.

The "line of inheritance" that engendered the juvenile troupes of Australasia can be traced to Richard D'Oyly Carte's experiment with child performers during the London Christmas holiday season of 1879–80. His production of *H. M. S. Pinafore* by children, for children, produced wide-ranging consequences in Australasia and subsequently across the theatrical touring networks of "the East." Within five months of the *Children's Pinafore*, two separate juvenile "Pinafore" troupes were formed in Australia, and by 1883 at least three more were touring Australia and

New Zealand with an expanded repertoire of comic operas.[1] While the Pollard family became synonymous with juvenile light opera throughout the next 30 years, during the first decade of the twentieth century the Pollards were joined on international touring routes by Hall's Juveniles, Liddiard's Juveniles, and in 1909, by Maurice Bandmann's Merry Little Maids, a mixed-age troupe of adult, juvenile, and child performers.

In November 1910, the Australian Federal government enacted an Emigration Bill that prevented "any child who is under contract to perform theatrical, operatic, or other work outside the Commonwealth" to be taken out of Australia, except in cases where a permit was issued.[2] It also provided a legal determination of the term "child" (up to 16 for a boy and up to 18 for a girl), and strengthened the Government's right to intervene between child and parent if the child was deemed to be at risk.[3] Two years later a similar bill was brought forward in England, the Children (Employment Abroad) Bill, introduced in 1912 and ratified as law in 1913. The last British Act to address aspects of employment distinct from educational implications, it imposed the requirement of a license before a child was taken out of the United Kingdom for the purpose of singing, playing, performing, or being exhibited for profit. It stated that no "child" (under 14) was to be sent abroad for entertainment purposes and that no "young person (between 14 and 16) was to be sent without a specified licence."[4]

These laws, enacted at both periphery and center, were the result of four decades of political, social, and legal pressures brought to bear upon the meaning of a child, and which had steadily reduced the legally sanctioned spaces that children could occupy. It might be argued that in Britain, the passing of the 1870 Education Act began the long and often tortuous process of defining the rights of children that would preoccupy legislators and social investigators until after World War 1. The Australian colonies embarked on a similarly complex process of education reform in 1872 and it was not until the War years that compulsory education laws developed consistency and strength across the country's six states.

Part of the problem lay in the definition of childhood itself, exacerbated by attempts to determine legally its parameters. This would become particularly problematic when authorities tried to differentiate between children and so-called juveniles. At the same time this distinction would be extensively employed by entrepreneurs seeking to circumvent legal restrictions about the employment of children in the entertainment industry. We have discussed elsewhere that the increased visibility of child performers, both in England and in the Australasian colonies throughout the latter years of the nineteenth century:

coincided with increasingly determined efforts to legalize the importance of a universal education, to place the vagaries of entertainment within an ordered structure of legal precedent and to accommodate the economic significance of children as providers and consumers within the highly developed middle-class constructions of childhood.[5]

We believe that two complementary trajectories inform any discussion about the uses of young people during the period: the need to identify and, after identification, the need to reclaim young people, whether from the harsh conditions of urban life or from the depredations of employers and even parents. As we shall see, a third factor was injected into the process of reclamation: the need to organize. Examining the transmission of cultural popularities concerning children between the imperial center and its periphery, our focus is on the interplay between the political pressures brought about by well-meaning social commentators, the *realpolitik* that inflected the positions of managers and parents alike, and popular performances by children that channeled some of the social and political anxieties during the late Victorian and Edwardian periods until World War 1.

MORAL PANICS

It might be argued that the three intertwined preoccupations of identification, reclamation, and organization were all manifestations of middle-class attempts to control the uncontrollable elements of young people who appeared to threaten the verities of childhood, itself a middle-class construction. That is not to deny that children were at risk nor to diminish the earnest efforts of social commentators and legislators to improve the health and well-being of children themselves. Yet it is inescapable that these same adults were motivated by a vision of what children should be as much as what children actually were. This would become an increasing problem in the face of rapid urbanization. As children were obliged to join a workforce to support themselves and their families, however casual or spasmodic this might be, any singular notion of childhood was thus eroded. To the social observer, the large numbers of unemployed or casually employed young people posed a potential threat to social stability.[6] Observers were equally exercised by pernicious influences that might shape young attitudes and suggest activities to them, usually identified as criminal. In Britain, this lay at the heart of the moral panics to which John Springhall has referred.[7]

The pressure to identify destructive influences found expression in the opposition to cheap theaters ("the penny gaffs") and cheap juvenile literature

("the penny dreadful") from the late 1830s until the 1880s. Concerns were raised not so much about who went to the penny gaffs or read the penny dreadfuls but rather the moral positions that they might suggestively impose on young people: the resourceful, amoral villains and the resourceful, anti-authoritarian young heroes as models of behavior. "Middle-class Victorians found in these adolescent rebels an uncomfortable contradiction to their romantic and nostalgic images of childhood purity and innocence, inseparable from a state of weakness and dependence."[8] Opposition to the "gaffs" was moreover a manifestation of the anti-theatrical prejudice that would find a voice in responses toward the employment of children in the entertainment business. The popularity of the "penny dreadfuls" would be channeled by the publishers of juvenile literature who used the demands of the emerging youth market for their own ends and whose strategies would coincide with the rise of popular imperialism from the end of the 1870s: "themes expressed in the old dreadfuls had to be tamed, politicized and re-directed to serve the needs of empire."[9]

Social observers in the Australian colonies expressed similar concerns about the absence of "childhood" from many children's lives; "their spring, like that of the climate here, is an almost indefinable streak between winter and summer" wrote William Howitt in 1855.[10] Two decades later J. S. James noted the prevalence of very young girls in the sex-trade in Melbourne's Bourke Street, "some merely children." He thought "the state of morality amongst the working girls in Melbourne is worse than in Paris, and they commence their downward course earlier." In a nearby concert hall, youths, boys, and "a sprinkling of girls" made up the principal part of the cheaper seats and James thought the song and dance performance of a girl "of about ten," sandwiched between performances "of the usual low music-hall style," were only redeemed from indecency by her obvious youth and innocence.[11]

As we shall see, the imperialist tide would also affect the matter of youth organization and the nature and definition of youth itself. Before any remediation could take place, however, the first priority was to identify young people as a whole.

IDENTIFICATION

It is of course artificial to separate questions related to a child's education from those related to employment, and indeed the various British Education Acts from 1870 clearly acknowledged that any regulation determining a child's education would impact upon the child's capability to

undertake employment other than on a part-time basis. Yet it was important to establish a point of departure. The Elementary Education Acts of 1870 and 1876 suggested that attendance at school should be obligatory for children aged between 5 and 13 years of age. The latter act also stipulated that: "a person...shall not take into his employment any child who is under the age of 10 years." Nevertheless it offered some critical exemptions. If employers could prove that "such employment, by reason of being during the school holidays, or during the hours during which the school is not open, or otherwise, does not interfere with the efficient elementary instruction of such child, and that the child obtains such instruction by regular attendance for full time at a certified efficient school or in some other equally efficient manner"[12] then they were no longer liable.

By the end of the century the question of identification was as elusive as ever particularly as it coincided with the emergence of the subgroup of juveniles, which had become an increasingly pervasive market force. When in 1900 a case was brought before the High Court challenging the expenditure of elementary educational monies by the London School Board, it raised the question of identification again because, as *The Times* reported,[13] the need to determine who was a child and who was an adult lay at the heart of any determinations that the court might make. In his judgment, Justice Wills in effect gave up, noting that:

> no definition has been given as a child. It is impossible to lay down any definitive boundary as separating children from young men or young women, or any other description by which an advance beyond childhood may be indicated. Practically, I suppose, that at somewhere between 16 and 17 at the highest, an age has arrived at which no one would ordinarily call childhood.

In 1872, two years after the introduction of comprehensive education reforms in Britain, the Australian colony of Victoria followed suit, legislating that children between the ages of 6 and 15 must attend school on half the days that school was open. Public instruction laws and the later Factories and Infant Life Protection Acts of the 1890s may be analyzed as attempts to notionally mark the end of childhood.[14] If we averaged out the ages marked by this raft of different legislation we could say that a boy's childhood ended at 14 while a girl's childhood ended at 16. Adults were meant to be responsible for young people until these ages, whether the children were at school or not. As in Britain, however, these laws did not inculcate a common social agreement upon the identification of a child. In 1890, the prosecutor in a legal test case of child entertainers explained to the bench of Melbourne magistrates that "the legal definition of a child

was a person under twenty-one years of age,"[15] and 20 years later, during the parliamentary debates leading to the Emigration Bill of 1910, politicians held divergent opinions as to the age at which young people, young males in particular, ought not be deemed a child. As one Senator quipped: "My boys when ten years old travelled without any one to look after them. If they had not been able to travel alone I should not have thought them much 'chop.'"[16]

Certainly World War I demanded a fresh investigation of the youth question. In 1916 at the request of Arthur Henderson, the president of the Board of Education in Britain, a committee was set up: "To consider what steps should be taken to make provision for the education and instruction of children and young persons after the war."[17] The committee's final report that appeared in 1917 would have an effect on the Education Act of 1918, in particular its recommendation to raise the school leaving age to 14 and to abolish the half-time arrangement whereby children could split their time between school and employment.[18] In Australia between 1910 and 1916 the two most populous states, Victoria and New South Wales, enacted laws requiring children up to 14 years to attend school on every half-day that school was open.[19] The Commonwealth Emigration Bill of 1910 determined, however, the age of children was up to 16 for a boy and up to 18 for a girl, independent of whether they were at school or not. By the War years, therefore, the question of identification would appear to have been laid to rest, at least for the moment.

RECLAMATION

If the question of identification proved difficult and at times contradictory, the processes of reclamation proved equally confusing and confused. While it had been relatively easy to proscribe children from working in textile mills using the various Factory Acts in the early part of the nineteenth century, attempts to place children working in the entertainment industry within such restrictions proved highly problematic. Moreover, the employment of children needs to be seen within a context that somewhat paradoxically emphasized both protection and control. For example the passing of the Children's Dangerous Performances Act of 1879 (Britain) prohibited the employment of children under 14 in such performances. This Act was amended in 1894 by the Cruelty to Children Amendment Act that demanded that all children under 16 who were trained as circus performers, acrobats, or contortionists needed to be specifically licensed.[20] But by 1889 concerns about the welfare of children had fused matters of

employment with matters of education in that the compulsion to attend school directly affected the capacity of children to be employed. This immediately impacted upon families to whom the income generated by children was a significant weekly contribution. Moreover, employment that compelled children to work outside school hours for long periods was now defined as akin to cruelty. Thus the arguments about late hours, inadequate parental supervision, and the exploitation by employers assumed an added moral dimension.

In 1902 and 1903, the ambivalences toward the employment of children in entertainment were perpetuated. The Employment of Children bills sought to prevent children from being employed after 9 p.m. and to raise the minimum age that a child could be employed from 7 to 10. Arguments in Parliament relating to the employment of children particularly focused on touring children. Sir John Gorst, the vice president of the Committee of the Council of Education, for example, alleged that:

> They were children who were dragged from town to town, and so far from being well-cared for, they were let out by drunken mothers who led them wretched lives and they were given in charge of the woman who kept the theatre wardrobe, or whoever else would take care of them at the cheapest possible price.[21]

Ernest Gray, the member for West Ham North, stated that:

> nothing could be more injurious to girls of tender years than to have to go into some of the dressing rooms where adults were preparing for the stage. The children travelled from one town to another in winter. They travelled about on the Sunday to get lodgings; they went before the magistrates on Monday morning to get licences; they were called for a rehearsal—sometimes for two—and then they went to the stage on Monday evening...[I] could conceive of nothing more likely to injure the moral character of young children than this.[22]

As we shall see, the question of touring would accentuate the loopholes in legislation and prove to be an ongoing source of irritation and argument both in Britain and Australasia.

ORGANIZATION

Parallel to the legislative measures concerned with reclaiming children through educational control, and not unrelated to them, were the deliberate attempts to organize children and to suggest strategies for social cohesion

by providing them with new models of social behavior, especially for boys. Volunteer groups and cadet corps flourished in schools after 1863 and military drill was enshrined in the Education Codes of 1871 and 1875.[23] Journals like the *Boys' Own Paper* (first published in 1879 by the Religious Tract Society) began to utilize the techniques of the "penny dreadfuls" to present "imperial ideas in all their nationalist, racial and militarist forms in adventure stories and historical romances."[24] Although the principles of organized athleticism emanated from the public school system, they filtered down very quickly. John MacKenzie suggests:

> Deliberate efforts were made to suck working-class children into a consciousness of imperial and military destiny, both through the curriculum and through drill and exercise. In the public schools the same effects were achieved by relating sport to the imperial obligation, and by ensuring that the message was potently carried through the paraphernalia of school magazines, tablets, speech days and chapel services. Outside school, efforts were made from the 1880s to seize children with the same world view through youth organisations, often associated with the Churches."[25]

Drawing on case studies of working-class children, Stephen Humphries asserts:

> working-class children were generally much more responsive to lessons and activities that were inspired by imperialism than they were to any religious influence in school...Most important, however, the ideology of imperialism made a direct appeal to working-class youth because it reflected and reinforced a number of its cultural traditions, in particular the street gangs' concern with territorial rivalry, and the assertion of masculinity.[26]

Stories in periodicals like the *Boys' Own Paper* had emphasized the bravery and independence of boys journeying to the far reaches of the Empire and these complemented the efforts of organizations to instill a sense of youthful self-reliance as well as discipline. Many of the youth organizations had strong religious roots, such as the YMCA and YWCA formed in 1844 and 1855 respectively, and the Boys' Brigade in 1883, which itself spawned a host of imitators in the period from 1891 to 1899.[27] These, however, were dwarfed by the success of Baden-Powell's Scout movement, which commenced in 1907. This had no religious affiliations and appealed in particular to lower middle class and skilled artisan groups. The principle behind it was that of national efficiency to combat "the threat of national decadence...evident in both the supposed physical deterioration of the British race and the lack of enthusiasm for Empire."[28] In order to foster a

"healthy population" young people needed an antidote to "the debilitating effects of urban society" and to develop an "enthusiasm for open-air life on the frontiers of the Empire and in the countryside of Britain."[29] What this suggests is that by the end of the Edwardian period, new approaches toward the reclamation of young people, regardless of class distinctions, lay in their organization into units that emphasized group solidarity, a sense of "family" perhaps. Such qualities might equally characterize a juvenile theatrical touring company.

It is perhaps ironic that as legislators became exercised by the treatment of children in the workplace generally and the entertainment industry in particular,[30] Richard D'Oyly Carte should have embarked on a venture that would have the global as well as national implications to which we have referred earlier. Not only did this result in a proliferation of so-called juvenile opera companies performing versions of Gilbert and Sullivan as well as staples of the musical comedy repertoire like *Les Cloches de Cornville, La Fille de Madame Angot,* and *The Belle of New York,*[31] but when these companies toured to China, South Africa, India, and the Philippines, they became in effect informal emissaries of Empire, enshrining the organizational and collective discipline ideals that had emerged and that Baden-Powell had articulated.

The influence of Carte's experiment in Britain is demonstrated in the career and practices of the Warwick Gray's Juvenile Opera Company. Gray had been contracted to perform the role of Private Willis in *Iolanthe* for the last four weeks of its season at the Savoy Theater in 1883 and subsequently that of Guron in the premiere season of *Princess Ida* from January to October 1884.[32] In an interview with the *Pall Mall Gazette,*[33] he stated that his formation of a children's company had been triggered by D'Oyly Carte's success with the children's versions of *H. M. S. Pinafore* in 1879, and subsequently *The Pirates of Penzance* during the Christmas season in 1884. He appears to have had no further engagements with the D'Oyly Carte company because by May 1885, his newly formed children's opera company of 32 was performing in Cornwall with an adaptation of Lecocq's *La Fille de Madame Angot.*

A statement addressing the current disquiet about children on stage prefaced Gray's interview in the *Pall Mall Gazette*. After stating that the employment of children in the theater had periodically "disturbed the consciences of the British public" it went on:

> This year those philanthropists who have interested themselves in the matter have been more energetic, and on Saturday the theatrical managers received an

order from the Home Office forbidding the engagement of any children under ten years of age in pantomimes or burlesques. Hitherto the School Board has granted exceptions for rehearsals indiscriminately; and it has been computed that at this season one thousand small children pick up a more or less precarious livelihood on the boards of London theatres, concert-halls, and circuses. How many of them are under ten years of age is a piece of information that has never been ascertained; but there is no doubt that a considerable number of these little mites are only eight or nine years of age, perhaps even younger.

The interview took pains to differentiate the conditions of performance between pantomime and those of Gray's company. "Pantomime children," said Gray, "form a class entirely different to that constituted by 'my family.'" He pointed out that unlike pantomime seasons when children were employed for the run of the play, his company stayed together, and in fact by the end of 1886 had been touring for 20 months. He deprecated restrictions on the employment of children under 10 as of little significance by suggesting that the members of his company were slightly older. Moreover, the article emphasized the importance of education by indicating that half the company had passed Standard 6, 25 percent had passed Standard 5, while the youngest members "were still pursuing their studies." If these assertions were accurate then half the company would have been at least 11 with 25 percent at least 10, while the remainder were somewhat younger. The mix of ages and educational abilities made legal intervention extremely difficult. Three matrons supervised the children under the guidance of Mrs. Gray. Many of the children's parents banked their wages. Thus Gray was careful to emphasize the duty of care.[34] By December 4, 1888 the company had performed 1,147 times in London and the provinces.

TOURING THE EMPIRE

The organization of Warwick Gray's company along lines that, ostensibly at least, emulated an extended family, also typified the organization of the Australian juvenile troupes to which we referred earlier. They stayed together for lengthy periods (contractual evidence is scant but eighteen months to two years are the terms mentioned in news reports); wages were paid to parents, thus tacitly demonstrating that the children's labor was both an apprenticeship for future adult employment and a welcome contribution to the fiscal stability of their families. Additionally, the assignation of "matrons" to oversee the physical and moral care of the children, and the employment of teachers who travelled with the company to conduct

regular school lessons, answered potential enquiry and criticism as to the moral, religious, and secular education of the children.[35]

Theatrical touring throughout Australasia necessitated intercolonial movement using the coastal and Tasman routes that linked New Zealand, Tasmania, and Australia's mainland. Each of the self-governing colonies formulated education, labor, and child protection laws independently of each other and somewhat erratically across the latter three decades of the nineteenth century, informed by precedent laws in the "Mother Country." It was thus inordinately difficult for producers with children in their theater companies to accommodate the various colonial laws on a protracted tour. Broadly speaking, such companies were assisted by the fact that Australia's education laws lacked significant weight during the late nineteenth century. Although politicians and educators had argued for a long time that compulsory attendance requirements were too low and strategies for their implementation were too weak, it was not until the early years of the twentieth century that education reform gained in strength, backed by the weight of significant legal action against parents who did not comply.[36] It is perhaps not so surprising then, that producers of the popular juvenile troupes turned to the Asia-Pacific touring routes during the first decade of the twentieth century—when there was no longer a legally sanctioned space for these companies within Australia.

HALL'S AUSTRALIAN JUVENILES

On September 28, 1900, the Cape Town periodical *The Owl* announced the return of Hall's Australian Juveniles after an extensive tour of South Africa that included Durban, Pietermaritzburg, East London, and Kimberley and reported that: "the present tour has been the most successful of any company in South Africa."[37] No reference was made to the fact that the company was touring in the midst of the Second Anglo-Boer War, which had started in October 1899 and would continue until May 1902. Strictly speaking this was not a children's company since all the participants were aged between 11 and 17. Yet notices continued to describe them as "the little ones" reflecting the uncertainties about the definition of childhood felt in Britain and Australia where the child performers had been engaged.

The entrepreneur Harry L. Hall had himself been a child performer. As such he had worked with his father John L. Hall who had been performing on the Australian and New Zealand stages since 1854. His son appears to have been successful as a comic performer and in 1897 had visited South

Africa with Pollard's Opera Company and had stage managed the Pollard's Liliputian Opera Company's production of the *Belle of New York*. Hall returned to Australia to assemble his own juvenile company in 1899 for a South African tour. He obviously retained his Pollard connections because members of their Liliputian Company were included; he also retained the services of some of the older Pollards as support staff since they obviously knew the South African context well.[38] By July 2, 1900, the company were performing Gilbert and Sullivan's *Patience* at Scott's theater, Pietermaritzburg, and on July 5 Powyer and Sprange's *The New Barmaid*.[39] By September 1900 the company's repertoire included *The Belle of New York* (which Hall had already worked on), *Morocco Bound*, *Go Bang*, and *Paul Jones*, and had already toured extensively.[40]

The Cape Town responses were unequivocally favorable. Particularly noticed were the energy of the young performers and the facility with which the female performers played male roles, suggesting something about the strength of the company: the boys seem to have been responsible for the comic male roles.[41] The company continued to tour South Africa throughout 1902. In the newspaper reports that constitute the historic record of Hall's Juveniles in South Africa there is no evidence indicating the composition of the audiences or whether children formed a significant component of those audiences. The glimpses we have reflect the military presence: a Private Hodgson from Victoria, camped in Newcastle, between Durban and Johannesburg, noted that he was able to see the company on a special pass on November 26, 1901: "They are splendid and it gave me the greatest longing for home." Even Baden-Powell, after the triumphant resolution of the siege of Mafeking, saw them in Durban and "graciously signed his autograph in each of their birthday books, of which there were about forty."[42]

After May 1902, the company returned to Australia having performed successfully in Durban and elsewhere. Some of the performers left the company to continue a career in Australia but Harry Hall immediately engaged another juvenile company. After auditions in Melbourne and Sydney he employed 30 children for a two-year tour of South Africa and departed Australia with them on March 25, 1903.[43] By now their repertoire had diversified to include Edward Solomon and H. P. Stephens's comic opera *The Red Hussar* and J. T. Tanner's *The Transit of Venus*.[44]

Hall, however, died suddenly of pneumonia in October 1903, leaving the running of the company to his wife and presumably his Pollard support group.[45] She was reported as doing good business in Kimberley with her new company of 11–18 year olds.[46] There were, however, signs of

strain: Seccumbe, the company's manager, challenged Hall's wife, asserting that he should have control over "certain children belonging to the company." The Chief Justice in Cape Town dismissed the case and suggested that the parents of the children in Australia should be consulted in the case of any future claim.[47] There is no evidence of any further action in the South African press and one can assume that Mrs. Hall cut her losses and returned to Australia in 1904.

LIDDIARD'S BIJOU TROUBADOURS

Also comprising young performers engaged in Australia, the Bijou Troubadours toured the Asia-Pacific region from early 1906 until late 1910. Producer and manager, Tom Liddiard had previously worked with various theatrical companies "in India and the Far East" including the Stanley Opera Company,[48] although his association with the theater may have come initially through his sister, Fanny, an actress who was well-known to Australian audiences since the early 1880s.[49] Fanny Liddiard's role as her brother's agent in Australia is indicated in a news item from August 1908 reporting that she had come to Melbourne from Java with the aim of "engaging a new juvenile vaudeville show for the East."[50] Two months later the newly recruited troupe departed Australia to tour under the management of Tom Liddiard.[51] Reports from Singapore and India during 1908 describe the size of the company size as "about a dozen clever juveniles the girls being twice as numerous as the boys,"[52] but also as 30 clever children, "The Cleverest Troupe of Juvenile Artists Touring the World,"[53] making it difficult to ascertain the precise number of the company.

That the young performers were employed through theatrical networks in Australia and immediately transported to performance venues in the Asia-Pacific region is suggested in other news items of the time. The *Coburg Leader* reported that a local child, Dinah Campbell, had accepted a two-year contract with "the Liddiard Juvenile Company to tour through India and the far East." Apparently known to her local community through her charity performances, little Dinah Campbell was moreover the *second* pupil of Madam Lilley to have recently been offered a theatrical engagement in India.[54] The congratulatory notice about a local child suggests also that individual child performers were engaged at irregular intervals, perhaps to boost the numbers and skills of troupes that were already on tour. Moreover, the presence of Madam Lilley the dancing and singing teacher suggests a theatrical network inclusive of stage teachers and families willing to set their children on a course for the professional stage.

Throughout the period 1906–1910 Liddiards' Bijou Troubadours did not perform in Australia but appeared on multiple occasions in Singapore (including Tanglin Barracks),[55] Java, Rangoon,[56] Calcutta,[57] Secunderabad (where they entertained regiments stationed there),[58] and the Philippines. It was the troupe's visit to the Philippines that contributed to a "moral panic" brewing in Australia during 1910 over the engagement of children for theatrical companies "in India and the East." The Consul-General in Manilla wrote to the Australian Department of Foreign Affairs about an 11-year-old boy, Neill Connelly, who had sought assistance from the Consul on account of ill-treatment within Liddiard's company. Allegations against the theatrical manager were that the boy had been detained for two years although his contract was for 18 months, that the children of the company were fed two meals a day, at 11 a.m. and 5 p.m., that they had to rehearse every morning for three hours before being fed, and that their schooling was denied and some of the children were practically illiterate. The Consul-General in Manilla further observed that Liddiard was taking the children to military camps and "out of the way places in such a rough country as Mindanao where they must necessarily be subjected to hardships such as children should not undergo without very good reason."[59]

The (Australian Commonwealth) Emigration Bill was enacted in November 1910 and within several weeks Liddiard's company returned to Melbourne,[60] where theater producer, William Anderson, immediately employed the children for the Christmas pantomime season of *The Old Woman Who Lived in a Shoe*.[61] Australian newspapers reported extensively on Anderson's pantomime tour of the Australian states throughout much of the following year (1911) and upon Liddiard's juveniles who continued with Anderson for this tour.

BANDMANN'S MERRY LITTLE MAIDS OPERA COMPANY

In February 1909, the *Otago Witness* (Dunedin, New Zealand) announced:

> A new Juvenile Opera Company, organised by Mr H. P. Lyons,[62] on behalf of Bandmann, the well-known entrepreneur, will leave Melbourne by the R.M.S. Orient for India, opening at the new Empire Theatre, Calcutta, in March. The company, which consists of some 30 accomplished children, headed by Rosie Fitzgerald[63] and Madge Myers,[64] is in charge of Mrs Baptiste, and is said to be very complete in all details.[65]

The "Merry Little Maids Opera Company," as Bandmann's troupe was known, played Singapore during May. News reports indicate it comprised young adult performers such as Florence Beech, the leading lady,[66] some juveniles, and some children who filled the stage picture, sang, and danced in the ballet sections of the shows. In the case of *The Merry Widow*, children also took some roles as specially noted by the reviewer for the *Straits Times*.[67] Subsequent reviews of *The Gay Gordons* and *Gentleman Joe* similarly delineated between the age groups of the cast through references to "girls," "children," and "youngsters."[68]

The well-received season at Singapore's Victoria Theatre closed on May 19,[69] at which point ten of the juvenile members of the company returned home, little more than three months since their departure from Melbourne. Although noted in the *Straits Times*, no particular reason was provided.[70] Perhaps this rupture of the recently assembled troupe was due to homesickness on the part of the children, or to unusually short contracts. In the light of touring patterns throughout the region it seems unusual that the full troupe did not meet its target of Bandmann's theater in Calcutta before the return home of a considerable number of its members. The children's return to Australia may also have been due to the "moral panic" that was stirring there concerning children's theater companies touring "India and the East." During the months since Bandmann's juvenile contingent had left Melbourne a steady stream of news reports in that city's *Argus* newspaper—concerning cruelty and moral mismanagement of juvenile performers with Pollard's Liliputian Opera Company in Madras—was stimulating political pressure to put an end to the practice of engaging child performers for international theater companies. Bandmann may have sensed that the tide of public opinion was turning against theatrical producers of children's companies and acted to stem moral censure of his professional activities by sending the youngest children home.

News reports about the excursions of the company's advance agent, J. A. F. Young indicate the territory covered by the troupe during 1909. After Singapore they visited Java, Kuala Lumpur, Ipoh (Malaysia),[71] Penang, and Hong Kong. A notice in the *Straits Times* of May 28 that the troupe was heading "as far north as Shanghai and Japan" was verified later in the year by a letter written by the second engineer on the P&O steamer "Sardinia," to a friend in Dubbo, New South Wales:

> Between Shanghai, Yokohama, and back to Hong Kong we had as passengers 'Bandmann's Merry Little Maids Opera Co.' They played at the different places we sailed at, and the largest audience they had was at Taingtan, also the

nicest little theatre, which was attached to one of the principle [sic] hotels there, and while I'm on the Opera Co. I might as well say the chorus were engaged in Melbourne, ages ranging from about 7 to 18. I don't know what the original number was, but we had twenty-one juveniles, and the Melbourne dialect was very freely spoken on board. The principals were engaged at home ['at home' may mean the UK]. I heard them in the "Merry Widow" and "Veronique," and they did very well."[72]

The troupe subsequently visited Singapore again, the sultanate of Deli (Sumatra), and Calcutta.[73] It is unclear from the news coverage exactly when the company was dissolved but news reports about the Merry Little Maids cease in late 1909.

MORE MORAL PANICS AND TRANSGRESSIONS

As indicated earlier, the "moral panic" that gave rise to the Australian Emigration Bill was in response to the negative reports about ill-treatment of child performers with Liddiard's Juveniles in the Philippines, and Pollard's Liliputian [sic] Opera Company in Madras. Formed in Melbourne in July 1909, the new incarnation of Pollard's troupe comprised seven boys and seventeen girls who ranged in age from 6 to 17 and were contracted for two years.[74] Eight adults were responsible for stage management, the "mothering" of the children (a female to oversee the girls and a male to oversee the boys), and included a chemist to oversee the children's health and a schoolmistress.[75] Many parents had received the children's salaries 12 months in advance prior to embarkation in Melbourne; others had received money in advance to buy clothes for their children before they went away.[76] After seven months touring to Java, Singapore, Penang, Calcutta, Bombay, Secunderabad, Bangalore, and Madras, a news item in the *Madras Times* brought to light the alleged ill-treatment of children in the company by the manager, Arthur Pollard.[77] Events came to a head when concerned citizens who suspected maltreatment of the children intervened and removed five boys under 14 and ten girls under 16 from Pollard's care. When asked, 22 of the 24 children of the troupe said they wanted to be released from Pollard's guardianship and were subsequently placed under the care of concerned residents in Madras who then organized the children and most of the adult members of the company to give concerts in aid of a fund to pay the children's passage home to Melbourne.[78]

Condemnation of the professional engagement of children for touring theater companies, and for parents who connived to take pecuniary

advantage of their children,[79] featured in news reports as well as the parliamentary debates on the matter. The combination of unscrupulous theatrical entrepreneurs, unparented children, and the "distant, wild, non-Christian countries"[80] that constituted "Asia" had a powerful effect upon Australia's media, politicians, and lobby groups. In exercising its duty of *parens patriae*, the State gained the power to reclaim children from these potentially destructive influences.

In England, the Children (Employment Abroad) Act of 1913 came during yet another period of "moral panic." Concerns about the "deterioration of the race" had surfaced after the Anglo-Boer War and they were joined by concerns relating to white slavery and the exploitation of girls in particular. Yet unlike events in the Australian parliament several years earlier, the debates surrounding the passing of the 1913 Act were desultory, perhaps because the issue of touring companies of children and their control had been palmed off to local educational authorities and was no longer a national one. National priorities were now focused on addressing matters of defense in the light of potential armed conflict. Nevertheless, there may also be some credence in the argument that attitudes toward young people, particularly boys, were changing during the late Victorian and Edwardian periods and that these may have been influenced by the emergence of popular imperialism.

While managers would have been inhibited from touring companies overseas in the light of the new legislative measures, the formation of children's companies in Australia, for example, continued unabated. Major entrepreneurs like Anderson and J. C. Williamson toured Australia with new companies. But they were careful to iterate serious concern with their duty of care. In an interview with Jessie Brenan who trained the J. C. Williamson company children,[81] she emphasized that six adults were employed, including teachers and a certificated nurse. She averred that there would be less "physical degeneration" if more children undertook her training and that as a consequence there would be "fewer of the unhealthy adults we see about." Yet the evidence suggests that some managements were still prepared to take their chances. For example, another Pollard Juvenile Opera Company was touring Canada in 1912 and 1913. It had stopped over in Honolulu and opened in Seattle, August 25, 1912. A Winnipeg newspaper described them as "samples of young Australians of which any country might be proud...Wonderful intelligence, vivacity, adaptability, and histrionic power, combined with unusually good voices and physical vigor."[82] They billed themselves as the Original Pollard's Australian Juvenile Opera Company to distance themselves from the "spurious" one that was "foisted upon the public in the Orient."[83]

The Winnipeg newspaper comments suggest that despite preventative legislation, the young performers of these theatrical companies would continue to exemplify the imperial ideals of youth that had coalesced and strengthened since the mid-nineteenth century. After all, they moved in socially cohesive groups serving the outposts of the realm with entertainment skills that were learned and practiced through "drill and exercise." In so doing they demonstrated publicly that they were clever, bright, gregarious, independent, self-reliant, adventurous, and enthusiastic as they toured the Empire entertaining its people.

NOTES

1. Gillian Arrighi and Victor Emeljanow, "Entertaining Children: An Exploration of the Business and Politics of Childhood," *New Theatre Quarterly* 28:1 (February 2012): 1–55, at 48.
2. *Argus* [Melbourne], November 10, 1910, 6.
3. *Australian Federal Parliamentary Debates*, October–November 1910, 5994 (hereinafter referred to as PD Oct–Nov 1910).
4. *Era*, April 19, 1913: 11, and "Children (Employment Abroad) Bill," *The Times*, February 7, 1913, 10. This appears to have been occasioned by another "moral panic" about young girls and may also have been influenced by the passing of the White Slave Traffic Act in the US Congress in 1910.
5. Arrighi and Emeljanow, "Entertaining Children," 41.
6. Charles Booth estimated that between 1851 and 1881 children under 15 represented 35 percent of the population of England and Wales. The Australian colonies recorded similarly high rates of youth. During the 1890s 45 percent of the population of New South Wales was under 20 and "by the end of the century, in all the eastern mainland colonies, the largest cohort was that aged between 10 and 14 years." Bradley Bowden, "A World Dominated by Youth: Child and Youth Labour in Queensland, 1885–1900," in *The Past Is before Us*, eds. Greg Patmore, John Shields, and Nikola Balnave (Sydney: Australian Society for the Study of Labour History, 2005), 37–45.
7. See John Springhall, *Youth, Popular Culture and Moral Panics* (New York: St. Martin's Press, 1998).
8. Springhall, *Moral Panics*, 61 and quoting Marjory Lang, "Childhood's Champions: Mid-Victorian Children's Periodicals and the Critics," *Victorian Periodicals Review* XIII (1980): 22.
9. Patrick A. Dunae, "'Penny Dreadfuls': Late Nineteenth Century Boys' Literature and Crime," *Victorian Studies* 22:2 (1979): 139.
10. William Howitt, *Land, Labour and Gold or Two Years in Victoria* [1855], quoted in Gwyn Dow and June Factor, eds. *Australian Childhood: An Anthology* (Melbourne: McPhee Gribble, 1991), 49.

11. John Stanley James, *The Vagabond Papers*, [1877–78], quoted in Dow and Factor, *Australian Childhood*, 82–89.
12. *Elementary Education Act, 39 and 40 Vict. Ch. 79, pt.1.*
13. *The Times,* December 21, 1900, 6.
14. The *Infant Life Protection Act* (Victoria, 1890) and *Infant Life Protection Act* (NSW, 1892) both deemed an adult's responsible care for a boy ended at 14 and for a girl at 16. The NSW Factories Act of 1896 determined that no person under 14 could be employed in a factory or a shop.
15. *Argus* (Melbourne), May 1, 1890, 11.
16. Senator McDougall, PD Oct–Nov 1910, 6074.
17. Quoted in J. Stuart Maclure, *Educational Documents: England and Wales 1816 to the Present Day* (London: Methuen, 1965), 167.
18. The report also pointed out that using the census returns of 1911 together with the Board of Education's statistics, "there were about 2,700,000 juveniles between the ages of 14 and 18 and of these about 2,200,000 or 81.5 percent were not enrolled in any school."
19. Alan Barcan, *A History of Australian Education* (Melbourne: Oxford University Press, 1980), 206, 210–211. *Education Act* (Victoria, 1910); *Public Instruction (Amendment) Act* (NSW, 1916).
20. Frederick Keeling, *Child Labour in the United Kingdom* (London: P.S.King, 1914).
21. Parliamentary debates, Official Report, House of Commons, vol. 124, cols. 336,337,344, quoted in E. R. H. Ivany, "Theatrical Children and the Law," *The Solicitor* 17 (November 1950): 247–48.
22. Ibid.
23. See John M. MacKenzie, *Propaganda and Empire: The Manipulation of British Public Opinion 1880–1960* (Manchester: Manchester University Press, 1984), 228.
24. Ibid., 203.
25. Ibid., 228.
26. Stephen Humphries, *Hooligans or Rebels? An Oral History of Working-Class Childhood and Youth 1889–1939* (Oxford: Blackwell, 1981), 41.
27. See John Springhall, *Youth, Empire and Society: British Youth Movements 1883–1940* (London: Croom Helm, 1977).
28. Ibid., 57.
29. Baden-Powell quoted in Allen Warren, "Citizens of the Empire: Baden-Powell, Scouts and Guides and an Imperial Ideal 1900–1940," in *Imperialism and Popular Culture*, ed. John M. Mackenzie (Manchester: Manchester University Press, 1986), 240.
30. The *Factory and Workshop Act (41 & 42 Vict. C. 16)* was passed in 1878 stipulating that no child under 10 could be employed and that education was mandatory for those up to 10.
31. See Gillian Arrighi, "'D'Oyly Carte's Pantomimes': Complementarity and Innovation," *Popular Entertainment Studies* 3:2 (2012): 31–44.

32. "The Gilbert and Sullivan Archive," accessed February 28, 2011, http://math.boisestate.edu/gas.
33. "Children on the stage," *Pall Mall Gazette,* December 6, 1886, 4–5.
34. "Theater Royal-La Fille de Madame Angot," *Belfast News-Letter,* May 15, 1888, 5.
35. Arrighi and Emeljanow, "Entertaining Children," 49.
36. Barcan, *Australian Education,* 206.
37. *The Owl,* September 28, 1900, 620.
38. *Launceston Examiner* (Tasmania), August 19, 1899, 4; "South African Notes," *Referee* (Sydney), February 27, 1901, 10.
39. See "Amusements in South Africa," *Era,* July 28, 1900, 15, and "Children in opera companies," *New York Times,* July 29, 1882, S1.
40. All the plays had large female casts, which was probably the reason for their choice in the first place.
41. See "Hall's Australian Juveniles," *Cape Times,* October 12, 1900, 5.
42. *Bacchus Marsh Express* (Victoria), February 15, 1902, 4 and *Referee* (Sydney), March 27, 1901, 10 quoting a report in the London *Era.*
43. *Otago Witness* (Dunedin, NZ), March 18, 1903, 57.
44. *The Red Hussar,* a comic opera was first performed in 1889. Solomon's *Billee Taylor* featured in the repertoire of Warwick Gray's company of juveniles. *The Transit of Venus* was first performed in 1898 in Dublin.
45. Death notice, *Argus* (Melbourne), November 7, 1903, 9.
46. *Examiner,* (Launceston) March 17, 1904, 7.
47. Reported in "Hall's Australian Juvenile Company," *Evening News* (Sydney), February 25, 1904, 6.
48. *Singapore Free Press and Mercantile Advertiser,* July 24, 1908, 5.
49. Fanny Liddiard performed in J. C. Williamson's inaugural Australian production of *H.M.S. Pinafore* in 1881 and the following year appeared with the newly founded Comic Opera company of Williamson, Garner, and Musgrove.
50. *Evening Post* (Wellington, NZ), August 28, 1908, 11.
51. *Otago Witness* (Dunedin, NZ), October 28, 1908, 69.
52. *Singapore Free Press and Mercantile Advertiser,* July 24, 1908, 5.
53. *Times of India,* November 12, 1908, 3.
54. *Coburg Leader* (Melbourne), September 21, 1907, 1.
55. *Straits Times,* February 8–June 14, 1906; *Singapore Free Press and Mercantile Advertiser,* July 24, 1908, 5 and January 4, 1909, 8.
56. *Times of India,* September 7, 1906, 7.
57. Ibid., February 13, 1908, 6.
58. Ibid., November 2, 1908, 38.
59. PD Oct–Nov 1910, 4535.
60. *Bendigo Advertiser* (Victoria), December 3, 1910, 3.
61. *Evening Post* (Wellington, NZ), December 10, 1910, 11.
62. Lyons was a veteran theatre agent (*New Zealand Mail,* March 4, 1903).

63. Two years earlier (1907) 15-year-old Rosie FitzGerald had starred in the J. C. Williamson production of the Seymour Hicks and Walter Slaughter musical, *Bluebell in Fairyland* (1907).
64. The *Bendigo Advertiser* (Victoria), May 7–28, 1907 recorded Madge Myers' participation in the inaugural Austral Competitions for theatrical performance.
65. *Otago Witness*, February 17, 1909, 69 and March 3, 1909, 69
66. Florence Beech had been married since 1902 and had given birth to a child in 1904 (*The Straits Times*, February 16, 1911, 2).
67. Ibid., May 17, 1909, 7.
68. Ibid., May 17, 1909, 7, for review of *The Gay Gordons*; May 14, 1909, 6 for review of *Gentleman Joe*.
69. Ibid., May 18, 1909, 8.
70. Ibid., May 20, 1909, 6.
71. Ibid., May 14, 1909, 6.
72. *Dubbo Liberal and Macquarie Advocate*, September 22, 1909, 4.
73. *Straits Times*, September 18, 1909, 6.
74. *Madras Times*, March 17, 1910, 22.
75. Ibid., February 14, 1910, 4; March 10, 18; and March 17, 22.
76. Ibid., February 24, 1910, 10.
77. Ibid., February 24, 1910, 3.
78. *Argus*, March 21, 1910.
79. PD Oct–Nov 1910, 5995.
80. PD Oct–Nov 1910, 4536–38.
81. "The Child and the Stage," *Barrier Miner* (Broken Hill, NSW), May 8, 1911, 7.
82. Quoted in the *Advertiser* (Adelaide), October 26, 1912, 8.
83. "Theatrical Gazette," *Referee* (Sydney), January 8, 1913, 15.

4. British Child Performers 1920–40: New Issues, Old Legacies

Dyan Colclough

In the closing decades of the nineteenth century two distinct phenomena—the development of the vast, economically and culturally significant, performance-based leisure industry and the emergence of the emotionally valued, sentimentalized cult of the child—were brought together and became mutually reinforcing. The representations of childhood that emerged from this symbiosis fuelled the aspirations of an increasingly child-focused society, concerned to protect these vulnerable waifs, while compromising the welfare of the real children representing them on the stage. Despite a sustained campaign by the National Vigilance Association (NVA) that aimed to convince the public that young entertainers were workers, activists failed to secure protection for theatrical children through existing child laws.[1] Indeed, at the very moment when child labor was increasingly regarded as neither desirable nor necessary, demand for and supply of performing children was escalating.[2] Child performers were the last child workforce to be taken under the protective umbrella of British legislation. Ultimately, via an amendment to the 1889 Prevention of Cruelty to Children Act, a system of licensing was introduced, which allowed children to be employed in the theatrical industry, subject to certain criteria. However, the statute included a clause that gave discretionary powers to the local courts that granted licenses, which meant that the degree to which each child was protected was contingent on an individual magistrate's interpretation of theatrical work.[3] Those responsible for implementing the law, by choice, neglect or ignorance contributed to evasion and ensured the continued exploitation of individual child performers. These

children were made more vulnerable by the general belief that their situation had been legally addressed and need no longer be a source of concern. The inadequacies associated with the regulation and policing of theatrical child employment are made visible in the oral testimonies of British men and women who worked as child entertainers during the 1920s and 1930s. What follows is an exploration of this legislative legacy that will set the theory of protective child labor law against the realities of the work undertaken by young performers.

A SPECIAL CASE

The employment of child entertainers proved problematic for legislators largely because those who had a vested interest in the continued supply of stage children attracted powerful support. This was rooted in the latter part of the nineteenth century. Motivated by the key incentives of monitory reward and/or the prospect of fame, the multitude of men and women whose livelihoods depended on the success of the theatrical industry, the parents and guardians of child performers and the children themselves, colluded with employers in concealing the true nature of child employment. Campaigners highlighted the true, arduous character of training and performance, but in the face of this, the industry sustained public demand for watching children on stage. This was achieved by presenting young performers as cosseted beings eternally engaged in play. The industry relied on the creation and promotion of a propagandist public persona for young entertainers, in order to mask the private persona of the child as worker.

All child legislation subsequent to 1889 included a clause that specifically related to the employment and education of the children who performed. These clauses paid lip service to the state's responsibility to protect children while doing relatively little to shield young performers from the exploitation that so often accompanied stage work. With regard to the employment of children in theaters and in the face of agitation from theatrical entrepreneurs,[4] the 1903 legislation consolidated the pattern initiated in 1889 and shaped government attitudes toward the employment of stage children up to and beyond World War II.[5] At every legislative juncture, positions were reiterated. Thus child performers worked for more hours over longer periods than children employees in other trades.[6] Those associated with the industry and fans of child entertainers laid emphasis on the public's "right" to watch child performers, while objectors claimed "the public have no right, to any benefit or pleasure which causes injury to

those who provide it."[7] The continued power of the theatrical industry in its successful promotion of stage performance as play rather than as work is evident in the treatment of child performers as a special case from 1889 onward. Typical propagandist support claimed that:

> As a general rule all these young children had to do was group themselves on the stage...and their duties could not be properly called work at all. The children looked upon it as amusement and it enabled them to earn a very good wage.[8]

Some 30 years later, Italia Conti who went on to become one of the largest purveyors of children to the industry, echoed this sentiment in her contribution to the Theatrical Children's Licensing Committee (TCLC) report "To the child its performance on stage is not a *task*, not *work* but recreation and play."[9] This contrasts sharply with one backstage witness who stated in 1896 "I don't believe on children coming on the stage so young. The little kids they look half dead by the time to go."[10] From the late nineteenth century, laws concerned with the employment or education of children incorporated clauses that in effect, exempted child performers from some aspects of compulsory school law and allowed them to work at ages and times outlawed in any other area of employment. Clauses acknowledged concerns about the situation of stage children by shifting responsibility for the granting of theatrical licenses from magistrates to local education authorities, through the introduction of matrons to ensure the welfare of touring children, by altering the minimum age requirements for performers and initiating mandatory parental consent.[11] However, legislation was only as effective as the extent to which it was implemented. The oral testimonies presented here are revelatory in showing the laws to have been inadequate, poorly implemented, and deliberately evaded. Moreover these recollections are able to show how this translated into real world experience.

MARSHALING THE EVIDENCE

The value of oral testimony to this study is immeasurable; however, as with all historical evidences one must remain mindful of the fallible nature of source materials. The issues associated with oral testimony and autobiography are well documented and do not require further elaboration at this juncture.[12] Nevertheless, it is important to define their value in supporting and sustaining arguments within this chapter. Of course, innumerable

interviews with child performers can be located within periodicals and newspapers from the last quarter of the nineteenth century, when the popularity of child performers was at its height.[13] Crucially though, these came from children who had achieved some level of fame. Reading between the lines of their self-promotion and boasting about numerous engagements can expose the closed world of relentless and heavy work regimes. Something that gives particular kudos to the testimonies that feature below is that they came from "jobbing" child entertainers. This is rare. Children who did not find fame are representative of the majority of young entertainers, yet their voices have seldom been heard. The careers of such children were short and low key. Their testimonies hold less likelihood of any hidden agenda, since fame and its responsibilities were not issues for these peripheral children. This gave them the freedom to be candid about their experiences as child performers; interviews drawn upon here offer history from below in its truest sense.

RAISING THE CURTAIN ON LEGISLATION

In 1919, the British government in overdue recognition of the inadequacy of the current system, set up an inquiry to review the licensing of child entertainers.[14] From the outset the inquiry doubted that it was possible to design a scheme that would allow children to remain in theatrical employment while simultaneously insuring that their educational and welfare needs were kept within the parameters of the law.[15] This however did not prevent them from devising a compromise solution. This in itself signifies an acceptance that protection and access to education were somehow less important for child entertainers than it was for all other children. Moreover, the incorporation of specific clauses into successive legislation aimed at child performers created an illusionary screen that simultaneously allayed concerns about the situation of such children, while actually making them more vulnerable to exploitation.

Space here does not allow detailed discussion of the Theatrical Children Licensing Committee Report. However, some of the most contentious issues are highlighted below. The recommendations aimed to provide protection that better equated to that enjoyed by child workers in other trades. Recollections from child "beneficiaries" of the new licensing system, however, call into question the practical application of the post-1919 license and its perceived protective properties. The significance of oral testimony is evident here, as it provides insights into the practical implications of

TCLC recommendations and the mechanisms used to evade regulation, that are not otherwise accessible.

The most radical proposed change to existing law saw the responsibility for issuing licenses taken from local magistrates and placed with Local Education Authorities (LEA). The Committee's rationale was that LEAs were already familiar with the children and their circumstances, so when assessing an application for a license, were better able to ensure protection. Such safeguards were contingent, however, on applications being made for licenses in the first place. In 1926, John Knight regularly toured the country as a magician's assistant despite being three years below the legal minimum age of 12 years: "For a very long time there was never any problem with me working, no one ever bothered with a license for me."[16] Setting aside the "illegality" of such performers, John's experience highlights the unreliability of official statistics that were calculated on the basis of the number of licenses issued. His case was not unique in that it demonstrates the continued existence of a wide vested interest in the employment of underage entertainers perpetuated by deliberate and systematic collusion of parents, employers, and children.

John's family was dependent on his earnings and his father was committed to securing underage employment for his son: "My school did not often question my lack of attendance but if they did my dad was always ready with a cover story for me, making up all sorts of excuses. You know I was ill and all that sort of thing."[17] John's career was temporarily cut short while on tour when a School Board officer, in pursuit of another underage performer on the same bill, discovered him. This was a girl of similar age to John who toured and performed with her parents. "They'd been doing the same as us, dodging everyone. They must have played somewhere with keen authorities and come unstuck. Most of these truant people never bothered. I mean I played loads of towns with no bother." Clearly, earlier piecemeal application of the law continued under the new regime. John did not hear of any penalties being applied to his father or the magician for touring a nonlicensed child. Either way, the experience did not deter them and he was soon reinstated:

> We got round it by the magician going on stage on his own and I would be sat in the audience like a paying customer. The magician would shout out, "I require the assistance of a small boy." Dave always chose me and that was one way of getting round it. I was actually supposed to be watching the show you see? They couldn't prove I was working for money but I got my wages all the same.[18]

John's experience reveals less about the inadequacy of the revised protective law and more about the LEA's careless implementation of regulations designed to protect young entertainers.

Testimonies reveal not only flaws in the licensing system but also a willingness of some to exploit these. As the law stood in the 1930s every child between 12 and 14 years who wished to take part in any paid performance, had to have been granted a council license before commencing an engagement.[19] However, Jean Silcock recalls the simplicity in which this could be evaded:

> I used to attend the local dance school, just for fun, not to go on stage or anything like the other girls. My mam's bad experience on tour as a kid in 1902 put paid to that. Looking back on it now, I think she was right. It seems to me things hadn't changed much from my mam's time on stage. I remember, one girl in my dance class had to pull out of a tour and the teacher wanted me to take her place. It would have been against the law I was too young to get a license. I wasn't twelve. The teacher had it all worked out though didn't she? She only wanted me to work under the other girl's license. She said "it'll be alright we can use her birth certificate for you."[20]

Even though the new licensing system required the applicant to provide two photographs of each child performer, the child was not required to be present when a license was applied for; with the complicity of parent, agent, and/or employer, it was possible for any underage child to perform using an older child's birth certificate. Hilda Black recalled that "younger sisters in dance troupes often impersonated older sisters so they could earn."[21]

Employers and parents were not alone in their willingness to evade protective laws. Some children were prepared to do this without any coercion. In a clause attached to the 1933 Children and Young Persons Act, parental consent became a prerequisite for a child to go on tour. Sadie, however, took it upon herself to forge her father's signature and her mother was happy to conspire: "We didn't tell dad the half of it." Sadie's mother basked in the glory of her daughter's new found fame and according to Sadie, both her parents appreciated the extra money she sent home.[22]

Hilda was also intent on becoming famous and insured that her parents never had sight of the consent form, which she duly completed herself and, "no-one was the wiser." Accounts such as this are crucial to our understanding of the life experiences that form theatrical childhoods. Testimonies provide a rare opportunity to challenge the widely accepted notions of the theatrical child as submissive, passive, exploited being who worked only for the benefit, needs, and desires of adults. Even though all interviewees

British Child Performers 1920–40 79

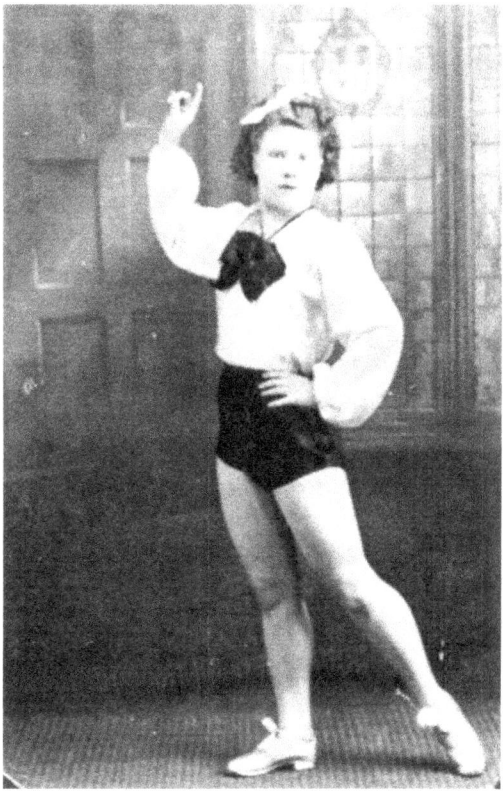

Figure 4.1 Hilda backstage in the 1930s. From the author's collection.

admitted to adopting a subservient demeanor, they viewed this as a fair trade off for the rewards to be had from audience adulation. The latter was fleeting compared to the hours of backstage rehearsal, preparation, dedication, travel, and, sometimes unwanted attention, but oral testimony has confirmed that the majority of "jobbing" child performers chose this way of life over and above any alternatives. It was not forced upon them.

Celebrity and glamor were born of audience misconceptions created by the industry and it was in a child performer's interest to keep up this façade. Moreover it offered children a priceless commodity that was not available from any other form of child labor—emotional incentive. During their performances children would sing the songs, dance the steps, and speak the lines that they had practised innumerable times

during training and rehearsal. On stage though, the whole nature of this work was transformed. The key to this conversion was the presence of an audience. When in front of an audience the child's identity shifted from worker to performer. This was the key that compelled the child into accepting its demanding laboring duties and fuelled the desire to continue to perform.

This longing to be elevated from the crowds was both classless and universal. Recollections of well-known celebrities equate with those interviewed here. One celebrity noted that a receptive audience could be both seductive and addictive to a child "The applause went to my head like champagne...from that moment on I devoted all my time to begging my parents to allow me to go on stage."[23] Those whose testimonies are included here may well have played in less salubrious venues but this did not tarnish the rewards associated with their work. John remembered fondly that "When we were on the stage, the world of reality didn't exist. The only thing that counted was the applause. Escapism yes, but what a beautiful escape into the world of make-believe and the reward of knowing that you had just entertained a theatre full of people, who led very drab lives."[24] Sadie echoes this sentiment:

> It was like the audience giving you a great big hug. You could control the audience you could make them laugh and make them cry. Not many kids at that time had chances like that. Kids were usually told to sit down and shut up.[25]

All testified that as child entertainers the public provided them with celebrity status, albeit on a modest scale, even though the glamor was more apparent than real. Clearly, as children, the interviewees were happy to exploit the carefree identity that the industry had created for them. This fitted with the public's perception of their glamorous existence and ensured that they were honorary guests at parties and events and received gifts and letters from their fans.[26] Of course, although celebrity status was the most prized aspect of the work, it was just one element of a very arduous occupation and some recommendations from the 1919 report suggest that the authorities were developing a new understanding of the child entertainer as laborer. The inquiry identified the particular vulnerability of touring children. The most daunting aspect of touring, for many children, was being away from home for protracted periods. Children forfeited the domestic setting for a series of theatrical digs that changed each Sunday with every new town visited. The most progressive step toward the protection of child performers came with the Committee's acceptance that their welfare was

entirely dependent on the adult who toured them and that this held the potential for abuse and neglect:

> It is obvious that in the hands of an unsuitable matron the system is open to great possibilities of abuse...the person in charge of the children should be a person approved by the Local Education Authority. One aim of the Committee was to ensure that "no matron had been actuated by motives other than a desire for the welfare of the children in their charge."[27]

An account from interviewee Jean regarding her own mother's experience at the beginning of the century supports TCLC anxieties about possible abuses:

> My mam said she was desperate to return home from touring. She was suffering awful ill treatment from them who was supposed to be looking after her. She tried to pawn her watch but he told the police who went to ask madam if it was right...She played bloody hell...but my mam got home the minute she got her hands on some money...they weren't looking after them they were making money off the kids, half feeding them.[28]

Of course at that time Jean's mother did not enjoy the legal security proposed in 1919. That said, the Committee's recommendations on this matter proved both simplistic and inadequate. An applicant for a child's license had only to name its matron. The LEA would then be obliged to form its own opinion of that person. There were no guidelines offered as to how this might be established or protocols to insure the named individual was the person who actually accompanied the children. Despite the acknowledged possibility for abuse implied by touring, the issue of chaperoning and subsequent legislation around this was never adequately addressed. Oral testimony reveals the consequences of these decisions for some touring children.

As the daughter of a theatrical landlady, Mary Irwin's recollections are particularly valuable because she befriended numerous child performers who confided in her.[29] Her unique position meant that she got to know the child behind the public persona and came into contact with child entertainers from all over the country and who represented every performance genre. She recalled that a variety of supervisory arrangements were made for such children, some more acceptable and rigorous than others. She singled out one troupe, for particular praise. "The Nine Dainty Dots, now they were healthy, happy children under the care of Mr. and Mrs. Wallace." This was the same Wallace couple that gave evidence to the TCLC in 1919.

Mary's glowing testimony explains why the Committee found, "no evidence that the matrons or other persons responsible for such children were in any way unsuitable or had been actuated by any motives other than a desire for the welfare of the children."[30] This goes some way to explaining the TCLC's confirmation of the essential adequacy of the existing scheme and the need for only minor changes in order to protect children from abuses that *were* identified during the inquiry.

One area of concern was raised with regard to sleeping arrangements: "We have heard of cases in which four children have been required to sleep in one bed."[31] Mary's experience suggests that that this issue had not been fully addressed by the late 1920s:

> My Mother had taken a booking for six girls and their matron but on that Sunday afternoon twelve girls came marching along Turncroft Lane. She said the booking for the other six had fallen through. She begged my Mother to take them all... They slept four in a bed. Well I heard a few years later that this was a regular thing to get twelve girls housed for the price of six. These girls were not really cared for properly. Scarcity of food and all letters sent home were censored... My father said they were half starved.[32]

Mary also suggests that while some matrons were prepared to compromise the well-being of their young charges they were not as willing to sacrifice their own comfort, "I remember she [matron] had a bed sitting room and all her meals were taken there and may I add very superior meals to the ones served to the girls."[33]

Echoes of negative experiences for children from abusive matrons that were evident in the first two decades of the twentieth century persisted into the 1930s, by which time the legacy of the 1919 recommendations had found their way into the 1933 Children and Young Persons Act. As Jean recalled:

> One time a matron wanted to bring twelve girls to the guest house when she had only booked for six. The Education said we were only qualified to have five children. Matron said "it's alright you've got that big bed, three at the top and three at the bottom. Two can be in a single bed." So mother said "Yes but that's only eight and I'd rather not." Me mam got on to the education. They said me mam had done right.[34]

It is not clear just how representative Jean's mother was of the majority of theatrical landladies. Her guest house was, in accordance with the 1919 recommendations, vetted by the LEA. It is difficult to imagine that

all would have passed LEA inspection if indeed they were inspected at all. Hilda found standards in some houses significantly inferior to those she was accustomed to at home:

> My mother was a good cook. We always had decent, filling meals at home. I only ever went hungry when on tour. What I didn't like was the state of some of these places. I mean some of them were filthy, you know bed bugs and the lot. Many a time I had to cover my bug bites with make up before performing. People thought it was glamorous but it wasn't. [Hilda became tearful and it was clear that some sixty plus years after the event such experiences continued to have a profound effect on her] I mean my mother always had a clean table cloth at home, you didn't tell your mother half of it. Backstage was no better. We had cold, damp dressing rooms and there was no privacy. Some girls used to pee in the sink! After a while though you just got on with it because you knew you would be on stage that night.[35]

It must be remembered that theatrical landladies were, first and foremost, business women. Often they were the main family breadwinner. They relied on word of mouth recommendation within a network of touring performers and returning custom.[36] This implies a degree of compliance or collusion in order to secure a loyal and regular returning clientele. Hilda, who toured with large dancing troupes, stated that sleeping several in a bed was the norm. "Oh yes we would sleep six in a bed top to toe while on tour. The beds were sometimes made bigger by placing a board between the bed and some chairs and a few more got stuffed in beside us." As a child, Hilda came under the so-called care of several unscrupulous matrons:

> After these shows one was ravenous. I often used to sneak down in the middle of the night and raid the landlady's larder, pinching bread and butter...I found out afterwards when they weren't feeding you properly and you suffered all sorts of hardships they were making money off you...Madame got a lovely wardrobe of clothes out of us.[37]

Jean's testimony concurs with Hilda's claims:

> Matron sent a letter to book some girls in [to the theatrical guest house] and she wrote they like rice pudding and potato hash. When they arrived the matron tried to get my mother to water down the rice pudding and put less meat and more potatoes in the hash. Fancy trying to do that? They were growing and used so much energy in the theatre. My Mother refused. Matron was trying to make money out of them.[38]

Of course there is no suggestion here that abuse and neglect were the norm. Just as Mary confirmed that *The Nine Dainty Dots* received the best of care from their employers during the 1920s, Sadie emphasized that throughout the 1930s she only met with kindness and love. She said of the married couple who toured her troupe, "they treated me like a daughter, they wanted to adopt me!"[39] Nevertheless, this level of care was far from universal. Recollections of experiences in the 1920s and the 1930s demonstrate a continuation of welfare problems that the TCLC had set out to address in 1919.

Prominent among these, was the perceived need to reconcile the employment of performing children with their right to an education. The Committee accepted that young entertainers, as direct consequence of their labor, were at a disadvantage in this respect. The work left children too tired to concentrate at school. Evidence from educationalists described performing children as:

> frequently tired [with] little interest in their work in school and they are backward in many branches of education... On the other hand our evidence was to the effect that they were remarkable for general intelligence and culture and considerably superior in those respects to many children educated in Public Elementary Schools.[40]

Perhaps it was the reassurance that the paucity of formal education was compensated for by the attainment of alternative qualities derived from theatrical employment that made Committee members relatively relaxed about the extent to which the education of child performers was affected by their work. While conceding that "the facts... as to the hours and conditions are undisputed and speak for themselves," they were convinced by declarations made by the children who appeared alongside their employers as witnesses to the TCLC. The children stated that "they enjoyed their work and it did not tire them... We have little evidence of undue fatigue except such as was derived from the teachers in the schools."[41] This assertion informed subsequent recommendations with regard to education. Despite insisting paradoxically that child performers should be allowed a holiday because, "children who appeared in entertainments are often employed for long and continuous periods,"[42] the Committee took a lenient view of arrangements for schooling. Their justification for this was that few children would be involved and only for short periods of time.[43] It was agreed that touring children could attend different schools each week in line with changing venues. A proposed suggestion for the future aimed to designate a teacher in larger towns especially to accommodate the educational needs of touring children.

Toward 1940 when Kathy Dene was a featured child in a show she recalled having backstage tutoring. This was the case when she was talent spotted and toured at length as part of the George Formby All Star Road show. Kathy was integral to the show and her schooling arrangement allowed her to be on call all day, every day at the theater.[44] For the majority of "jobbing" performers, however, the system established in 1919 structured their education throughout the 1920s and 1930s. In 1937, it was claimed that "while the children are on tour their education is not neglected.... They have to attend school... the person in charge has to carry record books in which head teachers enter particulars of the children's work and attendance at school."[45] Interviewee Sadie recalls receiving her education in this manner. Although she did regularly attend school, while on tour her education was less than adequate: "They used to give you the marks that they thought you needed. You see these teachers didn't care because you were only there a week you used to get your ticks because you would be at a different school in a different town the next week." Sadie's learning needs were not met in the classroom but her thirst for admiration was certainly satisfied in the various schools she attended: "Children at the schools used to bring us presents and we did get invited to places. The children and the teachers wanted to know all about our stage life." This clearly shows how the stage persona dominated public perception and the extent to which this could take precedence over the needs of the child. Sadie's teachers might not have prioritized her education but they were caught up in the celebrity of her employment. "I remember one teacher taking me round all the classes to show them all my hairstyle which was a short bob with a heavy fringe. Oh! They made you feel special, like a star."[46]

Thus the notion of celebrity and the need for appreciative applause were as much a draw to theatrical children in the 1930s as it had been to their stage-struck, Victorian predecessors and this was fed by public approbation. Paradoxically, these were the persistent lures that assured the industry the full cooperation of its child workforce. Sadie believed that she received "a different type of education, it was an education in life. I got to see places and meet people from all walks of life and I knew how to behave in their company." John's recollection concurs with this even though as an illegal worker he did not attend school while on tour:

> I had to leave the digs at 9 a.m. and be back for my tea at 5 p.m. and so I was free to go and explore the different towns that we visited. This was a great education to me and it made me independent and confident. I was streetwise and could look after myself and that set me in good stead my whole life.

Similarly Hilda said:

> schooling wasn't important to me. I knew all I needed to know to earn money to send home. I don't remember any book for the teachers to sign. The profession taught me skills. I may not have been top of the class in sums but I knew if an employer was trying to pay less than was due to me."[47]

These positive recollections, however, did not reflect the continued anxieties of some teachers. The welfare of child actors was the main topic of debate at the Annual Conference of the National Association of Head teachers in 1937.[48] Calls for a change in the law had reverberated with those voiced by teachers some 50 years earlier.[49] Educators in both periods recognized the detrimental effect of employers' demands on the schooling of child performers. Each challenged employers' claims that the work entailed a short activity of play on stage: "Rules at first appear satisfactory but things were not always as they seemed. The actual performance might last for ten or fifteen minutes but children were invariably kept at a late hour until the person in charge was at liberty to take them home." Joyce's testimony shows that literal conformity to the legislation could actually increase the vulnerability of children "the law said we had to be out of the theatre at 10 p.m. I don't know why because the older girls hadn't finished and so we couldn't go home. We had to hang around outside to wait for them and Madam to take us home. We never got to bed before 12 o'clock."[50] This questions the validity of one claim that "The County Council exercises the most vigilant care over these young performers and whether they remain in London or go into the provinces, they are 'shepherded' to use an official phrase, all the time till they return to their homes."[51]

Toward the 1940s educationalists remained unconvinced by such claims.[52] In 1919, it was recommended that child performers undergo medical examinations when being issued with a license. Ultimately, however, it was agreed that an LEA could go ahead and grant a license with a promise that a medical inspection would follow at a later date. Twenty years on teachers suspected that medical certificates were issued on the basis of misleading information that played down the extent of the work and its consequences on a child's well-being. Sadie was the only interviewee who remembers undergoing quarterly medical checks by an LEA. Hilda's response was more typical "I never remember anyone examining me or the younger ones when I joined the older troupe. I think there was a lot of faking and flannelling going on but I don't remember anyone coming." As with previous generations of child entertainers, protection promised

in law was so often illusory owing to a combination of weak enforcement and deliberate evasion of protective laws. Furthermore, the notion of the theatrical child employee at play was and continues to be ingrained in the British psyche. Moreover, evidence suggests that this ingraining was transnational. Shauna Vey has shown that although more comprehensive preventative laws were in place in the United States, American theatrical employers adopted similarly evasive strategies and continued to illegally employ theatrical children. Also, as foreign troupes were not covered by the law in either country. American children frequently performed in Britain and British children were regularly engaged overseas.[53] Within this climate, the recurrent inclusion of a clause particular to entertaining children, within revised child legislation, was more likely to sanction and enable their work rather than protect them as child laborers. Interviews conducted during the early 1990s, with men and women who as children were on stage during the 1920s and 1930s, fully support the argument that nineteenth-century patterns of theatrical child work and evasion of child laws were prevalent throughout the interwar years and that on the eve of World War II, child entertainers had little more actual protection than their predecessors of the late nineteenth century.

CONCLUSION

The inclusion of clauses relating to child performers within legislation from 1889 can be seen as state recognition of the need to regulate the employment of young entertainers. However, the same protective clause also held the potential to disenfranchise this group of children. It was the continuing discretionary powers that the law afforded to those who granted licenses that laid the children vulnerable. The degree of protection they received was contingent on individual interpretations of theatrical work. Weak and piecemeal implementation of inadequate protective laws served to further dilute the extent to which children were shielded. A willingness by vested interest parties, including the children themselves, to circumvent what little protection did exist furthered their risk of exploitation. All the above was fuelled by the promotion of the child's public persona of the child at play and the veiling of its private identity of child laborer. The compliance of theatrical child workers with adult demands made them vulnerable to hardships and exploitation. This same act of collusion though led to young performers satisfying their hunger for celebrity and enjoying the associated benefits attached to this. Simultaneously the child performer comprised both victim and agent.

NOTES

*With thanks to Victor Emeljanow and Pat Ayers for their mediation and contributions to earlier drafts of this chapter.
1. C. T. Mitchell letter to *The Times,* April 18, 1889; M. Fawcett, *The Times,* February 5, 1889.
2. Ellen Barlee, *Pantomime Waifs, or, a Plea for Our City Children* (London: Partridge, 1884), 8; "Child Workers in London," *The Strand Magazine,* May 1891, 501–11. For more examples and further discussion on any of the points raised in this chapter see, Dyan Colclough, "Manufacturing Childhood: The Contribution of Child Labour to the Success of the British Theatrical Industry 1875–1903," (PhD thesis, Manchester Metropolitan University, 2008).
3. The Prevention of Cruelty to Children Act, 1904, as amended by section 13 (2) of the Education Act, 1918, accessed January 23, 2013, http://www.bopcris.ac.uk/bop1917/ref990.html.
4. "Children on the stage." Managers combine against the new Bill, *Daily Express,* April 9, 1903, 3.
5. The most radical protective proposals came via the 1914 Denman Bill. These were rejected after opposition from theatrical employers. N. Daglish, "Education Policy and the Question of Child Labour: The Lancashire Cotton Industry and R. D. Denman's Bill of 1914," *History of Education,* 30:3 (2001): 291.
6. Typically one eight-year-old boy was employed for six nights per week until 10 p.m. over several months "Cases in Court," *Stage,* February 23, 1899, 11.
7. Daglish, "Education Policy and the Question of Child Labour," 302. See also, "Poplar Children and the Pantomime; A Budget of Essays," *The Times,* February 4, 1914, 11; "Children on the Stage: Some Effects of the New Employment Bill," *The Times,* March 20, 1914, 5.
8. The House of Lords. The Protection of Children Bill" reported in *The Times,* August 6, 1889, 4.
9. Theatrical Children Licences Committee Report, Sessional papers, July 1919, Cmd. 484, vol. XXX.
10. Interview with Miss Fanny Laughton, chorus lady, Theatre Royal, Drury lane, January 2, 1896. Charles Booth, *Survey Notebooks,* B156, 13–32. Notebooks are held at the Archives Division of the British Library of Political and Economic Science, London. Online catalogue http://www2.lse.ac.uk/library/archive/Home.aspx.
11. Education Act, 1918 c. 39 Regnal. 8 and 9, Geo 5. http://www.legislation.gov.uk/ukpga/Geo5/8–9/39/contents; 1933.Children and Young Persons Act /Geo5/23–24/12 http://www.legislation.gov.uk/ukpga.
12. The Oral History Society, accessed April 1, 2013, http://www.ohs.org.uk/index.php.

13. An approximation of numbers can be found in, Third Report on the Royal Commission of Education Parliamentary Papers, 1887, vol. XXX. Minutes of Evidence, Cardinal Manning, question number 50468, Millicent Fawcett, answer number 50469, 308; T. C. Davis, "The Employment of Children in the Victorian Theatre," *New Theatre Quarterly* 2 (1986): 116–35, 117; "Children in Theatres," *The Times*, July 16, 1887; E. Barlee, *Pantomime*. 8; "Child Workers in London," George Newnes, *The Strand Magazine*, January–June 1884: 11, 501–11.
14. See Reports for 1893, 326; Report for 1895, 205. Quoted in Frederick. Keeling, *Child Labour in the United Kingdom* (London: Kingston, 1914), 14.
15. Theatrical Children Licences Committee Report, Sessional papers, July 1919, Cmd. 484, vol. XXX, 9.
16. Interviewee 1: January 19, 1994. John Knight was born in Manchester in 1917. He went on to have a successful lifelong career as a professional musician.
17. Interviewee 1.
18. Interviewee 1.
19. "L.C.C. and children in pantomimes, 'shepherding' young performers, from a correspondent," *The Times*, December 13, 1938, 21.
20. Interviewee 2: December 18, 1993. Jean Silcock was born in Manchester in 1920. She helped her mother to run a guest house for theatricals during the 1930s and 1940s.
21. Interviewee 3: December 11, 1993. Hilda Black was born in Blackpool in 1918. Because Hilda was so small she was able to tour with a children's troupe until the age of 16.
22. Interviewee 4: January 19, 1993. Sadie Male was born in Manchester in 1920. Her stage career in pantomime and variety began in 1932 and ended in 1937.
23. H. Gingold, *How to Grow Old Disgracefully* (London: Victor Gollancz, 1989), 31.
24. Interviewee 1.
25. Interviewee 4.
26. All interviewees concurred with this.
27. Theatrical Children Licences Committee Report, Sessional papers, July 1919, Cmd. 484, vol. XXX.
28. Interviewee 2.
29. Interviewee 5: January 23, 1994. Mary Irwin was born in Stockport in 1905. Mary helped her mother run a guest house for theatricals during the 1920s.
30. Theatrical Children Licences Committee, 9.
31. Theatrical Children Licences Committee, 7.
32. Interviewee 5.
33. Interviewee 5.
34. Interviewee 4.
35. Interviewee 3.

36. J. K. Walton, *The Blackpool Landlady: A Social History* (Manchester: Manchester University Press, 1978).
37. Interviewee 2.
38. Interviewee 4.
39. Interviewee 4.
40. *Theatrical Children Licences Committee Report*, 28.
41. Ibid.
42. *Theatrical Children Licences Committee*, 30.
43. *Theatrical Children Licences Committee*, 28.
44. Interviewee 6: July 16, 1993. Kathy Dene was born in Manchester in 1924. She was a lifelong variety entertainer.
45. "L.C.C. and children in pantomimes, "shepherding" young performers," *The Times*, December, 13 1938, 21.
46. Interviewee 4.
47. Interviewee 3.
48. "Welfare of Child Actors," *The Times,* May 19, 1937, 11.
49. M. Fawcett, "Employment of Children in Theatres, No.2, What the Teachers of the Children Say," *The Echo*, December 10, 1888. Page unavailable.
50. Interviewee 7: August 30, 1993. Joyce Wilson. Born in Preston in 1926, she was coerced into performing by her mother and she really did not enjoy her short-lived career.
51. "L.C.C. and children in pantomimes, 'shepherding' young performers, from a correspondent," *The Times*, December 13, 1938, 21.
52. "Welfare of Child Actors," *The Times*, May 19, 1937, 11.
53. S. Vey, "Good Intentions and Fearsome Prejudice: New York's 1876 Act to Prevent and Punish Wrongs to Children," *Theatre Survey*, 42: 1 (May 2001): 54–68. See also, T. J. Gilfoyle, "The Moral Origins of Political Surveillance in New York City 1867–1918," *American Quarterly*, 38: 4 (1986): 637–52; Children (Employment Abroad) Bill [H.L.] HL Deb 22 April 1913, 14, cc238–51.

Part II By Children/for Children ~

5. "How much do you love me?" The Child's Obligations to the Adult in 1930s Hollywood

Noel Brown

The Hollywood child-star film of the 1930s remains one of the most historically visible sites of cultural tension between the social conception of the child as priceless object, and, conversely, as exploitable entity. Child performers had become enormously popular attractions on the late eighteenth-century and early nineteenth-century stage, but commercial cinema, with its global reach and sophisticated production methods, offered the possibility of the most powerfully appealing and highly determined representations of childhood ever devised. With particular reference to such performers as Shirley Temple, Freddie Bartholomew, Deanna Durbin, Jane Withers, and Jackie Cooper, this chapter explores the representation of children on screen in Hollywood movies of the 1930s, and their placement within the social and economic contexts through which childhood operated. Although critics have rightly suggested that the Romantic archetypes associated with childhood—namely innocence and moral virtue—freely circulate in this cycle of child-star films,[1] this chapter argues that Hollywood's treatment of child performers was far more ambiguous. Many such films reflect a broader ambivalence regarding the social status of children by alternately upholding a Romantic ideal of childhood while actively emphasizing the child's obligation to the adult. The most prevalent examples of this obligation—and the ones which this chapter specifically addresses, in turn—are (i) a blatant and multifaceted fetishization of the screen child; (ii) the casting of the child as emotional laborer; and (iii) the behind-the-scenes financial exploitation of the child

performer. But first, the 1930s child-star film must be placed within its cultural and cinematic contexts.

THE CHILD-STAR FILM

Child stars had been popular in Hollywood since the early 1910s, when commercial cinema was in its infancy. Such child actors as Baby Marie (Osborne), Baby Peggy (Montgomery), and Jackie Coogan appeared prominently both in shorts and feature films. Young performers were contracted to one of a number of film studios or independent producers. Completed films were sold to exhibitors, who designed their movie programs to offer something for "everyone" (within the practical confines of that term). Movie programs typically incorporated a variety of punchier (often comedic, animated, or action-orientated) short films, regarded as ideal entertainment for children, alongside a feature-length film aimed primarily at adults. Mary Pickford—one of the three great stars of silent-era Hollywood, alongside Douglas Fairbanks and Charlie Chaplin—achieved fame playing child roles in a succession of children's literary adaptations, such as *Cinderella* (James Kirkwood, 1914), *The Poor Little Rich Girl* (Maurice Tourneur, 1917), *Pollyanna* (Paul Powell, 1920), and *Little Lord Fauntleroy* (Alfred E. Green and Jack Pickford, 1921). However, Jackie Coogan is perhaps the best-remembered silent-era child performer, due largely to his pivotal role in Chaplin's great tragicomedy, *The Kid* (1921).

By the late 1920s, child-star films had declined in popularity.[2] After the transition to sound, feature films—which often featured all-adult casts—became the dominant mode of exhibition. Hollywood cinema became more overtly "adult" with the advent of talkies, leading simultaneously to calls for censorship and to fears that the lucrative "child audience" would be alienated.[3] However, it was not until 1934 that child-star films and juvenile screen performers became the focus of an unprecedented and phenomenal burst of public affection that endured until about 1938. The mid-1930s cycle of child-star films emerged as a response to two prevailing concerns, one industrial and the other social. First, the major studios had been subject to fierce criticism in the United States regarding their neglect of the "family audience"; with powerful civic and religious lobbies demanding wholesale reform and the mounting threat of Federal intervention, the studios established the Production Code—a rigorous system of self-censorship—in early 1934.[4] Over the next few years, the rise of "family"-suitable films rose substantially, and the child-star film became

a major "family" genre.⁵ Second, the popularity of child-star films during this period can be attributed to a collective desire among Depression-era audiences for joyous, optimistic narratives that galvanize and unite all facets of the movie-going public through affirmative representations of society's most vulnerable and venerated members.⁶

THE 1930S HOLLYWOOD CHILD STAR

At her peak, Shirley Temple—surely Hollywood's most iconic child star— may have been the most priceless and beloved object in the United States. In a well-known but possibly apocryphal 1934 speech tacitly acknowledging her predominantly adult appeal (and utility), President Roosevelt is said to have eulogized: "it is a splendid thing that for just 15 cents, an American can go to a movie and look at the smiling face of a baby and forget his troubles."⁷ A rare example of a movie star capable of transcending barriers of class and culture, Temple was not only Hollywood's top film star between 1935 and 1938, but she also lent her name to an enormous range of consumer goods, including books, records, dolls, toys, shoes, and underwear.

Although they never approached Temple's popularity, Freddie Bartholomew and Deanna Durbin were also "priceless" Hollywood children. Bartholomew—a Londoner, but with a cut-glass English accent that was both aspirational and didactic—was discovered by legendary film producer David O. Selznick, who was mounting a prestige adaptation of *David Copperfield* (Clarence Brown, 1935), and was seeking an unknown to play the young title character. Bartholomew made a major impact in the role. *Boys' Life* called him a "juvenile genius" worth "going miles and miles to see,"⁸ and, signed by MGM to a seven-year contract, Bartholomew subsequently starred in *Little Lord Fauntleroy* (John Cromwell, 1936), *The Devil is a Sissy* (W. S. Van Dyke, 1936), *Captains Courageous* (Victor Fleming, 1937), and *Kidnapped* (Otto Preminger, 1938), among others. Deanna Durbin made her mark in Universal's hit family musical, *Three Smart Girls* (Henry Koster, 1936). A talented opera singer, Durbin's roles combined polished song-and-dance performances with youthful ingénue, and later she starred in several similarly profitable vehicles, including *One Hundred Men and a Girl* (Koster, 1937), *Mad about Music* (Taurog, 1938), *That Certain Age* (Edward Ludwig, 1938), and *Three Smart Girls Grow Up* (Koster, 1939). Like Temple, Durbin reputedly saved her studio from bankruptcy; her impact was acknowledged by the Academy in 1938 when (alongside Mickey Rooney) she was awarded a Juvenile Oscar. The only previous recipient of this award had been Temple, in 1935.

Despite the imperatives of the 1938 Fair Labor Standards Act, the Federal child labor law that was intended to keep under-14s out of the labor market, attitudes toward children as economically useful members of the workforce were still-widespread, retaining currency in small-town and rural areas.[9] Within the films of the time, these attitudes can be perceived in the sentimentalized, purportedly "authentic" depictions of Jackie Cooper and Mickey Rooney. Although undeniably leavened by sentiment, their personae draw upon the classically pastoralist literary tradition of Mark Twain, Tocqueville, and other influential chroniclers of small-town America in their fallibility, stoicism, and masculinity. The latter trait reflects a characteristically small-town conviction that "character-building" forms of child labor (notably agricultural work among young boys) were not only nonexploitative, but actively beneficial.[10]

Cooper's comparatively tough, streetwise filmic persona—which implicitly disavows the overt femininity of such priceless children as Temple and, more pertinently, Bartholomew—may be gauged from the titles of his films, which included *Peck's Bad Boy* (Edward F. Cline, 1934), *Tough Guy* (Chester S. Franklin, 1936), *Boy of the Streets* (William Nigh, 1937), and *Gangster's Boy* (Nigh, 1938). The feature-length film, *Peck's Bad Boy*, retains the naturalism implied by the titles of these earlier productions, but imbues Cooper with a sentimental, dyed-in-the-wool Americanism, neatly underpinned by a scene in which his father approvingly describes him as:

> a regular kid...a little mischievous, sure. But what kid isn't? [...] Here's the way I look at it. If your boy has never climbed your neighbor's apple tree, or driven a cow into someone's garden, or broken a window, I'd say, well, "put laced pants on him"!

Rooney's star persona was not dissimilar to Cooper's. He starred in the *Mickey McGuire* (1927–34) short films of childhood misadventure before embodying the ageless, all-American small-town adolescent as Andy Hardy in MGM's phenomenally popular family series (1937–46), through which he became Hollywood's top box office attraction from 1939 to 1941. Rooney's and Cooper's fictional misadventures are placed within their socializing contexts; mischievous behavior (in boys) is seen as characteristic and natural, as long as it is transient, and part of a healthy process of maturation. Bill Peck's and Andy Hardy's childhoods (like that of their literary antecedent, Tom Sawyer) are rendered as pastoral arcadias, where hard work and (wholesomely) hard play serve as vital ingredients in molding a new generation of productive, but not excessively rapacious, patriotic citizens. In both the "priceless" and "authentic" models of childhood, adult

concerns and desires remain palpable, whether overt (as in the former) or sublimated (as in the latter), as the following discussion illustrates.

FETISHIZATION OF THE SCREEN CHILD

The "priceless" screen child was more clearly a subject of fetishization than the "authentic" child. As Charles Eckert has observed, "Shirley [Temple] in film and story was as highly finished an object as a Christmas tree ornament"; in realization "the surface was often too perfect to be accepted and [...] deceit was suspected."[11] Some contemporary observers facetiously "maintained that [Temple] was a thirty-year-old midget with a shaved head and a wig."[12] Several critics have perceived an ambiguously sexualized quality in the 1930s child star, especially Temple, who began her acting career at the age of three in the so-called Baby Burlesque shorts produced by Educational Pictures, where young children mimicked and dressed up as adult stars. Among the sex sirens Temple imitated were Mae West and Marlene Dietrich. Novelist Graham Greene infamously (and libelously) labeled her a "complete totsy" possessing a "well-developed rump," arguing that "her appeal is more secret and more adult," and that "adult emotions of love and grief glissade across the mask of childhood, a childhood skin deep."[13] Greene alleged that:

> Her admirers—middle-aged men and clergymen—respond to her dubious coquetry, to the sight of her well-shaped and desirable little body, packed with enormous vitality, only because the safety curtain of story and dialogue drops between their intelligence and their desire.[14]

These unsettling observations fail to account for the hordes of juvenile admirers these child stars amassed,[15] but Salvador Dali clearly felt similarly. In his 1939 collage entitled "Shirley Temple, the Youngest, Most Sacred Monster of the Cinema in Her Time" Dali spliced Temple's head atop a painting of a large-bosomed lioness, a vampire bat perched menacingly on her head.

What we see on-screen in movies that present the "priceless" child figure is hardly so blatant, consisting of little more than occasional and unsubstantiated conflations of parental, filial, and romantic attachment. Certain individual scenes across several productions—and pertaining to a number of child performers—occur as potentially revealing. In the Jane Withers vehicle *Ginger* (Lewis Seiler, 1935), a fractious marital relationship is satirically invoked in the early scenes between Withers' character named Ginger,

who is an orphan, and her feckless guardian, O. P. Heggie's Uncle Rex, when the child signals her displeasure that once again he has been drinking in a notorious neighborhood bar. An actor, Uncle Rex placates her by performing Shakespearean verse, and Ginger requests that he plays the part of Romeo. Kissing her on the forehead, he replies, "Yes, I'll play Romeo. But you must be my Juliet. For you are, truly, my own dear Juliet." Smiling back at him, Ginger replies, "I should be sore at you [...] but you're such a sweet guy." A quasi-romantic (which is *not* to say sexual) relationship is signaled in two ways, firstly through Uncle Rex's "seduction" of Ginger using his adult skills as a performer, and secondly with the disarming assertion that he is a "sweet guy," language surely more appropriately directed toward a suitor.

In *Three Smart Girls*, the relationship of Penny (played by Deanna Durbin) with her absentee father (Charles Winninger) is rendered problematic by his sudden return after an absence of ten years, by which time she has matured into adolescence. There is a striking scene where Penny sings to her father on her bed. During her rendition of the explicitly romantic number, he takes hold of his daughter's hands, leaning forward in admiration. Immediately thereafter, he appears, momentarily, to be reaching for a kiss, only for Penny to recline back on her bed, obliviously, with the words, "tuck me in, Daddy." In *Little Lord Fauntleroy*, the Little Lord of the title (Freddie Bartholomew)—having been summoned to England—must make his farewells to his friends, one of whom, the elderly shopkeeper Mr. Hobbs (Guy Kibbee), he entreats to visit him. Hobbs replies, "Oh, I'll come and visit you. I won't be able to help myself." But such inferences are partly a function of performance; Kibbee's line might barely raise an eyebrow but for his leeringly prurient delivery. And it may well be that such representational ambiguities arise from the fact that these films purposely depict extreme forms of sentimental attachment rarely seen in everyday life, and hence are particularly liable to be interpreted as inappropriate.

Perhaps the most disturbing ambiguity occurs in the Temple vehicle *Poor Little Rich Girl* (Irving Cummings, 1936), in which Shirley—having broken free of her pampered, ivory tower life with her wealthy father and set forth into the world-at-large—is secretly pursued by the shadowy Flagin (John Wray). Often silent, framed by dark shadows and a sinister half-smile, he is undoubtedly malign; in one scene, he is seen gazing through the windows of Temple's bedroom, watching her sleep. This sequence, in addition to later ones where he attempts to gain her trust by offering sweets, invite inferences of pedophilia, although his subsequent inquiries as to her father's wealth imply that his true motivation is blackmail. However, the

character is shrouded in ambiguity, the possibilities unresolved (and necessarily unspoken, in Code-era Hollywood).

We know that child stars were (and still are) carefully selected to correspond to a physical ideal. Cary Bazalgette and Terry Staples have argued that:

> It is clear from numerous accounts of [...] "searches" for new child stars (which are also of course publicity stunts) that the child actors in family films had to offer not only national and ethnic identification to the child audience but sexual appeal to the adult audience as well.[16]

There are two particularly notable examples of such talent-hunts in 1930s Hollywood. Charlotte Henry, a 17 year old from Brooklyn, beat seven thousand other contenders for the role of Alice in Paramount's adaptation of *Alice in Wonderland* (Norman Z. McLeod, 1933).[17] And Tommy Kelly was selected from (allegedly) more than twenty-five thousand boys to star in Selznick's *The Adventures of Tom Sawyer* (Norman Taurog, 1938). Having initially determined to cast an orphan in the hope of eliciting "a warm public feeling,"[18] Selznick's "search" apparently "extended into almost every state of the union, scores of cities, towns and villages."[19] Kelly's successful audition was coyly attributed to "the Irish twinkle in [his] blue eyes, something about the way he wore his tousled hair, [and] something about his infectious grin."[20]

Patently, not only were child stars assessed in terms of perceived physical attractiveness, but there was also a strong correlation between attractiveness and venerated qualities such as "innocence" and God-given morality. As a case in point, never cruel or thoughtless, and always emotionally intelligent, the moral perfection of Temple's characters corresponded with her physical perfection. Both aspects draw power from their transcendence of the ephemeralities of the sociocultural context, implying that she is somehow separate from (or elevated above) the Depression-era anxieties that her films address. But whereas Temple was sparklingly attractive and sweet-natured, with fair hair and precision curls, her Fox stablemate, Withers, was dumpy, with frizzy, mousy hair and a pronounced Southern accent. The *New York Times*' review of John G. Blystone's *Little Miss Nobody* (note the playful but pejorative title) unenthusiastically describes her as "a competent little actress who seems to be growing, however, in physical size as well as cinematic stature."[21] The same paper had earlier predicted that "[she] is going to grow up one of these days and become a heavyweight wrestler."[22] As we have seen in the case of her film *Ginger*, Withers' star persona was

eventually reconfigured to one of rough-hewn innocence (and hence pricelessness). However, in her first film—the Temple vehicle *Bright Eyes* (David Butler, 1934)—her physical imperfections are mirrored by a selfish and spiteful disposition. Withers' character, Joy Smythe, has been infected with adult neuroses (she has a psychoanalyst!) and has too much knowledge for her age. Unlike Temple's character, she does not believe in Santa Claus or in any other figure from child mythology, and has a ruthlessly sadistic streak, bullying Shirley, ripping a doll's head off, demanding a machine gun for Christmas, and mimicking gunning down her parents. For a preadolescent girl to display aggressively masculine traits, or "adult" behavioral characteristics such as cynicism, knowingness, or sexuality, is invariably coded as perversion, since they destroy the facade of innocence.

The cultural capital of the innocent child can be gauged by the strength of the opposition when deviations from this archetype occurred. For instance, initial reports from Universal Studios that Durbin's 1939 vehicle, *Three Smart Girls Grow Up*, was to be her first "glamorous" role met with hostility from the *New York Times*, who delightedly reported that:

> Miss Durbin [...] is still her delightful self, a joyously half-grown Miss with a fresh young voice, clear eyes, a coltish gait and the artless art of being as lovely, refreshing, and springlike as nature has made her.[23]

There is a tangible sense of hypocrisy in the unspoken decree that a sexualized child becoming a sexually maturing adolescent is unpardonably indecent. The likes of Jackie Cooper and, particularly, Mickey Rooney were able to avoid such a backlash, because they never conformed to the innocent child archetype. Of course, whatever the merits of the accusation that Hollywood willfully sexualized its child stars, the parallel (but interrelated) charge of ethnic exclusivism is beyond reasonable refutation. Aside from productions aimed squarely at juvenile audiences—such as Hal Roach's admirably progressive *Our Gang* shorts (1921–44), where a succession of black children mixed with their white counterparts without subordination—there was a notable absence of non-Caucasian child performers in leading roles.

EMOTIONAL LABOR

Of course, the popularity of the classical-era Hollywood child star can also be attributed to the affirmatively nonsexual emotions they were capable of arousing through their carefully orchestrated performances. John F.

Kasson perceptively positions Temple as an "emotional laborer"—a concept which, in Kasson's words, "has not been developed as has that of physical labor, and it has been especially neglected with respect to children."[24] Both in front of and behind the cameras, Temple, Durbin, and others promoted values of unity among individuals and social groups. A recurrent trope is the symbolic reunification of a divided nation. In many films set in the present day, such as *Our Little Girl*, *Ginger*, *Poor Little Rich Girl*, and *One Hundred Men and a Girl*, it is the working and business classes that need to be reconciled, in order to facilitate the successful implementation of Roosevelt's Depression-era recovery programs. In the Temple vehicle *The Little Colonel* (David Butler, 1935), set shortly after the American Civil War, the North and South are symbolically united by the marriage of Elizabeth (Evelyn Venable), the daughter of the former Confederate Colonel Lloyd (Lionel Barrymore), to Yankee soldier Jack Sherman (John Lodge), and by their daughter (played by Temple)—who, suggestively, is named Lloyd Sherman. Only Temple is able to transcend the politicking between the two sides, as well as the racial divide (represented by Colonel Lloyd's black servants, whom she befriends). The old and new generations, too, are brought together by shared values and common purpose.

Colonel Lloyd is one of several gruff, ageing, emotionally withdrawn bachelors Temple successfully charms in a succession of films. The coldly cynical mobster Sorrowful Jones (Adolphe Menjou) in *Little Miss Marker* is an extreme forerunner to the likes of Uncle Ned (Charles Sellon) in *Bright Eyes*, Colonel Williams (C. Aubrey Smith) in *Wee Willie Winkie*, and Adolphe Kramer (Jean Hersholt) in *Heidi*, many of whom adopt an orphaned Temple. In each instance, it behoves the child to offer *emotional* support to the adults, who do their best to provide their surrogate children with *material* comforts. Perhaps the most striking example of this near-symbiosis is Shirley's relationship with aviator Loop (James Dunn) in *Bright Eyes*. Shirley's now-deceased father was Loop's best friend from early childhood, and he considers her a surrogate daughter. He repeatedly asks her, "How much do you love me?" usually after giving her some kind of gift. His emotional reliance on Shirley is doubtless heightened by the perceived betrayal of his ex-fiancée, Adele (Judith Allen), who left him at the altar, and (prior to their climactic reconciliation) he has been unable to move on, romantically. He is clearly starved of affection, living in barracks with his fellow pilots on an airfield, and only seems happy when with Shirley—who showers him with hugs and kisses on demand.

Hollywood children played a similarly important role in the emotional lives of their parents. The "pushy parent," whose disappointed aspirations

for stardom are channeled vicariously through their child, was, even then, a show-business cliché. Diana Serra Cary—the former silent-era child star Baby Peggy—recounts that, most often:

> it is the parents and not the performing child who become incurably hooked on both the big money and fame accruing to the family [...] Most common is the "stage mother" who wanted a theatrical career for herself but was thwarted by her parents or an early marriage. In this manner Gertrude Temple fulfilled her dream by pushing Shirley, and revelling in her reflected glory.[25]

Jane Withers' mother was similarly driven:

> She wanted desperately to act—more than anything else in life. But her family was a respectable German family of Louisville and they didn't believe in such things for their daughters [...] So Jane's mother married and went to Atlanta to live, swearing that if—no—*when* she had a daughter, that daughter should be what she had always longed to be—an actress. Don't most parents see in children a second chance at life?[26]

Probably in an attempt to preempt accusations of exploitation, parents and producers tended to insist that their child performers remained happy and unaffected by their fame and wealth. Everything from receipt of a very low weekly allowance to regular on-set schooling was paraded as evidence of normalcy. This propaganda was often reinforced in the popular press. A journalist who "interviewed" Temple for the Christmas 1935 issue of *Photoplay* delightedly informed readers that Shirley was exactly as she appeared on screen.[27] Indeed, her contract allegedly contained "an unusual proviso: if at any time the Temples should feel that screen work was changing their daughter's personality or keeping her from being absolutely normal, they could [...] retire her from the screen."[28] Yet the disproportionate number of child stars that have suffered mental health and addiction problems (for example, Macaulay Culkin and Lindsay Lohan), and the tragically early deaths of several others (including Bobby Driscoll, John Charlesworth, Judy Garland, River Phoenix, and Corey Haim), testify to the potentially corrupting consequences of stardom in youth.

FINANCIAL OBLIGATIONS

This leads to the notorious but oddly under-addressed question of economic exploitation. The financial debacles in which Jackie Coogan, Freddie Bartholomew, and others were embroiled are prefigured in *Little*

Miss Marker, where the appropriately named Marky (Temple) is held as a "marker" (that is, collateral), by bookmaker Sorrowful Jones against her reckless father's bad bet, and then used by the gamblers to "fix" bets. It is very obviously a Depression-era film, the threat of financial ruin and poverty hanging heavily over every major character (and ultimately driving Marky's father to suicide). Marky herself is monetized, with Sorrowful placing a $20 value on her head, reasoning that "a little doll like that's worth twenty bucks, anyway you look at it" (in fact, unwanted children were worth up to $1,000 on the black market).[29] Sorrowful's valuation of Marky violates the prevailing orthodoxy (at least in metropolitan areas) that children were priceless.[30] Yet far from constituting merely an unsavory reminder of a practice long since abandoned, such naked commercialization and monetization of Hollywood's child performers remained commonplace.

At the most blatant level, several prominent child-stars were victims of their parents' or guardians' conviction that they were entitled to squander their child's earnings (all monies received by minors being the legal property of their guardians prior to 1938). The most notorious victim of this legal throwback was Jackie Coogan, who earned anywhere up to $5,000,000 from his career, of which a mere $250,000 remained when he came of age. Coogan's mother, Mrs. Lillian Bernstein, saw no reason to couch her financial management of her son in secrecy or double-talk; she and her husband regarded it as their legally enshrined right to dispose of his earnings howsoever they saw fit, and she was deeply aggrieved when her son filed suit to recover his lost earnings. After a long, highly publicized court battle, Coogan and his mother agreed to split the $250,000 of his estate that remained, and subsequently reconciled.[31] As a result of this case, the California superior court passed the Child Actors' Bill in 1938—colloquially known as the Coogan Act—which stipulated that half a child's earnings should be placed in trust.

Bartholomew, meanwhile, was at the center of one of the period's most brazenly covetous examples of child financial exploitation. Having been raised by his Aunt Millicent, Bartholomew became an attractive commercial proposition following the success of *Little Lord Fauntleroy*, and his estranged parents filed in the American courts for custody. The case took an unusual turn when Bartholomew's father abruptly opposed his wife's suit, perhaps influenced by his sister, Millicent, who argued that her sister-in-law was "not a fit and proper person to be guardian of the child," and that her interest in Freddie was "only for the purposes of exploitation and publicity."[32] Nevertheless, the legal wrangles continued for some

seven years, leaving him almost penniless. Bartholomew's Aunt attempted to negotiate a pay-rise from MGM, but the studio demurred, and Miss Bartholomew elected to withhold him from further roles until the matter was resolved. Bartholomew thus lost a high-profile starring role in the film *Thoroughbreds Don't Cry* (Alfred E. Green, 1937), and a mooted adaptation of Kipling's novel *Kim*, and his career never fully recovered.

One may assume that the profile of Shirley Temple, and the apparent fiscal propriety of her parents (her father was a bank manager), insured her from such exploitation. However, as Kasson explains:

> not until she was twenty-two years old and at last insisted on seeing her financial records did she discover how disastrously her father and her business partner had squandered her earnings her family had received from her films, licenses, and royalties. Of the $3,207,666 in earnings her family had received in her name, only $44,000 remained.[33]

Ironically, Temple chose to protect the memory of her parents by keeping these financial irregularities private until long after their deaths.

Of course, the economic value to the film industry of the most popular child stars (to say nothing of society-at-large) is virtually incalculable. Reputedly, Temple and Durbin almost single-handedly rescued their respective studios.[34] Yet sentiment played a small part when a child performer's commercial usefulness expired. Jackie Cooper, having been the industry's top child performer a mere two years earlier on a salary of $75,000, was released from his MGM contract in October 1936. One contemporary newspaper article reported (somewhat gleefully):

> the tow headed youngster has come to the end of the trail as a film star. Other deals, pending now, may postpone the final result for a few months, but for all practical purposes, Jackie is ready for temporary retirement.[35]

Ironically, Cooper was one of the few major Hollywood child stars that forged a relatively successful career as an adult character actor.

The wealthiest child stars were able to "retire" comfortably, in contrast to the many unfortunates who were unable to resist the lure of the bright lights and then failed to hit the big time. In July 1935, *Photoplay* interviewed Mimi Shirley, the mother of young actress Anne Shirley. The widowed Mrs. Shirley had first attempted to "break" her daughter into Hollywood in 1922 because she felt there was "no other way of surviving in a world that has no work to offer a mother who insists on keeping her child with her."[36] Having endured several years of penury, in which she

and her mother survived only on occasional bit-parts and hand-outs, at the age of 16 Anne Shirley was unexpectedly cast in the lead role in RKO's production of *Anne of Green Gables* (George Nichols, Jr.). Yet Mrs. Shirley emphasized:

> Whenever I see a newly-arrived, hopeful mother leading her child to the studio gates, I want to shriek out at her, stop her by force and make her listen to me. I want to ask her if she can go three days in a row without food, manage to keep a landlady waiting a year and a half for the rent, work twelve hours a day on her feet in a grocery store to keep her baby from starving between studio calls. [...] And I want to plead with her not to deprive her baby of its birthright to a normal world of regulated naps, sunbaths and sandpiles for the million-to-one chance of repeating a Coogan or a Temple triumph.[37]

Bizarrely, but perhaps tellingly (in its reaffirmation of Hollywood's ineffable magnetism), the interview ends with Mrs. Shirley expressing her gratitude to the motion picture industry because it "gave Anne a chance to survive. And please, is there some way we can tell every mother in America with a talented child that Hollywood offers her just that?"[38]

Despite the manifest risk of rejection, penury, unwanted publicity, overwork, emotional obligation, and financial exploitation, several child stars also reflected on this era as a lost bastion of hope and innocence. Jackie Coogan recalled:

> Learning I was broke, not rich, when I came of age was a disappointment. But I wouldn't trade away my "kid" years for anything. In those days, we had no laws to protect us, so I was on call for as many hours of the day as the producer demanded, sometimes working into the night. But there was a sweetness about those days that made up for the long hours [...] There was love for kids in those days you don't see much-of anymore.[39]

Jane Withers, meanwhile, seems to have no regrets at all concerning her career in Hollywood. In one interview, she admits to feeling "very blessed to [have] grow[n] up in films [...] and to start out so very young," and expresses disappointment that the child actors of today have fewer opportunities to showcase their talents.[40] Perhaps these forms of nostalgic valorization reflect the broader values of hope and optimism encapsulated by the 1930s child-star film, and reiterated in America's insistent self-proclamation as a "land of opportunity"; a defiant disavowal of disturbing countervailing realities that serve to disrupt the utopian fantasy.

Yet such uncritical retrospectives were by no means universal among grown-up child stars of Hollywood's "golden age." As we have seen, Diana

Serra Cary forged a second career as a chronicler of the life of the child star, and she gives unstintingly unsentimental accounts of how the avarice of studios, the selfishness of parents and the ineffectiveness of child labor legislation impacted directly on the young performer.[41] Deanna Durbin, in the words of biographer Zierold, "did not enjoy her decade of fame as a movie star" and retired to Switzerland in her early twenties.[42] And, perhaps most tellingly, in later life Shirley Temple—who negotiated her post-Hollywood career better than most, becoming the US ambassador to Ghana and then Czechoslovakia—publicly admitted that Graham Greene had a point when he libelously insisted that she was sexualized by her films.[43]

THE END OF THE CHILD-STAR CYCLE

Ironically, by the time the Coogan Act was passed, the child-star craze had largely run its course. During this period most of the top performers hit puberty—a developmental stage anathema to the genre's firmly established ethical and behavioral boundaries between childhood and adulthood. Age and appearance were all-important. Jackie Cooper later claimed that, "I was simply an attentive youngster who could take direction. Great directors make great child actors."[44] Universal Studios attempted to negotiate the shift in Durbin's persona from precocious sexual innocent to romantically interested teenager in *That Certain Age*, which sees her vying for the attentions of a worldly and debonair war reporter (Melvyn Douglas). No longer a priceless, irresistible object, she has become a young woman entering the game of courtship from the lowest tier, and ultimately her character finds solace in the arms of a gauche Jackie Cooper. Perhaps because she began her film career already on the verge of adolescence, Durbin's decline was relatively protracted—unlike that of Temple, who was released by Fox in 1940, and Withers, whom she joined in retirement several years later.

New "family" genres also emerged, most notably the small-town family series (epitomized by MGM's Andy Hardy comedies). Subsequent films were not merely vehicles for extraordinary juvenile talent. The Freddie Bartholomew MGM adventure-films *Captains Courageous* and *Kidnapped*, Selznick's *The Adventures of Tom Sawyer*, the Shirley Temple confections *The Little Princess* and *The Blue Bird* and the Judy Garland-starred fantasy *The Wizard of Oz* (Victor Fleming, 1939) all articulate a shift in narrative emphasis from the child star as central object of attraction to a more diversified range of pleasures, including starry casts, expensive Technicolor, elaborate set design and eye-catching art direction. Such films were intermediaries between the objectified child-star films of the mid-1930s and

the lush family comedies of the 1940s, where youngsters such as Margaret O'Brien and Elizabeth Taylor took their places within more broadly represented family units. In demographer Leo Handel's 1940s study, the child-star film ranked as the least appealing genre among adult men and women—a precipitous decline from its days of box office domination just a few years before.[45] By 1954, only one child performer—MGM's Sandy Descher—was under major studio contract.[46]

Few high-profile Hollywood child stars of the 1930s were exempt from the physical, emotional, and economic obligations to adults that have been discussed in this chapter. Those child actors who avoided such obligations had their career choices limited to shorts or second-features intended chiefly for juvenile consumption. "Poverty row" studios such as Republic and Monogram, and mini-majors such as Universal and Columbia, did not have the resources to compete with the biggest Hollywood studios, so adapted to the market by targeting older children and teenagers, who were compulsive filmgoers and typically attended movie theatres independently of their parents.[47] Unsurprisingly, such audiences demanded less sentimental condescension, and young protagonists with a greater sense of dynamism and autonomy.[48] Many such productions offered largely self-sufficient child figures no longer dependent on or obligated to adults, and with whom the predominantly adolescent audiences could identify. Examples include Roach's child-centered "Our Gang" shorts; First National's "Nancy Drew" series (1938–39), which centered on adolescents; Monogram's "Frankie Darro" series (1938–41) and Warner Brothers' "Dead End Kids" (1937–39),[49] which both feature older teenagers and young adults. Unlike Temple, Durbin, and Bartholomew, whose presence and popularity allowed them to *transcend* narrative, the actors in these series remained *subordinate* to narrative. These were uncomplicated movies, without a moral message or social purpose. We can only speculate about how adult audiences responded to these films, but reviewers were generally dismissive. Partly, this is because they were cheap and hurriedly constructed; but surely it is also because they seemed to offer visions of childhood free from nostalgia, valorization, didacticism and an obligation to satisfy adult emotional and material needs.

NOTES

1. See, for instance, Karen Lury, *The Child in Film: Tears, Fears and Fairytales* (London and New York: I. B. Tauris, 2010), 65–73; Ian Wojcik-Andrews, *Children's Films: History, Ideology, Pedagogy, Theory* (London: Garland, 2000),

72–73; Jane O'Connor, *The Cultural Significance of the Child Star* (London and New York: Routledge, 2008).
2. See Alice Miller Mitchell, *Children and Movies* (Chicago, IL: University of Chicago Press, 1929), 36–37.
3. See Noel Brown, "'A New Movie-Going Public': 1930s Hollywood and the Emergence of the 'Family' Film," *The Historical Journal of Film, Radio and Television* 33:1 (2013): 1–23, for an in-depth examination of Hollywood's relationship with the "child" audience during the early 1930s; also see Douglas Hodges, "Remember Youth or Lose B. O. of Tomorrow, Declares Barker," *Exhibitors Herald-World*, November 8, 1930, 44.
4. The Production Code was intended to limit the filmic representation of such "adult" elements as violence, sexuality, profanity, obscenity, vulgarity, and other "repellent subjects," while upholding the sanctity of the law, religion, family, and national honor. Although cunning producers often found subtle ways of circumventing its prescriptions, it remained in operation until 1966, at which point its credibility had been fatally weakened by repeated transgressions.
5. Noel Brown, *The Hollywood Family Film: A History, from Shirley Temple to Harry Potter* (London and New York: I. B. Tauris, 2012), 29–36; 44–51.
6. On the cultural need for such films during the Depression years, see Charles Eckert, "Shirley Temple and the House of Rockefeller," in *Stardom: Industry of Desire*, ed. Christine Gledhill (London and New York: Routledge, 1991), 60–73; and John F. Kasson, "Behind Shirley Temple's Smile: Children, Emotional Labour, and the Great Depression," in *The Cultural Turn in U.S. History: Past, Present, and Future*, eds. James W. Cook, Lawrence B. Glickman, and Michael O'Malley (Chicago and London: The University of Chicago Press, 2008), 185–216.
7. Cited in Kasson, "Behind Shirley Temple's Smile," 187.
8. Franklin K. Matthews, "Movies of the Month," *Boys' Life*, March 1935, 26.
9. Viviana A. Zelizer, *Pricing the Priceless Child: The Changing Social Value of Children* (Princeton, NJ: Princeton University Press, 1994), 65.
10. Ibid., 77.
11. Eckert, "Shirley Temple and the House of Rockefeller," 61.
12. Norman J. Zierold, *The Child Stars* (London: Macdonald, 1965), 77.
13. Graham Greene, "Wee Willie Winkie; The Life of Emile Zola," in *The Graham Greene Film Reader: Mornings in the Dark*, ed. David Parkinson (Manchester: Carcanet, 1993), 233–34.
14. Ibid.
15. See Kasson, "Behind Shirley Temple's Smile"; Georganne Scheiner, "The Deanna Durbin Devotees: Fan Clubs and Spectatorship," in *Generations of Youth: Youth Cultures and History in Twentieth-Century America*, eds. Joe Austin and Michael Nevin Willard (New York and London: New York University Press, 1998), 81–94.
16. Cary Bazalgette and Terry Staples, "Unshrinking the Kids: Children's Cinema and the Family Film," in *In Front of the Children: Screen Entertainment and*

Young Audiences, eds. Cary Bazalgette and David Buckingham (London: British Film Institute, 1995), 92–108, at 95.
17. "In Wonderland," *Time*, December 25, 1933.
18. Rudy Behlmer, ed., *Memo from David Selznick* (New York: Viking Press, 1973), 124–25.
19. Matthews, "Movies of the Month," 21.
20. Ibid.
21. B. R. Crisler, *The New York Times*, November 3, 1938, 27, 1.
22. Frank S. Nugent, *The New York Times*, December 11, 1937, 22, 2.
23. Frank S. Nugent, *The New York Times*, March 18, 1939, 9, 2.
24. Kasson, "Behind Shirley Temple's Smile," 204–5.
25. Diana Serra Cary, "Foreword" to Tom Goldrup and Jim Goldrup, eds., *Growing up on the Set: Interviews with 39 Former Child Stars of Classic Film and Television* (Jefferson, NC: McFarland, 2002), 1–2.
26. Anthony McAllister, "She Had to be Famous," *Photoplay*, November 1935, 72–73, 90.
27. Adela Rogers St. John, "Shirley Wants the Quintuplets for Christmas," *Photoplay*, December 1935, 22–25, 97.
28. Zierold, *The Child Stars*, 63.
29. Zelizer, *Pricing the Priceless Child*, 14.
30. The cultural assertion of the pricelessness of children is difficult to reconcile with the then-profitable business of children's life insurance during the first half of the twentieth century. For an examination of how the business of children's life insurance developed in parallel with the increasing perceived social value of children and childhood, see Zelizer, *Pricing the Priceless Child*, 43–48.
31. "Actor Coogan, Mother to Split What Remains," *The Milwaukee Journal*, March 14, 1939, 16.
32. "Freddie Bartholomew's Mother Loses Fight for Custody of Son," *The Painesville Telegraph*, April 23, 1936, 3.
33. Kasson, "Behind Shirley Temple's Smile," 209–10.
34. Wojcik-Andrews, *Children's Films*, 72. See also Kasson, "Behind Shirley Temple's Smile," 190–91, for an overview of Temple's commercial value to Fox.
35. "Jackie Cooper All Through, the Pity of It, He's Only 14," *The Milwaukee Journal*, October 27, 1936, 21.
36. Helen Whitfield, "What Really Happens to Movie Children?," *Photoplay*, July 1935, 42–43, 89.
37. Ibid.
38. Ibid.
39. Hank Grant, "Jackie Coogan: No Longer a Youngster," *The Evening Independent*, December 18, 1962, 10.
40. Leo Verswijver, "Jane Withers," *Movies Were Always Magical: Interviews with 19 Actors, Directors, and Producers from the Hollywood of the 1930s through the 1950s* (Jefferson, NC: McFarland, 2003), 202–16.

41. See particularly Diana Serra Cary, *Hollywood's Children: An Inside Account of the Child Star Era* (Texas: Southern Methodist University Press, 1997) and *Whatever Happened to Baby Peggy? The Autobiography of Hollywood's Pioneer Child Star* (Albany, NY: BearManor Media, 2009).
42. Zierold, *The Child Stars*, 190.
43. Mark Lawson, "Most Sacred Monsters," *The Guardian*, June 1, 2007, 231.
44. Ibid.
45. Leo Handel, *Hollywood Looks at its Audience: A Report of Film Audience Research* (Urbana, IL: University of Illinois Press, 1950), 124.
46. "Youthful Ideas For Filmization Imbue Vet Megger Taurog," *Variety*, December 6, 1954, 2.
47. For an overview of demographic research on the US movie-going public of the 1930s and 1940s, see Handel, *Hollywood Looks at its Audience*, 99–125.
48. For a contemporary discussion of the tastes of young movie-goers during the period, see Richard Ford, *Children in the Cinema* (London: Allen and Unwin, 1939).
49. See Brown, *The Hollywood Family Film: A History, From Shirley Temple to Harry Potter*, 57–62.

6. Shifting Screens: The Child Performer and Her Audience Revisited in the Digital Age ❦

Gilli Bush-Bailey

"GET ON BOARD"

In January 1970, I began work on a 17-part television series for children. I was 14 years and seven months old and this was not my first professional engagement as a child performer.[1] In fact I considered myself to be an experienced jobbing actress who had to fight hard through the many days of large-group auditions and screen tests required by the Anglo/American team of producers for this film series intended for the small screen. I was cast as "Billie," the capable, motherly but tomboyish girl in a gang of seven children who shared an abandoned London double-decker bus as their gang hut and used the scrapyard it was set in as their playground. *Here Come the Double Deckers* was first broadcast in the United Kingdom in January 1971, a month after the first screening on ABC in America in September 1970. While some critics thought this hybrid show too mid-Atlantic for wide appeal, children on both sides of the ocean were captivated by the gang's weekly adventures. We sang and danced our way through attempts to build a hovercraft, create a robot, race go-karts, make a movie, rescue a dog, rescue a one-man band, go camping, and, of course, put on a show. There was rarely a storyline that didn't involve some kind of disaster that characteristically involved a chase or a slapstick routine, before arriving at a satisfactory and tidy resolution at the end of each 25-minute episode. Heralded by the *Daily Mail* as "a mixture of Our Gang and the Monkees with a dash of Mack Sennett,"[2] the series included guest appearances by some of the most respected British film comedy actors. But, largely, this

was a show about an "ordinary" group of kids enjoying an extraordinary set of adventures in a world where parents and school were conveniently absent. The show's title sequence has the gang riding on an open-top London double-decker bus, singing the catchy "Get on Board" theme tune, with Buckingham Palace and Trafalgar Square projected behind them. In the closing titles, the gang lean out of the back of the bus, waving to the viewers as they chant the self-conscious refrain of "see you next week." The press clippings in my personal collection of *Double Deckers* memorabilia reinforce the conceit of the gang as "normal" children, referring to the seven "unknown" child actors chosen from "2,000" applicants. The *Sun* celebrates "the discovery" of "real, live kids, who can dance, sing and act" and "who are now about to become internationally famous."[3] The *Daily Mail* suggests that "the BBC outbid ITV" paying "£6,000, the most it has paid for an 'outside' children's series."[4] Another paper hails our cast of young performers as "mini-stars," who are assured of a second series as the "show has already earned $500,000 in export sales" having been "rated America's second most successful children's TV show."[5]

The apparent delight with which the press in the 1970s effortlessly elide the labor of untrained, "natural" child performers, with the generation of economic profit for the adult world of the entertainment industry is worth noting. As other chapters in this collection demonstrate, there is much about the child performer that has long troubled a society unable to reconcile the pleasurable emotions evoked by watching "natural" child performers with the wholly unnatural pursuit of a child's paid career in the entertainment industry. Expressions of shock and concern at working conditions have all too frequently arisen from revelations of child exploitation, coercion, and/or abuse in the cause of entertainment. Such concerns have echoed down the centuries and across national and international boundaries, juxtaposed with further expressions of shock when former "child stars" transgress the natural innocence assumed in their performance and stories of drink or drug related episodes in their early adult life begin to emerge. No such stories dogged the cast of *Here Come the Double Deckers* who were, in fact, a mixed bag of trained and untrained child performers.

Peter Firth (Scooper), Brinsley Forde (Spring), Michael Audreson (Brains), and I, all had experience of filmmaking and had benefitted from early actor training and, in my case, a considerable amount of dance training too. Bruce Clark (Sticks), Douglas Simmonds (Doughnut), and Debbie Russ (Tiger) were new to professional performance work and of these three, only Debbie continued as a professional child performer. Peter Firth has since pursued a successful international career as a screen actor, Brinsley Forde

Shifting Screens 113

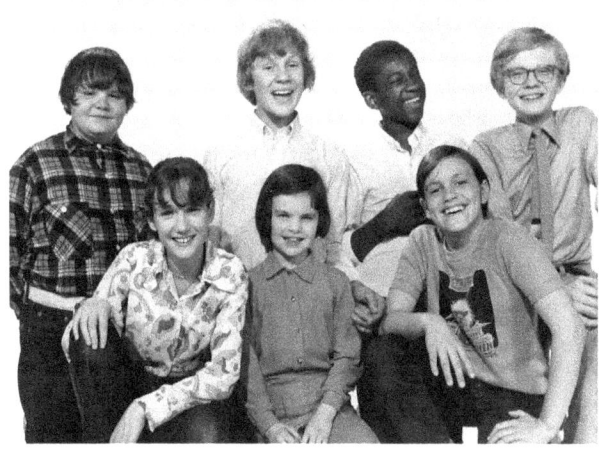

Figure 6.1 Cast of *Here come the Double Deckers*. L to R: back row: Douglas Simmonds (Doughnut), Peter Firth (Scooper), Brinsley Forde (Spring) Michael Audreson (Brains). Front row: Gillian [Bush] Bailey (Billie), Debbie Russ (Tiger), Bruce Clark (Sticks). From the author's collection.

founded the chart-topping UK band *Aswad*, and Michael Audreson went on to appear in films and television as an actor and is now an independent producer. I also continued to work as an actress on television, radio, and the theater, before temporarily hanging up my Equity card in 1992 to pursue an academic career.

So this chapter is not a work of childhood confession or gossipy revelation, but it *is* a work of unabashed autobiography, bringing together as it does, my remembered experience as a child performer with the critical perspectives of my current academic discipline in theater and performance history. My own take on that history has, as I increasingly realize, been shaped by my 25 year acting career and, particularly, by my adolescent experience as a "child" performer. I will begin by considering further the cultural legacy of innocence that is axiomatically attached to concepts of the "natural child" performer, and juxtapose the cultural resistance to notions of professionalization and expertise in the performing child with my own experience of training and performance. Bringing together the approaches of performance history with sociology and childhood studies, I discuss how societal attitudes to the performing child have influenced the legislation (currently

under British government review) affecting the control of earnings made by young professional performers. In the final section of the chapter, I return to the specific case of *Here Come the Double Deckers* to consider the response of its young audience. I am not, however, primarily focussing on a discussion of children's television viewing in the 1970s, but rather on the powerful memories of those who now reflect on their devotion to the show; reflections expressed via the global medium of the web and more personally through the email correspondence I have received over the past three years or more. The initially surprising arrival of emails "for Billie" in my college inbox has led to extended exchanges with four particular correspondents who have generously shared their memories of *Double Deckers* with me, revealing their sense of connectedness with the performing children they not only watched each week but with whom they also felt they shared their young lives; these are, in so many ways, my virtual childhood playfellows and schoolmates—remembering adventures from different sides of the screen.

I should at this point make clear that while I claim a very particular perspective on the subject of this study, I am also aware that those very credentials could be considered to rule me out as a useful critic. I am, however, alert to the lure of memories, remembered, relived, and repackaged in works of autobiography and biography, worked out to some extent in the introduction to my recent book on the professional life of Frances Maria Kelly (1790–1880), who also started her long career as a child performer and brought those experiences together with other stories from her long career as a professional actress in her one woman show, *Dramatic Recollections* (1832).[6] Such performative acts of embodied memory are usefully contextualized by sociologist Paul Connerton in his exploration of *How Societies Remember*:

> Concerning memory as such, we may note that our experience of the present very largely depends upon our knowledge of the past. We experience our present world in a context which is causally connected with past events and objects, and hence with reference to events and objects which we are not experiencing when we are experiencing the present. And we will experience our present differently in accordance with the different pasts to which we are able to connect that present. Hence the difficulty of extracting our past from our present: not simply because present factors tend to influence—some might want to say distort—our recollections of the past, but also because past factors tend to influence, or distort, our experience of the present.[7]

Connerton's work on group or shared social memory is particularly pertinent to the section of this chapter that concerns the memories of the now

adult correspondents who recollect their childhood experience of watching *Double Deckers*, and for whom, in some sense, the email communication with me is framed by the memory of the 14-year-old girl who once sang and danced on their television screens. But the relationship between past and present, how and why we should be concerned with it and, in Connerton's terms, bringing "recollection and bodies" to perform together in an act of cultural memory is at the heart of my current work as a theater historian. In a deliberately self-conscious move to "own" the power of embodied memory, I created and performed a 30-minute "performance paper" that draws together Kelly's reflections on being a child performer with my own, illustrating that talk with images from my early television work and, at one point, dancing along with my 14-year-old self in a moment from *Here Come the Double Deckers*. Some in my largely academic audience were surprised to discover their own half-forgotten childhood memories of watching the show and expressed a sometimes embarrassed delight in the connection between past and present. It is with a similarly mixed response that I want to take a very specific look at the child performer that was/is me, now and then, then and now. The double-take will, I hope, bring a fresh perspective that might give rise to new evaluations of the way we tell the stories of the child performer, the child star or, as I saw and still see my younger self—the working actress.

THE "NATURAL" CHILD

Romantic notions of the innocent child are deeply embedded in our shared cultural (or social) memory, informing our constructs of the "natural" child who is idealized as unselfconscious, free of the constraints of self-knowledge that beset the adult world. In a recent special edition of the *Lion and the Unicorn*, a collection of essays devoted to a focus on the child performer, Amanda Phillips Chapman unpacks the Romantic tradition in which the "the child features as a valorized figure of natural grace and beauty, and childhood as an as-yet-unfallen state in a fallen world."[8] Chapman reminds us that Schiller, Rousseau, and Wordsworth have exerted a powerful influence in constructing notions of the authentic child in "isolation from the social," being in "a state of autonomous separation, free from insidious interpolation and deformation by the social."[9] This is, of course, to simplify a much deeper and philosophically more complex set of arguments, but the Victorian understanding of Romantic ideals, and the state of childhood as a time and place of innocence, is still powerfully shared in our cultural memory. This is at its most complex in

the vexed relationship between work and play that has informed society's attitude to the child performer. Anne Varty's *Children and Theatre in Victorian Britain: 'All Work, No Play'* offers a detailed study of the cultural conditions and actual experiences of the performing child, alongside the convoluted, often contradictory, attempts made to justify their presence on the stage as merely unselfconscious play before a delighted (paying) audience: "The fusion between playing and acting, captured in the term 'playacting,' existed from the perspective of the audience rather than the child, and it was a fusion nurtured by the Victorians as it supported both the aesthetics and the politics of the stage child"[10] and, I would add, the economic realities of the entertainment industry. Although we are now inclined toward suspicion concerning some prominent (male) Victorians' attitudes toward children, we would, I think recognize Ernest Dowson's publicly expressed admiration for the natural and unaffected performance given by eight-year-old actress Minnie Terry, "with as utter an absence of self-consciousness or affectation, and as perfect a spontaneity, as if she were in her own nursery at home."[11] Child stars continue to be lauded for their natural, unaffected performances but we have perhaps shifted the emphasis from the natural, unaffected child to the supposed ideals of the "authentic" child.

The current emphasis on "authenticity" is explored by Helen Freshwater in her article on the child performers in the long running global success that is *Billy Elliot the Musical*. In the aptly titled "Consuming Authenticities" Freshwater notes how the British publicity machine behind the musical "makes much of the backgrounds of the boys who play Billy"[12] in the triumphant story of a boy who realizes his dream to become a dancer against the backdrop of the 1984 miners' strike in the North East of England. Freshwater points up the creative team's commitment to keeping the show "authentic," as confirmed by its writer Lee Hall, who insisted "that the three boys selected to share the role for the London premiere were 'real life Billy Elliots'...they were 'the sons of a steelworker, a builder and a pipefitter.'"[13] Freshwater adroitly strips the complex layers of packaging around this show and exposes the burden of "authenticity" carried by the boys who have successfully navigated the audition process, a process in which, as Freshwater notes, the production team continues to "actively discriminate in favor of boys from Northern, working-class backgrounds"[14] reinforcing the "real-life" journeys of the boys hoping to realize their dreams of stardom on the West End stage. I am particularly interested in the way Freshwater deals with the fact these child performers are "talented dancing children," exploring how that talent and, notably, their professional training are recognized and disguised in turn. This is powerfully conveyed in Freshwater's

discussion of a key moment in the second act when "Billy" completes a complicated and physically testing "dance" with his imagined adult self:

> as he stands, arms and legs outstretched, holding a pose that signals the completion of his routine, many in the audience rise to their feet and applaud... Up until this point the child performer's dancing is supposed to convey his love of dance, and his latent ability, but not his accomplishment. The latter's display is what audiences pay to see, and the ovations performed in response to it may be a way of signalling appreciation at its successful delivery.[15]

As a nineteenth-century theater historian I take particular pleasure in this description of a well-crafted "claptrap"; the performer freezes in tableau, almost daring the audience *not* to stand and applaud—and this specific moment is achieved and held by an accomplished child performer. This is not, in Varty's terms, an expression of play but a realization of the training and practice of the young professional performer and it is to the question and concerns about training the child performer for professional, and *ipso facto*, paid work that most disturbs our notions of a desirably "normal" childhood.

"DON'T PUT YOUR DAUGHTER ON THE STAGE MRS WORTHINGTON"[16]

Jane O'Connor cuts through the hegemonic weight of Romantic ideals of childhood with detailed reference to recent theoretical work in sociology and child studies in her 2008 study, *The Cultural Significance of the Child Star*. O'Connor's book expands her argument beyond the individual case studies of particular child performers to include the cultural context in which their work is performed and received in Western society. She directly confronts the contradictions arising from received notions of childhood, locating the starting point for her sometimes provocative investigation with an assertion of the key parent/child relationship and social constructs of the "proper" parent:

> The message is loud and clear: the responsible parent does not even consider allowing their child to become a professional performer. Within this largely middle-class discourse, then, being a 'proper' parent involves protecting your child from the entertainment industry, and being a 'proper' child involves not performing for money.[17]

There are a number of assumptions relating to class-based norms that might be challenged but the age-old enemy of the still widely held (neo-)Romantic

ideals of all that is "natural" for both parent and child, are "industry" and "money." As O'Connor goes on to demonstrate, late twentieth-century theories of childhood in Western economies have continued to reinforce or dispute ground identified by predominantly "middle-class right-wing edicts of 'normality.'" The performing child disturbs such ground at its very base, essentially questioning the desired understanding of children as dependent and separate from the world of commerce or work:

> The very fact that they work in a professional capacity negates their dependence on adults and challenges the modern concept of the 'emotionally priceless yet economically useless child,' as identified by Zelitzer...It is not surprising then that writing about child stars tends to cast them as victims of adult greed and cruelty, in order perhaps to avoid their 'conceptual eviction' from the category of 'child' altogether.[18]

In our late-capitalist Western society we have deeply conflicted attitudes toward "children" and commerce. We resist the identification of children as a recognized consumer group even if, as parents, we are quick to ensure we provide the latest "must-have" item. We rather admire the celebration of the teenage "dot.com" millionaires[19] but express concern for the future of child stars who have million-dollar contracts for movie series such as *Home Alone* and *Harry Potter*. Perhaps we express particular concern for performing children because they are, after all, selling themselves. There is something both admirable, and worrying, in seeing their small bodies exhibiting an array of physical skills learnt in order to get the job done.

Our response to this anxiety is, on the one hand, legislation to protect performing children from exploitation of personal and financial kinds and, on the other, to allow for specialized education in private, fee-paying, stage schools which are recognized as *bona fide* places of training, actively preparing young performers in order to secure early entry to the highly competitive professional world of the entertainment industry. There are many such schools and they vary in the quality of their vocational training, their academic provision, and the amount of paid work they expect, or allow, their pupils to undertake. Between 1966 and 1970 I attended Arts Educational School in London[20] where my weekly routine involved daily ballet lessons, one other vocational class in singing, modern dance, tap, musical appreciation etcetera in one half of the day with conventional academic subjects taken in the other half of the day. Arts Ed. (as it is still known) was largely interested in preparing its pupils and students (those over 16) for life as professional dancers. My parents paid the school fees and were delighted when I was included in the children's corps de ballet

for Festival Ballet's productions of *Sleeping Beauty* and *Nutcracker* (1967). We were rehearsed and chaperoned by one of the senior ballet teachers in the school and when we were eventually backstage, we were taught how to behave in the professional and disciplined manner of our chosen profession as ballet dancers. The extent of our complete and unquestioning obedience is best demonstrated in a moment when, in a final dress rehearsal for *Nutcracker*, the group of girls performing "the mice" duly placed our head costumes on and, discovering we could not see at all through the eye holes, stood quietly as we had been told to do in the wings. On cue, we set off onto the stage, falling over one another in an ungainly sightless heap as we attempted to carry out the dance exactly as instructed. I was greatly relieved when I had the opportunity to swap the rigors of the corps de ballet with an appearance in a television costume drama and exchange the discipline of the school chaperone for that of my mother. As a chaperone she was no less strict about observing the rules of the profession, having been an actress, stage-manager, and agent herself. Her determination to ensure that I was both completely professional in my approach to rehearsal and performance, and yet still a "normal" child is best expressed in an interview she gave to a local newspaper. My mother speaks of seeing that I must be protected from being "spoiled" or "hurt," that I had to learn "the value of money," keep up with my education ("it's sometimes difficult for her to keep her nose to the grindstone") and that for her part, she had to deal with "various practical problems because Gillian is young, and yet is a working actress."[21] My working life did mean that I fell behind at school, in academic and vocational training. This added to a self-conscious separation from my school friends who also had mixed feelings about my bid to return to friendship groups after each job finished. I hit my fifteenth birthday during filming for *Double Deckers* and after much "discussion" with my parents, I effectively left full time education at Arts Ed., taking national examinations at one of two "crammers" (private fee-paying tutorial establishments) that I managed to attend in between television work.

A QUESTION OF PAY

Other chapters in this book refer specifically to the history of legislation and the changes in the regulations governing licenses issued to theaters and producers wishing to employ child performers, but I now touch briefly on current moves to change the legislation in England and Wales, drawing particular attention to the management and protection of young people's earnings. In America, the scandals surrounding the misappropriation of

monies earned by child stars are numerous. In 1938, "Coogan's Law" stated that in future all earnings by a child should be protected from exploitative parents or managements (so-called following the court case brought by the adult Jackie Coogan who sued his mother and step-father for $4 million spent by them from his earnings).[22] By the 1960s, the regulatory regime[23] in Britain, which gave local authorities the right to issue the licence for a young performer's employment, also gave them the right to stipulate how a young person's earnings should be saved for their use in adult life. It was then with some surprise that I found no mention of earnings at all in Sarah Thane's review of current legislation, undertaken at the behest of the previous government and published on February 26, 2010.[24] The subsequent public consultation on proposals for legislative change, launched by the Department of Education in England and the Welsh Government in May 2012 does, however, make the following suggestion:

12.8 Children's earnings

In most cases child performers do not earn large sums of money, but in some cases their earnings may be substantial. Under current regulations, the local authority stipulates how a proportion of the child's earnings should be saved. We propose to abolish this requirement because this is a matter for the child and their parents to decide and the state should not interfere unnecessarily in family affairs.[25]

The proposal, it seems to me, is a decisively retrograde step that ignores historical precedents and fails to take into account the complexity of the contemporary "family." Statistics on the number of children experiencing more than one family group calls into question the implicit assumptions and, therefore, the potential complexity in the configuration of the "parents" who decide how best to save or spend a young performer's earnings. If, as in many cases, those earnings also pass through a theatrical agent (and/or one attached to a theater school), it is likely that between ten and twenty-five percent of the sum will already be deducted in fees and charges. But, as I have indicated earlier, there is something deeper at work here, expressed in the reductive attitude to the size of earnings "most" young performers accrue and revealing a reluctance to admit that children "work."

The reluctance to acknowledge the young performer's professional services by proper payment has been the subject of repeated press interest. The earnings of children appearing in the lead role in the Royal Shakespeare Company's hit musical *Matilda*, now running in London's West End at the Cambridge Theatre, are the latest to be subjected to scrutiny. Lindsay Watling writing for the *Evening Standard* notes that the leading role of

Matilda, shared by four girls, attracts a salary of £60 per show, "a fraction of the fee their US counterparts will earn."[26] Watling goes on to quote Sylvia Young, the principal of the London-based theater school that trains many of today's young performers, who acknowledges that the girls "are not paid as well as they should be." In her newly published "guide for children and parents" casting director Jo Hawes makes a brief reference to the issue of salary, stating that:

> In theater, children should receive half of the current adult Equity minimum divided by eight for performances. Equity minimums paid to adults are based on the size of the theater in which the show is performing. Children are paid per performance, not per week because they do not do an eight-show week. Some producers do not pay children at all and whilst it is frowned upon not to pay it is up to the parents to make a decision as to whether to accept the terms and conditions.[27]

Although Jo Hawes makes it clear that she considers children should be paid, she also advises parents to "weigh up the experience the child might be getting if they do appear in a production unpaid." In the current atmosphere of economic recession where unpaid internships and work experience are widely promoted as the best means "to get on the ladder,"[28] we can recognize the attraction of a cultural (re) turn toward Victorian notions of "play" not "work" as discussed earlier in Anne Varty's study of child performers. It is encouraging, therefore, to see that after years of refusing to consider representing young performers, the actors' union, Equity, has now moved to make children as young as ten eligible for membership and thus, union protection. An announcement in the industry press, the *Stage*, refers to *Matilda* as an example of Equity's concern that child performers should now have the protection of the union. More importantly, perhaps, is the union's recognition that performing children are at the start of their professional careers:

> One of the things that has been troubling us is that we do miss professionals who emerge at a very early age. You now have quite a few people who worked on Harry Potter who clearly are going to make a substantial career out of the industry and we were not able to offer them membership and therefore the support they might need.[29]

As Jane O'Connor argues, the professional child, the wage-earning child, the child stars "are not 'normal' children in our society...The status of child stars as children in contemporary society is also challenged by entrenched ideas about the dangers of precocity and of growing up too soon."[30]

O'Connor does not differentiate between children coming from nontheatrical families and those brought up in theatrical/industry families. My parents were very typically middle class in their aspirations for their children and their fears about the dangers of growing up too soon, but they were also theater and television people and so, in many ways, it was very "normal" for me to enter the same profession as them. We talked about theater and television a lot in our house, and my inevitable precocity was sat upon hardest when I made dismissive comments about other programs or, worse still, other child performers. I was not a child star on a million-dollar contract with a film studio, but I was always keenly interested in what I was to be paid for each job. I had an agent, an accountant, and my own bank account from the age of 12. I worked consistently on television well into my late twenties, drawing on the lessons I gained on the set as much as the training in the rehearsal room and dance class. My aspiration was to continue to be what I thought I already was—a professional working actress. But retrospectively, I now think I worked just as hard at performing the "normal" child the adult world feared I was not. Reassuring directors and casting agents that I was a convincing "child" was an important part of securing the parts I was employed to perform.

SHIFTING SCREENS

The move away from that life toward a new career as an academic, felt at first like a welcome opportunity to put clear blue water between myself and that problematic child. It was as if I had internalized the hegemonic dis-ease with me/"her" and the unnatural experience of a professional child performer. In the mid-1990s maintaining that distance became less possible. The creation of the *Double Decker* website, the rerelease of the soundtrack and, eventually, a DVD of all 17 episodes, prompted invitations to publicly reminisce, which I reluctantly and only occasionally accepted.[31] It was, after all, little to do with my life and work as an academic theater historian. In 2006, I began my research and writing on the life and stage career of Fanny Kelly, an actress who started her professional theater work at the age of seven years. Her adult reflections on her experiences, written and performed in a series of monologues in *Dramatic Recollections* (1832), provided an unexpected bridge to the reassessment of my own childhood career. My sense of the importance of *Double Deckers*, and my own part in it, opened up new ways of seeing Kelly's work, but my sense of its importance in more lives than just my own shifted dramatically when I received emails like this one:

> this may be of no import or interest and maybe you hear it a lot. This is a quick email to say you are a small part of my happy memories. I have been revisiting as much of my childhood as possible over the past few years (I'd call it 'finding myself' but that would be pretentious!), including the dvd of the Double Deckers. It made me smile all over again as I remembered just how much I treasured those programmes the first time round. It becomes a small part of the cumulative happiness of people you've never met. If that were me I'd be very proud! Thank you for the laughs.
>
> Yours, Ross.[32]

Although not the first email addressed to me as "Billie," Ross Smalley's self-deprecating suggestion that there was something to be regained by reaching out across the distance of 40 years suggested to me a new value and a new way of thinking about my own performing past, not only as a private, individual memory but also as part of a shared past that is formed and informed by more than one set of memories. To this end I embarked upon a longer period of correspondence with Ross and three other *Double Decker* enthusiasts, inviting them to say more about the series that, in one way or another, stood as a beacon for us all in our very different, but somehow shared childhoods:

> I had this unique friendship with the Double Deckers gang. I was the only child in the land that had a regular meet with them, and they of course knew me by name, as I knew theirs, and they could see me looking into their world as they looked out. I had every right to regard myself as the 'eighth Double Decker'... Of course they existed. The yard, the bus, the clubhouse. I imagined they'd be located somewhere near Trafalgar Square... and one day I would find them all and they of course would have found me. (Michael J. Adam)

In the 1970s my awareness of being seen and "known" by other young people was relatively limited. But now, as these distant childhood friends offer their memories, I am struck by the totemic position that the show, and my own part in it, plays in our newly wrought but still virtual friendship and, in the way we think about the child performer and her audience.

> The *Double Deckers* may have been a hugely idealistic fantasy of childhood, but I think that was why it was so loved. No one hated or bullied, anything was possible, bad things happened sometimes but you knew they would turn out for the best... You were all actors but also all real, and if I made my way to London I would have found the den eventually. (Ross Smalley)

The emphasis on the adult reception of the performing child, the "small yet big" child who, somehow, gives the adult permission to access the

hopes of the inner child has perhaps masked the ambitions and aspirations of the child audience. The desire for equality and fairness expressed in the *Double Decker* gang was particularly important to Steve, one of several US-based fans to contact me. For Steve, the curiously British/American hybridity of the show offered a way in to understanding new models of social interaction:

> My school district began mandatory integration in 1971 when I was 13. Prior to that, I had *never* been in school with an African-American. I'd seen black kids in media in stereotypical roles. But when I stop to think, gee, who was the first young black person I ever saw doing what other kids do?—having fun, being creative, cracking jokes—it would have been Brinsley Forde. Having Brinsley gallivanting around on-screen with the rest of the cast was more important to me than I ever realized at that time... The little kindnesses woven into the plots were also important. Peter offering to walk Debbie home when she was tired, or you taking her to the restroom (do you say loo?)... Having those "good turns" show up in the scripts turned out (just like Brinsley's presence) to be more influential in my life than I imagined at the time. (Steve Bauer)

As a child performer I had no sense that I was involved in any kind of social agenda (and frankly I doubt that the producers aspired to that either). Looking at the series 40 years on with a more critical lens, quickly reveals the extent to which *Double Deckers* works to reinforce (middle-class) notions of children's "natural" good behavior, particularly in the many "good deeds" the gang performed for others—such as the episode in which the gang put on a comedy sketch show (based on the format of *Rowan & Martin's Laugh In*, NBC, 1968–73) to raise money for a "seeing-eye" dog (the British expression of "guide-dogs for the blind" was considered too oblique for an international audience). Tim Jarrett watched the *Double Deckers* from his childhood home in a farming community in Northeast Georgia. He speaks of the various attempts he made to carry out the same good deeds the gang enacted but, as he explains here, there were times when such attempts were beyond the reach of Tim and his friends:

> after the "Laugh In" episode we decided to try to put on a show at the local community center. This project never really went beyond the planning stages though because we lacked one crucial element, any sort of talent whatsoever. (Tim Jarrett)

Like Ross Smalley, Tim was all too aware of the difference between fiction and reality but the overlap between the imagined and the achievable did not mar the enjoyment of the possibilities. Jane O'Connor suggests

that "by separating child stars from other children both conceptually and materially...such individuals become simply images or simulacra of real children and as such are denied full personhood in the social world"[33] but, from the evidence here, it is clear that as children "difference" was recognized and in sharing memories of their past belonging, separateness was, and is, erased. The web as a vehicle for expressing and experiencing memory as community is relatively new and will surely change our understanding of socially constructed memory. The fireside is now the Internet. The tales once told and retold in the flickering light of the flames are now exchanged on computer screens. I am struck by the sense of belonging by this new fireside/site as a place not only to share memories but also to remember and be remembered by images brought back so vividly and viscerally through their World Wide Web presence. When Paul Connerton says that "images of the past and recollected knowledge of the past...are conveyed and sustained by (more or less ritual) performances,"[34] I wonder to what extent he envisaged the power of such performances played and replayed, "shared" and "liked" (in more or less ritualistic ways) through websites, Facebook and YouTube. And how such shared memories might change our social construction of the child performer in the past, present, and future?

NOTES

1. The *International Movie Database* records my appearances in two British television series and six other single episode performances on television prior to *Here Come the Double Deckers*. http://www.imdb.com/name/nm0047271/.
2. Brian Dean, *Daily Mail*, undated clipping, personal collection.
3. Philip Phillips, *Sun*, undated clipping, personal collection.
4. *Daily Mail*, undated clipping, personal collection.
5. Unidentified newspaper clipping, personal collection. It is worth noting that contractual arguments resulted in additional fee payments for two repeats of the show on British television. No payment was made for any sales or additional merchandising deals in the USA or elsewhere.
6. See Gilli Bush-Bailey, *Performing Herself: AutoBiography and Fanny Kelly's Dramatic Recollections* (Manchester: Manchester University Press, 2011), Introduction, 3–10.
7. Paul Connerton, *How Societies Remember* (Cambridge: Cambridge University Press, 1989), 2.
8. Amanda Phillips Chapman, "The Riddle of Peter Pan's Existence," *The Lion and the Unicorn* 36: 2 (April 2012): 136–53, 137.
9. Ibid., 138.

10. Anne Varty, *Children and Theatre in Victorian Britain: 'All work, No Play'* (Basingstoke: Palgrave Macmillan, 2008), 10.
11. Ernest Dowson, quoted in *Children and Theatre in Victorian Britain: 'All work, No Play,'* 11. Dowson is among several writers and poets of the period whose relationship to children has been questioned in light of more current concerns about the eroticized child.
12. Helen Freshwater, "Consuming Authenticities," *The Lion and the Unicorn*, 36: 2 (April 2012): 154–73, at 161.
13. Ibid., 161.
14. Ibid.
15. Ibid., 169.
16. Noel Coward, "Don't Put your Daughter on the Stage Mrs Worthington" (1934), accessed January 30, 2013, extract from http://www.songfacts.com/detail.php?id=11902. Contrary to popular belief, Coward's lyrics do not warn of the moral dangers for a young girl taking up the stage as a profession but rather that the ambitious mother has failed to see that her daughter has neither the "looks" nor talent to "earn a living wage." Coward was, of course, a child performer himself, making his first professional appearance on the stage at the age of 12.
17. Jane O'Connor, *The Cultural Significance of the Child Star* (New York and London: Routledge, 2008), 1.
18. Ibid., 22–23. O'Connor establishes the theoretical ground for her study in a carefully considered discussion of key figures in sociology and childhood studies including Jenks, Hockey and James, Ariés Zelitzer, and Edelman whose understanding of the child as a signifier of heteronormative right-wing values is particularly revealing.
19. See, for example, http://www.promotionalcodes.org.uk/frugal-blog/6359/young-entrepreneurs-top-25-teenage-millionaires/, which identifies the top teenage earners from the United States and the United Kingdom who have successfully exploited the Internet market.
20. Arts Educational Schools has now moved from central to West London. They no longer have a school agent and see the work of the school as providing a broad creative arts base for all their pupils. They do have some pupils who work professionally but the emphasis is now on post 16 and undergraduate programs for professional preparation. I am grateful for their generosity in allowing me to visit the school again and in responding to my enquiries.
21. Unattributed press clipping, personal collection.
22. See Jane O'Connor, *Cultural Significance of the Child Star*, 50–52 for more on Coogan's legal battles and also Noel Brown's chapter in this volume. Gary Coleman and Macaulay Culkin are more recent examples of child performers seeking legal redress against their parents for misuse of funds created by their professional work as child performers.
23. There have been various changes to the regulations governing the employment of children in the entertainment industry with 1968 being the most

recent benchmark against which new regulatory change in England and Wales is currently being considered.
24. See http://www.education.gov.uk/inthenews/inthenews/a00209481/biggest-overhaul-to-child-performance-regulations-in-over-40-years, accessed January 25, 2013.
25. Email exchanges with officers from the Department of Education's Targeted Safeguarding Policy Unit appear to have concluded with a message on February 26, 2013, expressing "thanks" for my interest in the Child Performance Consultation and providing a link to the report on the Consultation: http://www.education.gov.uk/childrenandyoungpeople/safeguardingchildren/a0068886/safeguarding-child-performers. It appears from additional documents available on the site that there has not been sufficient agreement to warrant major changes to the current employment law but the situation is far from clear.
26. Lindsay Watling, "Child Stars of West End Hit Get Just £60 a Show," *Evening Standard*, December 3, 2012.
27. Jo Hawes, *Children in Theatre: From the Audition to Working in Professional Theater, a Guide for Children and Their Parents* (London: Oberon Books, 2012), 117.
28. Ibid., 117.
29. Martin Brown, quoted in Mathew Hemley in the *Stage*, May 17, 2012.
30. Jane O'Connor, *Cultural Significance of the Child Star*, 23.
31. Initially I accepted a couple of "phone-in" contributions on radio and agreed to contribute an interview for the website but turned down an invitation to appear on *The Graham Norton Show*.
32. My thanks to Ross Smalley, Michael J. Adam, Steve Bauer, and Tim Jarrett for giving me permission to include extracts from their emails recalling their memories and reflections on our childhood friendship. Michael and Ross both live in the United Kingdom, while Tim and Steve are based in the United States. I have also received emails from women but none chose to respond to the invitation to share more of their memories. See also http://www.facebook.com/pages/Here-Come-the-Double-Deckers/181228481939219 and the official DD website for more comments and memories http://www.thedoubledeckers.com/index.htm.
33. Jane O'Connor, *Cultural Significance of the Child Star*, 146.
34. Paul Connerton, *How Societies Remember*, 4.

7. The Business of Children in Disney's Theater ◈

Ken Cerniglia and Lisa Mitchell

In Disney's 2012 Tony Award-winning Broadway musical *Newsies*, the young reporter Katherine seizes the opportunity to break out of the society pages by risking her job to cover the nascent newsboys' strike. During her first-act solo turn, Katherine sits alone at her typewriter: "Give those kids and me the brand new century and watch what happens."[1] Set in 1899 and based on the true story of a high-profile children's strike that set the stage for labor reform in the coming decades,[2] *Newsies* taps into tropes of youth potential that have been reliable fuel for the entertainment business ever since. Whether professional performers, theatergoers, participants in school plays, or beneficiaries of philanthropic outreach efforts, children lie at the heart of Disney's theatrical mission.

Since the Broadway premiere of *Beauty and the Beast* in 1994, Disney Theatrical Group (DTG), whose productions have grossed billions of dollars worldwide, has invested substantially in the next generation of theatergoers and theater makers. A global brand synonymous with "family entertainment," Disney tends to build its products and experiences around youth, optimism, access, and opportunity.[3] Nearly all of Disney's Broadway, touring, and international productions have employed in principal roles at least two professional child actors at any given time.[4] But DTG's interaction with children extends far beyond its professional employment practices via a variety of educational products and programs for young theatergoers and theater participants. For example, study guides are available for free download to schools across the globe, educational workshops in New York City significantly enrich the theatergoing experience for young audiences, and a UK educational program comprising video content and worksheets for *The Lion King* aligns with the national curriculum. In addition, Disney

musicals created for amateur young performers have been licensed for over forty thousand productions worldwide since 2005,[5] and DTG's outreach initiative—Disney Musicals in Schools—has established theater programs in 45 public elementary schools in New York and Nashville, with others on the way in Las Vegas and additional cities across the country.

In this chapter, we employ research on contemporary practices in professional and educational work with children in theater, interviews with Broadway professionals, and our own work with Disney's stage musicals to investigate the business of employing children to create theater, the business of employing theater to educate children, the relationship between the two, and how integrating philanthropy can enhance good business.[6]

EMPLOYING CHILDREN TO CREATE THEATER

Now 20 years old, veteran actor Henry Hodges begins his recently published handbook, *How to Act Like a Kid*, with this provocative statement: "It's fair to say that being a performer saved my life. I'm not being melodramatic. My years in elementary school were awful."[7] Henry made his professional stage debut at the ripe old age of four, and by eight he was playing the role of Chip (a castle servant boy turned into a teacup due to an enchanted curse) on the national tour of Disney's *Beauty and the Beast*. He recounts auditions as particularly difficult: cold-reading was not his forte, but he quickly learned to adapt. He knew he was a good actor, so if he could negotiate his way through the first reading of his audition sides and memorize the material right away, his auditioners would never know he struggled with the written word. His technique worked, and after seven months on tour, Henry was asked to play Chip on Broadway.[8] This Broadway debut was just the start of a notable career in which a youthful Henry went on to originate the role of Jeremy Potts in *Chitty Chitty Bang Bang* before returning to the Disney stage as one of three actors to first play Michael Banks in *Mary Poppins*. Henry, who is dyslexic, credits the professional theater with instilling in him a robust work ethic: if he works hard at something—whether reading a book, blocking a scene, applying to college, or making the transition from juvenile to mature roles—he can achieve it.

The confidence and energy of professional young performers like Henry, especially those who stay grounded as real kids and remain emotionally open to audiences, add something vital to the Broadway theatergoing experience, especially for children. According to DTG President and Producer Thomas Schumacher:

When an audience comes to a show and there's a range of characters from kids to adults, it changes the tone backstage, it changes the performance—it gives every level of the audience some entry point. When kids are watching Henry play Michael Banks in *Mary Poppins*, they're seeing the show through his eyes. That's their entry point.[9]

After nearly two decades and one hundred first-class productions around the globe,[10] the children who have been employed to perform in Disney musicals number in the thousands. *Beauty and the Beast* professionally employed at least two boys to play Chip at any given time, totaling over twenty Chips for the Broadway production alone.[11] Subsequent Disney musicals added to the ranks of roles for child performers: Young Simba and Young Nala in *The Lion King*, Jane and Michael Banks in *Mary Poppins*, Young Tarzan in *Tarzan*, Flounder in *The Little Mermaid*, and Les in *Newsies*.[12] US-based productions hire two alternating youngsters per role (one to perform, one to cover), with the exception of *Mary Poppins*, which employed three sets due to the extra rigor and stage time for the Banks children. Abroad, more restrictive child labor laws require many more children to be hired (and even show-specific schools to be erected) to keep eight shows running per week, making Disney one of the largest global employers of children in live entertainment. While none of the company managers, child wranglers, tutors, directors, or other workers we interviewed would dispute the value of these performing minors to their respective shows, employing children in the professional theater requires considerable extra cost, care, and compassion.

Besides talent, one of the most important factors in young performers' success is their parents. Stories of "show parents" overwhelming reluctant children, and driving them to become "stars" are legendary. From the overbearing character Mama Rose in the musical *Gypsy*[13] to the outrageous moms and dads on any number of cable television reality shows, the warning signs of parents who will interfere with production and consequently sabotage their children's performing careers have become part of the industry consciousness. Although some degree of training is important, ideal professional child actors need to bring their natural "child" selves to the stage. Broadway producer Jennifer Maloney looks for one thing in particular when auditioning young performers for her shows:

> That they actually like to perform. When a child walks into a room for casting, can you see that they enjoy it? No hesitancy. We want an open, kidlike spirit. If a child becomes too self-aware that they're doing something cute—or *I'm*

performing now—they lose their natural manner. The beauty of children is their willingness to try new things with no baggage.[14]

In a *New York Times* article about the preponderance of children on stage in the 2012–13 Broadway season, Robert Pogrebin profiles the professional child actors in five new shows and investigates directorial perspectives on their employment.[15] Matthew Warchus, director of *Matilda* (based on the novel by Roald Dahl), who shares a wariness of over-prepared "show kids," sought four young actresses without previous stage experience to rotate through the title role of the new musical, which demands a naïve, "out of place" sincerity.[16] James Lapine, director of the 2012 Broadway revival of *Annie*, comments:

> You want kids that are not ruined, that haven't done so many shows that they have sort of lost who they really are. I didn't want show kids. I wanted kids who had some rough edges to them and were able to be gritty and fearless. Show kids who have been groomed since 3 to be on commercials and TV are very slick, and you don't have a sense of who's behind there.[17]

Veteran casting agent Jim Carnahan concurs about what he finds most impressive about children in the audition room: "Being absolutely natural. The less coached they are, the more likely they'll be called back or get a part. I've never known a director to respond to a kid who has been drilled on their performance by a parent. It can cost them the part."[18]

The desire for authenticity in child stage actors is not restricted to the United States. In early 2013, Nana Bediako made headlines in the United Kingdom at age seven as the youngest actor to be cast as Young Simba in *The Lion King*—most boys are nine or ten before they are physically and emotionally ready to step into the role. After an extensive, six-month audition and training session with dozens of other hopeful actors that has become *de rigueur* for the show around the world, Nana's achievement is even more remarkable in light of the fact that he is the son of an immigrant single mother, Matilda Doateng, who grew up in Ghana lacking any experience of musical theater. With no professional expectations, she saw the audition process merely as a beneficial activity for her son: "I never expected him to get through. He was just enjoying the experience."[19] In the midst of his incredible success as a professional young performer, which already includes starring in an advertisement with international soccer star David Beckham, Nana reports that one day he would like to be a doctor.[20] His enjoyment of the process and nontheatrical aspirations are the type of unpolished charm that Maloney, Warchus, Lapine, and Carnahan see as ideal.

Where *Mary Poppins* attracted veteran child performers for over six years on Broadway, *The Lion King*, which in the United States strives to cast primarily from the African-American community, often serves as young actors' entrée into the professional performing world. Since only the children are auditioned and hired on the basis of their talent—but their families come with the package—most company managers conduct an extensive orientation session for both children and parents on the first day of rehearsal. The list of rules and expectations often sends the "green" ones reeling, and it takes several weeks for them to settle into this major lifestyle change. The company managers we interviewed were split about their preference for experienced performers or newcomers. While some found it a relief to work with children and families who already know the ropes, others preferred to be the ones to orient them to the "right" way to do things before they developed bad habits. Many interviewees acknowledged the incomparable joy of experiencing a kid's first professional rehearsal or performance. However, company managers tend to keep emotional distance from children and their parents so they can better maintain the guidelines and expectations of professional production and issue reprimands if needed.

Outside of state laws that require work permits and minimum tutoring hours (three per day) for children who need to miss school because of work, in the United States there are no official industry guidelines for employing children to work in the theater. Most professional children are treated like every other member of Actor's Equity Association (AEA), earning the same wages and benefits and being held to the same requirements of attendance and behavior. However, some child-centered standard practices and allowances have evolved. For example, in accordance with AEA requirements to provide a "responsible person" to chaperone cast members under 16 years of age during rehearsals and performances, commercial producers have hired a dedicated "child wrangler," but parameters of employment and compensation remained vague until the summer of 2012. Now unionized as Child Actor Guardians under the International Alliance of Theatrical Stage Employees (IATSE, Local 764) in an agreement with The Broadway League (the professional association of Broadway theater owners and producers) and receiving regulated pay and benefits,[21] these professionals are responsible for ensuring juvenile performers' safety and understanding of what is required of them professionally. They take the children from their parents at the stage door, shuttle them between rooms and backstage, and return them to their families after work is over. Depending on the production and the individuals, the child wrangler may also help coach the child's

performance and act as a confidant. For resident ("sit-down") productions, children usually live at home and attend their regular school with special permission to miss certain days for matinees or required rehearsals. Because children on tour cannot attend regular school, the teacher who travels with the company (contracted by industry-wide resource On Location Education[22]) is usually contracted by the producer to additionally serve as child wrangler. In this situation, the teacher/wrangler cannot help but become involved in the lives of the young performers and maintaining perspective is sometimes challenging. The most important determinant of a child's success in a given production is a loving and stable home life with as much "normalcy" outside of show hours as possible. Ideal parents want the opportunity for their children (not themselves), and ideal children have a love and vocation for performing that will be fostered by this professional employment. Unfortunately, there's no effective way to screen for an ideal orientation and background, so producers and company managers must be prepared to deal with all kinds of families and attitudes. While most children and their families do brilliantly, on rare occasions a company manager has had to ban an overly involved parent from the theater or even involve the authorities when a situation became untenable. Socioeconomic status is not a reliable indicator of ideal home stability for young performers; there have been poor families who are models of attentiveness and responsibility as well as rich families who fail to provide guidance and support. For many years, families of young performers in the entertainment industry, who are usually naïve when a child develops a serious interest in the stage or screen, were often prey to charlatans and unsavory business practices and consequently developed unproductive attitudes and behaviors based on gross misinformation. Now, with the aid of the Internet, there are many more resources available to parents, easy ways to check up on suspected scams, and a generally healthier and more supportive business environment for children interested in becoming professional performers.[23]

Since working on a Broadway or other first-class production is professional, union-supported employment in the United States, child actors can make quite a lot of money, but the cost to their families for indulging this work can also be high.[24] As of 2013, the AEA minimum wage is nearly $1900 per week (almost $100,000 per year) plus benefits, and those on tour receive an additional per diem for food and housing. For New York–based companies, the law stipulates that 15 percent of a child's pay must go into a trust fund, but the rest can be used as the child and parents see fit. Ideally, this money is tucked safely away for a college education.

However, families who relocate in order for the child to take the job may need to use the salary to pay living expenses; in these and some other cases, the child becomes the breadwinner. But in most cases, parents or guardians are employed and cover basic needs so that the children can save most of their earnings.[25]

While each show and performer is unique, we discovered a surprising uniformity of experience among interviewees who had worked on a Disney show as or with a young performer. Perhaps because Disney shows are explicitly created for families, there is an inherent valuing of children and childhood in the rehearsal room and the theater. More than one interviewee referred to the Disney child performer's experience as "the best of both worlds"; the children were held to professional standards for their work ethic and performance, but they were also embraced as children in their own right. Especially at the historic New Amsterdam Theatre, which serves as DTG's headquarters and housed *The Lion King* from 1997 to 2006 and then *Mary Poppins* until 2013, the culture is very child centric; the crew went above and beyond their professional duty to care for the children, for example, by creating an elaborate trick-or-treating environment for Halloween. Most Disney backstage areas have a "swear jar" to encourage adults to use appropriate language around the children; money collected is donated to Broadway Cares/Equity Fights AIDS. On tour, productions usually sponsor educational field trips so that the young students can get the most out of the places to which they travel. Debbie Shrimpton, who has worked for over a decade on *The Lion King* with the Young Simbas and Nalas in four countries and is currently the resident director on the US tour, could not be more enthusiastic about her job and her love and respect for young performers and their artistic process: "I don't teach them the show; I lead them to discover it."[26] Unlike adult actors, child performers develop *themselves* along with their characters. Critical feedback therefore requires extra sensitivity. Suggestions for improvement are always accompanied by praise so that the young performers are consistently validated, get more invested in the rehearsal process, and ultimately take full ownership of their performances.

As engaging as the learning process can be for a young actor, and as incomparable an experience it is to perform in front of hundreds of people, the end of the ride is inevitable. Because these juvenile roles have height limits and particular vocal ranges, children grow out of them fairly quickly. Boys usually leave when their voices change, and girls when they get too tall. Six-month contracts are readily renewed if performers remain in good standing and within role requirements, but as growth spurts are

unpredictable, they can also end mid-contract, in accordance with a "specific growth clause" for juvenile actors included as a rider to the standard Equity Production Contract, such as this one for *Mary Poppins*:

> It is hereby acknowledged that Actor currently weighs ___ pounds and is ___ inches in height. Producer shall have the right, but not the obligation, to terminate this agreement with no less than two (2) weeks' written notice without regard to Rule 70D ("Just Cause") of the Production Contract, should any of the following occur: (a) actor achieves a weight gain of fifteen (15) or more pounds and/or a height increase of two (2) or more inches; (b) in Producer's opinion, in consultation with the Director, the Actor's physical development has caused the Actor to "outgrow" the role; and (c) in the Musical Supervisor's and/or Musical Director's opinion, Actor's physical development has caused the Actor's voice to change rendering Actor unable to execute properly the musical material of the role.[27]

Producers, company managers, child wranglers, and resident directors do everything they can to prepare the children and manage expectations; however, children still dread "the talk" and a few have considered skipping meals so they don't grow. In one unfortunate coincidence of bad timing, the treble voices of Cody Hanford and J. J. Singleton, who had created the role of Flounder for *The Little Mermaid*, both dropped during the 2007 stagehands' strike that suspended performances for over two weeks and postponed the show's opening; the young actors had to be replaced just before opening night. To soften the blow, the producer and composer had the young actors record Flounder's solo in the doo-wop number "She's in Love" (featuring the mermaid Ariel's sisters), so that they could have personalized copies of the cast album as a memento of their contributions.

Most of Disney's performing children are 10–12 years old and stay in the shows an average of 12–18 months. Because what they do is so thrilling and the bonds they create with the company, especially the other children, are so strong, their final performances are, without fail, tear inducing for everyone. To mark the occasion, most companies have created official farewell ceremonies for the departing youngsters. Some go on to other shows, but many return to life as "normal" kids, with this once-in-a-lifetime experience to be forever cherished. Child performers take varied paths once they age; some continue in the professional theater, many go to college for various studies, and others enter the workforce in other fields. Katherine Doherty, who originated the role of Jane Banks in *Mary Poppins*, is currently a student at Brown University. She reunited with DTG when she was employed as the Education & Outreach intern during the summer of

2013, and she cites her experience in the professional theater as her motivation for facilitating theatrical experiences for other children.[28]

Maintaining the professional/child balance is at times very difficult for child actors, and those surrounding them must then weigh options and make difficult decisions. Jane Hodges, a stage parent who for over a decade tirelessly supported Henry's performing career by traveling with and home-schooling him, recalls a couple of instructive examples:

> I remember one young actor who was so distraught that he would miss his brother's bar mitzvah that he cried for an hour backstage. Finally, stage management decided to let him take the show off. Your child has one childhood and you have to make sure he is happy in it. In one Broadway show, Henry had three understudies. Toward the end of the run, he wanted to take a few shows off so his understudies could have a chance at the part. The stage manager told him he couldn't because he needed to uphold his contract and work every show unless he was sick. The stage manager said, "This is a business, not a school play."[29]

When one is steeped in a professional theater realm such as Broadway, where everyone around is working at the top of his or her craft and there to earn a living, it is often easy to forget that the vast majority of global theatrical activity takes place in the amateur realm. While some children work to become professional performers, most children go to theater and participate in school plays for educational benefits and just plain fun.

EMPLOYING THEATER TO EDUCATE CHILDREN

Recognizing the importance of youth to its core business beyond the young characters it creates and young actors it employs, DTG has invested in robust educational programs and products. In 2008, the division consolidated previous *ad hoc* offerings by creating a dedicated department. The mission of DTG Education & Outreach is to develop the next generation of theater makers and theater audiences and to inspire children, parents, and communities through arts education. With a faculty of teaching artists at the heart of the team, the work comprises educational programming related to its Broadway shows, the development of musicals for young performers, and philanthropic outreach programs to engage children and communities through theater making and theater appreciation. Disney teaching artists boast professional theatrical experience and thorough classroom training, and many have both Broadway credits and advanced degrees in education. As a result of significant program growth since 2008, the original staff of 12 teaching artists doubled by 2013.

In the last 20 years, Broadway audiences have grown by 67 percent and attendance by those under 18 has increased by a staggering 180 percent. Going back further to the 1980–81 season, child audiences were statistically untraceable, illustrating the scope of growth over three decades.[30] Today, schools and youth groups constitute a measurable portion of Disney's Broadway ticket sales, and DTG has recognized an opportunity to add value to this significant audience's theatergoing experience: groups booking directly through DTG's ticketing team gain exclusive access to experiential workshops taught by a pair of Disney teaching artists. As of mid-2013, DTG's Broadway offerings include *The Lion King* and *Newsies*, with *Aladdin* expected to arrive in early 2014. For *Newsies*, children learn Christopher Gattelli's Tony Award-winning choreography to "Seize the Day" (a musical number in which the newsboys actively strike); for *The Lion King*, they explore the African chants and choreography to "Circle of Life" (opening number where the animals of the savanna gather at Pride Rock to meet the newborn lion prince) or "Lioness Hunt" (in which the lionesses ritualistically stalk and kill a gazelle). The workshops provide rigorous learning experiences designed to teach choreography and music that is as close as possible to the Broadway production. Gattelli personally taught the unmodified "Seize the Day" dance to the teaching artist faculty, who in turn elected to keep the standard high, knowing that young people would rise to the challenge of learning the original content. The groups purchasing workshops vary widely in experience and demographics and include preprofessional dance academies, public middle schools, and even family reunions. While the teaching artists strive to engage children in the same rigorous content performed on Broadway eight times a week, optional modifications in key areas provide accessibility and differentiate the instruction to serve all learners. Children who participate in workshops experience the artist's process before they attend the show, allowing them to more deeply observe the performance. Their Broadway-going experience is enriched, then, when they see professional performers and think, "I learned how to do that." With firsthand experience, children who participate in a workshop subsequently notice nuance in the production. They contemplate differences in character interpretation between their own understanding and that of the professionals, criticize technique and ability, and consider the artist's process. In addition, deep interaction with professional theatrical content in this way reveals career possibilities students may not have previously considered.

In order to give children even more opportunities to engage with Disney's theatrical content, DTG began to create musicals for students to perform

in school in 2003. Because of the volume of licensing, these musicals are a modestly profitable and self-sustaining business that helps provide access to the performing arts to children around the world. Through 30-minute KIDS musicals for elementary school, 60-minute JR. musicals for middle school, and full-length shows for high school, young performers bring new and classic Disney stories to life for audiences in their communities. DTG has carefully constructed its KIDS and JR. shows to align developmentally and academically with key phases of student development. To date, there have been over forty thousand productions of Disney youth musicals such as *101 Dalmatians KIDS*, *The Little Mermaid JR.*, and *High School Musical*, representing some 1.5 million student performers. Participation in theater and exposure to professional productions can sometimes lead to an interest in a career in theater. A third-grade student who participated in his school's production of *Aladdin KIDS* commented, "The teachers give us education so we can go to these kind of jobs when we're older."[31] But such connections require the opportunity to participate, which is troublesome for children from low socioeconomic backgrounds who are less likely to have in-school theater programs or tickets to the professional theater.

EMPLOYING PHILANTHROPIC OUTREACH TO BRING THEATER TO MORE CHILDREN

Realizing the great need to support children's access to the arts, particularly in the poor urban neighborhoods surrounding New York City's theater capital, many Broadway producers and industry organizations make philanthropic and in-kind donations a priority, despite the field's inherent fiscal challenges.[32] Over the years, DTG has invested substantial resources in arts education and provides heavily subsidized tickets for New York City public-school children from low socioeconomic communities. For many children, the program marks their first visit to Manhattan, let alone a Broadway house. Schools in the Broadway outreach program can elect to receive a free preshow workshop taught by Disney teaching artists and designed to prepare students for their trip to the theater. Each workshop is custom-built to meet the unique learning requirements of each group; past workshops have included mask making for *The Lion King*, the physics of flying for *Mary Poppins*, and voice and agency for *The Little Mermaid*. Immediately after these outreach schools see the show, they participate in a moderated question-and-answer session with cast members after the curtain has come down. With each show running over two-and-a-half hours, student participants are regularly exhausted by the time the "talkback" rolls

around. Particularly aware kids or teachers will usually ask a few questions of the adult performers who donate their time in the name of education, but everything changes when a couple of preteen performers shuffle out and plop themselves down on the apron of the stage. Arms shoot to the air with questions for the young performers. "Do you have to go to school?" "Is it fun riding the ostrich?" "Do you really have a British accent?" "Do you ever get nervous?" "Are you rich?" "How can I be in the show?" These regular school children perk up with possibility upon seeing their peers model talent and success in front of an audience of over 1,500 people. That someone of their age could appear and excel on a Broadway stage suggests anything is possible; consciously or unconsciously they realize, "That could be me!"

DTG created a theater development program using its shows for young performers because the disparity of access by underprivileged children also extends to in-school arts programs. While the division's Broadway outreach program prepares children from low socioeconomic backgrounds to attend a professional performance, the goal of Disney Musicals in Schools—now DTG's flagship outreach program—is to develop a culture of theater production within high-need urban elementary schools. Over the course of a 17-week semester, students in the third through fifth grades embark on a journey that begins in the "gym-atorium" (or other multipurpose space) and culminates in the performance of a fully produced school play. Throughout the course of the free program, pairs of teaching artists visit the schools each week to lead students and teachers through the process of rehearsing and performing a musical. Each school in the program selects one of Disney's 30-minute KIDS musicals and commits a team of educators to partner with teaching artists and learn the ropes. In January, when rehearsals begin, the formal theatrical production process is foreign to both students and teachers. By May, students have mastered the experience of performing a musical, and teachers have gained the professional development necessary to support student productions in future years.

DTG has focused this program to primarily serve public-school students living at or below the federal poverty level. Doug Israel's recent assessment of arts education in New York City public schools revealed that: "the great majority of the city's public schools were failing to meet the minimum state requirements for arts education as set by the New York State Education Department."[33] Since theater education positively impacts upon students beyond learning in the arts, DTG wanted to help "level the playing field" for disadvantaged students. According to research by James Catterall, "Students with high levels of arts participation outperform "arts poor" students by virtually every measure. Since arts participation is

highly correlated with socioeconomic status, which is the most significant predictor of academic performance, this comes as little surprise." However, Catterall found "statistical significance in comparison of high and low arts participants in the lowest socioeconomic segments. This closer look showed that high arts participation makes a more significant difference to students from low income backgrounds than for high income students."[34]

Benefits of participating in a school musical also extend to social-emotional development. For example, children who perform in a school musical develop strong self-efficacy concepts[35] and are more likely to stay in school than their peers without access to the arts.[36] Disney Citizenship's priority of "championing the happiness and well-being of kids"[37] is reflected in DTG's commitment to being a catalyst for these arts-education benefits for children, especially those who might otherwise have no access to theater. A Disney Musicals in Schools student participant shared:

> Last year, in fourth grade, I was more nervous than I am now. I didn't used to participate in class because I thought I was going to get the wrong answer. This year, the production helped me not to be nervous. I dance and sing and the nervous feeling just goes away. Now I'm not afraid of getting the wrong answer. *Aladdin* taught me a lot, like not to be shy and to learn from your mistakes. Then, next time, you won't make a mistake.[38]

With Disney Musicals in Schools' strong success rate—90 percent of participant schools continue a sustained school theater program—DTG recognized an opportunity to expand programming to children in other parts of the country. In 2010, the division partnered with the Tennessee Performing Arts Center (TPAC) to offer Disney Musicals in Schools to students in the Metro Nashville Public School district. This unique blend of a commercial theater producer, nonprofit arts center, school district, and corporate charity partnering to bolster arts-education has been an intriguing model for policy and reform. The pilot program at TPAC proved successful, and the programming is ongoing in Nashville. DTG and Disney Citizenship are continuing to expand programming with nonprofit partners around the country.

At the end of the semester, schools are invited to participate in a program-wide showcase on the professional stage of the sponsoring arts organization. During the Disney Musicals in Schools Student Share celebration in New York each June, elementary school students from across the city's five boroughs make their Broadway debuts for an audience of their invited family and friends. DTG's own staff, show cast members, and special guests attend the performance at which each school performs

a number from its very first school play—on the same stage as a Disney Broadway show. During the event, professional child actors from Disney shows come out and answer questions about their experiences for the audience of amateur young performers. At that moment, DTG's businesses of employing children to create theater, employing theater to educate children, and employing philanthropy to bring theater to more children come together in an emblematic synergy that comes as close as anything to fulfilling DTG's mission to delight and inspire the next generation of theater audiences and participants.

In ideal circumstances, DTG's profitable businesses support its philanthropic work, and its philanthropy helps raise awareness of its businesses and builds good will for the Disney brand. But articulating business and outreach goals so that they function symbiotically and are not confused—both internally and in the public sphere—is often challenging. The common factor is DTG's focus on children and their stories, needs, and development. While the needs of children remain great, the challenging work will continue.

The metaphoric and material power of children in Disney's theater is exemplified in the penultimate scene of *Newsies*. The newsboys' union leader Jack Kelly meets alone in the penthouse office of *The World* with its publisher, the mighty Joseph Pulitzer, who has been brought to his knees by a city-wide general strike of juvenile workers who have joined in solidarity with the newsies. The strike comes to an end not by one side vanquishing the other, but by a child-conceived "compromise we can all live with" that allows Pulitzer to save face.[39] The potential of youth is validated not by a celebration of naïve idealism, but rather by a recognition of children's invaluable place, worth, and agency in an adult-controlled world. In both drama and real-world practice, this is the business of children that inspires Disney's ideal theater.

NOTES

1. *Newsies*, by Alan Menken (music), Jack Feldman (lyrics), and Harvey Fierstein (book). Unpublished opening night script (March 29, 2012), 53 (Disney Theatrical Archives.) See also Ben Brantley, "Urchins With Punctuation," *New York Times*, March 30, 2012 (review).
2. The strike was sparked by the largest newspapers—Joseph Pulitzer's *New York World* and William Randolph Hearst's *New York Journal*—refusing to lower their wholesale price to the newsboys from 60 cents per hundred back to 50 cents per hundred after the increased circulation during the Spanish-American War of 1898 had long faded. These events were registered by Governor Theodore Roosevelt, who would become President of the United States in a few short

years, and Lewis Hine, an educator who would go on to photograph children for the National Child Labor Committee. (Jacob Riis, a Danish immigrant who became a friend of Roosevelt, had published a famous photo-account of urban poverty in *How the Other Half Lives* in 1890.) For more information on child labor and early twentieth-century reforms, see David Nasaw's *Children of the City: At Work and at Play* (New York: Oxford University Press, 1986).
3. Ironically, the dramatic conflict in many Disney stories stems from a young protagonist in jeopardy—often with at least one dead parent—who must find his or her way to safety.
4. Disney was not the first or largest employer of children in professional musical theater on a per-show basis. Significant precedents include *The King and I* (1951), with its chorus of Siamese children; *The Sound of Music* (1959), with its chorus of Von Trapp children; *Oliver!* (1960), with its chorus of workhouse children; and *Annie* (1977), with its chorus of orphan girls.
5. Disney licenses a number of its mainstage musicals through Music Theatre International (www.mtishows.com) for amateur performances. Disney has also created or adapted musicals specifically for children performing in school, with music in appropriate keys and shorter running times: KIDS musicals for elementary school-aged performers (8–10) are 30 minutes long; JR. musicals for middle-school-aged performers (11–13) are 60–75 minutes long. Sheet music is interpolated into scripts to teach music notation, although students can learn and perform to fully orchestrated recordings featuring professional child singers from Nashville, Tennessee.
6. While we regularly welcome and engage external criticism of Disney projects as we pursue artistic and educational integrity and better business practices, this chapter offers a descriptive, insiders' perspective of Disney's work with children on stage and relies on our own work, observations, and research. We extend our heartfelt thanks to the many colleagues and industry professionals who generously agreed to be interviewed for this project, including Eduardo Castro, Dave Ehle, Laura Eichholz, Tim Federle, Jodi Green, Michael Height, Henry Hodges, Christina Huschle, Todd Lacy, Jeff Lee, John Mara, Thomas Schlenk, Debbie Shrimpton, and Lori and Kolton Stewart.
7. Henry Hodges and Margaret Engel, *How to Act Like a Kid: Backstage Secrets of a Young Performer* (New York: Disney Editions, 2013), xiv.
8. Producers frequently test emerging talent on the road before making an invitation to join the show's Broadway cast, should an opening arise. For many professional child performers, taking professional work in musical theater often means that families have to split up, with one parent staying at home with other children, and one going to New York or on the road with the performer. If travel per diems are spent wisely on food and accommodations, touring performers can usually save their salaries while on the road—salaries they'd have to spend on expensive housing in New York if they worked on Broadway. So, while Broadway work generally has more prestige, touring can be more lucrative.

9. Hodges and Engel, *How to Act Like a Kid*, ix. Thomas Schumacher is the author (with Jeff Kurtti) of *How Does the Show Go On?: An Introduction to Theatre* (New York: Disney Editions, 2007).
10. "First-class" refers to top-tier, union-represented productions in prominent cities and venues. This number includes all productions produced, coproduced, or creatively supervised by Disney Theatrical Productions, the production arm of Disney Theatrical Group. The number does not include the thousands of productions of Disney musicals DTG has licensed to theaters in which Disney Theatrical Productions has no creative involvement.
11. At least 100 actors have been employed as Chip in the dozen or so touring and international replica productions of *Beauty and the Beast* during the past two decades. This does not take into account those Chips in the 4000 licensed professional, amateur, and school productions since 2004.
12. *The Lion King* (1997) is based on the 1994 Disney animated film about a young lion who learns to embrace his destiny to be king of the Pridelands; Young Simba is the lion protagonist in the first act, and Young Nala is his best friend. *Mary Poppins* (2004), based on the book of P. L. Travers and the 1964 Disney film about a magical nanny who assists a family in need, was coproduced by Disney and Cameron Mackintosh, Ltd.; Jane and Michael Banks are the unruly children of an overworked banker who does not have time for them. *Tarzan* (2006) is based on the 1912 Edgar Rice Burroughs novel and the 1997 Disney animated film about a young man raised by gorillas in Western Africa who comes into contact with humans and must decide who he is; Young Tarzan is the protagonist for the first half of the first act and makes an appearance as a memory near the end of the show. *The Little Mermaid* (2008) is based on the 1837 story by Hans Christian Andersen and the 1989 Disney animated film about a young mermaid who gives up her voice to become human; Flounder is the title character's best friend. *Newsies* (2012), described in this chapter's opening paragraph, is based on a 1992 Disney live-action film; Les and his older brother Davey, who become newsboys when their father loses his job due to a work-related injury, get caught up in the strike. *Newsies* has also employed a handful of other performers who were technically minors, but at age 17 they do not require the special accommodations of the child actors explored in this article.
13. *Gypsy* (1959) was written by Arthur Laurents (book), Jules Styne (music), and Stephen Sondheim (lyrics), and originally directed by Jerome Robbins. It was based on the 1957 memoir of strip-tease artist Gypsy Rose Lee.
14. Hodges and Engel, *How to Act Like a Kid*, 61.
15. Robin Pogrebin, "Broadway Babies," *The New York Times*, June 2, 2013, Arts & Leisure, 6. See also Robert Simonson, "Wanted: Child Actor—Make That Four," *Playbill* (July 2013): 8–9.
16. Warchus takes excellent care of the four young actresses, who each perform the taxing role of Matilda only twice a week and always appear for press opportunities as a foursome so none is privileged.

17. Pogrebin, "Broadway Babies."
18. Hodges and Engel, *How to Act Like a Kid*, 78.
19. Rachael Getzels, "Youngest Simba Roars on Stage," *Wood & Vale Express (Main)*, April 18, 2013.
20. Ibid.
21. See Daniel Lehman, "Child Actor Guardians Ratify Contract with Broadway League," *Backstage*, August 1, 2012.
22. "On Location Education," accessed May 5, 2013, www.onlocationeducation.com.
23. "The BizParentz Foundation" has become a comprehensive clearinghouse of key resources, accessed May 5, 2013, www.bizparentz.org.
24. All US actors, including children, must earn at least AEA minimum, even if they perform only a portion of the weekly shows. According to British Equity, children working in London's West End theater earn only half of the adult minimum wage, which is significantly less than Broadway compensation, but they are usually restricted from performing more than twice a week and have more stringent requirements for schooling.
25. For a series of short video interviews with show kids from early 2013, see http://www.playbill.com/multimedia/video/5351/Kids-From-Newsies-Talk-Dream-Roles-With-Better-Nate-Than-Ever-Author-Tim-Federle, accessed May 5, 2013.
26. Debbie Shrimpton, Phone interview, September 26, 2011.
27. Hodges and Engel, *How to Act Like a Kid*, 109.
28. Katherine Doherty, Personal interview, July 2, 2013.
29. Hodges and Engel, *How to Act Like a Kid*, 104–5.
30. Karen Hauser, "The Demographics of the Broadway Audience 2011–2012," The Broadway League, October 2012, 5,
31. Student interview from PS 254, April 13, 2011, Disney Theatrical Archives.
32. Seventy percent of commercial Broadway shows fail to recuperate their initial capitalization.
33. Doug Israel, "Staying in School, Arts Education and New York City High School Graduation Rates" (New York: The Center for Arts Education, 2009), 3.
34. Edward B. Fiske, ed., *Champions of Change: The Impact of the Arts on Learning* (Washington, DC: Arts Education Partnership, 1999), 8.
35. Lisa Mitchell, "Self-Efficacy and Theatre Production in Urban Elementary Schools" (MS thesis, The City College of New York, 2011).
36. Israel, "Staying in School," 3.
37. Disney Citizenship ensures the massive organization's efforts are both ethical and progressive. "2010 Citizenship Report," accessed August 10, 2013, http://thewaltdisneycompany.com/citizenship/reporting/report-archive.
38. Sample from a DMIS student journal, Spring 2011, Disney Theatrical Archives.
39. *Newsies*, 103.

8. Young Mammals: The Politics and Aesthetics of Long-Term Collaboration with Children in Mammalian Diving Reflex's The Torontonians ~

Broderick D. V. Chow and Darren O'Donnell

INTRODUCTION

In 2006, Mammalian Diving Reflex, a performance company based in Toronto, Ontario, led by artistic director Darren O'Donnell (coauthor of this chapter), gained its first international success with the performance *Haircuts by Children,* which involved children as performers and facilitators. *Haircuts* was preceded by an earlier collaboration involving children, *Diplomatic Immunities: Life at Age Nine* (2005). Prior to this piece, Mammalian made performance by and for adults, involving variously or in combination, theater, solo performance, and "relational,"[1] social, and socially engaged art practice.[2] In *Haircuts by Children,* a group of students from grade five and six (ages 10–11 years) at Parkdale Public School were trained to cut hair, and gave free haircuts at four Toronto locations. Following its success in Toronto, the piece swiftly became (in the words of Mammalian's website) "Canada's most happening performance art export,"[3] as the model, though not the same children, was subsequently seen in 27 cities from Los Angeles to Sydney.[4]

Due to the challenge of writing about a participatory performance that has not been personally experienced, some writers have privileged a reading of *Haircuts* as a typical example of children in the entertainment

industry with a contemporary art spin. Lourdes Orozco locates *Haircuts by Children* within a set of recent performance works for adults that "use" children including Belgian company, Ontroerend Goed's *All That Is Wrong* and *Once and for All We're Gonna Tell You Who We Are So Shut Up and Listen*, or Tim Etchells and Victoria's *That Night Follows Day*.[5] The children in *Haircuts by Children*, in this reading, are "performers." Nicholas Ridout calls *Haircuts by Children*, flatly, "service economy performance."[6] Hairdressing is an ideal example of what Hardt and Negri call "affective labor," requiring not only material skill but also a labor of performance (putting the client at ease, developing an easy and open relationship with them)[7]. Ridout argues that instead of engaging in the representational labor of playing a character, the children's performance is a performance of labor itself. A typical service economy exchange is framed as aesthetic experience due to the age of the laborer involved.

These readings, however, misunderstand that "service" in this performance is strategically used by Mammalian to catalyze other relationships. Creating an affective environment controlled entirely by children generates a strange and awkward intimacy between the stylist and client, where both must navigate a spatial and social proximity that our culture conventionally forbids. Both parties engage in unsafe behaviors (talking to strangers, letting a child near your head with scissors) that require trust. From the point of view of the relationship, rather than the image, *Haircuts* is a socially affective gesture that acknowledges and tentatively ameliorates the Foucauldian deployment of "safety" that has dictated both the separation of children and adults, and the control over children's bodies, when certain tasks are involved. *Haircuts by Children* should therefore be seen as the beginning of an innovative and unique collaborative relationship between Mammalian Diving Reflex and children, a collaboration that has less to do with service economy and much more to do with quietly radical ideas; including the development of future cultural producers, the valuing of the local, the right to the city, and friendship as a political principle. Mammalian's subsequent work with teenagers, addresses the development of productive collaborative relationships between children and adults even more overtly. This chapter is not about the global phenomenon of *Haircuts by Children*, but rather, what followed. It is about The Torontonians, a "nested mentorship" program established in 2010 by a core group of 20 teenage collaborators and 15 adults. In this program, artists and children work together to create a range of events and experiences—often involving public intervention and participatory performance structures. The project is local, tied to residents in the neighborhood of Parkdale, and (very) long term. Indeed, a public

succession plan sees that the teens inherit the company in their twenties. Presenting their work in the national and international art scenes means these teenagers *work* in the entertainment industry. But, as we argue, their work is of a particular sort, and aims at particular effects.

Mammalian regards children as full collaborators and emergent cultural producers in their own right. This approach is distinct from the cultural policies of nearly all Canadian cities, which focus on theater for children (child as emergent consumer), theater as/in education, or theater and performance deployed as a way of ameliorating problems of inclusion or adjustment. Mammalian's prerogative has less to do with solving social problems than taking the rhetoric of the creative industries at its word, and addressing the major oversight of Canadian civic cultural policy by potentially developing the next generation of artists. The collaboration *does* have the potential to create positive effects, but in a stealthy way. Instead of a top-down pedagogical/facilitation model in which the artist "applies" the skills of theater and performance to solve a problem, the positive effects are two-way, with effects on the consciousness of participating adults, host cultural institutions, parents, adult public, as well as the young people.

At their heart, though, The Torontonians are a group of kids[8] who make events. They self define as artists. So what are the aesthetics of The Torontonians' work, and how can they be understood? How do their aesthetic choices resonate with the social aims of the company/collaborative endeavor? What is the political value of enabling children as cultural producers (as opposed to simply performers or employees)?

The following chapter contextualizes the project, before analyzing The Torontonians' aesthetic and political implications. We develop two frameworks through which the project can be conceptualized. First, it may be understood through the political rubric of *friendship,* between two identities—child and artist—that have been excluded from the reality of third wave gentrification currently taking place in Parkdale, The Torontonians' local neighborhood. Second, and more speculatively, the collaboration resonates with philosopher Walter Benjamin's "Program for a Proletarian Children's Theatre," a short text of propositions for childhood pedagogy in the theater, which never came to pass. While we make some claims to the social impact of the project, the project is not yet completed, and therefore we do not seek to evaluate or advocate the model. Rather, this chapter, based on observation carried out in 2011 and 2012, captures and conceptualizes a moment in a long-term project.

This chapter has been composed through dialogue. In 2011, and again in 2012, Broderick (a Canadian academic based in the United Kingdom)

was able to spend some time with Darren and The Torontonians. Following these meetings, Broderick and Darren exchanged ideas in emails, in online chats, and over Skype. The pronoun "we" used throughout represents a dual voice that holds in tension the results of conversations, discourses, and disagreements. This makes for a strange and sometimes difficult hybrid subject-position in the research process, one which is both insider engaged in artistic research, and privileged stranger or outsider to the group, attempting to describe and understand the aesthetics of the art and process. Both subject-positions are helpful toward understanding The Torontonians, though neither author is one of the teens. Therefore, we accept that The Torontonians themselves, as the teenage objects of this research, could—and almost certainly *would*—tell us to "fuck off."

CONTEXT: CHILDREN IN THEATER AND THEATER FOR CHILDREN IN CANADA

In a meta-analysis of the culture plans of ten major Canadian cities (Vancouver, Calgary, Edmonton, Saskatoon, Toronto, Montreal, Halifax, Moncton, St. John's, and St John),[9] summarized here, Darren argues that in respect to youth, Canadian cultural policy instrumentalizes the arts to promote the reproduction of the existing industry. By encouraging the attendance of children at cultural events, Canadian cultural policy is largely centered on audience development, ensuring the next generation of (for example) theatergoers. This model can be called the Theater *for* Children model—age-appropriate theater events that habituate young people to the practice of theatergoing.

Canadian cultural policy is even more narrow concerning the participation of children in the arts, which is held to be of value mainly in terms of its social utility, as either (a) a means of fostering social inclusion or attending to the effects of economic disadvantage or isolation (though not their underlying structural causes), or (b) a way of teaching other, more *serious* subjects, such as Math or Science. This model might be called the Applied Theater or Community Arts model. As Eleonora Belfiore and Oliver Bennett have argued, art as "political instrument" is part of the network of apparatuses, objects, and mechanisms that make up the complex form of power Michel Foucault calls "governmentality." Without necessarily being "propaganda," the arts may be used to promote certain behaviors, values, and activities. The belief in Victorian England in the civilizing power of museums is echoed in the use of the arts as a tool to promote social cohesion in a contemporary multicultural society like Canada.[10]

Therefore, art for children and the participation of children in art is, in Canadian policy, instrumentalized along two axes: economic and social. Yet these policies do not consider fostering new generations of artists to be significant either economically or socially. Despite recent rhetoric on the "creative economy" and culture's supposed central role as a driver of economic activity and urban regeneration (see, for instance, Richard Florida's oft-cited *The Rise of the Creative Class*, 2002), these documents do not entertain the suggestion that young people *might*, through participation in theater, performing arts, dance, fine art, and music *become* artists themselves. Canadian civic cultural policy, it can be argued, holds to an "elitist" model of artistic production, in which talent is innate to some and not others.[11] Participation in the arts is seen as a private expenditure (music lessons, drama camps) and not a public good, leading to an inequality in who "arrives" as an artist into the scene as an adult.

Neglecting the child *as* artist is particularly contradictory when considering Parkdale, The Torontonians' urban locale (the teenagers have all, at one point or another, lived in Parkdale). Parkdale is an ideal example of gentrification, an urban process often associated with cafés and boutiques but which relates to children and youth on a fundamental level. As Sharon Zukin explains, gentrification is "a movement away from child-centered households toward the social diversity and aesthetic promiscuity of city life."[12] Gentrification is analyzed in terms of three social processes called "waves." In the first wave, artists are attracted to a marginal area by cheap rents, large spaces, and a sense of "authenticity." Once the concentration of artists has made an area attractive, affluent buyers and developers move into the terrain—with the inevitable rise in rents pushing the artist out. Finally, as Stuart Cameron and Jon Coaffee explain, in third-wave gentrification these processes are cemented in public-policy[13]—as in the rhetoric of "creative cities" and the "cultural economy." Parkdale is currently undergoing its third wave. A key feature of Parkdale is inexpensive apartment housing that is home to predominantly immigrants—visible minority youth account for 74 percent of the youth population, many of whom are refugees from places including Sri Lanka, Tibet, and Hungary. While as of yet there are no planning activities listed on the City of Toronto's website that would displace this population, they may be subject to what Katie Mazer and Katharine Rankin call "displacement pressure," that is, "the social, emotional, and symbolic dimensions of displacement—the everyday ways in which people are dislocated from the social spaces of their neighborhoods."[14]

Parkdale materializes the rhetoric of Canadian civic cultural policy on two levels. In its third-wave, it embodies the values of the "cultural

industries" as well as being conditioned by actual public policy in this area. Additionally, the large immigrant youth population is precisely the demographic targeted by the Applied Theater model of civic cultural policy that aims at social inclusion. As Natalie Shirer points out, arts participation in this model is deployed to build employment skills that may be applied in any setting.[15] But rarely is the acquisition of specific skills required by an arts career the goal of this public policy driven outreach work—these skills, it would seem, should be acquired privately.

FROM ARTS PROVIDER TO THE TORONTONIANS

The Torontonians initiative engages with two groups—the local child and the artist—that have been excluded by the *reality* of gentrification while being embraced by its rhetoric. In 2007, Mammalian initiated *Parkdale Public School vs. Queen Street West,* a multiyear project consisting of a number of creative collisions between children at the eponymous school (the same school that had hosted *Immunities: Life at Age Nine* and the original *Haircuts by Children*) and artists and businesses in the area. Projects included *Eat the Street,* in which a jury of children performed as food critics, eating at 12 neighborhood restaurants over the course of a month and presenting awards to the establishments, all of whom were winners. The audience was invited to have dinner with the children, an aesthetic decision that reflects Mammalian's debt to "relational art" or "social practice," and one that recurs in the practice of The Torontonians. In *The Senior Strings vs. Blocks Recording Club,* Parkdale Public School's senior strings class accompanied three bands that co-own Blocks Recording Club, a cooperatively run music distribution company in Toronto. The project highlights Mammalian's interaction between children, creative practice, and local enterprise.

In this project, Mammalian's role remains that of arts *provider,* not dissimilar to the Applied Theater model of youth participation in the arts. A key shift took place in summer 2010, when (then) 14-year-old Sanjay Ratnan, a participant in *Eat the Street,* contacted Mammalian looking for artistic activities during the summer. Sanjay gathered some friends, and in collaboration with the company, shot a short dramatic video based on a script by Darren about the emotional and physical challenges of touring artistic work. In contrast to a more typical form of Applied Theater engagement in which the youth might be asked to represent their own concerns in their own voice, this video intentionally played on the mismatch between the ages of the characters and their life concerns with the ages and concerns of the teenage performers.

A series of small projects followed, leading to The Torontonians, a long-term collaboration between the initial group of teenagers (some of whom had collaborated in one form or another, since age nine) and a group of artists and creative professionals. As Mammalian describes: "The long-term goal of The Torontonians is to cultivate artists, producers, technicians and administrators, and for those youth who choose to follow other career trajectories, positions on arts organizations' boards of directors."[16] This mentorship is facilitated through a series of collectively generated projects that take the young participants seriously as *artists,* rather than participants in an educational experience. These include *Dare Night, 12 Hour Zine Machine* as part of Toronto *Nuit Blanche* 2012, and *Nightwalks with Teenagers* (discussed at length below). The collaborative relationship is cemented by a succession plan that demonstrates the mutuality of self-interest at work in this initiative, as opposed to motivations of altruism or charity: the public promise made to the teenagers is that they will inherit the company in their twenties (approximately 2020), and with it, its artistic direction and administrative management.

The shift from an arts provider model to one where Mammalian engage with the teenagers independently outside the institutional structure of the public school or the purview of education (which, we should point out, was initiated by one of the kids themselves), necessitates a different collaborative relationship. The collaboration is framed or perceived as collaboration between practicing, adult artists and young people as *artists in their own right.* Therefore, the initiative departs from more typical conceptions of mentorship as stewardship, guidance, and pedagogy, to a radical conception of mentorship as *friendship.*

FRIENDSHIP, COMMUNITY, AND THE POLITICS OF SOCIALLY ENGAGED ART

"Community" has long been a macro-aim not only of arts outreach but also of what art theorist and curator Claire Bishop calls the "Social Turn" in fine arts, the "surge of artistic interest in participation and collaboration that has taken place since the early 1990s, and in a multitude of global locations."[17] As social theorist Miranda Joseph points out, community is posited as the other to our "current fallen state of alienation, bureaucratization, rationality."[18] Discourses of community tend to celebrate the local, authenticity, and shared identity. The problem is that socially engaged art practice that aims at building community can be instrumentalized in service of some of the more brutal neoliberal economic policies.

What Joseph calls the "Romantic" ideal of community is often wedded to the dissolution and breaking apart of the welfare state and other structures of social welfare under neoliberal governments (including Canada's current Conservative government, led by Prime Minister Stephen Harper). Joseph notes that nonprofit organizations, including arts providers, "often stand in for community metonymically. One gives to 'the community' by contributing labour or money to a nonprofit."[19] These organizations formalize giving and caring. But these organizations also step in to fix problems from which the state has withdrawn its fiscal and custodial responsibility. Community development, then, is somewhat inseparable from the ideology of the "Big Society," promoted by David Cameron's Conservative-Liberal coalition government in the United Kingdom; which aims to further decentralize public services to a local level. The Romantic conception of community is also potentially exclusionary as it is defined through shared identity; in defining who is authentically "inside" a community we also define who falls "outside" its metaphorical gates. Furthermore, the rise of social practice that values community and participation over aesthetics has paralleled neoliberal public policy. As Bishop argues: "The UK context under New Labour (1997–2010) in particular embraced this type of art as a form of soft social engineering."[20]

As "social practice," The Torontonians initiative models a form of collaborative practice that posits an alternative conception of "community," based on the affective relationship of friendship. Friendship as a political principle has three primary characteristics that we analyse in turn: it is *affective* ("felt," rather than "meant"); it is *open*; and it is *mutual*.

Affect

"Community" is often synonymous with shared identity (the "Asian Community," the "gay and lesbian community"), which tends problematically to ignore a vast range of affiliations, relations, and alliances, all of which hold a different affective quality. By "affective" we mean to draw attention to the qualities of *feeling* in relationships; these can be conceived of as emotions, though not necessarily. Friendship is a particular type of affiliation or relationship that is primarily affective: after all, who knows when you've "built a community," but you can certainly *feel* when someone is your friend. Sara Ahmed notes that the reason structures of power often seem intractable is that subjects become *emotionally* invested in these structures "such that their demise is felt as a kind of living death."[21] A project that aims at creating alliances through the affect of friendship, regardless

of individual identities, is potentially better placed to challenge these investments than one that aims at building a community, which potentially reinforces attachment to existing structures of power. Friendship's potential to trouble structures of power is suggested by E. M. Foster's lines in *Two Cheers for Democracy:* "If I had to choose between betraying my country and betraying my friend I hope I should have the guts to betray my country."[22]

Openness

Friendship is an open, unlimited political field. As an affective formation that is not reliant on shared identity or filiation, anyone can potentially be your friend. For example, the political theorist Leela Gandhi celebrates "minor" gestures of friendship between "excluded" identities (for example, Victorian homosexuals and Indian radicals) in the late nineteenth century as a form of anticolonial politics and ethics. These networks of alliance and solidarity across difference, she argues, have the power to create change, whereas, "[...] when confined to the canonical generalization of established affective formations (of family, fraternity, genealogy, filiation), community lapses all too often into a dull, replicative economy, ill-equipped to the task of positing alternatives."[23]

Mutuality

Friendship, rendered as *philia* in Ancient Greek, was a political principle put forward by Aristotle in the *Nicomachean Ethics*. Key to *philia*'s distinction from the three other Greek words for love—*agape* (unconditional love), *eros* (passion), and *storge* (affection)—is its mutuality. Whereas communities may contain numerous asymmetrical relationships, *philia* begins with equality, with both partners mutually responsible to the other. This mutuality is embedded in The Torontonians' public promise of succession/inheritance.

Mammalian facilitates friendships between artists and children through a generous amount of unstructured leisure time—the kids and artists socialize together without any pedagogical purpose. This has meant a huge investment in terms of time—in the first year of the initiative, around five hundred adult hours, or ten weeks of labor—but also a transformation in the attitude of the facilitator, as more time is spent socializing than on artistic projects. The activities of this social time are mutually agreed upon, but the quality is most decidedly determined by the youth, who,

due to numbers, tend to overpower the adults. The company's *Mammalian Protocol for Collaborating with Children*,[24] based on the United Nations' Convention on the Rights of the Child, outlines the company's stance on a number of the youth's rights, including freedom of expression. Thus swearing—for example—is not censored. When Broderick first met three of the Torontonians (Sanjay, Virginia, and Nerupa) in Montreal, he was taken aback by the adult content of their discussions with Darren and their language in the presence of a mentor who is *in loco parentis*. Darren explained that his rule is to always let the kids set their "level" for language and discussions—not to encourage, but neither to shut down discussions. While this is a small example, it demonstrates a principle that is realized in The Torontonians' performance work.

The equality of the collaborative relationship informs Mammalian's concept of Stealth Pedagogy. As opposed to top-down, arts provider mentoring where educational effects are always aimed at the children, Stealth Pedagogy sees the transformative effects as two-way. Of equal interest are the effects on consciousness of the adults in the host cultural institutions, parents, the adult public, and the facilitating adults. The presence of a child forces the adult to respond as either an authoritarian or an anarchist. The adult responds either by commanding the child's body, threatening punishment, telling her to sit down and be quiet; or taking great pains to negotiate with the child, who often turns out to be a formidable logician. Stealth Pedagogy also encompasses institutions. For example, in *The Producers of Parkdale*, a year-long residency at the Gladstone Hotel, The Torontonians were ostensibly learning to produce and curate their own events. What is more interesting is the way in which the management and cultural gatekeepers of the Gladstone Hotel were forced to *trust* this group of teenagers as artists, including them in their contribution to *Nuit Blanche* 2012, a prominent arts event sponsored by a major corporation (Scotiabank). By tying the children of Parkdale into the cultural circuits of Toronto, the initiative "empowers" young people, not by giving them self-esteem or skills (though these positive benefits are certainly possible), but by forcing adults to recognize the children as rights-holders in themselves.

There are other mutual benefits with regards to challenging the material conditions of cultural production. Artists' working lives, in Canada and elsewhere, are today characterized by a high degree of flexibility and mobility, with opportunities to move from project to project and to tour and travel held up as potential benefits of an arts career. But flexibility and mobility can easily be seen as a liability, with the artist forced to accept

precarious, unstable labor, and an exhausting lifestyle of international and national touring. For the most part, though, it is the job of children to be immobile. The child demands the right to a certain patch of the city, in order to grow and develop. The artist-child friendship therefore offers both groups the space to breathe and grow, and make visible their right to the city. So while an outreach model of youth participation in the arts might develop in children the skills to make them amenable to exploitation within an economy of precarious labor,[25] the long-term and embedded nature of The Torontonians is intended to draw attention to what Shannon Jackson calls our "non-autonomy" as human beings.[26] It is intended to engage with that most slippery of political arenas, *civil society*, that is, our common interests as social beings outside affiliations of family, state, or market. This concern with civil society is taken up in the aesthetics of The Torontonians' work, which highlights the necessity of public space as a site for free interaction and discourse.

THE AESTHETICS OF TALKING TO TEENAGERS

Focusing exclusively on the potentially positive social aspects of Mammalian's collaborative relationship with young people means that we might fall into the trap that Claire Bishop identifies in *Artificial Hells*—valuing the collaborative relationship over the aesthetics of the work. Therefore, in this final section of our chapter we turn to performance work produced by the teenagers in terms of its aesthetics, focusing on *Nightwalks with Teenagers* in Leeds, United Kingdom, for two reasons. First, as an event participated in by Broderick and facilitated by Darren (along with childhood education academic Stephanie Springgay), it provides the opportunity for a dual analysis of the live event. Second, this particular event, away from their local neighborhood, clearly frames the teenage Torontonians as artists *qua* artists—it was attended by a number of British artistic professionals including a number of directors of UK regional performance festivals, and took place under the remit of Performance Studies International #18, an international conference of performance scholars and artists.

The Torontonians describe *Nightwalks* as being inspired by the 2003 Toronto blackout:[27]

> It caused the citizens to leave their homes and technologies aside and go communicate with people in the city or around their neighbourhood. It gave everyone the opportunity to get to know the people around them whether it was the old lady down the street or the tall teenage boy who delivers their pizza."[28]

Attempting to recreate the "loving vibe" from 2003, in *Nightwalks* The Torontonians lead a group of adult audience members on a walk through the city, engaging in free and unscripted conversation with them while pointing out landmarks of interest and staging other performative interventions, including "dares." They write, "Normally adults are afraid of teenagers at night and teenagers are afraid to be themselves around adults. *Nightwalks* is used to let them both break the stereotype and be comfortable around each other, even if it's for a night."[29]

There is a clear and unusual artistic choice to draw on the blackout of 2003, an event nearly eight years prior to the first *Nightwalks*, during which most of The Torontonians would have been six to eight years old. The teenagers' framing of the work has a creative maturity, which is undercut by the boisterous, playful, and often crude content of the work itself. *Nightwalks* in Leeds, which took place in June 2012, begins on the steps of Leeds City Museum, in Millenium Square, around 9 p.m. As the audience/participants gather around the steps we see the teenagers in a large group, chatting, horsing around, dressed in normal streetwear. They are nearly all from a visible minority background and as such stand out against the people of Leeds, which is 85 percent white. Nerupa stands up and introduces the group, and the event: "Hello everyone, we're The Torontonians, and we're an art collective from Toronto. We make events and we go to events." The rest of the group introduce themselves in turn: Sanjay, Dana, Ahash, Tenzin, Virginia, Isabel, Kathy, Ngawang, Kiam, Chosang. As the sun begins to set, we start walking. The teenagers make casual conversation with the adults. Every so often, we stop, as the teenagers tell us about a landmark they have found on a previous reconnaissance mission. These range from the grandiose (a piece of public art) to the banal (the observation that in the UK McDonalds Restaurants feels it necessary to advertise the mayonnaise in a Chicken Mayo sandwich) to the scatological (what appears to be human faeces in a cardboard box inside a red BT phone box, which had thankfully been removed by the time the walk commenced). Each time we stop, the teenagers pull a "dare" from the hat. Some of these are for individual audience members to perform, and others for the entire group. Some are convivial and intimate: "Turn to the person next to you and confess a secret"; and some are juvenile, which is why halfway through the walk Broderick and a Leeds local found themselves gripping the waistband of the other's underwear, giving each other a "wedgie." But for the most part these dares show a clever play with the aesthetics of the private self and the right to the city. One dare reads: "Follow someone and pretend to worship them." We pick our target and run down the

street—the man, a stranger, with a female friend, seems to panic at first, but as we all get down on our knees, bowing our heads and arms to him, he begins to play along, bestowing benediction on his subjects. That this happens in an unlit passageway beside the Leeds market stalls is a key part of this action—it reclaims a space that might be thought of as unsafe for use by night.

Later we find ourselves with our noses pressed up against the window of a corporate eatery, staring at a group of diners inside. There is a beautiful, whimsical moment, under a streetlight, where one audience participant finds himself singing a popular love ballad to a female friend. The walk terminates at a Chinese restaurant where we order dumplings with the teenagers. There is no aesthetic justification for the choice of dumplings other than the fact that as the kids tell us, they often go out to eat after events, and *mómos,* or, Tibetan dumplings, are one of their favorite foods.

In one sense, *Nightwalks* seems to fit within a range of Situationist-inspired, psychogeographical "walking" arts practices (like those of Laura Oldfield Ford or the arts collective *walkwalkwalk*), aimed at reimagining our individual affective responses to the built environment. But in another sense, *Nightwalks* is less interested in the psychogeography of a particular city, and more in reclaiming any public space *as* public space. The city's built environment is only a container for the playful encounters between strangers enabled by the piece. This aesthetic aim coincides with Mammalian's participatory work with adults but also its method of collaboration; the encounters are unstructured moments of socialization. There is no overarching aesthetic through-line (the landmarks they point out seem to have no guiding principles, and some kids are more interested in some landmarks than others) and the dares are determined by chance. The encounter, an almost wasteful indulgence in the context of the purposeful city, is made valuable. As the walk goes on, participants begin to lose their inhibitions and take part in dares more freely, but also become more protective of their moments of silliness, challenging the stares of the public. After all, why *shouldn't* the city be a space for encounter without purpose or exchange?

If the teens have a guiding aesthetic, it is an aesthetic of awkwardness, and even discomfort. Most of the encounters highlight the (sometimes charming, sometimes *excruciating*) awkwardness of the moment when two strangers come together. With the enthusiastic facilitation of the teenagers, though, discomfort becomes a thing to *enjoy,* on the way perhaps to meaningful relationships. The highly contingent nature of the work shows the group's investment in *performance,* the artwork as "event." In Canadian

civic policy, youth participation in performing arts is often geared toward skills in planning, preparing, and presenting a rehearsed, repeatable performance, so The Torontonians present an interesting alternative. They are well aware of the shambolic nature of their work. They know they have created a one-of-a-kind event, and they have done so on their own terms.

In his 1929 text "Program for a Proletarian Children's Theatre," Walter Benjamin sets out a pedagogical program for children within the context of the theater, featuring a model of facilitation that prefigures Mammalian's scheme of mentorship. The theater, Benjamin argues, is the ideal site for the class-conscious education of the proletarian child, because "It is only in the theater that the whole of life can appear as a defined space, framed in all its plenitude," and because the bourgeoisie tends to fear the theater, which might "[...] unleash in children the most powerful energies of the future."[30] Today, arguably, the bourgeoisie has certainly come to terms with the theater for children by disciplining it—creating clearly defined boundaries in which youth participation can take place. What the bourgeoisie fear is not the corrupting immoral influence of the theater, but that the work of theater gives a space for the child's "actions" and "gestures," each of which is like "a signal from another world."[31] Which is to say, what Benjamin calls the child's "despotic" nature ("the child inhabits his world like a dictator"[32]) signals an outside, or alternative to the existing social mechanism. The work of the children's theater is to apply these signals of an imaginary alternative space to the material world, through improvisation: "And the synthesis of these gestures must become performance or theater, because they alone have the unexpected uniqueness that enables the child's gesture to stand in its own authentic space."[33] In this Benjamin echoes his image from the earlier *One-Way Street* (*Einbahnstraße,* 1928) of children playing at a construction site, who labor with the cast-offs of adult conceptions of material progress, subverting their use-values and rearranging their meanings.

The carnivalesque suspension of the social order in the children's theatrical play is echoed in the improvisational, public, uncomfortable, and socially levelling events created by The Torontonians. But it is in *how* this is to be achieved that Benjamin's Program resonates most strongly with Mammalian's mentorship initiative. Benjamin was adamant that the purpose of the Children's Theater was not to create a "fully rounded," that is, skilful or polished, performance.[34] The goal was to develop class-consciousness, not through direct moral instruction, but by placing the children in situations of collective (playful, artistic) labor, the basis of a dialectical pedagogy. "The tensions of collective labor are the educators,"[35] he writes. The teacher/director should not be an instructor, but a guide,

whose influence is indirect. Mammalian's friendship-led mentoring seems to actualize Benjamin's program. Letting the teenagers set the boundaries for language, content, and aesthetic practice as opposed to determining these in advance demonstrates trust in the "despotic"[36] world of the child's actions and gestures. Benjamin is correct that this education is ideally served by the theater, for, it is performance's contingent and improvisatory nature, its status as event, and the fact that it exists for its own purpose, that allows this renegotiation of ways of being together to occur outside ideological frameworks of skill-based pedagogy, employability, or social inclusion. Watching the teenagers at work, making the event happen, resolving tensions between themselves and with the adult artist facilitators, one notices their ease and skill at socializing, their gregariousness, and sometimes their dictatorial directness. The moral education has not been in interpellating the teenagers into preexisting ways of adult interaction, but in shifting and transforming the social terrain to include the voices of teenagers on their own terms. But we would argue that while *Nightwalks* seems anarchic in its aesthetic, its aim is less a carnivalesque suspension of the social mechanism described by Benjamin[37] so much as making the social mechanism *visible*. The performance, like The Torontonians initiative as a whole, reveals our embeddedness in a larger social structure by reminding us of people—children—at its margins.

CONCLUSION

To conclude, we return to *Haircuts by Children,* which launched Mammalian's long-term collaboration with the children of Parkdale, Toronto. Looked at again in relation to our analysis of The Torontonians, we might see it very differently. We have argued that youth participation in the arts in Canada is typically dominated by certain instrumental aims but rarely the development of new artists. This neglect of the next generation of artists means that the "creative cities" rhetoric is particularly pernicious; it fetishizes young people and artists while excluding them from its material transformations. The Torontonians initiative should therefore be read as a unique model of youth arts mentoring that does not aim at developing the local community but rather at a system of mutual self-interest that we, less cynically, call friendship. The initiative aims to activate civil society, an interest reflected in the aesthetics of the teenagers' work, particularly in the reclaiming of public space in *Nightwalks by Teenagers.*

Haircuts by Children can be seen as a first, tentative experiment into this arena. The piece is not simply a "wacky" juxtaposition of the child

as hairdresser, but a brief moment of actual empowerment, in which the adult is forced to recognize the child as a person, with power in the form of scissors and dye. To participate in *Haircuts by Children* is to trust a child who is also a stranger with your self-image, and, to an extent, your identity. As Mammalian writes, "For many it is actually less terrifying to contemplate allowing kids to vote!"[38] The Torontonians extends this empowerment through time, embedding it into local, and shifting social structures. As cultural producers who have inherited the material, social, and cultural capital of Mammalian Diving Reflex through the mentorship program and succession plan, these teenagers might eventually pose a challenge to the deleterious effects of gentrification and misguided cultural policy, working toward a sustainable, vibrant, arts economy.

Postscript

As we conclude this chapter, a new chapter in The Torontonians has been initiated by the announcement of the company's move to the Gladstone Hotel as "Teenagers in Residence." The hotel provides inexpensive office space to the company and free performance space to the youth, in addition to making connections between the Torontonians and the many arts groups that use the ballroom for events. The youth, in turn, offer an event documentation service as a site for media skills training (as well as generating an income for themselves). Many other collaborative ventures have been planned, and it is anticipated that the youth will come to be seamlessly woven into the cultural offerings of the hotel.

NOTES

1. Nicolas Bourriaud defined relational art as: "a set of artistic practices which take as their theoretical and practical point of departure the whole of human relations and their social context, rather than an independent and private space." *Relational Aesthetics* (Dijon: Les Presses du Réel, 2002), 113.
2. Some examples include, *pppeeeaaaccceee* (2003–5), *A Suicide Site Guide to the City* (2004–5), *Slow Dance with Teacher* (2007).
3. Mammalian Diving Reflex, "Haircuts by Children the Best of Performa 07," accessed January 20, 2013, http://mammalian.ca/template.php?content=social_haircutsNY.
4. The full list: Toronto, Los Angeles, Birmingham, Dublin, Portland, New York City, Vancouver, Sydney, Bologna, Terni, Trondheim, Victoria, Milan, Derry, Montreal, Newcastle, Perth, Regina, Norwich, Cork, London, Launceston, Nyon, Enschede, Prague, Austin, Glasgow, and Darwin.

5. Lourdes Orozco, "Who's the boss? Empowered Children in Contemporary Performance," paper presented at Performance Studies International #18, Leeds, June 2012, accessed January 20, 2013, http://www.pvac.leeds.ac.uk/psi18/files/2012/06/Updated-Abstracts-29-06-12.pdf. Ontroerend Goed's first performance with teenagers, *Once and For All...* premiered in Ghent in 2008, and toured across Europe and North America. Two other projects with teenagers, *Teenage Riot* (2010, Ghent) and *All That Is Wrong* (2012, Ghent) followed. Tim Etchells and Victoria's *That Night Follows Day* premiered in Ghent in 2007.
6. Nicholas Ridout, "Performance in the Service Economy: Outsourcing and Delegation," in *Double Agent*, eds. Claire Bishop and Silvia Tramontana (London: Institute of Contemporary Arts, 2009), 130.
7. Michael Hardt and Antonio Negri, *Empire* (Cambridge: Harvard University Press, 2000).
8. In Canadian civic cultural plans, teenagers fall under the category of "children and young people," or "children and youth," a grouping that follows the historical delaying of adulthood through secondary education. We therefore follow this terminology, interchanging children, young people, youth, teenagers, and teens. However, the word most used by the company is "kids."
9. Darren O'Donnell, "Children, Youth and the Culture Plans of Canadian Cities," accessed January 20, 2013, http://mammalian.ca/publications/#children-youth-and-the-culture-plans-of-canadian-cites.
10. Eleonora Belfiore and Oliver Bennett, *The Social Impact of the Arts: An Intellectual History* (London: Palgrave, 2010), 151–53.
11. The exception to this rule is the Halifax Culture Plan, which is the only Canadian civic cultural policy plan that takes into account the span of generations and the need to foster artists and talent within a thriving cultural economy.
12. Sharon Zukin, "Gentrification: Culture and Capital in the Urban Core," *Annual Review of Sociology* 13 (1987): 129–47, at 132.
13. Stuart Cameron and Jon Coaffee, "Art, Gentrification, and Regeneration: From Artist as Pioneer to Public Arts," *European Journal of Housing Policy* 5:1 (April 2005): 39–58.
14. Katie M. Mazer and Katharine N. Rankin, "The Social Space of Gentrification: The Politics of Neighborhood Accessibility in Toronto's Downtown West," *Environment and Planning D: Society and Space* 29:5 (2011): 822–39.
15. Natalie Shirer, "My True Voice: Fundamental Content, Individual Capability, Social Progress," *Arts Education Policy Review* 106:4 (2005): 25–33.
16. Mammalian Diving Reflex, accessed January 10, 2013, http://ckc.tcf.ca/org/mammalian-diving-reflex#program3.
17. Claire Bishop, *Artificial Hells: Participatory Art and the Politics of Spectatorship* (London: Verso, 2012), 1.

18. Miranda Joseph, *Against the Romance of Community* (Minneapolis and London: University of Minnesota Press, 2002), 1.
19. Ibid., 70.
20. Bishop, *Hells,* 5.
21. Sara Ahmed, *The Cultural Politics of Emotion* (Edinburgh: Edinburgh University Press, 2004), 12.
22. E. M. Forster, quoted in Leela Gandhi, *Affective Communities: Anticolonial Thought, Fin-de-Siècle Radicalism, and the Politics of Friendship* (Durham and London: Duke University Press, 2006), 9.
23. Gandhi, *Communities,* 18.
24. Mammalian Diving Reflex, "The Mammalian Protocol for Collaborating with Children," accessed January 20, 2013, http://mammalian.ca/publications /#the-mammalian-protocol-for-collaborating-with-children.
25. It is important to point out that precarious labor is hardly confined to the arts industries, but rather has become a defining factor of post-Fordist capitalist economies. See, for example, Luc Botanski and Eve Chiapello, *The New Spirit of Capitalism* (London: Verso, 2005).
26. Shannon Jackson, *Social Works: Performing Art, Supporting Publics* (London: Routledge, 2011), 212.
27. In 2003, a widespread power outage hit the Northeast coast of America, stretching up into Ontario and affecting a total of fifty-five million people. Most areas did not receive power again until 2 days after the initial outage.
28. The Torontonians, "Nightwalks with Teenagers," accessed January 20, 2013, http://www.thetorontonians.blogspot.ca/p/nightwalks-with-teenagers.html.
29. The Torontonians, "Nightwalks."
30. Walter Benjamin, "Program for a Proletarian Children's Theatre," in *Walter Benjamin: Selected Writings Volume 2, Part 1, 1927–1930,* eds. Michael W. Jennings, Howard Eiland, and Gary Smith (Cambridge and London: Harvard University Press, 1999), 202.
31. Ibid., 204.
32. Ibid.
33. Ibid.
34. On this Benjamin is rather withering: "The aristocratic dilletantism that is eager to make its poor pupils produce such 'artistic achievements' ended up by filling cupboards and memory with junk, which was piously preserved so that our mementos of early youth might survive to enable us to torment our own children." (204).
35. Benjamin, "Program," 203.
36. Ibid.
37. Ibid., 205.
38. Mammalian Diving Reflex, "Haircuts by Children the best of Performa07," accessed January 20, 2013, http://mammalian.ca/template.php?content=social _haircutsNY.

Part III Global Perspectives

9. The "little legong dancers" of Bali: The Rise of a Child Star in Indonesian Dance Theater ∾

Laura Noszlopy

INTRODUCTION

In 1952, 12-year-old Raka Rasmini and her friends Anom and Oka became the stars of the fêted Dancers of Bali tour of Broadway and the West End, which had been initiated and produced as a cultural and personal mission by the English impresario John Coast, with the support of Indonesia's first president, Soekarno. The "little *legong* dancers" came from the traditional Balinese village of Peliatan, near Ubud in central Bali. Although Bali's exotic allure has been well documented over the years, these three young girls, and Raka Rasmini in particular, stole the limelight. While the highly skilled 40-strong *gamelan* orchestra and the innovative revue performance proved popular with audiences in Europe and North America, theater reviewers focused on the charisma of the girls. Audiences were amazed at the professionalism, skill, and stamina of the child performers who, despite their diminutive stature and clear bemusement at being so far from home, appeared on stage unfaltering and perfect.

Dancers of Bali, coproduced by Coast and the Balinese leaders of the troupe, offered a snapshot of several of Bali's signature music and dance genres, as well as a couple of innovative creations steeped in traditional styles but designed to appeal to Western tastes and tightly abridged to accommodate theatrical standards. However, although the show as a whole was a hit, it was the young Raka, crouched low and clutching a pair of gilded fans/wings as she dances the *legong Garuda*, that has arguably become one of the iconic images of Bali.

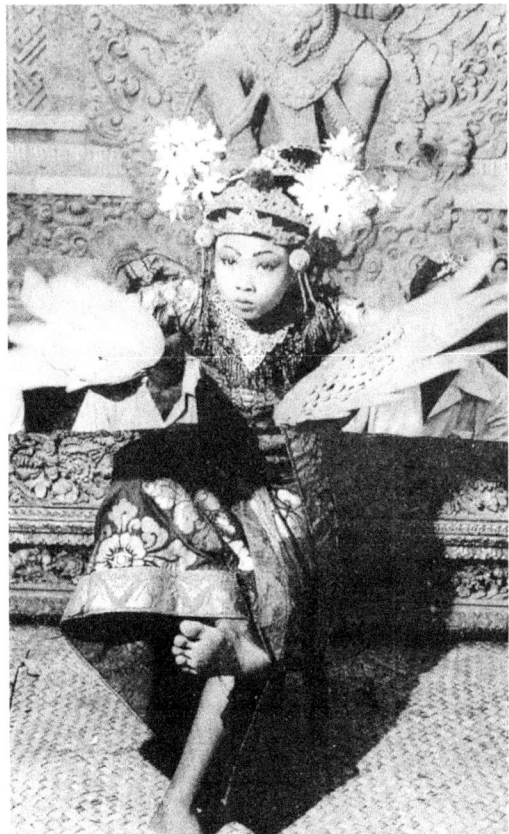

Figure 9.1 "Bird of Ill Omen," [1952], John Coast Collection, Courtesy of Laura Rosenberg.

This chapter explores the socioreligious and professional roles of children in Balinese dance theater through a biographical study of Raka Rasmini who, following a full career in performance precipitated by the 1952 tour, is now one of Bali's "veteran" artists and a most respected teacher of dance to children. I first encountered Raka while undertaking biographical research into the life and works of John Coast—a prolific memoirist as well as a theater agent and impresario who later managed (both as an employee of Columbia Artists Management and as an independent agent) some of the

world's leading names in opera. Coast's "great project" was to bring what he considered to be the wonders of Balinese performing arts to the attention of Western audiences, inspired by his time living cheek by jowl with Indonesian prisoners of war in a Japanese work camp and subsequently working for Indonesia's struggle for independence from Dutch colonialism. His long-standing love for ballet, opera, and theater, combined with his cultural and linguistic fluency in Indonesian, placed him in a good position to orchestrate the best of both worlds in this show.[1] Throughout this chapter I draw heavily on Coast's very detailed memoir of the tour and its context.[2] This written source is balanced with recent interviews conducted with Raka, Anom, and Anak Agung Gede Oka Dalem, the son of Anak Agung Gede Mandera, the Peliatan troupe's leader, and others during three research visits to Bali between 2008 and 2013.[3]

CHILDREN AND DANCE IN BALI

Like the Bali Hindu religion, dance, music, and drama are integral to the workings of Balinese society. All of these cultural forms are performed frequently, for both ceremonial purposes and entertainment (both in temple and more secular contexts). Ceremonial performances are considered to be offerings to the deities of the Bali-Hindu pantheon, while other displays are performed for both gods and humans (and, arguably, some are performed only for humans). Since the mid-twentieth century, and in the case study presented here, some performances are also performed entirely *outside* the ceremonial context, while still retaining some greater or lesser degree of ritual potency and sanctity.[4]

Children have long both witnessed and participated in this central aspect of Balinese culture and society. From infancy they accompany their parents and siblings to temple festivals and community events; they are not sent home to bed early but tend to stay until the end of a performance, sometimes until the early hours, drifting in and out of sleep, and taking in the atmosphere. They may also be active participants, either as key dancers in particular genres or, more recently, as dancing groups choreographed to augment adult dances.

Historically, children have had a crucial role in Balinese dance, particularly in the ritually potent dances of the inner temple, such as the *sang hyang dedari* (dance of the celestial maidens), which is often considered to be a stylistic precedent to *legong*. In the *sang hyang dedari* prepubescent girls, considered "pure" in body and spirit, fall deeply into trance as they

sway and writhe to the intoxicating rhythms of the *gamelan* ensemble and chanting. Late into the night the dance continues, the girl dancers often raised high onto the shoulders of men before a Bali-Hindu priest awakens them from their reverie with a sprinkle of holy water (*tirta*).

The *legong* is not generally considered to be so ritually potent as its predecessor, but many of the basic movements are similar, and the choice of virginal dancers wearing costumes of tightly wrapped brocaded cloth and heavily scented frangipani flowers are also a shared theme. It is sometimes said that the dance originated in the eighteenth century, precipitated by a dream dreamed by I Dewa Agung Made Karna, king of Sukawati, near Ubud. The standard *legong* (*legong kraton* or palace *legong*), however, is now usually performed in the outer courtyards or the more secular palace grounds and retells the doomed love story between the prince of Lasem and princess Langkesari.[5] Whatever its origins, *legong* is considered the emblematic dance of Bali, and it is used to teach the fundamentals of Balinese female dance.

Children are absolutely integrated into Balinese socioreligious life from birth. Their life cycles are marked and celebrated with performance, they play at working, they contribute real work around the household, and they participate in the intense ritual life that is so inherent to Bali Hinduism. The boundaries between childish and adult realms are less firmly marked than in many societies: if a shadow puppetry performance runs until 4 a.m., as traditional Balinese performances often do, the children stay out to watch with their parents and the community. Currently, children's music and dance performance, like the adult version in miniature, remains crucial to Bali's artistic and public life and is considered a key aspect of cultural preservation.

Since the 1970s, there has been an increasing trend for Balinese children to learn dance and music more formally and from an early age. Unlike the learning of the ritualized mechanics of worship, which occurs through immersion, observation, and mimicry, this more secular dance training resembles an educational apprenticeship with an elder *guru* or teacher. In the annual Bali Arts Festival, for example, many if not most of the huge range of performances and dance competitions are echoed with a parallel event peopled with child performers.[6] As part of Bali's public persona, children's performance often takes center stage with an appeal that, arguably, stretches back to the iconic little *legong* dancers of 1952. Few large-scale Balinese dance shows of the type shown to foreigners would be considered complete without the requisite, exquisitely costumed and formidably skilled child dancers.[7]

While the influence of foreigners—as tourists, academics, artists, and expatriate investors—and the processes of globalization more generally—through the capitalist economy, the tourism industry, as well as mass media—have impacted on the increasing professionalization of performance in Bali,[8] in general the Balinese attitude toward children and child performers has remained quite steadily positive. Children in Bali are typically held in high esteem, often spoiled with treats and considered sweet (*manis*), even when they are being naughty (*nakal*). That said, children are actively engaged at an early age both with emulating adult work (particularly the case for girls) and with participating in the traditional performing arts, which form such an integral part of the island's ritual life and social economy.[9] Indeed most community performance—as well as other ceremonial preparations such as food, drink, cleaning, and decoration—is performed by adults and children alike as a voluntary offering to gods and community (an act of *ngayah*). In contrast to discourses about child performers in the west, in Bali any suggestion that children dancing in public might be considered a form of exploitation is met with a blank, if quizzical, expression. How could that be so? They are children; they like to dance; it is sweet to watch. It seems disarmingly straightforward.

INTRODUCING IBU RAKA

An elegant woman enters the room, waving both her hands in a warm but rather regal greeting. No one would imagine she is in her mid-seventies. She moves like someone much younger. This is Ni Gusti Raka Rasmini and she is still agile and graceful, though she will in time recount the problems that she has with her joints after so many decades of dancing Bali's signature dance, the *legong*. Ibu Raka, as she is usually known, was a Balinese child star in the 1950s and continued to have an international performing career for much of her life. Coming from a culture in which individual status and success in the traditional arts tends to be subsumed by the collective genius and shared ritual goals, Raka's life story is quite unique but its trajectory also reflects some of the changes in the status of young performers in Bali and much of Southeast Asia.

JOHN COAST AND THE TOUR OF 1952

Raka was born in the small village of Peliatan on the outskirts of Ubud, in central Bali, Indonesia. Peliatan was at that time a sleepy place, peopled

mainly by rice farmers and craftspeople who lived in homes without electricity, along lanes shaded by palms where very few motor vehicles ever passed. Hers was a relatively humble family, but she lived close to Peliatan's palace and she was friendly with some of the higher caste little girls who lived there, though they weren't close. They played together as they skipped home from school and, one day, the head of the palace family, and the lead *kendang* drummer of the *gamelan* orchestra, Anak Agung Gede Mandera (known by those close to him as Gungkak) called Raka toward him: "Kah! Kah!" he called, using a local diminutive. "Come here to the house to dance. You should study with the other girls, with Oka and Anom."

Better I look for grain to make coconut cakes, thought Raka; I don't want to be a *legong* dancer. Her mother made very good coconut cakes, and what good was dancing anyway? Raka explained awkwardly (as she couldn't then manage the *alus* or refined level of Balinese that ought to be spoken by someone of lower caste status up to someone born into higher status) that she couldn't come and study dance at the palace: she felt out of place in the royal compound, she didn't know how to dance, her parents didn't think it was a good idea (even though her grandfather had been a dancer). But soon enough Mandera persuaded both Raka and her reluctant family to let her come and practice daily at the palace. After all, it was a long time since Peliatan had had a fine *legong*, and just lately an Englishman and his Javanese wife had driven up from the south of the island, enquiring about the village *gamelan*[10] and talking about a world tour.

Coast was to entirely change the course of Raka's life. Indeed, as an impresario in the making, he had a significant influence on the shape of nonceremonial performances in Bali: the types of revues that offer "tasters" of Balinese traditional (and not-so-traditional) dance to the island's visitors were very rare when Coast put together Dancers of Bali, but they are the norm now. It also set the stage for Balinese performers, particularly "star" players like Raka, to travel and collaborate internationally—the Peliatan *gamelan* and many of its dancers have continued to tour since, and have a somewhat exalted status both in Bali and overseas. The tour also had an impact in terms of professionalizing music dance theater and in cementing the notion of individual stardom in Bali's emphatically collective performance culture—where dancers usually dance together in role and the *gamelan* orchestra and its intricately interconnected music cannot be truly deconstructed from its constituent and various melodic parts. Coast noted this extraordinary togetherness the first time he heard the Peliatan *gamelan*

club play, but he also noticed an exceptional quality about Gunung Sari's performance:

> The metallophones hammered out patterns of such intricacy, such crisscross elusiveness, and with such a dazzling, brilliant zeal, as was assuredly outside my comprehension…This music broke its way into us…My whole Balinese horizon had been violently broadened in these few minutes…When at last I felt I could speak, we all went and sat on the floor with the club members. I told them, I think, that this was the most wonderful music I had heard in my life, anywhere, ever: that the western world must have an opportunity to hear it: that I hoped we would date our working together from that same night.[11]

Coast's intention to bring Balinese music and dance to the West was borne of a longstanding appreciation of ballet and opera from his early life in Britain and an ambivalent but enduring passion for Indonesia and the region developed in a time of conflict. Interned as a prisoner of war at the fall of Singapore in February 1942, Coast was confined with fellow prisoners of Indonesian, Dutch and "Indo" (Eurasian) origin in work camps along the River Kwai railway in Thailand, as documented in his first memoir *Railroad of Death*.[12] During internment he grew fascinated with their language, culture, and songs, an interest that precipitated his commitment to Indonesia's simmering nationalist and revolutionary sentiments, a cause which he later joined with a commitment almost unparalleled for a European. This was a turning point in Coast's life and, on his release and return to England, he immediately set about trying to ensure his return to Southeast Asia. Initially, he made contact with some of the very few Indonesians then living and working in London. This in turn led to his spending time in Holland where he brought together a diverse group of Indonesian students and helped them stage a performance of classical Javanese dance sketches, performed to a vinyl recording of *gamelan* accompaniment.[13] In 1946, the "Javanese Dancers" show toured a selection of UK theaters in an effort to showcase the human and artistic face of the colonized nation, thereby garnering support for the national revolutionary movement.[14] Coast then secured a junior post in the British Embassy in Bangkok where he again made contact with Indonesians working against the Dutch.[15]

In time, Coast left his secure post with the British Embassy and found a novel role as a kind of international press secretary for Soekarno's inner circle. He supported the revolutionary movement and for some years worked as a public relations officer, a "fixer" for pro-nationalist journalists and visitors, and a runner of the Dutch blockade (arranging illegal flights carrying

goods, arms, and political documents from Thailand and Singapore to reach nationalist enclaves in Indonesia via Dutch airspace). Eventually he suggested to the first president of independent Indonesia that he would like to retire to the island of Bali and put together a world tour showcasing Balinese music and dance. Soekarno, known for his love of both Bali and the arts (his mother was Balinese and he kept a palace home in the central foothills), agreed to support Coast's endeavors, acknowledging that such an artistic offering would be a useful tool for Indonesian cultural diplomacy in the West.

After investigating music and dance groups around the island of Bali,[16] Coast and his Javanese wife Luce were immensely impressed with the musicians of Peliatan and pledged to overcome a gamut of political and personal obstacles to ensure the group's departure for an international tour to the United Kingdom and the United States. Their affection for the *gamelan* club Gunung Sari was cemented when they met the dancing girls, who were already practising daily under the guidance of Mandera who led their movements with the beating of his *kendang*, a double-ended drum that is held in the lap and played with both hands, and that "leads" the rest of the ensemble and guides the dancers' steps.

John and Luce, by Coast's account, became besotted with Raka who was later to become their adopted daughter. This affection was mutual, according to Raka, and the warm filial relationship lasted throughout Coast's lifetime. Pak Mang Lotring—a senior musician and dancer from the coastal village of Kuta who was famed on the island for his virtuosity and for having taught visitors such as the Canadian composer and ethnomusicologist Colin McPhee—was chosen to teach the *legong*.[17] According to Raka, Anom had initially been chosen as the primary dancer (in the vital *condong*/bird of ill omen role in Peliatan's now famous *legong Garuda*), but according to Lotring, her feet were not straight and it would never be possible for her to achieve the correct alignment and movement. Anom was very beautiful, says Raka, and, as Mandera's niece, had far closer family ties to the palace—though not so close as Oka, who was in fact Mandera's own daughter from his second wife (interview, Ubud, October 2012). In that case, said Mandera, we will seek a new teacher (rather than a different dancer). Mandera went to the neighboring hamlet of Banjar Tengah and sought a dance teacher named Gusti Made Sengog, with whom he had a family bond. Lotring was taken home to Kuta and Made Sengog (known affectionately as Gusti Biang) took on the challenge of training the young *legong* dancers, having ascertained that their feet were still tiny and could therefore be swiftly corrected and

pointed in the appropriate directions. Gusti Biang "was a dark, craggy-faced woman, her mouth red-black from the everlasting chewing of betel, with piles of thick wavy grey hair falling about her face. She wore only an old *kain* [sarong cloth]."[18] She was an exceptional teacher but the training was harsh:

> At the very beginning the little girl's body would be tucked into the enveloping form of Gusti Biang behind her. The child's head would fit under the teacher's chin, and that chin and the guiding palms of the teacher's hands would indicate the head movements. Arms pointed out warningly before the child's eyes would anticipate the side glances of the eyes. The whole body would be precisely fitted into the teacher's, the child's back stemming from the teacher's belly. The teacher's arms would outline the child's arms, her hands holding and manipulating the child's hands and fingers; behind the child's legs would be the teacher's legs, which would shuffle, push and firmly kick the child's legs and feet into the right positions and sequences.[19]

According to Raka, the girls mastered the *legong* fairly well within three months of training; after five or six months Coast was invited to watch the dance. Raka said that they had worked so hard with Gusti Biang that they knew each tiny move exactly; they were nervous yet quietly confident (interview, Ubud, October 2012). The girls already knew that Coast planned, with the support of President Soekarno, to take a troupe abroad and Mandera often reminded them of this fact to coax along their practice. Mandera had been abroad during the 1931 Paris Expo tour, but none of the other members of Gunung Sari had travelled outside Bali. Coast and Luce visited Peliatan and watched the rehearsals every day for some weeks until they became convinced that this was indeed the group for the world tour. "For some inscrutable reason," he recalled, "partly personal desire, partly a balletomane's wish to show our Legong to people like Margot Fonteyn and Markova, partly a belief that such a group as ours would make a powerful, because nonpolitical, link between east and west, this thing had become what you might call 'my life's ambition.'"[20]

BECOMING A BALINESE CHILD STAR

Coast brought in two of Bali's brightest dance stars, I Mario of Tabanan—famed for his *kebyar duduk* dance as well as his association with visiting westerners—and young Sampih of Sayan—who had been both the houseboy and muse of the composer Colin McPhee[21]—to supplement Peliatan's local talent. When Freddie Schang, Jr., President of Columbia Artist

Management and the finance behind the US leg of the tour, first saw the show in Peliatan, he exclaimed to Coast:

> Ni Gusti Raka—there's your star! She's everything you wrote and told me about and then some more. She's *great*. She's so sweet I could eat her with a spoon. *All* the little girls are darlings—the American public will go crazy about 'em. They're terrific kids. You—you—you've got together a galaxy of talent that's going to make even Broadway blink. But what gets me is to think I come twelve thousand miles to this little mud-walled village under its coconut palms and find *great art!*[22]

With the inspiring help of Bali's most famous and innovative dancer, I Mario, Coast and Mandera had developed an innovative, globally appealing repertoire that did indeed result in a sell out tour and rave reviews.

The innovation within the *legong* was Raka's depiction of the emblematic Garuda bird, danced while balanced on top of a chair, with stunning golden wings strapped to her narrow, tightly bound back. She was just 12 years old when the training started in earnest. Raka's parents still did not support their daughter's involvement but she was dedicated and was already practising from morning until night with the other girls at the palace. As already noted, traditional dance training is intensive and can make quite extreme demands on the mind and body, even in the dance training schools (*sanggar tari*) of the present day.[23] Small children, whose bodies are still malleable, are literally moulded into the correct successions of forms and shapes, the syncopated rhythms seared into their psyches through relentless repetitions and adjustments. Raka recalls standing balanced on the stone and dirt wall at the back of the palace compound for hour upon hour in the harsh tropical sun. Wrapped tightly in cloth and with her back bent sharply backwards in the renowned arch shape of Peliatan's *legong*, it is hard to imagine how uncomfortable this would be. But it was deemed necessary for the girls' training and when Raka recalls such pains and strains, she recalls them with wistful laughter and some pride, and says she would do the same now with her young dance students.

Mandera and the other parents of the girls asked what would happen about their schooling during the tour and Coast answered that it wouldn't be a problem and that they could catch up later upon their return. It may be a sign of the age that their formal education was considered secondary to the greater good of the club and the tour, or perhaps it was considered that the experiences the girls would have while touring would far surpass what their learning would have been at school: certainly Raka considers the 1952 tour as absolutely formative in her life path. And so, a 40-strong

band of Balinese performers departed Jakarta in a specially chartered K. L. M. plane, packed heavy with the instruments of an almost complete *gamelan* orchestra and the costumes, props, and paraphernalia required for the show. Unfortunately for the jetlagged club, the British managers and their colleagues at the Indonesian Embassy in London had not properly organized the accommodation and "rice and spice" catering desperately needed on arrival in London. The girls, especially, were exhausted: "In the dining room the children sat wretchedly before the table. Anom had to be shaken gently to keep her awake. And again none of the little ones could eat. Anom started to cry quietly."[24] Raka remains stoic in her recollections of this initial encounter with Europe: the girls were brave and everything was just new and different. It is the weather—something Coast and the British managers could do nothing to mitigate—that haunts her as their worst discomfort. Coast managed to move the girls, at least, into a better hotel near to the theater, and a local Greek restaurant that could produce the necessary amounts of hot rice, meat, vegetables, and chilli for the Balinese was contracted to cater for the duration of the British performance run.

From the accounts of both Coast and Raka herself, it seems that while there was intense personal concern for the children's well-being, there was also a very pragmatic attitude toward their role as performers. Besides regular treats and some concessions to their comfort, the children were expected to behave as professionals, no more nor less than their adult co-performers. This would not have seemed extraordinary in the Balinese context, but it was more unusual and challenging away from home. The tension became clear, for example, when the girls were almost sent home from the Winter Garden Theatre in Drury Lane by union representatives who suspected that they were too young to be employed by the theater.[25] Raka recalls that in the original set the *legong* was danced first. Her role as *condong* was particularly appealing and indeed the sweetness of the lithe, prepubescent girls are a prerequisite of the dance style.[26] In an attempt to avoid the girls being sent back to Bali, Coast arranged for the union representatives to watch Raka dance her other, more adult role as the coyly flirtatious bumblebee in the *Oleg Tamulilingan* duet with Sampih, devised by Mario. Raka seemed so much "more mature" and "adult" in this new choreography that the union representatives allowed the girls to work; she recalls with some pride how she convinced them through her skill and stage presence to change their minds.

In his memoir, Coast recounts how the girls were exhausted by their intensive performance schedule and how he fruitlessly tried to negotiate

the dropping of a few matinees to keep the London schedule in line with what had been agreed for the New York run. But he also noted their total dedication and extraordinary stamina. In retrospect, Raka sighs at the memory of performing no less than six strenuous dances on each day of the tour (in two sets of three: matinee and evening shows). She reports with pride how, despite being soaked with sweat by the end of a show, she wasn't that tired—"maybe it was from the Garuda (the powerful bird she was dancing) or from 'the One above' that I found this energy," she says. Even at the hardest of times during the tour, she felt light (*ringan*) (interview, Ubud, September 2008). Among musicians and dancers in Bali this sort of feeling and strength can be called *taksu*—a spiritual energy and skill that allows such exceptional performances. And, as Coast had hoped, they did indeed get to meet Margot Fonteyn and the stars of Sadler's Wells.

Another factor that compensated the girls for their efforts was the wealth of new experiences and the resoundingly positive reception they received wherever they went, most especially once they started their five-week US tour at the Fulton Theatre in Manhattan. The Fulton season, organized by Columbia's Freddie Schang, Jr., was easier for the troupe. Their hotel accommodation was ample and they were provided with cooking facilities and quantities of rice, chilli, and good food. Moreover, the performance schedule was lighter than the London run: they performed seven nights of the week with only a Saturday matinee.[27] Raka recalls shopping trips, ice cream parlours, and not really wanting to go to the top of the Empire State Building (interview, Ubud, October 2012).

Not only did the show receive fantastic reviews but the dancers were also invited to private parties and public gatherings, to tour movie sets and to appear on television.[28] In New York, Dancers of Bali was sold out and the tour extended to include shorter but equally popular runs in Boston, Philadelphia, Newark, Washington, Cleveland, Cincinnati, St Louis, Chicago, Las Vegas, and Los Angeles. At one performance in Los Angeles, they received no less than seven curtain calls.[29]

The US press, in particular, reported on the political and diplomatic underpinnings of the tour (it was fêted as promoting East-West understanding, given that Indonesia was still seen to be rather "red" for American tastes) and on the logistics of bringing such a spectacle to a Western theater (the troupe brought many elaborate props and costumes, including a shaggy *barong*,[30] as well as an almost-full *gamelan* ensemble of instruments). As a result, Coast was praised for his management skills and good taste. Mostly, though, reviewers commended the program and the performers—especially

the little *legong* dancers and the "bewitching" Ni Gusti Raka: "an utterly lovely wisp of a girl, as serious as an owl until her smile breaks through... [she] is truly superb, technically and dramatically."[31]

> Their performance proved to be an exotic elixir of sound, color and movement which often roused the audience to cheers. The musicians and dancers were admirably free from stage fright and strain and the whole... had the stamp of a strong authenticity. [...] if anyone expects to see the undraped female figures displayed to Western eyes as in such films as Goona Goona, he will be mistaken. For the female dancers of Dancers of Bali are quite young girls, swathed tightly in heavy embroidered costumes making them somewhat resemble beautiful little insects with human heads and arms. The star dancer is Ni Gusti Raka, a 12-year old virtuoso who brought down the house with her performance of the classic Legong, a traditional dance of the island and the high spot of the night.[32]

The young dancers were adored by the rich and famous, by the theater staff, and by ice-cream servers in the local diners. According to one report, at Sardi's restaurant in New York, they arrived for a press call "wearing smiles as gay as their native costumes" and:

> posed for photographers with a pliableness (sic) which stemmed, no doubt, both from their training as dancers and their estimable good manners. They answered quite a lot of reporters' questions. They ate quite a lot of ice cream. And what they thought of the strange proceedings could perhaps be better guessed from their discreet laughter among themselves than from their shy smiles at us.[33]

Raka could hardly describe this success as a dream come true since their experiences in America were so new and not the material of Balinese dreams. Walt Disney invited them to meet him and spend a day at the movie studios, along with American dancer, ethnographer, and writer Katharane Mershon, a long-term friend of Coast's who shared his passion for Balinese culture. They befriended Bob Hope and Bing Crosby (stars of the recently completed film *The Road to Bali*), who in turn adored the girls and managed to joke their way through the language barrier. Raka recalls the simple pleasure of eating vanilla ice cream during the intermissions of each show (described in the Indonesian as "drinking ice"), an experience enhanced by its exoticism as electricity for refrigeration was still decades away for the inhabitants of Peliatan. All three girls savored this treat and it seems to have somewhat eased the anxiety caused by the lack of "good hot rice" that they had endured at the outset of their tour.

As Coast notes: "Raka, having seen her photograph in countless journals, was becoming conscious of her ballerina status, and when her understudy once danced her Bumblebee role to lighten her work for her, she refused ever again to wear the golden *kain* [sarong cloth] which the other girl had sullied."[34] But she also proved her "artistic integrity" when, while in Philadelphia:

> she danced her Bumblebee dance in the first half of the programme, but inexplicably refused to eat her ice-cream in the intermission while changing costume. In the second half, she danced in the Legong, played her Golden Bird role, took her final curtain-calls—and burst into uncontrollable tears... The little tot had felt part of her costume coming loose in the Bumblebee dance and was afraid it had been noticed. She had contained her weeping, however, until the whole performance was over.[35]

She also has memories of the girls dancing through (relatively minor) injury and illness as a point of pride and with a growing sense of professionalism. Resoundingly, however, Raka's recollections of her experiences and those of the club are positive. It was an experience "outside of the usual" (*luar biasa*).

Coast's association with the Dancers of Bali ended rather abruptly at the start of 1953 when the Indonesian government determined that the tour should continue through Europe, without John and Luce at the helm. Coast was terribly hurt and disappointed by this, not least because Columbia was just at the point where they could have extended the tour and facilitated some real profits for the club. He recalls the last minute shopping they did "to buy rubbers and extra clothes against the snow and cold"[36] once they had been handed their earnings from the tour. He notes that many of the club's members, including the children, had not wanted to spend their hard earned cash on superfluous items but rather wanted to save it to spend back in Bali.[37]

Raka and the troupe returned to Peliatan in 1953 to the excitement and awe of their families and neighbors. Raka's mother was shocked at how white the girls had become in those months away from the sunshine (they had spent the winter touring Europe, against Coast's advice); she was also horrified and frightened to see the girls walking in their new high heeled shoes (they had previously been mostly barefoot in Bali) (interview, Ubud, September 2008). Mostly, Raka says that the village was proud that its *legong* had been chosen and that it was an event that has changed Peliatan's reputation to this day.[38]

Mandera had brought with him, among other things, the Chevrolet station wagon he had hankered after for the duration of the trip, while the others had fine clothes to show and enough "gold money" saved to finance the purchase of rice fields and home extensions.[39] But fame has its price. In February 1954, less than two years after his triumphant return to the island, Raka's bumblebee counterpart Sampih was found strangled at the foot of a cliff near his home in Sayan, Ubud. Word has it that he was killed out of jealousy; his new watch was missing from his wrist and people were talking about the rather large motorbike and the rice fields he had purchased with the proceeds of the tour.[40]

Raka fared better. In 1955, at the age of 17, she married and moved to Bali's provincial capital, Denpasar. She was quickly approached by a series of Indonesian and foreign producers who invited her to dance, both in Indonesia and abroad. Unlike her companions Oka and Anom, and despite having young children, she continued to dance through the years, often bringing her offspring with her to the performances.[41] She has toured Europe, America, Australia, Japan, and Brazil, among other places. Her career was set on its course through this formative experience as a child star. These days, Raka still teaches young girls to dance *legong* and other classical Balinese dances. Either she teaches directly or, when her joints are troubling her, she directs lessons through her daughter Agung Istri Wirati. Raka is still active as a dancer, performing at special "veteran" displays of Bali's classic dances and celebrations of the island's cultural heritage. Along with the rise of traditional dance schools for Bali's children, there is also a growing trend in Bali for recognizing the island's maestros, those stars whose careers in the traditional performing arts have spanned the globe and invariably started in childhood.

NOTES

1. Although my background is in anthropology and I have been studying the arts and culture of Bali since the early 1990s, much of my recent work has focused on the juncture between ethnography and (auto)biography.
2. John Coast, *Dancing Out of Bali* (Singapore: Periplus Editions, 2004), first published as *Dancers of Bali* (New York: Putnam, 1953).
3. Research for this chapter was funded by grants from The British Academy and Cambridge University's Evans Fund. I would also like to acknowledge the support of the Department of Drama and Theatre, Royal Holloway, University of London, as well as Ni Gusti Raka Rasmini, Laura Rosenberg, Matthew Isaac Cohen, Mila Shwaiko, and Agung Istri Wirati.

4. For analysis of the distinctions between different types of performance in Bali, see Walter Spies and Beryl de Zoete, *Dance and Drama in Bali* (Singapore: Periplus Editions, 2002), first published in 1938 by Faber & Faber; and I Madé Bandem and Frederik Eugene deBoer, *Balinese Dance in Transition: Kaja and Kelod* (Kuala Lumpur: Oxford University Press, 1995).
5. For further details on *legong*, see I Madé Bandem, "The Evolution of Legong from Sacred to Secular Dance of Bali," *Dance Research Annual* 14 (1983): 113–19; Stephen Davies, "The Role of Westerners in the Conservation of the Legong Dance," *Contemporary Aesthetics* 3 (2011), accessed May 31, 2013, http://www.contempaesthetics.org/newvolume/pages/article.php?articleID=625; Stephen Davies, "Beauty, Youth, and the Balinese Legong Dance," in *Beauty Unlimited*, ed. Peggy Zeglin Brand (Indianapolis, IN: University of Indiana Press, 2012), 259–79; Stephen Davies, "The Origins of Balinese *Legong*," *Bijdragen tot de taal-, land- en volkenkunde (BKI)*, 164 (2008): 194–211; and Adrian Vickers, "When did *legong* start? A Reply to Stephen Davies," *Bijdragen tot de taal-, land- en volkenkund (BKI)* 165:1 (2009): 1–7.
6. See Laura Noszlopy, *The Bali Arts Festival – Pesta Kesenian Bali: Culture, Politics and the Arts in Contemporary Indonesia* (PhD diss., University of East Anglia, 2002).
7. See, for example, reviews of the Festival of Indonesia that toured the United States in 1990, accessed May 20, 2013, http://www.nytimes.com/1990/09/18/arts/review-dance-indonesian-festival-s-children-of-bali.html.
8. See Laura Noszlopy, "Freelancers: Independent Professional Performers of Bali," *Indonesia and the Malay World* 35:101 (2007): 141–52; Laura Noszlopy and Matthew Isaac Cohen, eds. *Contemporary Southeast Asian Performance: Transnational Perspectives* (Newcastle-Upon-Tyne: Cambridge Scholars Press, 2010); Matthew Isaac Cohen, *Performing Otherness: Java and Bali on International Stages, 1905–1952* (Basingstoke: Palgrave Macmillan, 2010); and Adrian Vickers, *Bali: A Paradise Created* (Ringwood, Victoria: Penguin, 1989).
9. See Bandem and deBoer, *Kaja and kelod*; Spies and de Zoete, *Dance and Drama*; and I Wayan Dibia and Rucina Ballinger, *Balinese Dance, Drama, and Music* (Singapore: Periplus Editions, 2004).
10. For a definitive guide to Balinese music with particular reference to *gamelan* styles, see Michael Tenzer, *Balinese Music* (Singapore: Periplus Editions, 1991).
11. Coast, *Dancing*, 59.
12. John Coast, *Railroad of Death* (London: Hyperion Press, 1946).
13. Reviewed by Beryl de Zoete in *Ballet* 2:2 (1946).
14. For details of this period, see Ben Anderson, *Java in a Time of Revolution: Occupation and Resistance, 1944–1946* (Ithaca, NY: Cornell University Press, 1972); George McTurnan Kahin, *Nationalism and Revolution in Indonesia* (Ithaca, NY: Cornell University Press, 1952); and Adrian Vickers, *A History of Modern Indonesia* (New York: Cambridge University Press, 2005), 85–112.

15. For a historically accurate and detailed account of this period, see John Coast, *Recruit to Revolution: Adventure and Politics in Indonesia* (London: Christophers, 1952).
16. Bali's performing arts are diverse; within the same genre, styles, and abilities can vary widely from place to place. Genres also come in and out of fashion; it seems *legong* had been on the wane at the start of the 1950s in comparison with the then-popular *djanger*, for instance, or the necessary and constant ritual dances of the temples.
17. See Colin McPhee, *A House in Bali* (Singapore: Periplus Editions, 2000).
18. Coast, *Dancing*, 61.
19. Ibid., 62.
20. Ibid., 121.
21. Colin McPhee, "Dance in Bali," *Dance Index* 7:8 (1948): 156–207; McPhee, *A House in Bali*; Carol Oja, *Colin McPhee: Composer in Two Worlds* (Washington and London: Smithsonian Institute Press, 1990).
22. Coast, *Dancing*, 165.
23. See Jonathan McIntosh, "How Dancing, Singing and Playing Shape the Ethnographer: Research with Children in a Balinese Dance Studio," *Anthropology Matters* 8:2 (2006), accessed May 1, 2013, http://www.anthropologymatters.com/index.php?journal=anth_matters&page=article&op=view&path[]=65&path[]=126.
24. Coast, *Dancing*, 192.
25. Though neither Coast's memoir nor Raka's memories can confirm the details, this was most likely due to the Children and Young Persons Act 1933 restricting the use of children in employment. In brief, the law defined a child as anyone of compulsory school age (up to age 16) and prohibited the employment of children under the age of 15 years (or 14 years for light work), during school hours, before 7 a.m. or after 7 p.m. on any day. Ambiguity surrounded the true ages of Raka and the other *legong* dancers because Balinese did not tend to attach importance to birthdays, focussing instead on other calendric milestones in the lifecycle; there was further ambiguity about the girls' status as foreign nationals and that they were not attending school (with permission from their Balinese parents).
26. See Davies, *Beauty, Youth*.
27. "Bali Troupe Here Tonight," *New York Times*, September 16, 1952, 33.
28. The Ed Sullivan Show, prerecorded and shown on October 26, 1952.
29. Coast, *Dancing*, 212.
30. A *barong* is an animal like creature crowned by a ritually potent mask (usually of a lion, boar, or Chinese dragon-like being) that forms an important part of many Balinese religious festivals and ceremonies. The Peliatan troupe's *barong* had to be sprinkled with holy water and asked for permission before it could travel or perform during the tour.
31. John Martin, "Balinese Troupe Shows Its Wares at the Fulton, Opening 5-Week Run," *New York Times*, September 17, 1952, 34.

32. "Exotic Elixir," *Wall Street Journal*, September 22, 1952, 6.
33. John Beaufort, "Little Bali Dancers Capture New York with Native Charm," *Christian Science Monitor*, September 13, 1952, 14.
34. Coast, *Dancing*, 205.
35. Ibid., 207.
36. Ibid., 217.
37. It is likely that at least a portion of the girls' earnings were to go back to the families at home, though I have not been able to ascertain the details of this. Coast continued to support his adopted daughter Raka for many years after the end of the tour. This is a relationship continued to this day by Laura Rosenberg of the John Coast Foundation.
38. A point corroborated by the descendants of Anak Agung Gede Mandera.
39. Coast, *Dancing*, 202.
40. James Murdoch, *Peggy Glanville-Hicks: A Transposed Life* (New York: Pendragon Press, 2002), 121.
41. It is very unusual in Bali for a woman to keep dancing once she has married and had children; this is especially the case for *legong* which—besides a few exceptions, such as the eminent dancers Raka and Bulantrisna Djelantik—is to be danced by prepubescent girls.

10. Child Training and Employment in Taiwanese Opera 1940s–1960s: An Overview ❧

Shih-Ching H. Picucci

Issues surrounding the ways in which children have affected theatrical performance in a European context have frequently generated discussion, in particular the role of children working in theater. Yet, similar issues that relate especially to traditional local theatrical performances in a non-European context have been insufficiently examined. One such example is Taiwanese opera (*gezaixi*: song drama). Similar to Beijing opera (or Peking opera), but distinct and unique in its modes of performance, Taiwanese opera first appeared approximately a hundred years ago.[1] It continued to flourish and indeed Taiwan's most renowned opera group, Ming Hwa Yuan Arts and Cultural Group, was elected as the representative family for Taiwan when UNESCO proclaimed 1994 as the International Year of the Family (IYF). This family-run troupe was founded in 1929 and has passed to the second and third generations of the family. They have not only endeavored to preserve its traditions, but have also made a concerted effort to promote the form nationally and internationally throughout the last century.[2]

Focusing on the period from Imperial Japanese colonization to shortly after Chiang Kai-shek's takeover of Taiwan, this chapter first argues that this time period featuring wartime hardships for the Taiwanese established the employment of female children in Taiwanese opera. In addition, the way in which child training in Taiwanese opera reflected the Confucian Chinese attitudes toward children is discussed. The ensuing discussion is

based on the experience of three acclaimed actresses who, born during this time period, recalled the type of training they received in their childhood. Their experience provides a valuable basis for understanding Taiwanese's ideas of children and childhood, themselves highly influenced by Confucian philosophy, during the period under discussion. Their success and examples have contributed to a transformation of the male dominated practice into a form which is chiefly interpreted by females, and this transformation has largely increased the employability of young female trainees in the profession of Taiwanese opera. The development of Taiwanese opera and the Taiwanese attitudes toward children find their parallels in the history of Taiwan as well as in the economic conditions of the time. Thus the making of Taiwanese opera is inextricably entwined with historical factors that directly influenced people's attitudes toward children in general and child training in Taiwanese opera troupes in particular.

BRIEF HISTORICAL BACKGROUND

China did not claim jurisdiction over Taiwan until the Emperor Kangxi officially incorporated the latter into the territory of the Qing Empire in 1684. Although crossing the Strait to Taiwan had been restricted, people from the Southern provinces of Fujian and Guangdong continued to migrate to the island, legally or illegally, in the following two hundred years.[3] The settlers in the area of Yilan, located in the north of Taiwan, sang their folk songs as an expression of nostalgia for their homeland, Fujian. Originated in Yilan and later disseminated to the nearby city, Taipei, as well as across the entire island of Taiwan, Taiwanese opera is said to have been born locally in Taiwan from the combination of Yilan's folk songs and the body movement and the music of *che gu xi*.[4] The precursor of Taiwanese opera began as a social activity, performed during the traditional local festivals as well as at important family occasions by male family members. In the early agricultural society before 1920, the men gathered every night to practice their acting skills and their instruments as a means of socialization and recreation after finishing their work in the farmland. More importantly, the performance served as a ceremony dedicated to the gods and ancestors to show appreciation for the agricultural harvest.[5] According to Fu-ling Yang, the combination of Yilan's folk songs and *che gu xi* did not turn into a commercial activity until 1920 when Taiwan headed toward the development of urbanization and modernization.

However, at the conclusion of the First Sino-Japanese War (1894–95), it was agreed that Taiwan together with the Penghu islands were to be

ceded to Japan, thereby including Taiwan within Japan's colonial territory for the next half century. At the beginning of the Japanese colonization, Taiwanese were not forced to identify with Japanese cultures and adopt the Japanese identity.[6] Thus, Taiwanese opera freely explored and absorbed different forms and styles of performance in the early stages of its formation. It gradually enriched itself and became a major theatrical form.[7] According to Shun-lung Wang's investigation into Japanese and Taiwanese literature dated before World War II, the term of Taiwanese opera (*gezaixi*) did not appear until 1927 in a Taiwanese newspaper.

During the first 20 years of Japanese colonization, Taiwanese opera became immensely popular across the entire island and reached its first wave of unprecedented success in the period between 1920 and 1930. However, between 1937 and 1945, tapping Taiwan for its resources, revenues, and wartime industry, Imperial Japan regarded Taiwan as an important base for the Southern invasion of Southern China and Southeast Asia. The increasing taxes and labor squeezed out of the Taiwanese made life harder than ever. In order to reinforce and consolidate the loyalty of the Taiwanese toward Japan, the latter had also carried out projects in this period intended to force the Taiwanese to identify with Imperial Japan.[8] These had included, for instance, the use of the Japanese language and the prohibition of the islanders' local languages, such as Hakka as well as Minnan, and Han Chinese cultures.[9] Lamley describes how "traditional Taiwanese operas and puppet plays were banned,"[10] more specifically, the Chinese plots together with their costumes were forbidden on stage, and only Japanese styles of performance and dress, for example, the kimono, were allowed. Performers had to wear *geta*, a type of traditional Japanese footwear, and the Japanese music style was utilized. No longer being entertained under such circumstances, attendances at plays began to falter. One after another opera troupes closed, and though a few continued to operate, it became hard for actors/actresses to make a living relying on this profession.

After the defeat of the Japanese in 1945, Taiwanese opera experienced a resurrection. Due to increased market demands, troupes of Taiwanese opera increased to more than 300 according to Hsin-hsin Tsai,[11] while Yang estimates the number to approximate 500 troupes from 1949 to 1956.[12] Many child performers were employed for minor roles, and a few trained children were given the opportunity to take lead roles,[13] for instance, the three actresses under discussion here, Ming-hsueh Hung (1936-), Li-hua Yang (1944-), and Little Ming Ming (1941-). Although Chinese cultures and languages were no longer suppressed, the stability

of people's livelihood and the quality of their life, rather than improving as had previously been expected, in fact deteriorated. After the Chinese official, Yi Chen, was appointed as administrator and commander of the Taiwan Garrison in 1945, his mismanagement led to severe corruption, inflation, unemployment, and food shortages, creating both economic and social turmoil. Scholars, such as Steven Phillips and Chi-tun Hsu,[14] have indicated that many military officials sent to the island were often responsible for theft, threatening behavior, and individual molestation, eventually leading to the outbreak of the 228 Massacre (or the 228 incident).[15]

TAIWANESE OPERA

Those who are likely to be reasonably familiar with Beijing Opera might find watching a performance of Taiwanese opera a very different experience. First, even for many Chinese people, it might be difficult to understand the singing of Taiwanese opera because the language used is not Mandarin Chinese as in the case of Beijing Opera, but Min Nan, a family of Chinese languages spoken primarily in Taiwan and a few parts of China, such as Fujian and Hainan. Whereas the Mandarin Chinese used in Beijing Opera is largely drawn from classical Chinese literature, the Min Nan sung in Taiwanese opera is a step closer to the spoken expressions that Minnanese would use ordinarily, including colloquial slang terms. When singing, the performers of Beijing Opera, especially actresses, tend to sing using a high pitched or falsetto voice, while the performers of Taiwanese opera use their natural voices. Furthermore, although the roles, such as *Sheng* (male characters), *Dan* (female characters), and *Chou* (a clown role), are similar in both operas, performers of Taiwanese opera apply a less exaggerated and heavy makeup than those of Beijing opera. For example, the heavily painted faces whose patterns and colors indicate a specific character in Beijing Opera are not commonly seen in Taiwanese opera performances. A distinct feature of Taiwanese opera, which is entirely different from Beijing Opera and deserves particular attention, is that the role of *xiaosheng* (the lead male character) is primarily performed by females.[16]

The three Taiwanese opera actresses discussed here, namely Li-hua Yang, Ming-hsueh Hung, and Little Ming Ming, are all renowned for playing the role of *xiaosheng* in Taiwan. Moreover, they have all been trained during the period of late Japanese colonization and the beginning of Chiang Kai-shek's regime. In 1944, Yang was born at the back of the theater where her mother was performing. Her first performance as a child character was well received in 1950 when she was six years old. She was one of the

first to take Taiwanese opera into the television industry in the mid-1960s and formed her own Taiwanese opera troupe in 1969. Yang is now both an actress and a producer, and her name is familiar in every household in Taiwan. Hung was raised and trained in her father's Taiwanese opera troupe, the Ta Chen Feng opera troupe. She has participated in numerous Taiwanese opera plays using different platforms, such as in open-air theaters, as well as radio and television programs. Although she is nearly 70 years old now, she has recently participated in plays organized by the Ming Hwa Yuan Arts and Cultural Group. Similar to Hung, Little Ming Ming's father also ran a Taiwanese opera troupe. Her first performance was as an old female character (*Chou*) in 1948, and it was not until 1954 she started to play a *xiaosheng*. In 1969, she organized her own Taiwanese opera troupe called Ming Hsia opera troupe where she delivered lectures to the trainees. Little Ming Ming has played in more than a thousand Taiwanese opera television episodes, and her most recent performance in a theater in Taipei was in 2011.

A number of factors have contributed to the rapidly increased number of actresses and girl trainees in Taiwanese opera troupes and their overwhelming popularity during the period under discussion. In late nineteenth- and early twentieth-century Taiwan, when the opera was still a social rather than a commercial activity, it was exclusively carried out by males, who played both male and female characters on stage. This was due to the fact that the organization of any ancestral ceremony and its details were considered a male prerogative. Mothers and wives, on the other hand, were expected to "stay home and serve their husbands and parents-in-law, and take care of children and housework."[17] Confucian philosophy dictated women's status and the space of their activities: they were subordinate to their husbands and restricted by the convention whereby women who drew attention to themselves in public such as acting on stage, would harm their reputation and, more importantly, that of their family.[18] Women were supposed to maintain a low profile both within the family and in public. Thus, bound by this aspect of the premodern Chinese belief, Taiwanese women were not given the opportunity to take part in the workforce until the period of Japanese colonization. According to Kelly Olds's study in female productivity in twentieth-century Taiwan,

> Under Qing rule, female human capital had been under-utilized due to the isolation of wives and daughters to preserve chastity. Under the strict law-and-order regime imposed by the Japanese, the Taiwanese became convinced that females no longer needed to be secluded and female labor participation rates dramatically increased.[19]

In addition, in her book about Taiwanese geishas, Hsu-ling Chiu refers to a document, published in 1901 by the Japanese government, which indicates the popularity with which the Japanese geishas were received in the colonized Taiwan, and this had in fact triggered the creation of the Taiwanese geisha.[20] Thus females performing on stage gradually became acceptable. Indeed, the first few female actresses joined and were trained in a Taiwanese opera troupe in 1922.[21] The appearance on stage is also mentioned in Li-hua Yang's biography where she states that her grandfather allowed her mother to act on stage at the time of the agricultural harvest when males were particularly busy between around 1930 and 1937. The success of female acting in theaters triggered a burgeoning interest among female audiences in going to a theater and this was recorded in a newspaper as early as 1927.[22] Plots that depicted females suffering from inequality in the society were particularly popular, largely because the actresses, along with the characters they played, echoed the unfortunate reality of women's subordination and their inferior status to men in the society. This had profoundly touched and reached the heart of female audiences who identified themselves with the characters portrayed.[23] Added to this was the success of actresses playing a lead male character (*xiaosheng*) on stage after 1930.

Employing actresses to play *xiaosheng* on stage began as a trial but was well-received and, unexpectedly, drew more female audiences into the theater. Yang's mother started to regularly play a *xiaosheng* after 1937. The interest in watching an actress playing the lead male character also derived from the traditional, conservative atmosphere of Taiwanese society at the time. When the lead male character was played by a man, it was considered improper for a female audience, particularly a married one, to demonstrate appreciation of his performance. On the contrary, when the lead male character was played by an actress, it was said by both Hung and Yang, that the females in the audience could feel free to make friends with the actresses, visit them backstage with permission, and express their admiration as well as affection.[24] Additionally, misunderstanding as well as embarrassment could easily occur when a scene of intimacy between the lead male and female character was performed, especially when the actor and actress were married and both were living in the same opera troupe. The founder of Ming Hwa Yuan Arts and Cultural Group, Ming-chi Chen (1912–97), recalled being aggressively stared at by the troupe's drummer when he himself, playing the lead male character in one play, fondled on stage the lead female character, who was the wife of the drummer. In order to avoid further awkward moments and potential conflicts, Chen decided to train female members to play the lead male character.[25]

The distinct feature of actresses playing the role of *xiaosheng* in Taiwanese opera was only gradually established during the time period under discussion. Hung recalled that the role of *xiaosheng* was primarily played by males but this was changed more evidently after 1945. She first played a *xiaosheng* when she was 17 years old at her father's Taiwanese opera troupe in 1953. Yang and Little Ming Ming, on the other hand, both played male child roles before the age of ten. Another reason contributing to the increased employment of young female trainees in opera troupes can be seen as a consequence of the interplay between cultural and societal factors. Before 1960 Taiwanese suffered from a lack of the knowledge and pragmatics of contraception. It was commonplace for an ordinary family to expect the birth of many babies; some families could easily have more than ten children. When they had too many children to sustain, parents resolved to give their children away or sell them. Little Ming Ming and Yang both draw the example of an old Minnanese saying, which best described this phenomenon of poor families sending children away: "powerless parents sending children to learn acting."[26] Additionally, against this historical backdrop of the male-dominated, wartime impoverished Taiwanese society, Olds points out the Chinese culture as a determining factor in deciding the value of female children. Girls were sometimes allotted a smaller portion of a family's food supply than boys and the parents simply justified that "females are just another mouth to feed and produce little,"[27] and young girls, more often than not, tended to be sold or given away. For instance, Little Ming Ming recounts that all of the children (more than a dozen) adopted by her father's opera troupe were girls.[28] At the same time, due to the high market demands, when the number of Taiwanese opera troupes amounted to more than 300—500 between 1949 and 1956 as mentioned earlier, more child apprentices were needed and recruited.[29] Taiwanese opera troupes became one among other places to which the impoverished children were sent or sold. For example, Chiung-chih Liao (1935-), a famous Taiwanese opera actress and multiple award winner in acting, was taken care of by her grandparents, both of whom passed away when she was 13 years old. Eventually, she was apprenticed to a Taiwanese opera troupe who paid 550 Taiwanese dollars for a contract of three years and four months when she was 14 years old.[30] In sum, the factor of the Japanese regime, the success of opera actresses playing a *xiaosheng* role and the male-dominated culture in the impoverished society all played a role in and contributed to the increased employment and number of girl trainees in Taiwanese opera.

TAIWANESE ATTITUDES TOWARD CHILDREN: LITTLE ADULTS

The image of a child as seen from the adult's point of view has certainly represented a key element in terms of the latter's attitude toward the former. The vision of the child as a pure, untainted creature, popular during the Romantic period across Europe, was a highly idealistic concept cultivated primarily to serve the expressive arts of the time, very much at odds with the period when child labor and poor conditions among unprotected children were the norm. This innocent, vulnerable image of the Romantic child in the West is in stark contrast to the Confucian image of the child in Asian contexts. The Confucian image of the child is represented by its notion of an ideal child, characterized by "a dislike of play" and "young but mature," who is regarded as a "little adult" in childhood.[31] Confucianism, according to Wei-ming Tu, is "a worldview, a social ethic, a political ideology, a scholarly tradition, and a way of life," and for over two thousand years it has served as "the source of inspiration as well as the court of appeal for human interaction at all levels" in East Asia.[32] Confucianism predominated in the most parts of Imperial China throughout its history, including its last dynasty—the Qing dynasty. Consequently, early immigrants from China to Taiwan retained the Confucian philosophy in their ways of thinking and related these to how children should be considered, treated, and raised. This Confucian notion of the ideal child continued to exert its influence in most sections of twentieth-century Taiwanese society. Children from a very young age were encouraged to learn how to be a proper human being through their performance as a good son/daughter. Expected to follow certain manners and show respect toward the elderly, a good son/daughter, most importantly, was obliged to carry out the virtue of filial piety. The definition of filial piety, however, was subject to slightly different explanations throughout Chinese history. According to David Jordan in his discussion of Taiwanese popular thought, filial piety comprises filial obedience and filial nurturance. The former is considered as "the most salient feature of filial piety," which embodies "the subordination of the will and welfare of each individual to the will and welfare of his or her real classificatory parents."[33] To children, this obedience was usually extended to their relations with other authorities, such as their masters, tutors, or elder relatives. Additionally, when children grew up, they were also expected to fulfill filial nurturance, represented by feeding (their parents) and by self-sacrifice.[34] It is this Confucian notion that dictated how children should behave and be raised in most parts of the twentieth century in Taiwan.

The role and expectation of the little adult fulfilling filial piety by helping the family can be observed in Yang's recollections of the errands she often carried out. For instance, when one performance finished, all of the children from her troupe would sweep under the audience's seats searching for objects left by the audiences. As they were generally poor, anything could be potentially useful. For example, they would collect longer cigarette ends for the adult members of the troupe who smoked. Both ends of the cigarette were cut and the remaining tobacco could be combined to make a whole cigarette. Moreover, Yang followed her parents and their troupe to perform at different theaters in different towns, one stop following another; thus, they had no fixed abode, and the backstage area of wherever they performed was their temporary house until they relocated to the next theater. When she went around exploring a new town with other children in the same troupe, she also had to look after her younger siblings (two younger brothers and two younger sisters), carrying one of them on her back and holding the others in her arms.[35] As parents were busy earning the daily bread, it was very common to see older children looking after their younger brothers and sisters in order to provide a contribution to the family's welfare. Little Ming Ming shared similar experiences, in that she, at three to four years old, took care of her baby brother when both of her parents were away from home. When her family moved in the opera troupe where her elder sister was playing the role of *Dan*, she was obliged to help because the opera troupe traditionally only provided meals for those who worked. Young children who lived with their parents in the troupe were also expected to contribute; thus, Little Ming Ming was learning and performing some minor roles when she was four or five years old. Furthermore, Hung recounted, when she was 11 years old, her father set up his own opera troupe and she had the freedom to choose whether to participate in the training or not. At the beginning, she was trained along with other children in the troupe, but shortly after she gave up, because the training was too harsh. She recalled that within two days of practice, her legs were so sore that she could not even walk or go to the toilet. Nevertheless, later, the trainer of the troupe told Hung that she would be able to help her father make a profit by performing as a role of *Sheng* or *Dan*. She then changed her mind and decided to undergo the excruciating training with other child trainees every day, considering that becoming a successful actress would be of help to her father's business and a way to fulfil her obligation of filial piety.[36]

To help with the family income, the child trainees began to perform some insignificant roles starting from a very young age. From Little Ming

Ming's example, we can see that a child could be employed as young as four to five years old. Yang also mentioned she contributed as an extra or by playing walk-on parts in her mother's troupe when she was four years old. According to Hung, most young trainees started to perform on stage as *Chou* (the clown role) because this role allowed a degree of flexibility to entertain the audience. When a young trainee, playing as a *Chou*, made a minor mistake, it could be easily overlooked. For instance, when Little Ming Ming was seven years old performing as an old female shop keeper in a play, she could not even reach the seat behind the shop counter and had to be held up. She would then improvise an amusing excuse to explain to the audience why she could not reach the counter. Although the parents did not entirely depend on the income the children earned through acting, they probably could not afford their children to stay idle. This can be observed by the fact that all of the three actresses' siblings also helped and performed in whatever troupe their parents worked for. Yang recalled that Taiwanese opera experienced a major decline toward the 1960s, and her parents became unemployed. At the age of 17, she decided to join a training program provided by a Taiwanese opera troupe, which organized a group of actresses to perform in the Philippines. During the one-year training in 1960, her entire family relied on the wages she derived from the troupe. When she returned from the Philippines, she had finally earned enough money to purchase the first house for her family in Taipei (before this, her family lived in a rental house).

The concept of the "little adult" in relation to children in the Chinese tradition resembles, to a certain degree, that of pre-eighteenth-century Britain. For instance, in his thoughts on pedagogy, John Locke (1632–1704) suggested that the nature of the child was seldom that of a child, but "treated as a small adult, the child was to be trained out of his childish ways into the moral and rational perfection of regulated manhood."[37] In Chinese families it could be observed that, in the cases of the three actresses under discussion here and in general in the twentieth century, the practice of "spare the rod and spoil the child" was commonly exercised to train the children out of their childish ways. When verbal persuasion did not achieve a desirable result, physical punishment was the typical measure to "help" the children to obey the rules and/or attain their goals. This measure of physical punishment was particularly employed in the opera troupe training, which adopted a rigid and strict discipline in twentieth-century Taiwan. To take an example, regardless of the weather conditions, be it the searing hot summer period or severe cold winter days, Hung recounted that all of the children in her father's troupe woke up at around six in the morning

to practice basic acrobatic skills and movements ranging from backbends, handstands, somersaults, to jumps, squats, and full leg splits. A session of handstand practice lasted five minutes; however, for those who failed or complained the session was often extended to ten minutes. When exercising squats, only the tips of the toes could touch the ground and thick iron chains were laid on the child trainees' arms in order for them to practice balance. Whenever children could not perform these to the satisfaction of the tutor, physical punishment was the inevitable consequence.[38] Yang also mentioned that training in her troupe was carried out under very strict discipline, in that the master demonstrated the movements once which the child trainees were expected to copy. If they failed to fulfill the master's expectations, the wooden rod would be prepared and "served." They woke up before dawn every day, and before eating anything, they had to practice basic acrobatics, gestures, and sword-play. Arduous and spartan though the training might appear, Yang was convinced that undergoing such a mode of training was necessary. Without such demanding and backbreaking training, she believed she would not have been able to do somersaults, jumps, and sword-play, carrying heavy accessories on her head as well as flags on her back for more than 30–40 minutes when she played the lead male role for the first time at the age of 16.[39]

This prevailing attitude toward children and the way of handling child training in opera generally during the first half of the twentieth century in Taiwan is further documented in an article focusing on the methods of training and the performers' own view of the style of Beijing opera. The study was based on interviews with a Taiwanese Beijing opera performer, Chu-hua Chiang, who received her training in Ta Peng Academy in Taiwan before the 1960s and performed in Taiwan as well as in the United States. She expressed the necessity of physical punishment when being asked about using physical punishment as a method of teaching.

> I believe in moderate beatings. Little mistakes do not require whipping. But if a child is to go through strict training, when he makes a big mistake he should be beaten. I have noticed that some of the students have slowed down in their learning because, I believe, they do not get physical punishment.[40]

In particular, when Yang mentioned the master's strict requirements, this clearly shows that the expectation of the quality of the skills and basic movements would not be adjusted merely because the trainees were young. On the contrary, the children were expected to perform as well as the master (adult). They were certainly not regarded as vulnerable or incapable,

but rather, as capable beings, who could succeed as much as adults in the near future through a little "help."

Immediately after the end of Japanese colonization, the corrupt Chinese government and its ill-management, mentioned earlier, finally incited the people to rebel and riot on February 28, 1947 (the 228 incident). Chiang Kai-Shek responded to this with a wholesale massacre of Taiwanese people. According to the *New York Times* on March 29, 1947.

> Foreigners who have just returned to China from Formosa corroborate reports of wholesale slaughter by Chinese troops...These witnesses estimate that 10,000 Formosans were killed by the Chinese armed forces...troops from the mainland arrived there March 7 and indulged in three days of indiscriminate killing and looting. For a time everyone seen on the streets was shot at, homes were broken into and occupants killed.[41]

Hung was 12 years old and had seen many corpses on the street of Tainan city during the massacre. She recounted that she could never forget this horrendous event. When she was hiding with others, she and her younger sister witnessed a person hiding along with them being shot in the head by a Chinese soldier and dying on the spot in front of their eyes.[42] Being a child certainly did not guarantee that they would not be killed in this situation, where they were expected to look after themselves to survive. Thus, children were compelled to become capable, independent individuals at an early age.

Taking such circumstances into consideration, it is no easy task to determine when children in mid-twentieth-century Taiwan stopped being considered "children." Walter Slote in his discussion of childhood transitions in Confucianism and within the family, mentions that children in Confucian families "were expelled from the womb not once, but twice: the first at birth, the second at 6 to 7 years of age."[43] Drawing examples from both Japanese and Korean mothers, he contends that children before six to seven years of age enjoyed a high degree of freedom and received the greatest attention. However, when they reached the age of six or seven, the Confucian "code of ethical conduct of right and wrong" was imposed, and "the switch from indulged childhood to child/adulthood [was] abrupt."[44] Although he points out that childhood and children's indulgence in Confucian families ended at the age of six to seven, he also notes that this timing could vary, depending on the society. From both Little Ming Ming and Yang's examples, we can see that they started to help in Taiwanese opera troupes before the age of six. The society factors we have discussed also compelled them to be mature.

Nevertheless, one might argue that Taiwanese children from a different (wealthy) family background and class might have had different experiences from Little Ming Ming's and Yang's. To answer this question, we may have to review one of the key points of Confucian philosophy. Central to Confucian conviction is the cultivation of self: learning to be human in relation to one's role in society. Only when everyone acts appropriately in accordance with the roles one plays, can political stability and universal peace be reached.[45] Therefore, regardless of the children's age, in the eyes of their parents, they would always be considered children and have to fulfil the responsibilities of their role (filial piety), even after their marriage. In the eyes of their opera master/trainer, the child trainees would always be seen as juniors who should follow certain etiquette rules, such as paying respect to the masters by calling them, for example, by their proper titles.

In sum, we have discussed the origin of Taiwanese opera and how it changed from a social to a commercial activity. Although the performance of Taiwanese opera in its traditional form was prohibited in the late Japanese colonization, we also note that it was in this period when Taiwanese women were encouraged to participate in the labor force and were allowed to perform on stage. Difficulties, hardship, and poverty due to the political changes for Taiwan and its people between the 1940s and 1960s also contributed to the employment of female children in Taiwanese opera, who could then break free from the Confucian idea of the role of women. Yet, the Confucian philosophy still prevailed, in terms of the people's attitudes toward children and child training in Taiwanese opera. The children were compelled and expected to become useful little adults who could provide a contribution to the family. The three testimonies presented in this chapter, albeit brief, contribute a snapshot of the real life experiences of child trainees in Taiwanese opera and how the Confucian doctrine materialized in the way adults considered them and expected them to be capable and well-mannered little adults. Due to the fast development of the country, in terms of its economic betterment and educational policy on mandatory education, it is no surprise that the conditions of training and recruitment have profoundly changed today.

NOTES

1. The direct translation of Taiwanese opera into English would be "song drama." The song refers to the folk songs of Yilan from which Taiwanese opera emerged approximately in 1911; see Tsu-shang Lu, *Taiwan dianying xiju shi* [The history of Taiwanese film drama play] (Taipei: Yin hua, 1961),

233–34. While some believe it was formed before that, most agree on its history of at least one hundred years; see Lu and, for example, Xiu-jin Huang, *Zushiye de nüer: Sun, Tsui-feng de gushi* [The daughter of the founder of a sect of Taoism: the story of Sun, Tsui-feng] (Taipei: Shi bao wen hua, 2000), 4.
2. See "A Brief Overview of the Centenary of the Republic of China," *Culture.tw*, last modified May 11, 2011, http://culture.tw/index.php?option=com_content&task=view&id=2064&Itemid=157. Also see the website of Ming Hwa Yuan Arts and Cultural Group for further information: http://www.twopera.com.
3. Chi-tun Hsu, *Taiwan jin dai fa zhan shi* [Modern History of Taiwan] (Taipei: Jian wei chu ban she, 1996), 43–48.
4. According to Yang, the early form of Taiwanese opera focused on singing the folk songs while sitting. It then combined the body movement and the music of *che gu xi* and Hakka tea picking. *Che gu xi* (car drum drama) is a comedy drama played for the purpose of divine worship and normally performed by only two players who put on exaggerated or ridiculous costumes and make-up to earn laughter. It was believed that *che gu xi* has more than 240 years of history. See Fu-ling Yang, *Taiwan gezaixi shi* [The history of Taiwanese opera] (Taichung, Taiwan: Morning Star Group, 2002), 38–46.
5. See Yang, *Taiwan gezaixi shi*, 24–25, 54–61.
6. Harry J. Lamley, "Taiwan Under Japanese Rule, 1895–1945: The Vicissitudes of Colonialism," in *Taiwan: A New History*, ed. Murray A. Rubinstein (New York: M. E. Sharpe, Inc., 2007), 204–5.
7. According to Yang, features of other kinds of operas, such as Beijing opera and Hakka tea-picking opera, were also integrated into the performance of Taiwanese opera. A number of Beijing opera troupes came to play in Taiwan, and some of them eventually stayed and taught the art and movements of combat in some Taiwanese opera troupes during the 1920s. Since then, combat has been integrated into Taiwanese opera. See Yang, *Taiwan gezaixi shi*, 38–46, 67–69.
8. See Hsu, *Taiwan jin dai fa zhan shi*, 381–82, 404–12, 433–38 and Lamley, "Taiwan Under Japanese Rule, 1895–1945."
9. Lamley describes how the Chinese-language sections were abolished in the colony's newspapers and classical Chinese was removed from the elementary school curriculum in order for the inhabitants of Taiwan to become "true Japanese." In addition, the Japanese state religion, Shintoism, was forced upon the Taiwanese; the traditional Han Chinese religions practised on Taiwan and in their shrines were to be eliminated. Wedding ceremonies were also supposed to follow the Japanese traditional model (Lamley, "Taiwan Under Japanese Rule, 1895–1945," 240–42).
10. Lamley, "Taiwan Under Japanese Rule, 1895–1945," 242.
11. Hsin-hsin Tsai, *Cui can ming xia gezaixi ying shi san qi hongxing xiao ming-ming juyi rensheng* [Little Ming-Ming's biography] (Yilan, Taiwan: Preparatory Office of the National Headquarters of Taiwan Traditional Arts, 2011), 30.
12. Yang, *Taiwan gezaixi shi*, 99.

13. See Tsai, *Cui can ming xia gezaixi ying shi san qi hongxing xiao ming-ming juyi rensheng*, 30–33.
14. See Steven Phillips, "Between Assimilation and Independence: Taiwan Political Aspirations Under Nationalist Chinese Rule, 1945–1948," in *Taiwan: A New History*, ed. Murray A. Rubinstein (New York: M. E. Sharpe, Inc., 2007), 282–284. Also see Hsu, *Taiwan jin dai fa zhan shi*, 461–66.
15. In the evening of February 27, 1947, a team from the Tobacco Monopoly Bureau in Taipei confiscated a widowed cigarette dealer's stock of cigarettes. When begging them to return some of the cigarettes for her living, she was hit savagely on her head by one of the agents with a pistol and eventually fainted. The crowd, already frustrated by the ongoing unjust corruption and unemployment, surrounded the agents, one of whom fired into the crowd and killed a bystander. This incited the people to rebel and riot on the following days, gradually spreading throughout the entire island. Chiang Kai-Shek and KMT responded to this incident with a wholesale massacre. It was estimated that in these ten more days approximately twenty-eight thousand Taiwanese people were killed and many had continued to be arrested and executed. See Hsu, *Taiwan jin dai fa zhan shi*, 1996.
16. For a more detailed overview of the differences, refer to Ella Lin, "The Difference between Taiwanese Opera and Beijing Opera," *Taiwanese Opera: Traditional Opera from Formosa*, last modified April 8, 2002, http://www.twopera.net/article/compare.php.
17. Xinyan Jiang, "Confucianism, Women, and Social Contexts," *Journal of Chinese Philosophy* 36:2 (2009): 234.
18. During most of the twentieth century and even before, the job of being an actor/actress was considered the lowest rank, on a level with prostitutes and servants, in Taiwanese society. Thus, only poor families would send their children to be apprenticed to opera troupes. See Kang-yan Pien, *Taiwan Fongsuizhi* [Taiwan customs records] (Taipei: Zhong wen, 1994), 147–48; and Mei-se Lin, *Gezaixi huangdi: Yang Li-hua* [Emperor of Taiwanese opera: Yang, Li-hua] (Taipei: Shi bao wen hua, 2007), 15–18.
19. Kelly B. Olds, "Female Productivity and Mortality in Early-20th-Century Taiwan," *Economics and Human Biology* 4 (2006): 212.
20. See Hsu-ling Chiu, *Taiwan Yidan fonghua* [Geisha arts in Taiwan] (Taipei: Yu shan she, 1999), 288–89.
21. Yang, *Taiwan gezaixi shi*, 74.
22. Ibid.
23. See Yang, *Taiwan gezaixi shi*, 74–75.
24. See the example of Li-hua Yang and the comments of her female fans and friends at http://www.rtbot.net/play.php?id=QOhU53sfuBE, accessed November 3, 2012. See also Lin, *Gezaixi huangdi: Yang Li-hua*, 131; and Hsin-hsin Tsai, *Yue ming bing xue xian: you qing ama Hung Ming-hsueh de gezaixi rensheng* [Grandmother Hung, Ming-hsueh's life of Taiwanese opera] (Taipei: Cultural Affairs Department of Taipei County Government, 2008), 66.

25. See Huang, *Zushiye de nüer*, 148–49. Chen's example was narrated by his daughter-in-law, Tsui-feng Sun, the most acclaimed Taiwanese opera actress at Ming Hwa Yuan Arts and Cultural Group. Further investigation is needed to determine whether his example should be considered unique or one among many others at the time.
26. Fu mu wu shengshi, sheng zi qu xue xi: powerless parents, "sending children to learn acting" (my translation). Interested readers can see a more detailed explanation at: http://taiwanpedia.culture.tw/web/content?ID=12935.
27. Olds, "Female Productivity and Mortality," 206–8.
28. See Tsai, *Cui can ming xia gezaixi ying shi san qi hongxing xiao ming-ming juyi rensheng*, 33.
29. For instance, it has been mentioned in Hong's biography that in 1946 the Tainan Theater was urgently recruiting child apprentices aged 15–18. See Tsai, *Yue ming bing xue xian*, 38.
30. In 1949, five New Taiwanese dollars could be converted to one American dollar, and 35 American dollars were worth 1 ounce of gold.
31. Limin Bai, "Children at Play: A Childhood beyond the Confucian Shadow," *Childhood* 12:1 (2005): 10.
32. Wei-ming Tu, "Confucius and Confucianism," in *Confucianism and the Family*, ed. Walter H. Slote and George A. DeVos (New York: State University of New York, 1998), 3.
33. David K. Jordan, "Filial Piety in Taiwanese Popular Thought," in *Confucianism and the Family*, ed. Walter H. Slote and George A. DeVos (New York: State University of New York, 1998), 268.
34. Jordan, "Filial Piety," 270–71.
35. See Lin, *Gezaixi huangdi: Yang Li-hua*, 40–44, 67.
36. Tsai, *Yue ming bing xue xian*, 48.
37. Peter Coveney, *The Image of Childhood* (SI: Penguin Books, 1957), 40–41.
38. Tsai, *Yue ming bing xue xian*, 48–49, 52–53.
39. Lin, *Gezaixi huangdi: Yang Li-hua*, 54–55, 75–76.
40. Donald Chang, John D. Mitchell, and Roger Yeu, "How the Chinese Actor Trains: Interviews with Two Peking Opera Performers," *Educational Theatre Journal* 26:2 (1974): 189.
41. Tillman Durdin, "Formosa killings are put at 10,000," *New York Times*, March 29, 1947, accessed July 8, 2012, http://www.taiwandc.org/hst-1947.htm.
42. See Tsai, *Yue ming bing xue xian*, 39.
43. Walter H. Slote, "Psychocultural Dynamics within the Confucian Family," in *Confucianism and the Family*, eds. Walter H. Slote and George A. DeVos (New York: State University of New York, 1998), 47–48.
44. Walter H. Slote, "Psychocultural Dynamics," 49.
45. See Tu, "Confucius and Confucianism," 7–13.

11. Higher Wages, Less Pain: The Changing Role of Children in Traditional Chinese Theater

Mark Branner

One scene in Chen Kaige's[1] remarkable film, *Farewell My Concubine*, summarizes the powerful grasp that traditional Chinese theater once had on the imaginative lives of young people—both future performers and spectators alike. Two boys have deliberately run away from their Beijing Opera school, determined to escape the constant beatings and almost inhuman training regime. They race through the back streets of the city, eating forbidden snacks and enjoying their newfound freedom. As if by chance, they stumble into a bustling theater. With a sudden and ear-splitting cacophony, the performance begins. Blaring reeds, metal gongs, percussive mallets on wooden blocks, and tautly wound string instruments break the silence with a decided clap of sound as an army of actors carrying banners fills the stage. Then, in a spectacular display of almost superhuman ability, another actor clothed in a vibrant-colored silken gown enters, performing repeated backflips with increasing speed. Suddenly the lead actor enters. His painted face—a remarkable pattern of lines, shapes, and hues—seems already otherworldly as he too adds to the visual and aural excitement, belting out a piercing introductory statement to begin the narrative and amplify the cacophony of sound and spectacle already swelling the space. The boys, jostled behind a large crowd in the back of the theater, squirm to get a better look. Suddenly they decide to take turns sitting on one another's shoulders, allowing the boy on top to see over the crowd. As the sound of the introduction builds to a crescendo and the

lead performers begin to sing, the camera slowly zooms in on the faces of the two boys. Both are transfixed. One has tears streaming down his face, the other urinates down the neck of the boy he is sitting upon. This one spellbinding initiation into the full spectacle of this art convinces the boys to return to the school, knowing full well that their return will result in severe beatings from their master for their disobedience. But what else can they do? They have seen, heard, and felt the power of the theater and will never be the same.

With a unique synthesis of performing arts—acrobatics, singing, acting, dancing, pantomime—traditional Chinese theater is a performer-driven *tour de force*—capturing nearly all of the senses. Various translations in English have been given for this unique Chinese art form, known inclusively in Mandarin as *xiqu*. These include "Chinese song theater," "Chinese music drama," and "Chinese Opera."[2] In essence *xiqu* encompasses the major indigenous Chinese theater forms—all actor-centered work that combines music, song, acrobatics, acting, and other elements into a plot-based drama. In traditional Chinese theater, the "actor's total physical being is keyed to a pitch of instantaneous response at several levels, a transcendent deployment of his own dynamism, and it is to achieve this prized state that every actor is submitted to long and merciless training."[3] The years of intensive training that it takes to achieve this transcendence on stage historically developed from childhood through adolescence and into adulthood. Most performers enter traditional theater training before the age of ten and endure at least seven to eight years of formalized schooling, followed by several additional years apprenticed to a local troupe. Thus, children serve as the lifeblood of traditional theater as young artists are either tutored by traditional Chinese theater masters or nurtured in traditional Chinese theater schools, then adopted into traditional Chinese theater companies, and, after years of study, practice, and apprenticeship, eventually fill out the casts on traditional Chinese theater stages.

TRAINING CHILDREN TO "EAT BITTERNESS"

As the first foreign student formally enrolled at the Sichuan Opera School during the academic years 1995–96, I found myself surrounded by dozens of children training to be traditional Chinese theater performers. Though my blonde, lanky, twenty-something self literally stuck out like a monster among a sea of black-haired nine to fourteen year olds, I was allowed to participate in all of the daily training practices and observe firsthand the

culture and climate of theater training that has developed over hundreds of years.

"To understand traditional Chinese performing arts, you must understand eating bitterness."[4] The Chinese term—*chi ku*—literally means to "eat bitter" and is central to the training of children in traditional Chinese theater. Offered as a compliment of the highest praise—"that foreigner can really eat bitterness"—or used as the foulest pejorative—"he'll never amount to anything, he can't eat bitterness"—the phrase refers to the ability to endure great pain, tolerate deprivation, brave withering criticism, and suffer physical abuse, all with the goal of performing miraculous feats on stage. My master teacher would often repeat a mantra as we attempted to live through his training methods, "We eat bitterness in order to appear effortless on stage."[5]

In order to accomplish the almost superhuman demands of traditional Chinese theater, all students must endure great pain. In our daily training, we would often stretch for hours at a time, legs spread into a horizontal split with the master teacher repeatedly coming up behind each student and leaning his or her full weight on the student in order to press the child nearer to the ground. My foreign status certainly spared me the full extent of pain involved in these sessions, but my child compatriots were much less fortunate and would literally scream in agony, tears streaming down their faces as their muscles were forced into unnatural positions. In order to build leg strength, heavy sandbags would be tied to each student's calves and then the children would be directed to hop up flights of stairs—with older students expected to clear four to five steps in each bound. Often the greatest pain would result from exhaustion, not just exertion. To perfect backflips, children would be asked to perform dozens of them in a row, sandbags still firmly affixed to their legs. This would often result in students literally falling on their faces after the sheer exhaustion of 30 sequential backflips. Repetition to the point of exhaustion was common in all subjects—acting, singing, acrobatics, etc. No proverbial bell would save the students as teachers could demand that a child sing a phrase over and over and over again, despite the formal end of a class period.

In addition to enduring the pain of training for a life in traditional Chinese theater, children tolerate many deprivations during their years of training. In enrolling formally at the Sichuan Opera School, I had wanted to experience everything that a typical student experienced. Fortunately for me, the regulations at the time did not allow me to stay in the student dormitory. After viewing the accommodations, I am sure that I could never have stomached the living conditions that tens of thousands of

Chinese children bravely bear—not just in traditional theater schools, but in schools across the country. In 1995, the minimum number of students staying in a small dormitory room was ten. These dormitory buildings provided the barest minimum, a concrete shell with unfinished and unpainted walls and floors. Windows were often missing panes of glass or were simply filled with newspaper. This meant that the rooms were constantly full of mosquitoes, cockroaches, and other pests. Beds were simple metal frames and no mattress was provided. Children would often lay a piece of cardboard over the wire support slats to serve as the mattress. Those more fortunate might receive a coarsely woven reed mat instead of cardboard. None of the rooms was provided with any heat or cooling mechanism. Hot water for showers was a luxury and was provided once a week at most. Additional examples abound, but the conclusion is easy to make. Children in traditional theater schools have little in the way of creature comforts.

The withering criticism that children brave on a daily basis in the training process is another element of eating bitterness. During my time at the school I rarely witnessed teachers offering positive affirmation to children. Instead, the default mode seemed to be severe verbal criticism. "What are you doing?!" "You call that an entrance?!" "Not like that!" "No, stupid. Wrong again!" This verbal barrage follows children throughout their days. One unique aspect of this constant stream of criticism is that the denunciations can come from a variety of sources—not just the child's primary teacher. Often one of the janitors of the school would stop and watch our class's training sessions and then offer his verbal criticism of each student's respective work. Our master teacher would allow various janitors to add his or her opinions on our training and then pick up where the janitor had left off. This happened on numerous occasions, with other teachers and individuals with whom we'd had absolutely no contact given free rein to condemn elements of our performing technique.

Finally, the use of corporal punishment to enforce compliance has been accepted as a common convention in traditional Chinese theater training and students have historically received this physical abuse as standard practice. I witnessed the wide-ranging use of beatings—with a hand, a switch, or any object that happened to be nearby—upon young opera students. One incident in particular, stands out as a definitive example of the fundamental difference between actor training in the West versus training in China. A group of young girls, ranging from ten to twelve year olds, were rehearsing their entrances, a formalized synthesis of pantomime, movement, and sung or spoken introduction. Their female teacher was sitting off to one side of the stage, slumped down in a chair, shouting bitter critiques.

"Do it again!" "You call that an entrance? Again!" One young girl was asked to perform her introduction over and over, receiving a harsher and harsher verbal lashing each time she finished her opening bit. Finally, after receiving another bark from the instructor to repeat her moves, the girl muttered something under her breath. I doubt that even the teacher heard what was said, which may have simply been, "Again?" But, perceiving backtalk, the teacher sprang to life from her slumped position and struck the student's cheek with an audible and angry open-handed swat. The student nearly fell to the ground from the blow and immediately began sobbing hysterically while the teacher stood over her, swearing rebukes at a deafening volume.

The most amazing detail about this entire incident, however, is that later that day, the same teacher sat cradling the student she had earlier beaten severely on the face. The teacher was stroking the student's hair as if the girl were her own daughter and the student looked up at the teacher, apparently chastened and completely forgiving of the teacher's harsh discipline. This casual acceptance on both sides—teachers and the students—of corporal punishment came as an absolute shock. As a recent graduate from a typical Western liberal arts college majoring in theater, the chasm in teaching methods employed when learning an art in China versus the training employed in my own country could not have been more clearly delineated.

My experiences studying Sichuan Opera in central China during the 1990s were in no way atypical of traditional Chinese theater training—across regional forms, across decades of history, and across the geographic boundaries of China. Jackie Chan, the international action movie star, began his career as a student of *xiqu*. Although he studied *jingju* (Beijing Opera) and his training took place in Hong Kong in the early 1960s, he describes his decade-long training under his master teacher in this way:

> I sweated and cried and bled under my Master's hands. I cursed his name when I went to sleep at night, and I swallowed my fear and hatred of him when I woke in the morning. He asked for everything we had, and we gave it to him, under pain of injury, or even death.[6]

In fact, when asked whether the harsh training methods I experienced at the Sichuan Opera School differed significantly from other forms of traditional Chinese theater—*jingju, yueju, kunju* (Beijing Opera, Yue Opera, Kun Opera)—my teacher's response was immediate, "Very little."[7]

In the mid-1990s the teachers at the Sichuan Opera School were rather blasé about the repeated uses of corporal punishment. The general sentiment could be summed up in the belief: "Well, this is how we were taught. It has always been this way." Even those teachers who did not employ

corporal punishment acknowledged as much. My mentor, for instance, never used corporal punishment, though most Western students would consider him to be incredibly hard-nosed. But he freely admitted to the pervasive use of corporal punishment from every one of the teachers he could remember when he was a student. In fact, in the mid-1990s some of the older teachers at the school would decry the easing of corporal punishment practices, citing this as a reason for the decline in the quality of younger performers. Historically then, in the traditional Chinese training environment, students are not merely subjected to intense physical demands, asked to survive for years with almost no "luxuries" (hot water, a mattress, etc.), and bear up under intense verbal censure, but they are likely to be beaten by instructors if their efforts are deemed less than exemplary.

The eight years of training that children receive of each aforementioned element—enduring great pain, tolerating deprivation, braving withering criticism, and suffering physical abuse—teach the student how to eat bitterness. Those who survive this treatment for the requisite years emerge as truly amazing performing artists. However, this system of training is certainly not for everyone and has obvious drawbacks. The attrition rate of students during the long process of cultivation in the 1990s was significant. Teachers at the Sichuan Opera School would consider it a very good year if close to one third of an initial class that began studying together seven or eight years previously actually graduated.[8]

A LITTLE LESS BITTERNESS, PLEASE

Of course, the mid-1990s are now ancient history when considering the rapid pace of development in China. Many of these long-established practices of training children to eat bitterness are changing rapidly or have already changed. When asked how the relationship between teachers and students has changed in China over the past 20 years, my master teacher nearly erupted:

> It is totally different now! There used to be an enormous amount of respect given to teachers. Now everything is centered on the student. The students come only to get what they want out of the training. They don't care about honoring the art or honoring their teachers. In the past there was an agreement between the teacher and the student. The teacher would be a master and become like a parent to the student for eight to ten years. Now students determine how long they want to study and how hard they want to study. Now, we give the students whatever they want.[9]

This eruption led my teacher to launch into a story that obviously caused him great personal distress, as it reflects just how radically and quickly training practices have changed from the traditional ideal of master/student that he has devoted his life to:

> Not long ago one student came to studying *bian lian* from a master teacher [*bian lian* is a seemingly magical face-changing effect that is widely considered to be one of the most distinctive effects of Sichuan Opera, as the performer quickly changes painted faces in full view of the audience]. But, as soon as the student had learned the effect, he quit all of his study and went out to make as much money as possible—only performing the *bian lian* effect for tourists without any context of Sichuan Opera. Then, when his teacher fell ill, he didn't even visit him in the hospital or call. In fact, he didn't even contact the family or attend the funeral when the master teacher died![10]

The hurt contained in my master teacher's voice as he recounted this story was palpable. The expectation of a student to his or her master in the past would have been entirely different. Instead of the total neglect described, the student would be expected to act like a son or daughter to the master teacher, providing care and comfort in times of trial. Historically students owed a debt to their teachers that required a lifelong commitment. However, the training methods that have developed over hundreds of years, especially the relationship between teacher and student, have vanished almost overnight.

Asked what other training practices in traditional Chinese theater have changed over the span of 20 years, my master was quick to respond. While the practice of corporal punishment is still common today, the effect and use of it has changed significantly:

> In the past there was indeed a 'culture of hitting.' This is the way students were taught. It is the way that we were taught. Now, there are only a few instances when corporal punishment is used. One is when a student has been told to do something repeatedly but simply doesn't listen. The other is when a teacher actually cares for a student and knows that the student isn't really trying.[11]

My teacher went on to explain that if a student's training these days is too grueling, the student is likely to simply leave the school and look for better career options. In my teacher's opinion, the painful eating of bitterness that all children historically endured when studying traditional Chinese theater—enduring great pain, tolerating deprivation, braving withering criticism, and suffering physical abuse—has been altered so

significantly that many graduates don't even have the rudimentary skills needed to succeed as well-rounded traditional theater performers.

Other recent changes have dramatically altered the demographics of the student body. As a student of traditional Chinese theater in the mid-1990s, a majority of those studying were young boys. This makes logical sense, since three of the four main role types (*sheng, dan, jing, chou*—male, female, painted face, clown) in traditional Chinese theater are reserved for male actors. This is no longer the case. While the total student body at the Sichuan Opera School has declined from more than a hundred students in 1995 to less than forty today, almost two-thirds of these students are now young girls. When asked about this change, my teacher explained that the recent imbalance is caused by financial realities. With the radical changes to China's economy, fewer and fewer traditional opera troupes are now operating. This creates a challenge for any young graduate from a traditional theater school. However, those troupes still operating are eager to find attractive young women to showcase, drastically changing the repertory of traditional plays to provide patrons the chance to view attractive young female actresses. In addition, my instructor noted that young women could easily use the skills they learn from studying traditional theater to perform at restaurants, act as hostesses in karaoke bars, or even go into modeling.

YOU'VE LEARNED TO "EAT BITTERNESS"... NOW WHAT?

Graduating from a traditional Chinese theater school grants the student entrance into a network of government-funded troupes operating throughout each province.[12] In China's planned economic system, this is commonly referred to as the Iron Rice Bowl, based on an idiom that indicates that an individual's needs (his or her "rice bowl") will always be met. Under the Iron Rice Bowl system, once an individual receives a position with a government-funded work unit, he or she is guaranteed housing, a salary, health care, retirement benefits, everything needed to care for an individual throughout his or her life.[13] Prior to the economic reforms of the last several decades—commonly referred to as "Reform and Opening"[14]—this form of job placement was the standard practice among most individuals in China. Individuals would be assigned to a specific work unit and they could essentially rest in the assurance that the state would care for them.

The actual practice of apprenticeship for young traditional Chinese theater performers in local troupes can be likened to that of a tenure process in

a standard Western academic setting. As an "assistant performer," the individual is expected to continue his or her education, learning new operas, studying with the new "teachers" in his or her new troupe, continuing to review with instructors from their former school, etc. As a recent graduate, the student is a "third rank" performer and is expected to put in this extra effort for at least five years before being considered for a salary increase and raise in status.[15] Beyond this initial five-year stage, the performer will have to dedicate at least another ten years before he or she can qualify for consideration as a "first rank" performer, along with an additional pay increase.

The fifteen years of additional work required to achieve the top performing rank is a difficult pill to swallow after a student has already endured eight years of suffering in training to be a traditional theater performer. The initial salaries offered to recent graduates vary by location and province, but are typically quite low. Recent graduates from the Sichuan Opera School were only given $700 RMB per month (about $115 USD), though this doesn't account for some additional benefits received (subsidized housing, free health care, etc.)[16] As a result of these low salaries and the continuing arduous road required to slowly move up the rank and salary ladder, most performers today eschew the apprentice designation and try to market themselves as "experienced actors" at venues that are often far afield from traditional theater stages (nightclub entertainments, restaurants, local television studios, etc.). In a recent conversation with my former mentor, he decried this behavior, stating, "These new graduates think they know everything after learning just three operas. They know nothing! They are just like everyone else in the country—including our leaders." Then he uttered a commonly heard phrase as if it were an expletive. "These performers are just 'eager for instant success and quick profits.'"[17]

In fact, many of the Sichuan Opera performers I interacted with in the mid-1990s were already beginning to moonlight at restaurants and karaoke bars, adding to their meager salaries. Though the Iron Rice Bowl was to have sustained them financially, allowing them to focus solely on their art, the recent economic reforms allowed for a rapid increase in the price of many goods and the chance for individuals leaving state-owned enterprises to make huge sums of money in a very short time. Traditional Chinese theater performers were not sharing in this newfound wealth and sought out "side gigs" to supplement their income. In fact, the need to find other sources of income is often not so much a matter of "keeping up with the Joneses" as simply finding a way to survive in a modern China that

seems to have changed almost overnight. Even my master instructor, a virtuoso of the clown role, who is vehemently against performers "dumbing down" the traditional form for cheap entertainment, began experimenting with all manner of "income addition"—establishing a small eatery outside the opera school compound, selling recordings of his performances at tea houses, etc.

THE GREATEST BITTERNESS OF ALL

The Opening and Reform policies have literally transformed China in just a few decades. As the fastest-growing economy in the world, China has quadrupled the per-capita income of millions.[18] What took the United States a century to accomplish, China has done in 20 years, as a booming middle class (estimated to exceed 800 million in a little over a decade)[19] strives to join a growing number of new Chinese millionaires and billionaires. This economic progress has spread to even second, third, and fourth tier cities. China's leaders have undeniably issued forth another cultural revolution—this one based not on an image of Mao on a red book, but of Mao on a $100 *yuan* bill:

> Inevitably, China's absorption of Western science, technology, and economic practices as well as its expanding international trade were accompanied by an inflow of Western political ideas and values. This inflow quickly turned into a tidal wave by the late 1980s, pouring into China through books, travel, phones, films, radio, television, fax, e-mail, the Internet, tourists, and advertising and popular culture from Hong Kong and Taiwan.[20]

This phenomenon of rapid globalization is seen in many other cultures. With the arrival of global goods, traditional artistic practices must suddenly compete with big-budget Hollywood films, television, and other mass-media entertainments. In China, however, the circumstances are more pronounced, owing to the radical difference between the nature of contemporary life and the period during which these traditional theater forms initially developed.[21] Traditional Chinese theater does not reflect any part of the reality of most young adults in contemporary China. One Chinese scholar notes, "Everywhere young people prefer pop music and American culture to traditional art. Where China is different is in the fact that we also lost our audience for the traditional arts for ten years during the Cultural Revolution. So this added fuel to the fire of a natural loss of interest resulting from globalization."[22] Thus, the overall interest

in traditional Chinese theater among the majority of the populace has declined sharply:

> Most young people find the dominant traditionalism of the Peking Opera boring. The Cultural Revolution, when all traditional items were banned, broke the thread of appreciation which had persisted since the birth of the genre. It created a generation which both could not understand the Peking Opera and did not see the point in trying to understand it.[23]

The tidal wave of Western culture coupled with the upheaval of traditional arts that the Cultural Revolution produced has decimated the interest in traditional Chinese theater. With all of the many challenges facing those children who decide to pursue a career as a performer of traditional Chinese theater, perhaps the bitterest realization of all is that the audience that they have trained so long and hard to entertain has vanished.

HIGHER WAGES, LESS PAIN

At the height of the Sichuan Opera School's influence, there were more than two hundred students studying to be traditional Chinese theater performers. Now there are fewer than 40.[24] While numerous reasons may be attributed to this steep decline, without question the two chief culprits are the economic changes of the last few decades and the institution of the One Child Policy.

In the past, despite the brutal training methods of children in these traditional forms, the decision to send a child to study theater could be easily justified. Most children studying traditional Chinese theater—both in the past and even up to the present day—do not come from families with great wealth or political connections. Instead, they come from small villages and farming communities where opportunities for advancement are scarce.[25] For at least the last century and a half, parents could legitimately feel that the rigorous and painful system of actor training would, in the end, lead to gainful employment. The school would provide for all of a child's needs and the child would emerge from this training period as a young adult with a marketable skill. Parents could reasonably justify that the system of actor training and employment was good for both the family and the child.

With China's economy booming, giving seven or more years of one's life to the grueling rigors of training required to succeed as a traditional theater performer is no longer seen as a good investment, even by peasant

families. As China adopts market-oriented reforms across the board, even in historically state sanctioned and sponsored enterprises like the performing arts, the guaranteed safety net of a regular income and gainful employment that previous generations expected, is quickly evaporating. In light of these changes, it seems only logical that ambitious students, even those from poor countryside homes, would find opportunities outside the harsh realities of becoming a traditional stage performer when making their way in the world.

One of the great pleasures of enrolling in the Sichuan Opera School was interacting with very young and very talented "performers to be." Perhaps the most talented student of all that I met was a slight, unassuming young man in his late teens. The two of us were both under the mentorship of the same master clown teacher and we would spend many hours together, stretching, balancing bowls on our shaved heads, repeating lines of text, singing, etc. This student, like most that I met, was from a poor village, far from the bustling city where our school was located. He was nearing the end of his time at the school and was looking toward a career in the theater. The year after I left, however, he was selected to be part of a privately funded cultural tour to the United States. This was a great honor and the student would be making at least twice what he could make at a local government-funded troupe in China. However, within a few months of his arrival to the United States, he defected from the troupe and found better wages washing dishes as an illegal immigrant in a Chinese restaurant. Rather than eating the bitterness of a low salary, performing what is recognized worldwide as one of the great world theater forms, this young man opted to eat the bitterness of life as an illegal immigrant with better pay.

His decision is mirrored every day in the new China. Young people in today's China can easily make up to $100 RMB per day or more ($16 USD) by working at McDonalds or at Kentucky Fried Chicken.[26] Others can instantly find short-term jobs at karaoke bars or Chinese restaurants.[27] These jobs do not necessarily require a high school diploma. Then, of course, there are the thousands of factories in China's larger cities that are eager to snap up untrained young adults into massive complexes that provide housing, food, and salaries far exceeding those of entry-level traditional Chinese theater performers. In just one week, young adults working at fast food restaurants, in karaoke bars, or in any number of manufacturing facilities, can earn more than the monthly salary of a student who has endured great pain for eight years of his or her life studying traditional Chinese theater. In fact, one student recently told us of his short-term job on a labor crew installing telephone poles in remote mountain regions. As

a recent high school graduate he had received more education than anyone on his crew. However, all of the other hardscrabble young men on the crew were earning at least double what a recent traditional Chinese theater graduate could make.[28]

The Iron Rice Bowl of China's previous planned economy was intended to allow traditional theater performers the ability to pursue their art without worrying significantly about financial matters. Parents could rest assured that their progeny were being provided for while gaining lifelong skills that would propel them after graduation into a state-supported troupe that would care for them throughout their lives, even after retiring from the stage. As the Iron Rice Bowl system has been replaced by market capitalism, young people are finding better salaries in almost every sector. Summarizing the reasons for the decline of students at the Sichuan Opera School, one teacher wrote:

> First, the poor salary. Second, the government and related cultural departments have not paid enough attention to traditional arts and the social status of these practitioners has naturally declined. Third, because of the new economy, people are eager to get rich, and they have impetuous attitudes.[29]

Compounding these economic realities, China's One Child Policy,[30] limiting the number of children most families can even conceive, has dramatically shifted the perceptions of China's vast majority. Instead of viewing child rearing as a challenging economic constraint—three or five or even ten mouths to feed—the average Chinese family now sees only one little "empress" or "emperor" to coddle, spoil, and direct toward an Ivy League education.[31] "When parents can have only one child, they do everything they can to help that kid get ahead."[32]

A professional Chinese acrobat friend intimated that his parents' real decision to send him to become a performer boiled down to a simple decision of family finances:

> My parents had several children already and they had difficulty feeding all of us. I was a rowdy boy who liked to jump off of things and tumble around. For my parents it just made sense to enroll me in the provincial acrobatic school. The school would provide for all of my physical needs—clothes, food, lodging—and my parents could still come visit me on the weekends.[33]

These provincial acrobatic schools follow an identical model to traditional Chinese theater schools. They are government-funded entities that train children to become professionals, thereby allowing the children to move

from training into apprenticeship positions for a base salary at a provincial acrobatic troupe. Prior to the implementation of the One Child Policy, these schools provided economic options for families with more than one child. These days, the decision to send a child away for eight years doesn't make economic sense. Even poor villagers can make $100 RMB a day installing telephone poles for government development projects.[34]

Instead of parents worrying about how they can feed their multiple children, now parents have one child and they worry about how they can maximize the earning potential of this "golden child." My teacher summed up the situation succinctly:

> There is great pressure to get everything exactly right with your one child. Parents want to send the child to the best elementary schools, provide the best tutoring, provide the right test-taking preparation so that their child can get into the best college and then earn the most money. Then, these children have to worry about how to buy a house as soon as they get married and then the cycle starts again when the former child has a child.[35]

Modern China's leaders have implied that "to get rich is glorious"[36] and parents and grandparents under the One Child Policy devote their entire focus to molding this only child, hoping to steer a young "emperor" or "empress" into a field that can produce a lucrative career. The lifeblood of traditional Chinese theater—the next generation—is drying up. Parents and children no longer consider a career in theater a valid economic option. Young boys and girls are not transfixed like the boys in Chen's film with magnificent actors upon the stages of traditional Chinese theaters.

CONCLUSION

The critical issue at stake in this discussion is that this most distinctive of Chinese arts will be relegated to a museum piece for tourists in the very near future. To a certain extent, this has already happened. Though the government still heavily subsidizes the practice of traditional theater forms,[37] it cannot replace the link that has been broken between the creators and potential innovators of this form, playwrights, actors, musicians, and the larger audience of China. Prior to the start of the Cultural Revolution in 1966, my mentor estimated that over two hundred Sichuan Opera troupes operated throughout China—most of these were based in the province of Sichuan, but some even operated several provinces away. Several Beijing Opera troupes used to operate out of the central Chinese

city of Chengdu. These traditional theater forms served as the nation's collective entertainment. Now, there are fewer than 20 Sichuan Opera troupes still in existence.[38] As China rushes headlong into modernity—demolishing tree-lined streets of courtyard houses that have existed for over a century to make way for stainless steel and glass skyscrapers or apartment complexes[39]—the collective cultural desire to hold onto traditional practices has been lost.

This is particularly true of the children who once were drawn to studying these traditional theater forms—often for financial reasons with the consent of their parents, but also for the aesthetic wonder of the art form and the incomparability of the performer on stage. As a student at the Sichuan Opera School in the mid-1990s, I was one of over one hundred *xiqu* students still pursuing this dream, before the complete effects of economic modernization had fully arrived. Now this number has dropped below 40.[40] Summarizing many of the points already introduced in this chapter, an instructor at the school cites the fundamental economic realities as the crucial reason for the precipitous decline in the school's enrollment:

> Low pay leads to the loss of many talented actors, and this decline in student enrollment is compounded year after year. In addition, there is a big problem for *xiqu* graduates in finding work, since a large number of basic performance troupes have been disbanded. In the past, those studying traditional theater forms were easily assigned a job by the country. Therefore, students had no fear of finding a job. But the school is still operating on a planned economy system that has no bearing on the actual market demand.[41]

The school is staying afloat by offering courses in television acting, modeling, and MTV-style dance training. In fact, they have become a very small unit within a much larger college. This allows them to stay alive while the college attracts additional students to "new" and "developing" fields such as television acting and television journalism. While students seeking to study traditional Sichuan Opera would formally enroll in a distinct school designed specifically for training young theater performers—proudly named the *Sichuan Opera School* of Chengdu, Sichuan—they are now studying in the traditional theater branch, a tiny department within the *Sichuan Artistic Institute*. Over five thousand students are enrolled in the *Sichuan Artistic Institute*, most of them obtaining college degrees that allow them to find a lucrative salary in an emerging field.[42] Less than 40 of these students are studying traditional Chinese theater.

The leadership of this new school has purchased a large plot of land outside the city and has constructed new training facilities and dormitories.

However, the majority of their "clientele" are no longer studying traditional theater forms. They are learning how to pose for cameras on the runway or sing in a modern pop style that is now the rage.[43] The leadership of the school is simply being pragmatic in "giving the students what they want." While the school itself may survive, the traditional form, Sichuan Opera that brought the initial school into existence is likely to fade away. This is happening to other traditional theater forms across China. Colin Mackerras summarizes the state of Peking Opera in this way:

> Peking Opera is no longer an art form relevant to the population. It does not push itself into the dreams of the people, and especially of the youth, in the way it once did…Like other regional styles of theater in China, the Peking Opera is becoming an art form for the special occasion.[44]

The staggering sense of awe that boys and girls used to feel when seeing traditional Chinese theater in all its splendor has been lost. Perhaps this is the greatest tragedy, for when the imagination of children is lost, how can a culture celebrate its past and look to the future?

NOTES

1. Chen Kaige, *Farewell My Concubine*, Miramax: 1993.
2. Much of the literature on *xiqu* in English tends to focus on *jingju* (Peking or Beijing Opera). Many of my personal observations, conversations, and surveys, however, deal specifically with *chuanju* (Sichuan Opera). The decline in the number of students studying *chuanju* is particularly severe and serves as a useful model for this broad survey.
3. Adolphe Clarence Scott, *An Introduction to the Chinese Theater* (Singapore: Donald Moore, 1958), 119.
4. Conversation with Zheng Yin Pin, Fall, 2006.
5. Conversation with Xu Ming Chi, Fall 1995.
6. Jackie Chan, *I Am Jackie Chan: My Life in Action* (New York: Ballantine, 1999), 2.
7. Conversation with Xu Ming Chi, June 12, 2013.
8. Survey of Sichuan Opera School, October 23, 2012. I issued a survey to instructors at the Sichuan Opera School to quantify certain elements of student enrolment. I also tried to elicit their opinions on the steep decline in student enrolment.
9. Conversation with Xu Ming Chi, July 1, 2013.
10. Conversation with Xu Ming Chi, July 1, 2013.
11. Conversation with Xu Ming Chi, July 1, 2013.
12. Conversation with Xu Ming Chi, June 12, 2013.

13. "China Glossary," Library of Congress/Federal Research Division/Country Studies, accessed July 10, 2013, http://lcweb2.loc.gov/frd/cs/china/cn_glos.html.
14. "Reform and Opening-Up," *China Daily*, accessed June 11, 2013, http://www.chinadaily.com.cn/china/cpc2011/2011-05/10/content_12480513.htm.
15. Conversation with Xu Ming Chi, June 12, 2013.
16. Survey of Sichuan Opera School, October 23, 2012.
17. Conversation with Xu Ming Chi, June 12, 2013.
18. Loren Brandt and Thomas G. Rawski, eds., *China's Great Economic Transformation*, (Cambridge: Cambridge University Press, 2008), 1–2.
19. Helen H.Wang, *The Chinese Dream: The Rise of the World's Largest Middle Class and What It Means to You* (CreateSpace Independent Publishing Platform, 2010), 6.
20. John Fairbank and Merle Goldman, *China: A New History* (Cambridge: Belknap Press, 1998), 408.
21. Elizabeth Wichmann, "Traditional Theater in Contemporary China," in *Chinese Theater: From Its Origins to the Present Day*, ed. Colin Mackerras (Honolulu: University of Hawaii Press, 1983), 197.
22. Jeffrey Hays, "Decline Of Chinese and Peking Opera and Efforts to Keep It Alive," *Facts & Details*, last modified March, 2012, accessed January 8, 2013, http://factsanddetails.com/china.php?itemid=2261&catid=7&subcatid=41#14.
23. Colin Mackerras, *Peking Opera* (Hong Kong: Oxford University Press, 1997), 61.
24. Survey of Sichuan Opera School, October 23, 2012. The school's largest enrolment was in 1966.
25. Conversation with Xu Ming Chi, June 12, 2012. Xu indicated that the vast majority of students, both now and in the past, are from poor country villages.
26. Conversation with Mai Jie Wu Lai, June 10, 2013.
27. Conversation with Mao A Ga, July 10, 2013.
28. Conversation with Mai Jie Wu Lai, June 10, 2013.
29. Survey of Sichuan Opera School, October 23, 2012.
30. Matt Rosenberg, "China's One Child Policy," *Geography.com*, accessed June 9, 2013 http://geography.about.com/od/populationgeography/a/onechild.htm.
31. Alexis Lai, "Chinese Flock to Elite US Schools," *CNN.com*, accessed June 7, 2013, http://edition.cnn.com/2012/11/25/world/asia/china-ivy-league-admission.
32. Nicholas D. Kristof and Sheryl WuDunn, *China Wakes: The Struggle for the Soul of a Rising Power* (New York: Vintage, 1995), 328.
33. Conversation with Zheng Yin Pin, Fall 2006.
34. Conversation with Mai Jie Wu Lai, June 11, 2013.
35. Conversation with Xi Ming Chi, June 12, 2013.
36. Evelyn Iritani, "Great Idea but Don't Quote Him," *Los Angeles Times*, September 9, 2004.

37. Conversation with Xu Ming Chi, June 12, 2013. Xu notes that Beijing and Shanghai still have large, financially successful troupes operating, but Chengdu, a city of nearly ten million, has trouble sustaining even one or two professional troupes.
38. Conversation with Xu Ming Chi, June 12, 2013.
39. Jeffrey Hays, "Urban Development and the Destruction of the Old Neighborhoods in China," *Facts and Details*, accessed June 22, 2013, http://factsanddetails.com/china.php?itemid=1158&subcatid=72.
40. Survey of Sichuan Opera School, October 23, 2012.
41. Survey of Sichuan Opera School, October 23, 2012.
42. Conversation with Xu Ming Chi, July 1, 2013.
43. Conversation with Xu Ming Chi, June 12, 2013.
44. Mackerras, *Peking Opera*, 67.

12. Defying Death: Children in the Indian Circus ∞

Jamie Skidmore

The traditional circus has always featured acrobats performing death-defying acts. Audiences sit on the edge of their seats as they watch tightrope walkers balance above their heads and trapeze artists fly through the air. We accept that adults risk their lives as a form of entertainment, but in the Indian circus children and teenagers also defy death on a daily basis. The circus in India has not always exploited its artists, as a role in the circus was once a desired profession.[1] This chapter examines the transformation of the Indian circus from an art form based on an indigenous martial art into a business that traffics in child performers. It juxtaposes a unique economic paradigm, the Kerala Model (named for the Kerala region in India), against a circus filled with indentured laborers with few rights or freedoms. Modern slavery is a complex issue, and children in the Indian circus are typically removed from a state of abject poverty and placed into a world devoid of caste or class. It is a community of acrobats and clowns, without the religious and societal restrictions found outside the circus tent in India. These children are provided with food, training, and a "tent" over their heads, but are trapped by contractual fees owed to the circus owners that may never be paid. This chapter describes the daily routine of a child working in the Indian circus, performing acts high above the ring with sketchy safety procedures, routines with fire and dangerous apparatuses, and sexually exploitative practices. The conclusion explores an alternative to a life of indentured servitude in the Indian circus. In the early 2000s, Bachpan Bachao Andolan (BBA), an Indian child rescue NGO began to free children from Indian circuses, providing the children with an education, skills outside the entertainment field, and freedom. The fieldwork for this paper was carried out over a three-month period in

2004 in various locations in India, including Delhi, Kerala, Ahmedabad, Pondicherry, and Dehradun. The work is based on visits to six circuses, interviews with circus owners, artists, and trainers, as well as interviews with Indian scholars, politicians, and activists.

AN INDIGENOUS MARTIAL ART

Kalaripayattu (*Kalari*) is a martial art form indigenous to Kerala, India. The practice of *Kalari* leads to a state of *meyyu kannakuka*, which roughly translates as "the body becomes all eyes."[2] Originally used as training for soldiers in hand-to-hand combat and with a variety of weapons, *Kalari* became popular in the early twentieth century as a method of training children to become Keralite circus acrobats. A martial art form may seem disconnected from the circus arts, but *Kalari* combines gymnastic moves with kicking, leaping, spinning, jumping, and balancing. Combined with the basic premise that "the body becomes all eyes," this training is ideal for the circus where acrobats depend on balance and acrobatic skill. Wire walkers, for example, use all of the skills found in *Kalari*. They obviously require balance to counter the oscillations of the high wire. They need to be acutely aware of their body in all directions, often moving backwards on the wire without looking, therefore depending on their body self awareness. Funambulists also perform flips, often backwards without being able to see the wire until late in their leaps, and jump rope while balancing high in the air.

THE KERALA MODEL

Kalari originated in Kerala, a politically unique part of India, where in 1957 it was "the first place on earth to democratically elect a Communist government, remove it from office, reelect it, vote the Communists out, and bring them back again."[3] The Communists were only in power for two years, but as a consequence, Kerala has in place an expansive social web of the kind normally only found in so-called First World or developed countries. It claims 99 percent literacy among its citizens, provides universal health care, has very long life expectancy and very low infant mortality rates. The region also has a surplus of white collar workers and fewer and fewer people to work in industrial, agricultural, or marine related jobs. The rate of unemployment in Kerala is also three to five times that of the rest of the country[4] and consequently, it has less and less infrastructure

to support its social web. The name for this phenomenon (a strong social system with little or no financial structure to support it long term) is the "Kerala Model."

Prior to Communist party driven reforms to the social system in Kerala, entering the circus was seen as an acceptable career path. M. V. Sankaran, a Keralite circus magnate and owner of several circuses, joined a gymnastics school in Tellicherry of his own accord at the age of eight or nine years. In the early 1930s, circus was one of the two major sources of employment in Tellicherry,[5] along with weaving. He studied *Kalari* at the school, which provided him with mental and physical conditioning. As he put it, *Kalari* taught him to be "alert" and to "react fast." At the age of 22, he went on to become a trapeze artist in the Indian-owned Rayman Circus where he worked as part of a team of six aerialists: five flyers and one catcher. After three years with Rayman's, he bought his first small circus in the early 1950s. He went on to become a multimillionaire as a circus owner, at one time owning or co-owning three of the roughly 12 major circuses in India: The Jumbo, The Great Royal Circus, and the Gemini.[6]

From the 1920s to the 1950s, and even into the early 1960s, most circus performers in India were from Kerala. The circus offered a prosperous life to people from socially and economically backward communities in the region. The circus, unlike Kerala or India as a whole, is a self-contained community without class or caste structure. Therefore, the same discriminatory practices facing lower castes in Indian society were not found within the circus. From its origins in India in 1882,[7] the circus followed the model of British and European circuses of the late nineteenth century. One exception to this was the training in *Kalari*, which was indigenous and unique to Kerala. To a large degree, the Indian circus as it exists today is a communal system where everyone works together for the greater good.[8]

In the late 1950s, another "communal" system was finding itself at the forefront of the Kerala political environment. With literacy rates rising and education accessible to everyone, the society was quickly advancing. According to Indian circus historian Mahesh Mangalat, in the late 1950s, M. T. Vasu Devan Nair, a prominent novelist, published a short story (in Malayalam, the language of Kerala) called *Valarthu Mrigangal* (*Domesticated Animals*), which depicted the circus in India as a place of torture, exploitation, and inhumane treatment.[9] Anecdotally, the result of this story was not the end of the circus in Kerala, but the end of Keralites performing in the circus. Citizens of the state no longer looked upon the circus as a viable career choice and so the circus needed to look elsewhere for acrobats, clowns, and jugglers.

INDENTURED CHILD LABORERS

In contemporary India, children do not run away to join the circus but are "sold" into it. The children are typically from poor northeastern Indian provinces such as Assam and Meghalaya, or from struggling Nepalese families. Circus agents travel to small villages and speak to parents about "hiring" their child to work in an Indian circus, often from Kerala. Families are told that their children will send home money and that they will be stars of the circus. Payments may be made in a variety of ways, such as an upfront fee that will be paid off through the child's work in the circus. Alternatively, the children may be given lump sums once a year when they make visits home. This can often be a corrupt practice, where the recruiter only pays half of the fee allocated by the circus owner, or doesn't provide a contract to the family. Often, the agent never pays the fee to the parents.[10] In instances where a contract is proffered, it becomes impossible for the child to ever pay it off. Although the child is paid as a performer, the amount he receives covers less than the fees required to pay for room and board with the circus. Each month the child may incur additional debt and so can never pay off the contract. Circus performers become indentured laborers, the modern equivalent of a slave, as they are perpetually bound by a contract that can never be paid off.

It is challenging to accept a positive spin on "slavery," but circus owners and artists argue on behalf of the benefits of the practice of indentured labor. The communal living style, as noted earlier, is one example where circus performers may be better off than before, as they are no longer seen as being lower class, but are now peers with the other members of the circus community. The claim can also be made that these children move from homes where they are often malnourished and even possibly starving, to an environment where they are well fed. As athletes, acrobats need to be nourished in order to perform, and Indian circus owners ensure that this is the case. The children who enter the circus may not be the only ones who are better off. Their families will potentially be able to feed themselves and their other children as well, as a result of the promised circus earnings. Legally, child performers in the Indian circus must be at least 14 years old. However, if all Indian circuses practised this law, only teenagers would perform in the ring. In my experience on Indian circus lots, when I asked an owner or administrator the age of a young performer, the reply was always that the child is "14 years old."

In addition to meals, the circus provides other necessities for the young performers. On the circus lot there are small, portable shelters for the

performers that are used for sleeping, living, and socializing. The structure is a wooden frame with a canvas roof and the walls consist of a double layer of canvas and mosquito netting. Typically, two performers live in one shelter, sleeping on cast iron beds. Best described as canvas tents, these structures may even have electricity to light a bulb or boil a cup of tea. There are places for personal items, and chests for storage. India has a tropical climate and these tents appear to provide adequate shelter from the elements and insects.

Besides providing a physical home for the circus members, the circus creates a sense of community. Most of the circus artists are from the lower classes or are untouchables. Caste is still an important factor in Indian society and mobility within the caste system does not exist as it does within the class system. The circus provides an escape from both the class and caste systems found in South Asia. Traditionally, this was the appeal for Keralites to join the circus, particularly during the early twentieth century. Since the 1960s, it has also been a benefit for the performers acquired from northeastern India and Nepal.

In the Indian circus, all of the performers are essentially peers. Within this paradigm there are experienced, intermediate, and novice levels of performers, and there is a natural hierarchy within these groups. However, unlike the caste system, these social divisions are minor and do not greatly affect day-to-day life. Religion, as well, does not tend to be a factor within the confines of the circus, as it is beyond the circus lot. This lack of caste or class system allows all of the performers to be equal members of the community.[11]

Although circus performers are for the most part treated equally, a hierarchy still exists within the Indian circus. The owners of the majority of Indian circuses still tend to originate from Kerala and along with their family members and a few friends, these men run many of India's circuses. Some of them, such as the circus owner discussed earlier, M. V. Sankaran, went from "scratch to multimillionaire."[12] India is a country of contrasts where extremely rich and excessively poor citizens often live within sight of each other. Imagine seeing a row of cardboard boxes along a sidewalk where homeless families live. The "homes" are not large enough for an adult to fully stretch out in, but it shelters a family of three or more. Behind is a condominium full of luxurious apartments owned by diamond merchants. Inside, the rooms are filled with frescos, pillars, marble, and stained-glass ceilings. On the circus back lot, the contrast between the rich owners and indentured laborers is not quite as severe. The owners also live in tents, although they are much roomier than those of their "employees."

The same food is served to the owners as to the performers, although in greater quantities. Visitors, both friends and business associates, dine at large tables where alcohol is freely passed around. The greater contrast exists outside the lot, where the owners spend much of their time. The children of the circus do not leave the lot, as it is both their home and "prison." The circus grounds are surrounded by large steel fences over ten feet high, built as much to keep the children in as to keep nonpaying guests out. Guards patrol the grounds, often dressed in army fatigues, ensuring that no one leaves. The owners, of course, are free to come and go as they please. In appearance, they do not appear wealthy, as they do not dress in expensive clothes. They do, however, possess chauffeur-driven cars, huge homes staffed with many servants that are large enough to easily house their own circuses, and often own exotic pets not indigenous to India.

The contrast between the owners and the trainers is also not noticeable on the circus lot. Older adults work with the children to teach them the skills that are necessary to perform in the circus. These coaches may be current circus artists, or they may be former performers who can no longer perform. They are a part of the daily routine of the younger circus acrobats and specialists. Circus life is very regimented and working in one is a full-time job, seven days a week. The morning is reserved for exercise and practice and performances occur twice a day, once in the afternoon and once in the evening. Even if the artists could leave the grounds, there would be little opportunity to do so with such an intense schedule. Starting calisthenics around 9 a.m., the circus children round out their day when the final show closes at 9 p.m.

DAYS OF DEFYING DEATH

After morning exercises, the performers spend time working on their current acts or learning new skills. Another benefit to the children in the circus is that they are provided with a skills base, although many of the feats the children learn fall into the "death-defying" category. There are, of course, many safe acts in the circus such as juggling, where the only real threat is a ball in the face. Most traditional circuses, in India and abroad, do not depend on "safe" acts to fill the seats. Some high-flying acts such as team trapeze are actually relatively safe, as long as the performer knows how to fall correctly. This is because the high-flying acts are performed over a net, so if a bar or catch is missed, the artist is "caught" in the safety net before hitting the ground. Other trapeze routines, such as the Washington trapeze definitely fall into the death-defying category.

The Washington trapeze is performed by a solo artist and typically no nets or lunges are used in this extremely dangerous act. Combining the artistry of the trapeze artist with the skill of the wire walker, the climax of the routine has the aerialist standing on the trapeze bar as it swings rapidly from side to side. As the bar picks up speed, the artist lets go of the ropes and balances on feet alone. The loss of balance could lead to loss of life. Lunges are small safety devices attached to the trapeze and worn around the waist of the aerialist. Common in the Western circus, they are generally worn whenever there is any real possibility of danger involved in an act. These devices also exist in Indian circuses but may only consist of a rope knotted around the child's waist. Typically, no safety device is used in an aerial act, as it would diminish the audiences' perception of the danger inherent in the performance.

Every dangerous act performed in a circus by an adult (such as the Washington trapeze) is attempted by a child in another Indian circus. This is partly due to the fact that most of these circuses perform the exact same slate of acts, usually with identical stunts and choreography. Travelling India from north to south and east to west, one will see the same routines again and again with little variation. There will be a fire-eater who will limbo under a burning pole of fire, elephants playing cricket, and team trapeze. During the team trapeze number, a clown will appear. He will accidentally fly out on a trapeze and his pants will be pulled off. The Indian circus gives new meaning to the term "routine" in their programs. The only way to distinguish one circus from the next is often by the color of the costumes. The repetition of the same acts also means that death-defying acts might be performed in one circus by an adult, in another by a teen, and in yet another by a child.

Within this discussion I am using the term death-defying to encompass acts that may burn skin, break bones, and cause paralysis or death. In North America, they are analogous to acts on TV that come with the caveat, "Don't try this at home." On television, the warning is aimed at children and teenagers who may foolishly attempt these dangerous acts, but in the Indian circus, defying death is part of the daily routine. In theory, the difference between an adult and a teenager or child attempting a dangerous act is that the adult can do so using sound judgment. Adults are aware of the risks and can decide whether or not it is a trick they should attempt. In both cases, the child and the adult artist will have received training in the act. Adults, we assume, are more aware of their surroundings and of their own personal abilities and limitations. When breathing or eating fire, an adult is better prepared when something goes wrong and

is hopefully able to minimize injury. Even if certain children can react at the level of an adult in this circumstance, it is unsafe to put them in such a dangerous position.

The fire-breathing routine is an excellent example of an act that often goes wrong. It is also an act that takes place in most Indian circuses where it is performed by adults, teens, and children. Breathing fire is best performed in a controlled environment where ambient conditions remain constant. When there are changes to the air pressure in the performance space, the fire-eater becomes at risk of something going wrong, such as a flashback of the flames being "breathed." "Don't inhale!" is a crucial piece of advice for a fire-eater. "The great secret of fire work is not to allow the fumes of gas you're eating to explode in your lungs... Once you've learned how to avoid that, your only worry is how to keep from being burned by the fire coming out of your mouth."[13] There is potential for catastrophic consequences at each stage of the act, whether in training or practice. A circus tent is an atmosphere that is poorly controlled at the best of times. A gust of wind at the wrong time through one of the flaps in the tent could lead to serious facial burns. The kerosene and white gas that fire-breathers work with are also dangerous and can negatively affect the artist over time. Fire-eaters have also been known to use gasoline in their acts, a fuel which is always easily accessible. In North America, children are not allowed to play with fire because they may burn themselves or even burn down the house. They are deemed as being too young to play with fire, but fire-breathing is a featured act in Indian circuses, where it is often performed by children as young as eight or nine years old.

The Golden Circus, playing in Ahmdebad in the Gujarat during the early 2000s, had a teenager performing the fire act. It is difficult to gauge age but he appeared to be anywhere from 15–18 years old. He was dressed in a shiny black vest, without a shirt on, and matching black pants. Close by was a teenage girl, similar in age and costume, except she was wearing a matching skirt. She danced a simple dance to the Michael Jackson song playing in the background (most Indian circuses have electricity in the tents to power sound and lighting effects). When the performer breathed fire or did the limbo under a flaming pole, the lights would dim to highlight the flames. The limbo pole was balanced on Coke or Thums Up [sic] bottles, so the acrobat was literally sliding under it on his back.

Fire-breathing in daylight does not have the same visual impact as it does in the dark. The Royal Circus, performing in Kunnamangalam, Kerala, around the same time as the Golden Circus in the Gujarat, was an extremely impoverished looking affair. The ceiling of its Big Top was

shredded at the rear of the tent from time and the elements, and was filled with patchwork pieces at the front. Most likely it was a secondhand tent, acquired from another circus. Compared to other circuses that appear to follow the laws related to the Indian circus (no children under 14 years of age, no lions or tigers, for example), the Royal Circus worked outside the law. Most of the acts were performed by underage children in threadbare outfits that could best be described as their underwear. The boys wore white sleeveless undershirts, sometimes known as a singlet, or tank tops. They also wore what appeared to be boxer shorts, although they may simply have been white shorts. Their feet were covered in black, knee length socks, which all seemed to be full of holes, and they wore no shoes. Like the tent, the costumes conveyed the sense of innate poverty. There was no attempt at an aesthetic or any "showmanship" in the costumes or setting. In the Royal Circus, a boy no more than ten years old performed the fire-breathing act. He also ate fire and spat or "breathed" fire after drinking (but not swallowing) kerosene. As in the Golden Circus performance described above, a girl danced in the background, but in this case she was a child approximately ten years old.

Other young boys and girls performed additional acts, sometimes representing games played in the schoolyard. For example, one young girl performed a hula-hoop routine, suggesting that she was living out a normal childhood. This, of course, is not the case as this was her job that she worked at for at least 12 hours a day. Surrounding this seemingly innocent hoop act were other illegal and dangerous performances. Another ten year old tied a rope around his waist with a loose knot and performed an act known as the Chinese Pole. The boy "monkey climbed" up the pole to the height of about 18 feet at which point an adult acrobat, who had been holding the pole, balanced it on his forehead. The boy then carried out a number of tricks customary to this act, such as the "Fish" and the "Flag," both acrobatic configurations where the artist's body is held perpendicular to the vertical Chinese Pole, creating the impression of a fish swimming or a flag waving in the wind. The sight of a young boy at the top of a pole balanced on a man's head had the effect of putting the audience on the edge of their seats.

Another boy in the Royal Circus performed aerial or "leather straps," an act that originated in the Qing Dynasty (1644–1911) in China.[14] The modern version of the routine consists of wrapping bungee-like straps around the wrists and arms and pulling oneself up in the air in this manner. Once the performer is high in the air, perhaps 20 feet or more, he spins back down to the ground in a manner that suggests he may not be able

to catch himself before hitting the ground. Various acrobatic stunts are carried out with the straps, sometimes with one arm, and sometimes with two, which involve a variety of different wraps, spins, falls, and flanges. It is an act performed in Western circuses by highly trained and muscled adults, but in India it is performed by teens and boys. The child who performed it in the Royal Circus was guided by a "coach" in clown makeup who appeared to bully him through the routine. The "clown" grunted at him and moved toward him at times in a threatening way in order to "encourage" him without any indication that this was part of the act.

Another dangerous act, performed for the audience's excitement and pleasure at the Royal Circus, was the "Cage of Death," an act that threatens death via a horrific crash and explosion. This routine consists of a large, circular, steel cage in which one, two, or three motorcyclists appear to defy gravity while utilizing centripetal force. Cyclists ride the full circumference of the cage, from side to side, and often from top to bottom as well. At times they ride upside down, narrowly avoiding the other motorcycles. The Royal Circus could only afford one "dirt bike" and the teenaged rider wore his street clothes, consisting of dress pants and a polo shirt, for the performance. Although this act did not have the added danger of a second biker, the cage was so poorly set up that four men had to hold on to the poles and other rigging that held it in place. The circular cage threatened to roll off of its structure throughout the number. The Cage of Death is an interesting act, as it encourages the audience to question the degree of danger inside the circus tent compared to the danger that exists on the roads in everyday society beyond the circus lot.

It is ironic that circuses are considered family friendly when in fact they tend to be sexualized events. Circus performers wear a wide variety of costuming around the world, from clown suits, to pant suits adorned with rhinestones, to the tuxedos worn by some ringmasters. In many Western circuses female performers wear skimpy costumes, with g-strings as a common costume piece in some numbers. Male performers may be treated equally to females in this regard, often wearing nothing more than a g-string in performances in both the richest and poorest Western shows. In comparison, the Indian circus shows a fair amount of restraint. Girls do appear in gymnast outfits akin to one-piece bathing suits, as well as wearing skirts and costumes that reveal their midriffs. "Genie" costumes are *de rigueur* in contortionist acts, featured in most Indian circuses. Boys wear shorts and often perform with bare chests or in revealing vests.

Prajisha was a "14-year-old girl" who wore a "bathing suit" style gymnast costume in the Great Bombay Circus in Secunderabad. As the tallest

of the young girls, Prajisha was likely older than most of the other children performing in the circus. Her daily routine was the same as that of other child performers: getting up early to train followed by two performances each day. One of her routines was performing on the high wire with two other girls. Perched high above the audience, the girls used balancing poles to maintain their footing on the wire. High wire acts are rarely, if ever, performed above nets or with any safety devices in place. Wire walkers believe that nets are useless in falls from the wire, because funambulists do not know how to properly fall into them. In training, wire walkers are taught how to hook an elbow or leg around the rope or wire when they lose balance. "Falling" is even a common part of the skipping routine that is executed on the high wire in many circuses. Funambulists will attempt to skip on a rope, but will miss and fall catching themselves by an elbow or knee. The fall occurs to create a sense of anxiety in the audience who often do not grasp the difficulty of this routine. The artist will remount the rope after the fall and then perform the act successfully.

The lack of a net certainly gives the appearance that the child wire-walkers in the Indian circus are risking their lives. Without first revealing the danger in the routine, the audience is not able to gauge the degree of danger that the high wire performer is in on the wire. Other safety devices, such as lunges or ropes tied around the waist would also detract from the "death-defying" aspect of the number. Consequently, Prajisha and her balancing partners did not wear any safety devices in their act.

Besides the funambulism performance, Prajisha, like most members of the Great Bombay Circus, performed in a variety of acts. Sometimes she performed as a dancer, at times as an aerialist, and also as a member of a cycling squad. Cycling teams are often the modern equivalent of a Liberty Act,[15] which is a synchronized performance of horses maneuvering through a series of patterns as a unit or in pairs. Instead of the horses, bikes were ridden by the performers in the Great Bombay Circus. The highlight of this number was six girls riding in a circle and holding hands while they were all balanced only on their back wheels. An indirect outcome of this routine was the sexual exploitation of Prajisha and her physical form. Billboards are common outside of Indian circuses, highlighting many of the acts to be seen inside. This signage is an important part of the advertising for the show, as the images are meant to draw families inside. Like a lot of media, the billboards tend to present exaggerated images of what will appear inside the tent. Hippopotamuses appear much larger than in reality, and performers appear "happier" than they do in the ring. Smiling acrobats are a rare occurrence in the Indian circus, where the

performers usually appear to be bored and merely going through the prescribed elements of the acts. Prajisha was featured prominently on one of the billboards, or at least her face made an appearance. Riding on her bicycle, she was depicted in a small bikini top and a very short skirt that rode up her right hip. Her teenage body was transformed into that of an adult, full-figured woman. In the routine the teenage girls in fact wore one-piece gymnastic costumes with silver sequins in the shape of flowers. The billboard image, however, was intentionally painted to create the impression that scantily clad, large breasted women appear inside the circus tent.

RESCUING CHILD PERFORMERS

The Indian circus has been in need of innovation for many years. One circus, Rambo, has been modeling a number of acts on *Cirque du Soleil* routines, such as the aerial cube where an aerialist hangs from a square frame and performs acrobatic moves. They realize that the world is changing and that if they do not change and innovate they will atrophy and cease to attract audiences. Since approximately 2003, children's rights organizations in India have also started to target the circuses in order to remove the child performers. BBA, a non-government organization in India that rescues children, made an agreement with the Indian Circus Federation (ICF) to remove children from the circus. The participating circuses agreed that they would no longer recruit children into their circuses, that they would release the current children in a timely fashion, and that the children would be returned to their families.[16] Unfortunately, the ICF does not represent all Indian circuses. It is unlikely, for example, that the Royal Circus is under the ICF's jurisdiction. Considering that the Royal Circus illegally exhibits contraband animals, it is hard to believe that it would end its practice of presenting underage performers. Kailash Satyarthi, a human rights activist and leader of the BBA, believes it is unlikely that the circuses will change their attitude toward providing education to child acrobats. As an alternative, the BBA has been removing child performers with the assistance of local authorities.[17]

Rescuing children and returning them immediately to their families has proven to be problematic. Often, children have suffered at the hands of their own family, or have been trafficked again. Consequently, the BBA has initiated an intermediary stage, which provides the children with an education. A number of education centers, or Ashrams, have been

developed in different locations in India. The BBA website describes the rehabilitation process:

> In the rehabilitation centers, children receive basic education in reading, writing and simple arithmetic to facilitate their absorption into mainstream schools as most of them have never received any kind of education. Children who cannot cope with the teaching are provided with vocational training of their choice such as carpentry, tailoring, painting, etc. Physical education is also imparted along with education on personal hygiene and etiquette. Social education on certain social and human rights issues such as child labour, child marriage, poverty etc is provided to instill in the children certain basic social values and to help them reflect on certain issues like women's rights, gender equity and environmental protection, making them responsible citizens. The committee system was devised to build confidence and promote leadership qualities. Children's' participation in campaigns is also encouraged for the same [sic] so that they act as leaders of today and of the future. Cultural education is also imparted in order to instill a sense of cultural pride among the children through patriotic songs, folk songs and dance forms, etc. Most important of all our rehabilitation centers try to restore the lost childhood of these children which we believe is one of their basic rights. After rehabilitation these children go back to their respective villages where they either enroll in schools or take up a job, if they are 18 years and above.[18]

These Ashrams are part of a greater initiative known as *Bal Mitra Gram* or Child Friendly Villages. The basic premises behind this idea are to eliminate child labor from the community, provide education for all school age children, give children a voice in the community through the creation of a child parliament, and to allow this parliament to take part in the adult parliament of the community.[19] Through these initiatives, the BBA is ensuring that children will no longer have to work as indentured laborers in the circus and in other industries. They are also educating communities about the pitfalls and dangers of child labor, which will hopefully end child trafficking in India. Encouraging the voice of the village children in community councils and providing an education for everyone will also have a positive impact.

In April 2011, the Supreme Court of India officially banned the employment of child performers in the circus. Although there is no guarantee that all circuses will adhere to this ban, it will mean that the legal system will be able to arrest and prosecute any company that breaks the law.[20] The BBA chose their fight against the circuses in order to raise awareness of indentured child laborers in the country. This battle has been won, but the war

continues against other employers of underage children in India. BBA continues to work with the Government of India to ban all children 14 years of age and under from labor of any kind. Meanwhile, the BBA continues to rescue children from various industries throughout the country.[21]

NOTES

*The fieldwork for this research was gratefully supported by the Shastri Indo-Canadian Institute.

1. Indian circus owner, in discussion with the author, Cannanore, Kerala, India, April 2004.
2. Phillip B. Zarrilli, *When the Body Becomes All Eyes: Paradigms, Discourses and Practices of Power in Kalarippayattu, a South Indian Martial Art* (New Delhi: Oxford University Press, 1998).
3. Shashi Tharoor, *India: From Midnight to the Millennium* (New Delhi: Penguin Books India, 1997), 68.
4. B. A. Prakash, ed., *Kerala's Economic Development: Issues and Problems* (New Delhi: Sage Publications, 2000), 19.
5. Telicherry, also known by its Malayalam name, Thalassery, was the capital of the region under the British Empire.
6. M. V. Sankaran, in discussion with the author, Cannanore, Kerala, India, April 2004.
7. Praveen P. Walimbe, *The World of the Circus* (Pune: Tanaya-Esha Publications, 2003), 9.
8. Mahesh Mangalat, Professor of Malayalam, in discussion with the author, Mahe, Pondicherry, India, April and May 2004.
9. Ibid.
10. Ibid.
11. Saji P. Jacob, Indian Professor of Sociology, in discussion with the author, Trivandrum, Kerala, India, May 2004.
12. M. V. Sankaran, Indian circus owner, in discussion with the author, Cannanore, Kerala, India, April 2004.
13. Daniel P. Mannix, *Memoirs of a Sword Swallower* (Hong Kong: V. Vale Publications, 1996), 20–21.
14. Fu Qifeng, *Chinese Acrobatics Through the Ages*, trans. Ouyanag Caiwei and Rhoda Stockwell (Beijing: Foreign Languages Press, 1985), 86.
15. Paul Bouissac, *Circus and Culture, A Semiotic Approach* (Bloomington: Indiana University Press, 1976), 1.
16. Bachpan Bachao Andolan: Save the Child Movement, accessed May 25, 2013, http://www.bba.org.in/resourcecentre/image/Child%20Labour%20in%20Circus.pdf.

17. Kailash Satyarthi (human rights activist), in discussion with the author, New Delhi, India, June 2004.
18. Bachpan Bachao Andolan: Save the Child Movement, accessed January 15, 2013, http://www.bba.org.in/whatwedo/.
19. "Child Friendly Village," accessed January 15, 2013, http://bba.org.in/?q=content/child-friendly-village.
20. "Supreme court bans employment of children in circuses," accessed January 18, 2013, http://www.thehindu.com/news/national/supreme-court-bans-employment-of-children-in-circuses/article1706035.ece.
21. Bachpan Bachao Andolan: Save the Child Movement, accessed August 20, 2013, http://bba.org.in/?q=articles/news.

Contributors

Gillian Arrighi is senior lecturer in the School of Creative Arts at the University of Newcastle, Australia. Her research on circus, and on children in the entertainment industry has been published in *Theatre Journal, Australasian Drama Studies, New Theatre Quarterly,* the *Journal of Early Visual Popular Culture,* and *Theatre Research International,* and in edited collections. She is associate editor of the scholarly e-journal, *Popular Entertainment Studies,* and her new book on the late nineteenth-century circus in Australasia, *Shaping Nationhood,* is due for release in 2014.

Mark Branner is assistant professor at the University of Hawai'i, Manoa and serves as the director of the TYA graduate program (theater for young audiences). He has toured nationally with various groups—including *Ringling Brothers and Barnum & Bailey, Diavolo, Monkey Waterfall*—and performed extensively in Asia, most notably in Sichuan Opera, a regional form of Chinese traditional theater. He and his family operate *CiRCO Redempto,* a community outreach program utilizing theater and the circus arts to benefit children from the Nosu Yi minority nationality of central China.

Noel Brown received his PhD in Film from Newcastle University, UK, in 2010. He is the author of *The Hollywood Family Film: A History, from Shirley Temple to Harry Potter* (I. B. Tauris, 2012), and the co-editor (with Bruce Babington) of *Beyond Disney: Children's Films and Family Films in Global Cinema* (I. B. Tauris, forthcoming). He is currently researching the history of British children's and family-orientated cinema, and writing a short book on the children's film genre for Wallflower Press.

Gilli Bush-Bailey is Visiting Professor in Women's Performance History at The Royal Central School of Speech and Drama, following 12 years in the Department of Drama & Theater at Royal Holloway University where she was Professor of Women's Theater History. She has published extensively on the professional practice of actresses, managers, and female playwrights, bringing her own professional practice as a child performer into new dialogues with historiography and autobiographical performance. Her recent

publications include *Performing Herself: AutoBiography & Fanny Kelly's Dramatic Recollections* (Manchester University Press, 2011), and a contributing chapter "Re:Enactment" in the *Cambridge Companion to Theater History* (2012).

Ken Cerniglia is a dramaturg, writer, and director. By day he is dramaturg and literary manager for Disney Theatrical Group, where he has developed over 40 shows for professional, amateur, and school productions, including *High School Musical, The Little Mermaid, Beauty and the Beast JR., Camp Rock: The Musical,* and *Peter and the Starcatcher*. He holds a PhD in theater history and criticism from the University of Washington and has published articles and essays in *Theatre Journal, Theatre Annual, Broadway: An Encyclopedia of Theater and American Culture,* and *Tarzan's Global Adventures: From King of the Jungle to International Icon*.

Broderick D. V. Chow is lecturer in Theater and Drama at Brunel University, London, UK, where he teaches theater history and leads the musical theater strand of the undergraduate theater program. His research concerns the intersections of performance practices, politics, ethics, and industrial change, especially in the world of work. He has published and presented on professional and amateur wrestling, parkour (free-running), and actor training. He is currently preparing a monograph on the fitness industry, masculinity, and the neoliberalization of work. He is co-editor (with Alex Mangold) of *Žižek and Performance*, forthcoming with Palgrave 2014.

Dyan Colclough teaches in the Department of History and Economic History at Manchester Metropolitan University. Her PhD entitled, "Manufacturing Childhood: The Contribution of Child Labour to the Success of the British Theatrical Industry, 1875–1903" was shortlisted in 2009 by The Economic History Society for the Thirsk-Feinstein PhD Dissertation Prize, and she has presented conference papers that include "Marketing the Pantomime Child: The Theatrical Training Industry and Its Practices" (University of Birmingham 2010) and "The Legacy of 'At Homes' for Victorian Middle Class Women 1780–1900" (Royal Holloway University of London 2011). Her most recent publication is entitled "'Oh No It Wasn't!': Theatrical Revelations from Child Performers During the 1930s," *Manchester Regional History Review*, (Spring 2012).

Rossella Del Prete is assistant professor of Economic History and Adjunct Professor of Financial History and Labor History, in the Department of Economics, Management and Quantitative Methods, Università degli Studi di Sannio, Benevento, Italy. She has a PhD in economic history and

her research fields are the economic histories of art and culture, economic institutions, education, labor and that of women. Her most recent publication is "Tra botteghe, cappelle e teatri: l'articolazione socio-professionale della famiglia dei musicisti a Napoli in età moderna," in G. Da Molin ed. *Ritratti di famiglia e infanzia. Modelli differenziali nella società del passato* (Bari: Cacucci, 2011), 51–71.

Victor Emeljanow is emeritus professor in the School of Creative Arts at the University of Newcastle, Australia, and General Editor of the e-journal *Popular Entertainment Studies*. He has published widely on subjects ranging from the reception of Chekhov in Britain and the career of Theodore Kommisarjevsky to Victorian popular dramatists. He co-wrote with Jim Davis the award-winning *Reflecting the Audience: London Theatregoing 1840–1880* in 2001 (University of Iowa Press) and his most recent book is "Herbert Beerbohm Tree" in the Pickering and Chatto series, *Lives of Shakespearian Actors* (2012).

Lisa Mitchell is an arts educator with a background in acting, directing, and producing. Currently, she is the Education & Outreach Manager at Disney Theatrical Group, where she develops the company's educational initiatives and engages young people through Broadway and student-driven productions. She is the Education Director for Two Turns Theater Company, co-chairs the Education & Outreach committee of The Broadway Green Alliance, co-chairs the Theater in Our Schools conference, and serves on the Teaching Artist Affairs committee for the New York City Arts in Education Roundtable. She holds a Master's Degree in Educational Theater from The City College of New York.

Laura Noszlopy is an anthropologist, writer, and editor specializing in Indonesian culture and society, and biographical writing; her PhD is from the Sainsbury Research Unit at the University of East Anglia. She is an Honorary Research Associate in the Department of Drama and Theatre at Royal Holloway, University of London, and also works as an editor for her consultancy katakata, the Lontar Foundation (Jakarta), *Indonesia and the Malay World* and *Inside Indonesia*, among others. She has published widely on contemporary Indonesian performance and is co-editor (with Matthew I. Cohen) of *Contemporary Southeast Asian Performance: Transnational Perspectives* (Cambridge Scholars Press, 2010).

Darren O'Donnell is a novelist, essayist, playwright, director, designer, performer, and nascent urban planner. He is the Artistic Director and Research director of Mammalian Diving Reflex and co-founder of The

Torontonians. His books include *Social Acupuncture*, which argues for an aesthetics of civic engagement and *Your Secrets Sleep with Me*, a novel about difference, love, and the miraculous. His best-known work is *Haircuts by Children*, which was first created in collaboration with the children of Parkdale Public School in 2006. In addition to his artistic practice, he is currently an MSc candidate in Urban Planning at the University of Toronto.

Shih-Ching H. Picucci received her Master's degree (2005) in TESOL at the University of Liverpool, UK. After a time as a lecturer at Lung Wha University of Science and Technology, Taiwan, she is presently undertaking a doctoral degree in Education at Durham University, UK. Her research interests include Chinese language and culture teaching, intercultural communication, identity, and material/textbook analysis. Currently, she is teaching GCE A/AS level in Chinese at Durham Chinese School and her upcoming chapter about textbook analysis of A level Mandarin Chinese in the United Kingdom will appear in the volume *The Teaching of Asian Languages in the 21st Century*, to be published by Cambridge Scholars Publishing.

Jamie Skidmore is professor in the English Department at Memorial University of Newfoundland, specializing in theater arts and video production. He has been working in the theater for almost 30 years as a designer, director, technician, author, and educator. His work in academia focusses on semiotics, performance theory, circuses, sideshows, and Newfoundland theater.

Shauna Vey is associate professor at the New York City College of Technology of the City University of New York. Her work has been published in *Theatre Survey, Theatre History Studies, Boyhood in America*, and *Querying Difference in Theatre History*. She is currently finishing a book on the Marsh Troupe, a professional company of child actors that toured the United States and Australia in the mid-nineteenth century.

Index

Page numbers in *italics* refer to figures. An "n" after a page number indicates a reference to an endnote.

12 Hour Zine Machine (performance), 153
101 Dalmatians KIDS (musical), 139
228 Massacre (Taiwan), 188, 196, 199n15

acrobatic schools, China, 213–14
actors' agencies, 5, 120
Actors' Equity Association, 121, 133, 145n24
The Adventures of Tom Sawyer (film), 99
affective labor, 148
Ahmed, Sara, 154
Aladdin (musical), 138
Aladdin KIDS (musical), 139
Albano, Gaetano, 20
Alice in Wonderland (film), 99
All That Is Wrong (performance), 148
Allen, Judith, 101
Andersen, Hans Christian, 144n12
Anderson, William, 64, 67
"angel choirs," 24, 25
Anglo-Boer War, 61, 67
Anne of Green Gables (film), 105
Annie (musical), 7, 132, 143n4
Annual Conference of the National Association of Head Teachers (UK), 86
Anom (dancer), 167, 169, 172, 174, 177

apprenticeships
 Chinese opera troupes, 208–9
 defined, 47n7
 demise of in America, 33, 36–7, 45
 freedom dues, 38–9
 the Marsh-Stewart contract, 37–9
 Neapolitan musicians, 3, 17–20, 25
 traditional craft apprenticeships, 35–6
Argus, 39
Aristotle, 155
Artificial Hells (Bishop), 157
Arts Educational School, London, 118, 126n20
Ashrams, 230–1
Aswad (band), 113
auditions, for child actors, 131–2
Audreson, Michael, 112, 113, *113*
Australia, regulation of child performers, 4, 52, 69n14
the "authentic" child, 116, 132

Bachpan Bachao Andolan, 219, 230–2
Baden-Powell, Robert, 58, 59, 62
Bal Mitra Gram, 231
Baldwin Locomotive Works, 38
Bali Arts Festival, 170
Balinese dance theater, children's role in, 8, 167–81, *168*
Bandmann, Maurice, 52, 64–5
Bangalore, 66

Index

Banjar Tengah (village), 174
barong, 183n30
Barrymore family, 5
Barrymore, Lionel, 101
Bartholomew, Freddie, 6, 93, 95, 96, 98, 102, 103–4, 106
Bartholomew, Millicent, 103–4
Bateman, Ellen, 36
Bateman, Hezikiah L., 36
Bateman, Kate, 36
Bateman, Sydney Cowell, 36
Bauer, Steve, 124
Bazalgette, Cary, 99
BBC, 112
Beauty and the Beast (musical), 7, 129, 130, 131, 144n11
Beckham, David, 132
Bediako, Nana, 132
Beech, Florence, 65
Beijing opera, 185, 188, 195, 198n7, 205, 214–16, 218n37
Belasco, David, 46
Belfiore, Eleonora, 150
The Belle of New York (musical comedy), 59, 62
Benjamin, Walter, 149, 160–1, 164n30
Bennett, Oliver, 150
Bernstein, Lillian, 103
bian lian, 207
Bijou Troubadours, 63–4
Billee Taylor (comic opera), 70n44
Billy Elliot the Musical, 116–17
Bishop, Claire, 153, 154, 157
Black, Hilda, 78, *79*, 83, 86, 89n21
The Blue Bird (film), 106
Bluebell in Fairyland (musical), 71n63
Blystone, John G., 99
boarding schools, for music apprentices, 17, 20, 22–4, 31n13
Bombay, 66
Booth, Charles, 68n6
Bourriaud, Nicolas, 162n1
Boy of the Streets (film), 96
Boy Scouts, 58–9

Boys' Brigade, 58
Boy's Life, 95
Boy's Own Paper, 58
Brenan, Jessie, 67
Bright Eyes (film), 100, 101
Broadway Cares/Equity Fights AIDS, 135
The Broadway League, 133
Broadway plays, 138
Brown, Clarence, 95
Burney, Charles, 24
Burroughs, Edgar Rice, 144n12
Burton, W. E., 34
Bush-Bailey, Gillian, 112, *113*
business managers, parents as, 49n58
Butler, David, 100, 101

cadet corps, 58
Calcutta, 64, 65, 66
Cambridge Theatre, London, 120
Cameron, David, 154
Cameron Mackintosh, Ltd., 144n12
Cameron, Stuart, 151
Campbell, Dinah, 63
Canada, 67, 150–2, 163n8
Captains Courageous (film), 95, 106
Carnahan, Jim, 132
Carte, Richard D'Oyly, 51, 59
Cary, Diana Serra, 102, 105–6
caste system, 221, 223
castration, of music pupils, 25–6
Catterall, James, 140–1
celebrity, 79–80
Chan, Jackie, 205
chaperones, for children, 119, 133–4
Chaplin, Charlie, 94
Chapman, Amanda Phillips, 115
Charlesworth, John, 102
che gu xi, 186, 198n4
Chen Kaige, 201
Chengdu, China, 215, 218n37
chi ku, 10, 203
Chi-tun Hsu, 188
Chiang Kai-shek, 185, 196, 199n15

Child Actor Guardians (US), 133
Child Actors' Bill 1938 (US), 103
child employment, banning of in India, 10
Child Friendly Villages, 231
child protection movement (US), 46
child trafficking, 219, 230, 231
child wranglers, 133–4
children
 the "authentic" child, 116, 132
 child entertainers as laborers, 73, 80, 87, 100–2, 112
 childhood innocence, 6, 54, 93, 100
 and commerce, 118
 as consumers of entertainment, 5–6
 defined, 52, 55
 demand for child performers, 74
 as emotional labourers, 100–2
 fetishization of, 6, 93, 97–100
 the "natural" child, 115–17, 118, 131, 132
 "pricelessness" of, 103, 109n30
 Romantic archetypes of, 6, 93, 115, 118, 192
 Taiwanese attitudes towards, 192–7
 theater outreach programs for, 7–8, 130, 136, 137–42
Children and Theatre in Victorian Britain: "All Work, No Play" (Varty), 116
Children and Young Persons Act 1933 (UK), 78, 183n25
Children (Employment Abroad) Act 1913 (UK), 52, 67
Children's Dangerous Performances Act 1879 (UK), 56
The Children's Pinafore (comic opera), 5, 51
China
 claim over Taiwan, 186
 Cultural Revolution, 210–11, 214
 economic development, 208–10, 211–12
 One Child Policy, 211, 213–14
 "Reform and Opening" program, 208, 210
Chinese song theater, role of children in, 201–16
Chinese *xiqu*, 8
Chitty Chitty Bang Bang (musical), 130
Chiung-chih Liao, 191
chuanju, 216n2
Chu-hua Chiang, 195
Cinderella (film), 94
circus performers, in India, 8, 10, 219–32
Cirque du Soleil, 230
Clark, Bruce, 112, *113*
Cline, Edward F., 96
Coaffee, Jon, 151
Coast, John, 9, 167, 168–9, 171–80
Coast, Luce, 174
Coburg Leader, 63
Coleman, Gary, 126n22
Columbia Artists Management, 168, 180
Columbia Studios, 107
comic opera, 51–2, 59, 62
Comic Opera company, 70n49
Communist Party, Kerala, 220, 221
community, 153–5
compulsory education, 52, 55–6, 61
Confucianism, 9, 185–6, 189, 192, 196–7
Connelly, Neill, 64
Connerton, Paul, 114, 125
conservatories, in Naples, 3, 15–32
Conservatorio di Musica di S. Pietro a Majella, 28
consumers, of entertainment, 5–6
Conti, Italia, 75
contracts. *See* terms of engagement
Coogan Act 1938 (US), 45, 103, 106, 120
Coogan, Jackie, 94, 102, 103, 105, 120
Cooper, Jackie, 6, 93, 96, 100, 104, 106
corporal punishment, 194–5, 204–6, 207

Costa, Gaetano, 20
Counter-Reformation, 31n18
Coward, Noel, 126n16
Cromwell, John, 95
Crosby, Bing, 179
cruelty, to children, 56, 57
 see also corporal punishment
Cruelty to Children Amendment Act 1894 (UK), 56
Culkin, Macaulay, 102, 126n22
Cultural Revolution, China, 210–11, 214
The Cultural Significance of the Child Star (O'Connor), 117
Cummings, Irving, 98

Dahl, Roald, 132
Daily Mail, 111, 112
Dalem, Anak Agung Gede Oka, 169
Dali, Salvador, 97
Dancers of Bali Tour (1952), 9, 167, 171–5, 176–80
Dare Night (performance), 153
David Copperfield (film), 95
"Dead End Kids" series, 107
"death-defying" performances, 224–9
Dene, Kathy, 85
Depression, 101, 103
Descher, Sandy, 107
The Devil is a Sissy (film), 95
Dietrich, Marlene, 97
Diplomatic Immunities: Life at Age Nine (performance), 147, 152
Disney Musicals in Schools, 130, 141
Disney Theatrical Group, 7–8, 129–42
Disney, Walt, 179
Djelantik, Bulantrisna, 184n41
Doateng, Matilda, 132
Doherty, Katherine, 136
Domenicucci, Giuseppe, 20
Domesticated animals (Nair), 221
dot.com millionaires, 118, 126n19
Douglas, Melvyn, 106
Dowson, Ernest, 116

Dramatic Recollections (solo show), 114, 122
Driscoll, Bobby, 102
Dunn, James, 101
Durbin, Deanna, 6, 93, 95, 98, 100–1, 104, 105–6
Dutch, in Indonesia, 174

Eat the Street (performance), 152
"eating bitterness," 203, 206
Eckert, Charles, 97
Education Act 1870 (UK), 52, 54
Education Act 1917 (UK), 56
Education Codes (UK), 58
education, of child performers, 84–7, 118–19, 133, 134
 see also theater outreach programs; training methods
Educational Pictures, 97
Emigration Bill 1920 (Australia), 52, 56, 64, 66
Employment of Children Bills (UK), 57
English Renaissance, 35–6
The Enlightenment, 15, 16
Etchells, Tim, 148
eunuchs, 22, 25–6
Evening Standard, 120

Factories and Infant Life Protection Acts (Australia), 55
Factory Acts (UK), 56
Fair Labor Standards Act 1938 (US), 96
Fairbanks, Douglas, 94
"family" films, 94–5
Farewell My Concubine (film), 201
Festival Ballet, 119
figlioli, 18–24, 25
filial piety, 192
film industry, in Hollywood
 change in role of child actors, 106–7
 children as emotional labourers, 100–2
 child-star films (1910–1938), 94–7

contractual and financial obligations, 102–6
end of the child-star craze, 106–7
fetishization of the screen child, 97–100
selection criteria for child stars, 99–100
stereotype of childhood innocence, 6, 93, 100
fire-breathing, 225–6
First Sino-Japanese War (1894–95), 186
Firth, Peter, 112, *113*
Fitzgerald, Rosie, 64, 71n63
Fleming, Victor, 95, 106
Florida, Richard, 151
Fonteyn, Margot, 178
Ford, Laura Oldfield, 159
Forde, Brinsley, 112, *113*, 124
Forster, E. M., 155
Foucault, Michel, 150
Fox, Caddie, 36
Fox Studios, 99, 106
"Frankie Darro" series, 107
Franklin, Chester S., 96
freedom dues, 38–9
Freshwater, Helen, 116–17
friendship, 154–7
Fu-ling Yang, 186, 193–5, 196–7
Fulton Theatre, Manhattan, 178
funeral rites, music for, 24–5

gamelan orchestras, 173
Gandhi, Leela, 155
Gangster's Boy (film), 96
Garland, Judy, 102, 106
Gattelli, Christopher, 138
The Gay Gordons, 65
geishas, 190
Gemini Circus, 221
Gentleman Joe, 65
gentrification, 151
George Formby All Star Road Show, 85
gezaixi, 8, 9, 185, 187

Gilbert and Sullivan, 51, 59, 62
Ginger (film), 97–8, 99–100, 101
globalization, 210
Go Bang (musical), 62
Goed, Ontroerend, 148
The Golden Circus, 226, 227
Gorst, Sir John, 57
Gray, Ernest, 57
Gray, Warwick, 59, 60
Great Bombay Circus, 228, 229
The Great Royal Circus, 221
Green, Alfred E., 94, 104
Greene, Graham, 97, 106
group memory, 114–15
guardianship, 40–1
Gubar, Marah, 6
Gunung Sari, 174, 175
Gusti Biang. *See* Sengog, Gusti Made
Gypsy (musical), 131, 144n13

H. M. S. Pinafore (comic opera), 51, 59, 70n49
Haim, Corey, 102
Haircuts by Children (performance), 147–8, 152, 161–2
Hakka, 187
Hakka tea-picking opera, 198n7
Halifax Cultural Plan, 163n11
Hall, Harry L., 61–2
Hall, John L., 61
Hall, Lee, 116
Hallam, Adam, 36
Hallam family, 3, 36
Hallam, Helen, 36
Hallam, Lewis, Jr., 36
Hallam, Nancy, 36
Hall's Australian Juveniles, 52, 61–3
Han Chinese, 187, 198n9
Handel, Leo, 107
Hanford, Cody, 136
The Happy Man (farce), 34
Hardt, Michael, 148
Harper, Stephen, 154
Harry Potter (films), 118

Hawes, Jo, 121
Hearst, William Randolph, 142n2
Heggie, O. P., 98
Heidi (film), 101
Henderson, Arthur, 56
Henry, Charlotte, 99
Here Come the Double Deckers (television series), 7, 111–15, *113*, 122–4
Hersholt, Jean, 101
Hicks, Seymour, 71n63
High School Musical, 139
Hinduism, 169, 170
Hine, Lewis, 143n2
Hodges, Henry, 130, 137
Hodges, Jane, 137
Hodgson, Private, 62
Hollywood. *See* film industry, in Hollywood
Home Alone (film), 118
The Honey Moon (play), 34
Hong Kong, 65
Hope, Bob, 179
How Societies Remember (Connerton), 114
How to Act Like a Kid (Hodges), 130
Howard, Caddie Fox, 36
Howard, Cordelia, 36, 38
Howard family, 4
Howard, George, 36
Howitt, William, 54
Hsin-hsin Tsai, 187
Hsu-ling Chiu, 190
Humphries, Stephen, 58

Ibu Raka. *See* Rasmini, Ni Gusti Raka
Illustrated Dramatic Weekly, 45
imperialism, 54, 58, 67, 68
indentured child labourers, 219, 222–4, 231
India, 63, 64, 65, 66, 231–2
Indian Circus Federation, 230
Indian circus performers, 219–32
Indonesia, independence of, 173–4
innocence, of childhood, 6, 54, 93
instrumental music, teaching of, 28, 29
International Alliance of Theatrical Stage Employees, 133
International Year of the Family (1994), 185
Iolanthe (comic opera), 59
Iron Rice Bowl (China), 208, 209, 213
Irwin, Mary, 81–2, 84, 89n29
Israel, Doug, 140
Italian opera, 3
Italy, unification of, 28
Ixion (burlesque), 42

Jackson, Shannon, 157
James, J. S., 54
Japan, colonization of Taiwan, 187, 197, 198n6
Jarrett, Tim, 124
Java, 64, 66
Javanese Dancers (dance troupe), 173
jingju, 205, 216n2
Jordan, David, 192
Joseph, Miranda, 153–4
JR musicals, for middle schools, 139, 143n5
The Jumbo Circus, 221
juvenile literature, 54, 58
Juvenile Opera Company, 59
juvenile troupes
 in Australasia and the East, 51, 59–66
 Dancers of Bali, 9, 167, 171–5, 176–80
 Hall's Australian Juveniles, 52, 61–3
 Juvenile Opera Company, 59
 Liddiard's Juveniles, 63–4, 66
 The Marsh Troupe of Juvenile Comedians, 3, 4, 34, 39, 40, 42–3, 44
 Merry Little Maids Opera Company, 64–6
 The Nine Dainty Dots, 81

Kalaripayattu, 220, 221
Kangxi, Emperor, 186
Kapellmeisters, 15, 20, 21, 22, 23, 27, 29
Karna, I Dewa Agung Made, 170
Kasson, John F., 100–1, 104
Kelly, Frances Maria, 114, 115, 122
Kelly, Tommy, 99
Kerala, India, 220–1
Kerala Model, 219, 220–1
Keralan circus performers, 8, 10, 219–32
Kibbee, Guy, 98
The Kid (film), 94
Kidnapped (film), 95, 106
KIDS musicals, for elementary schools, 139, 140, 143n5
Kim (film), 104
The King and I (musical), 7, 143n4
Kipling, Rudyard, 104
Kirkwood, James, 94
Knight, John, 77, 85, 89n16
Koster, Henry, 95
Kun Opera, 205
kunju, 205

La Fille de Madame Angot (musical comedy), 59
Lamb, Edel, 35–6
Lamley, Harry J., 187
Lapine, James, 132
Laurents, Arthur, 144n13
"leather straps," 227–8
legislation. *See* regulation, of child performers
legong dance, 8, 169–70, 174–5, 176, 177, 183n25
Lerman, Nina, 35
Les Cloches de Cornville (musical comedy), 59
licensing, of child performers, 73, 75, 76–8, 86
Liddiard, Fanny, 70n49
Liddiard, Tom, 63–4
Liddiard's Juveniles, 52, 63–4, 66

Li-hua Yang, 9, 187, 188–91
Lilley, Madam, 63
The Limerick Boy (farce), 34
Lion and the Unicorn (Chapman), 115
The Lion King (musical), 7, 129, 131, 132, 133, 135, 138, 144n12
The Little Colonel (film), 101
Little Lord Fauntleroy (film), 94, 95, 98
The Little Mermaid (musical), 131, 136, 138, 144n12
The Little Mermaid JR (musical), 139
Little Ming Ming, 9, 187, 188–9, 191, 193–4, 196–7
Little Miss Marker (film), 101, 102–3
Little Miss Nobody (film), 99
The Little Princess (film), 106
Locke, John, 194
Lodge, John, 101
Lohan, Lindsay, 102
Lotring, Pak Mang, 174
Ludwig, Edward, 95
Lyons, H. P., 64

MacKenzie, John, 58
Mackerras, Colin, 216
Mad about Music (film), 95
Madras, 65, 66
Madras Times, 66
Malaysia, 65, 66
Male, Sadie, 78, 80, 85, 89n22
Maloney, Jennifer, 131–2
Mammalian Diving Reflex, 8, 147–9, 152–3, 155–7, 159–62
Mammalian Protocol for Collaborating with Children, 156
Mancini, Nicola, 20
Mandarin Chinese, 188
Mandera, Anak Agung Gede, 169, 172, 174, 175, 176, 181
Mangalat, Mahesh, 221
Mario, I, 175, 176, 177
Marsh, George, 34
Marsh, Mary, 34
Marsh, Robert G., 3, 4, 33–4, 37–44

Marsh-Stewart contract, 3–4, 33–4, 37–46
The Marsh Troupe of Juvenile Comedians, 3, 4, 34, 39, 40, 42–3, 44
martial arts, Kerala, 220
Mary Poppins (musical), 7, 130, 131, 133, 135, 136, 138, 144n12
Matilda (musical), 120, 132
matrons, for child performers, 60–1, 75, 81–3
Mattei, Saverio, 27
Mazer, Katie, 151
McLeod, Norman Z., 99
McPhee, Colin, 174, 175
Melbourne, 54
Menjou, Adolphe, 101
mental health problems, for child performers, 102
Merry Little Maids Opera Company, 52, 64–6
The Merry Widow (operetta), 65
Mershon, Katharane, 179
Metro Nashville Public School, 141
MGM, 95, 104, 106, 107
Mickey McGuire (film), 96
military training, at school, 58
Min Nan, 188
Ming-chi Chen, 190
Ming Hsia opera troupe, 189
Ming-hsueh Hung, 9, 187, 188–9, 191, 193–4, 196
Ming Hwa Yuan Arts and Cultural Group, 185, 189, 190, 200n25
Ming Ming. *See* Little Ming Ming
Minnan, 187
mistreatment, of children, 66
Monogram, 107
Montgomery, Baby Peggy, 94
moral panics, 1–2, 53, 64, 65, 66–7
Morocco Bound (musical), 62
Murganza, Ferdinando, 20
music copying, 21
Music Theatre International, 143n5

musical patronage, in Naples, 24–6
musicians, training of, 3, 15–32
Myers, Madge, 64, 71n64

The Naiad Queen (play), 34, 39
Nair, M. T. Vasu Devan, 221
"Nancy Drew" series, 107
Naples. *See* Neapolitan music industry
National Studios, 107
National Vigilance Association (UK), 73
the "natural" child, 115–17, 118, 131, 132
Nautical Art School, Naples, 18, 31n9
Nautical studies, 18
NBC, 124
Neapolitan music industry, 15–32
Neapolitan School of Music, 19
Negri, Antonio, 148
New Amsterdam Theatre, 135
The New Barmaid (comic opera), 62
New Orleans Picayune, 39, 42
New York City public schools, arts education in, 140–1
New York Clipper, 41–2, 43
New York Journal, 142n2
New York Times, 39, 99, 100, 132
New York World, 142n2
newsboys' strike, 142n2
Newsies (musical), 129, 131, 138, 142, 144n12
Nichols, George, Jr., 105
Nicomachean Ethics (Aristotle), 155
Nigh, William, 96
Nightwalks with Teenagers (performance), 153, 157–9, 161
The Nine Dainty Dots, 81, 84
Nutcracker (ballet), 119

O'Brien, Margaret, 107
O'Connor, Jane, 117–18, 121–2, 124–5
O'Donnell, Darren, 147
Oka (dancer), 167, 172, 174

The Old Woman Who Lived in a Shoe (pantomime), 64
Olds, Kelly B., 189, 191
Oliver! (musical), 7
On Location Education, 134
Once and for All We're Gonna Tell You Who We Are So Shut Up and Listen (performance), 148
One Child Policy (China), 211, 213–14
One Hundred Men and a Girl (film), 95, 101
One-Way Street (Benjamin), 160
opera
 Beijing Opera, 185, 188, 195, 198n7, 205, 214–15, 216
 Chinese song theater, 202–16
 comic opera, 51–2, 59, 62
 Gilbert and Sullivan, 51, 59, 62
 Hakka tea-picking opera, 198n7
 Italian opera, 3
 Kun Opera, 205
 Sichuan Opera, 215–16, 216n8
 Taiwanese opera, 8, 9, 185–97, 198n4
 Yue Opera, 205
 see also *names of specific operas*
The Original Pollard's Australian Juvenile Opera Company, 67
Orozco, Lourdes, 148
orphans and orphanages, 17–19
Osborne, Baby Marie, 94
Otago Witness, 64
Our Gang (short films), 100, 107
Our Little Girl (film), 101
The Owl, 61

Pall Mall Gazette, 59
pantomime, 60, 64
Paramount, 99
paranza, 25, 26, 32n19
parents
 as business managers, 49n58, 101–2, 103–4
 as custodians of children's earnings, 38, 120, 126n22
 parental consent for child performers, 78
 "proper" parents, 117
 "show" parents, 102, 131, 134
Paris Expo (1931), 175
Parkdale neighbourhood, Toronto, 151–2
Parkdale Public School, Toronto, 147, 152
Parkdale Public School vs. Queen Street (performance), 152
Patience (comic opera), 62
patronage. See musical patronage
Paul Jones (musical), 62
Peck's Bad Boy (film), 96
Peking Opera, 185, 205, 216
Peliatan, Bali, 171–2, 174, 175, 180
Penang, 66
Penghu islands, 186–7
"penny dreadfuls," 53–4, 58
"penny gaffs," 53–4
philanthropic outreach programs, 137, 139–42
Philippines, 64, 66, 194
Phillips, Steven, 188
Phoenix, River, 102
Photoplay, 102, 104–5
physical punishment. See corporal punishment
piazza, 19, 21, 29, 31n10
Pickford, Jack, 94
Pickford, Mary, 94
Pietà dei Turchini, 17, 29, 31n14
Pirates of Penzance (comic opera), 59
Pogrebin, Robert, 132
Pollard, Arthur, 66
Pollard family, 52, 62
Pollard's Juvenile Opera Company, 62, 67
Pollard's Liliputian [sic] Opera Company, 62, 65, 66
Pollyanna (film), 94
The Poor Little Rich Girl (film), 94, 98–9, 101

248 Index

Poveri di Gesù Cristo, 17
Powell, Paul, 94
Prajisha (circus performer), 228–30
Preminger, Otto, 95
Prevention of Cruelty to Children Act 1889 (UK), 73
Princess Ida (comic opera), 59
Princess Theatre, Melbourne, 4
The Producers of Parkdale (performance), 156
Production Code (US), 94, 108n4
propaganda, 75, 102
Pulitzer, Joseph, 142n2
punishment, of children, 194–5, 204–6, 207
"pushy parent" syndrome, 101–2

Qing dynasty, 186, 189, 192, 227
Queen, Frank, 42
Quimby, Ian, 37, 38

Railroad of Death (Coast), 173
Rambo, 230
Rangoon, 64
Rankin, Katharine, 151
Rasmini, Ni Gusti Raka, 9, 167–9, 171–81
Ratnan, Sanjay, 152
Rayman Circus, 221
Real Collegio di Musica di San Sebastiano, 28
The Red Hussar (comic opera), 62, 70n44
redemption, of the soul, 31n18
Redgrave family, 5
"Reform and Opening" (Chinese reform program), 208, 210
regulation, of child performers
 in Australia, 4, 52, 61, 69n19
 evasion of child protection laws, 78, 86–7
 licensing of child performers, 73, 75, 76–8, 86
 in the UK, 4, 52, 54–7, 59–60, 67, 73–4, 78, 119–22, 183n25
 in the US, 45, 96, 103, 106, 120, 133
 see also terms of engagement
relational art, 162n1
religious rites, music for, 24–5
remuneration
 Actors Equity rates (UK), 145n24
 Actors Equity rates (US), 134
 Balinese child dancers, 180–1, 184n41
 child actors in 19th century America, 38, 48n31
 child television actors in the UK, 119–22, 125n1
 child's right to own income, 45
 Chinese opera performers, 209, 212, 215
 Disney child actors in 2013 (US), 134–5, 145n25
 exploitation of children's earnings, 103–6
 income protection in the UK, 119–22
 payment to children's parents, 38, 120, 126
Republic Studios, 107
Ridout, Nicholas, 148
Riis, Jacob, 143n2
The Rise of the Creative Class (Florida), 151
River Kwai, Thailand, 173
Roach, Hal, 100, 107
The Road to Bali (film), 179
Robbins, Jerome, 144n13
Rogers, John, 38
Romantic ideals, of children, 6, 93, 115, 118, 192
Rooney, Mickey, 95–6, 100
Roosevelt, Theodore, 95, 101, 142n2
Rorabaugh, W. J., 35, 37
Rousseau, Jean-Jacques, 115
Rowan & Martin's Laugh In (television show), 124
The Royal Circus, 226–7, 228, 230
Royal Shakespeare Company, 120
Russ, Debbie, 112

Sampih (dancer), 175, 177, 181
Sankaran, M. V., 221, 223
Santa Maria di Loreto (conservatory), 17, 18, 29, 31n9, 32n22
Sant'Onofrio a Capuana (conservatory), 17, 24
Sardi's Restaurant, New York, 179
Satyarthi, Kailash, 230
Scarlatti, Alessandro, 32n22
Schang, Freddie, Jr., 175–6, 178
Schiller, Friedrich, 115
schooling. *See* education, of child performers
Schumacher, Thomas, 130–1
Scott, Clement, 5
Scott's theater, Pietermaritzburg, 62
Scuola Musicale Napoletana, 16
Seccumbe, Mr (manager), 63
Second Anglo-Boer War, 61
Secunderabad, 64, 66
Sellon, Charles, 101
Selznick, David O., 95, 99, 106
Sengog, Gusti Made, 174–5
The Senior Strings vs. Blocks Recording Club (performance), 152
sexualization, of circus performers, 229, 230
Shanghai, opera troupes in, 218n37
Shastri Indo-Canadian Institute, 10
Shintoism, 198n9
Shirer, Natalie, 152
Shirley, Anne, 104–5
Shirley, Mimi, 104–5
"show parents," 102, 131, 134
Shrimpton, Debbie, 135
Shun-lung Wang, 187
Sichuan Artistic Institute, 215
Sichuan Opera, 215–16, 216n2
Sichuan Opera School, 10, 202–6, 208–9, 211–13, 215
Silcock, Jean, 78, 81, 83, 89n20
silent films, 94
Simmonds, Douglas, 112, *113*
Singapore, 63, 64, 65, 66

Singleton, J. J., 136
Slaughter, Walter, 71n63
slavery, 219, 222
Sleeping Beauty (ballet), 119
Slote, Walter, 196
Smalley, Ross, 123
Smith, C. Aubrey, 101
Soekarno, President, 9, 167, 173, 175
Solomon, Edward, 62, 70n44
Sondheim, Stephen, 144n13
song drama, Taiwanese, 8
The Sound of Music (musical), 7, 143n4
South Africa, juvenile troupes in, 61–3
Spaulding and Rogers' Museum and Amphitheatre, 40, 42–3
Spaulding, Gilbert "Doc," 40, 42, 43
Springgay, Stephanie, 157
Springhall, John, 1, 53
stage mothers, 102
stage schools, 45–6, 118
Stanley Opera Company, 63
Staples, Terry, 99
Stealth Pedagogy, 156
Stephen, H. P., 62
Stewart, Alfred, 3, 33–5, 37–46
Stewart, Hannah, 33–4, 37, 40–5
Stewart-Marsh contract, 3, 33–4, 37–46
Straits Times, 65
Styne, Jules, 144n13
Sumatra, 66
Sun, 112

Ta Chen Feng opera troupe, 189
Ta Peng Academy, 195
Taiwan Garrison, 188
Taiwan, historical vicissitudes, 186–7, 196, 199n15
Taiwanese opera, 8, 9, 185–97, 198n4, 199n16
talent-hunts, for child performers, 99, 112, 116
Tanglin Barracks, Singapore, 64
Tanner, J. T., 62
Tarzan (musical), 131, 144n12

Taurog, Norman, 95, 99
Taylor, Elizabeth, 107
Tellicherry, Kerala, 221
Temple, Gertrude, 102
Temple, Shirley, 6, 93, 95–102, 103–4, 106
Tennessee Performing Arts Center, 141
terms of engagement
 in 19th century England, 60, 74
 Australian juvenile troupes, 4–5
 Disney child actors, 135–6, 143n4
 Hollywood child stars, 95–102
 indentured child labourers, 222–4
 the Marsh-Stewart contract, 3–4, 33–4, 37–46
 Neapolitan music apprentices, 18, 25, 30n2, 31n13
 per diems during touring, 143n8
 standard Equity Production Contract (US), 136
Terry, Ellen, 46
Terry family, 5
Terry, Minnie, 116
Thane, Sarah, 120
That Certain Age (film), 95, 106
That Night Follows Day (performance), 148
theater
 in 18th century Naples, 26–7, 28
 acting as "play," 75, 116, 121
 apprenticeships in the English Renaissance, 35–6
 child actors in 19th century America, 33, 45
 child troupes in Australasia and the East, 51, 59–66
 Disney theater education programs, 130, 137–9
 Disney Theatrical Group, 7–8, 129–42
 "penny gaffs," 53–4
 professional acting schools, 45–6, 118
 propaganda about child performers, 75
 role of children in Chinese theater, 201–16
theater outreach programs, 7–8, 130, 136, 137–42
theatrical agencies, 5, 120
Theatrical Children's Licensing Committee Report (UK), 75, 76, 77, 84
Thompson, Lydia, 42
Thoroughbreds Don't Cry (film), 104
Three Smart Girls (film), 95, 98
Three Smart Girls Grow Up (film), 95, 100
Tobacco Monopoly Bureau, Taipei, 199n15
Tocqueville, Alexis de, 96
Toronto *Nuit Blanche 2012* (show), 153, 156
The Torontonians, 148–54, 156–8, 160–2
Tough Guy (film), 96
Tourneur, Maurice, 94
training methods
 Balinese *legong* dance, 8, 170, 174–6
 child actors in antebellum America, 35–6, 39, 45
 child musicians, 3, 15–32
 Chinese opera, 8, 10, 201, 202–8
 Indian circus performers, 10, 224, 225–6
 for the stage, 4, 118
 Taiwanese opera, 8, 185, 193–7
The Transit of Venus (comic opera), 62, 70n44
Travers, Mary, 144n12
Tsui-feng Sun, 200n25
Twain, Mark, 96
Two Cheers for Democracy (Forster), 155

Uncle Tom's Cabin (play), 36
underprivileged children, theater programs for, 139–42
UNESCO, 185

Index 251

unions, 121
United Kingdom
 child performers in (1920–40), 73–87
 children in the population (1851–81), 68n6
 Dancers of Bali Tour (1952), 177–8
 education of child performers, 84–7
 protection of payments to child performers, 119–22
 regulation of child performers, 4, 52, 54–7, 59–60, 67, 73–4, 78, 119–22, 183n25
United Nations Convention on the Rights of the Child, 156
United States
 child actors in the 19th century, 33
 Dancers of Bali Tour (1952), 178–9
 Disney Theatrical Group, 7–8, 129–42
 film studios establish Production Code, 94, 108n4
 regulation of child performers, 45, 96, 103, 106, 120, 133
Universal Studios, 95, 100, 106, 107
urbanization, 53

Van Dyke, W. S., 95
Varty, Anne, 116, 117, 121
Venable, Evelyn, 101
Vey, Shauna, 87
Victoria (artist), 148
Victoria (state), compulsory education in, 55
Victoria Theatre, Singapore, 65

walkwalkwalk, 159
Wallace, Mr and Mrs, 81
Warchus, Matthew, 132, 144n16
Warden, Edward, 41–2
Warner Brothers, 107

Washington trapeze, 224–5
Watling, Lindsay, 120–1
Wee Willie Winkie (film), 101
Wei-ming Tu, 192
West, Mae, 97
Williamson, J. C., 67, 70n49, 71n63
Winninger, Charles, 98
Winter Garden Theatre, London, 177
Withers, Jane, 6, 93, 97–8, 99–100, 102, 105, 106
The Wizard of Oz (film), 106
women, Confucian view of, 189, 197
Wordsworth, William, 115
work, as a means of social control, 17
working conditions, for child performers
 British child television actors, 112
 British child theatre actors, 74–5, 80–1, 82–3, 88n2
 Chinese opera performers, 204–6, 207
 Indian circus performers, 222–30
 Taiwanese opera performers, 194–5
Wray, John, 98

xiaosheng, 188, 189, 190, 191
xiqu, 8, 10, 202, 205, 215

Yi Chen, 188
Yilan, 186
YMCA, 58
Young, J. A. F., 65
Young, Sylvia, 121
Youth, Popular Culture and Moral Panics (Springhall), 1
Yue Opera, 205
yueju, 205
YWCA, 58

Zierold, Norman J., 106
Zukin, Sharon, 151

GPSR Compliance
The European Union's (EU) General Product Safety Regulation (GPSR) is a set of rules that requires consumer products to be safe and our obligations to ensure this.

If you have any concerns about our products, you can contact us on

ProductSafety@springernature.com

In case Publisher is established outside the EU, the EU authorized representative is:

Springer Nature Customer Service Center GmbH
Europaplatz 3
69115 Heidelberg, Germany

www.ingramcontent.com/pod-product-compliance
Lightning Source LLC
LaVergne TN
LVHW011811060526
838200LV00053B/3740